EDITED BY

MARK FRANKO AND

ANNETTE RICHARDS

ACTING ON THE PAST

Historical Performance Across the Disciplines

Wesleyan University Press

Published by University Press of New England

Hanover and London

Wesleyan University Press

Published by University Press of New England, Hanover, NH 03755

© 2000 by Wesleyan University Press

All rights reserved

Printed in the United States of America 5 4 3 2 1

CIP data appear at the end of the book

The editors would like to express their gratitude to the Getty Research Institute
for the History of Art and the Humanities, where this book was conceived
in 1994–95 during the scholar year devoted to Memory.

CONTENTS

I. Absent Bodies Moving through Time

II. From Authenticity to Performativity

III. Re-Enactments

SUSAN MCCLARY

JAMES MILLER

ACTING ON THE PAST

MARK FRANKO AND

ANNETTE RICHARDS

1. Actualizing Absence: The Pastness of Performance

THE EXUBERANT presence of performance masks an intrinsic absence. Necessarily temporal and temporary, performances are always in a state of appearing and vanishing; by definition transient, they are immediate yet quickly become historical. Performances of the distant past, however, those precluding personal or collective memory, raise with particular urgency the issue of absence. When the historian, archival inscriptions in hand, revisits the deserted site of display, the vivid presence of the performance is long gone. It is then that memory passes through theory by virtue of cultural necessity and the historian's interpretation becomes the prosthesis of an imaginary performative practice, returning theory to its etymological roots in vision and speculation.[1] Absent performative events have conceptual, imaginary, and evidential, as well as actively reproductive bases. They are especially characterized by movement between present and past, one in which archive and act, fragment and body, text and sounding, subject and practice, work in provocative interaction; it is the movement between past acts, texts, and their present-day interpreters that is central to historical performance studies as we conceptualize it in this volume. The essays collected here seek to reconfigure the epistemological status of the past as a theoretical activity of the present (or of other, subsequent past times) that becomes actual in and as critical performances. This collection pursues questions of historical imagination, ideology, and visuality as they relate to this new discipline-across-the-disciplines.

Performance studies originated in the 1960s and 1970s as a theoretical counterpart to avant-garde theater, informed by new developments in cultural anthropology and poststructuralist theory. Scholars tested the traditional fields of dance and theater history against an expanded field that included non-European theater, sports, ritual, and festival, and realized that the separation of performative endeavors into disciplines was an arbitrary product of Western cultural genres. A consequence of this expansion, however, appears to be an unavowed "presentism" in the dominant context of the modern. In keeping with presentism, immediacy and disappearance are currently key words in per-

formance studies. "One of the chief jobs challenging performance scholars," writes Richard Schechner, a founder of the field, "is the making of a vocabulary and methodology that deal with performance *in its immediacy and evanescence.*"[2] Given these consecrated theoretical motifs—immediacy and disappearance—it is not surprising that the two disciplines dominating the field have been ethnology and psychoanalysis, "the two great 'counter-sciences' of the twentieth century," as Hayden White has called them.[3] For both, the distant past is a construct of insufficient heterodoxy. The notion of presentness and its concomitant untraceable disappearance is confounded with immediacy, as it fades before our sight and hearing.[4]

But the past, and the performances to which the historical record attests, are *not* immediate and evanescent: they are absent, and yet they are the agents of spectral revisitings. Indeed, the pastness of performance has recently come to figure more centrally in performance studies. If performance is understood as "restored behavior," as fundamentally repetitive or reiterative,[5] (though the memory it retraces need not be authentic), it necessarily brings back the past to unsettle the present. In her introduction to *Performance and Cultural Politics* (1996), Elin Diamond theorizes performance as a site of contestation, where politics and identity are mapped out against a taught mesh of present and past.[6] This is the theme of Joseph Roach's groundbreaking *Cities of the Dead* (1996), in which Roach shows how, in the "circum-Atlantic interculture" he describes, history is transmitted through "gestures, habits, unstudied reflexes, [and] ingrained memories" and identity is constructed through performances of remembered and misremembered tradition.[7] What if the performative present were theorized as a trace operating "in reverse," a present coming into being rather than trailing off into nonexistence, whose return occurs within the visible and audible as material but not immediate? This complication of our understanding of the present figures performance as dynamic yet ghostly, informed by movements engaging other temporal dimensions—absent yet palpable.

What has remained relatively undeveloped in this field is the study of early modern performance, that is, performance up until the eighteenth century. Pre- and early-modern performances are neither wholly accessible textually (although the study of texts in this field is paramount) nor available through participant-observer process as lived and personally experienced, or as collectively remembered, events. This doubly incomplete status with respect to both text and event opens onto the question of absence; if texts are no longer the containers of the truth, and if events remain unavailable in their visceral facticity as "done deeds," then act and text can be summoned to redefine one another in or as the performative presence of interpretation. Each essay in this collection, whatever its particular subject, engages with movement from the historical past to the "reconstructive" past or present. The multifaceted understanding resulting from this movement proves to be extraordinarily fecund. It

yields gestures of interpretation and critical vision in writing and performing alike which connect these essays across their temporal and disciplinary borders. While the essays gathered here range from discussions of tragedy, music, rhetoric, spectacle (opera and ballet), and festival to sculpture, literature, photography, performance art, and critical theory, their main point is not the disruption of disciplinary boundaries *per se*, though the destabilization of these frontiers is a clearly recognizable, and not unwelcome, byproduct of performance studies. Rather, *Acting on the Past* is intended primarily as a critical intervention in performance studies, a challenge to the field to conceptualize the past and thus also to historicize itself.[8]

In the first section, "Absent Bodies Moving through Time," Karen Bassi's essay "The Somatics of the Past" explores the absence of a body (the spectacle) from the theoretical construct of Aristotle's *Poetics*. Taking as her starting point the conceptual but also palpably technical example of Muybridge's stop-action photography, Bassi describes the disintegration of past movement into discrete and frozen moments, like single photographic images; these moments constitute fragments of evidence which necessarily confront the epistemological problem of the past body in motion. In its reconsideration of the dynamic interplay between absence, evidence, and interpretation, Bassi's essay thus serves as a second introduction to the issues of this volume. The photographic image, which Bassi relates to the function of "autopsy," informs the historian's subsequent investigation into the actual place and theatrical identity of Helen's body in ancient tragedy, particularly in Euripides' *Helen*. Bassi explores Helen's multiple locations in different literary genres as a phenomenon of the disavowal of bodily absence that founds the very theory of tragic performance. Further, Bassi problematizes Helen's "place" as a feminine body in the terms of masculine discourse, and her examination of textual fragments links the epistemological dilemma of the body's absence to the sociological situation of woman's place in Greek culture. Here, absence gains a political dimension.

The notion of absence in performance has been dealt with through both ontology and performativity. In the first case, the "disappearing" character of live performances allows for contested identities to emerge, yet also to remain to a significant degree invisible. In the case of performativity, the reiterative potential of performance both fashions subjectivities and reveals that which those subjectivities do not aver. In both cases, the issue of visibility/invisibility leads to an inquiry into the politics of performance. Mark Franko's "Figural Inversions of Louis XIV's Dancing Body" explores the uncertainty of visibility, as political power and dance mold and contort the figure of the Sun King in seventeenth-century France. Franko shows how visibility and vision are destabilized in the interplay of omnipotence, omnipresence, and omniscience. As the symbolic becomes real in live performance, the king's dance functions as its own critique of monarchical power: the dancing body is a contested site

where the immediate force of the performative present calls into question the paradoxical power of the king's physical absence. Franko interprets a palimpsest of images of the dancing king, in modern reconstructions and postmodern deconstructions of baroque dance, and in verbal and visual depictions of the king's dancing body from his own lifetime. These images, refracted through theory, function as the working proposition for a "figural inversion" in which the baroque and the postmodern mirror and complete one another. By the very fact of its own movement of deferral and mirrored self-consciousness, dancing's absence to itself is revealed as a power mechanism of royal propaganda.

The ventriloquistic potential of performance to re-member an absent body, functioning as a prosthetic "operation" in its own right, is the subject of "Writing the Breast, Performing the Trace," by Joseph Roach and Shelby Richardson. In Fanny Burney's famous account of her mastectomy operation, and its reiteration in a contemporary performance art work by Carol McVey, performance is a necessarily harrowing experience where notions of reconstruction and healing coalesce in the ambiguous term "recovery." Roach and Richardson describe a sort of prosthesis whereby an absent body reaches with almost tactile powers into a "present" moment from which it had seemed excluded. It is the physical gesture of writing that enables this courageous gesture, both in Burney's composition of the "mastectomy letter" and in her novel *The Wanderer*, in which Burney's experience is histrionically reactivated. Issues of absence and performativity converge, to complicate and perturb our grasp of the present as well as our understanding of the relation of text, writing, and performance in the past. The performance of writing introduces a notion of deferral that is integrally connected to its function as recovery. Performance becomes a strategy for survival rather than an act of memorialization.

This transhistorical motion of bodies between visibility and invisibility resonates with that of marble figure sculpture in Catherine Soussloff's essay "Like a Performance." Introducing the second section of our collection, "From Authenticity to Performativity," Soussloff examines the historical pressure of classical statuary's performance as sent forward in time since the seventeenth century, first in Bellori's historiography, then in photographs of black bodies by Robert Mapplethorpe and Leni Riefenstahl. She points simultaneously to the unacknowledged historicity at work in the concept of performativity, as imported from philosophical discourse on speech acts. Indeed, a growing interest in "performativity" has brought the status of the past to the condition of theoretical crisis.[9] Soussloff shows how the issue of performance/performativity has to be made present here to deal with the absence of the historical in performance studies. Her essay indicates that Jacques Derrida's position in the speech act debate between himself and John Searle needs to be revisited, for the concept of performativity inherited from Austin by Searle addresses more than the location of agency in persons or in acts; it also serves subtly but forcefully to displace any notion of pastness from the concept of performativity.

Derrida's focus on "absence" (*l'absence*) and "remainder" (*la restance*) in his essay "Signature Event Context" points up this problem in Austin and Searle. Derrida contests the transparency accorded words by the context of their communication *in the present*. The presentism of Austin's conditions for a felicitous speech act, Derrida argues, masks the fact that language, understood as one of many forms of communication, remains and continues to communicate in the absence of its original interlocutors—a fact that is determinant for all communication. Furthermore, this essay brings into relief the significant semantic differences in Derrida's own critical vocabulary by comparing his use of "mark" (*la marque*) with that of "trace" (*la trace*).[10] The term *absence* calls forth the notion of remainder inherent in the mark. This remainder of the past, unlike the dematerialization suggested by the term *disappearance*, hints instead at the nagging presence of something material. Traces may fade completely, but marks tend to remain, like scars, yet without immediate reference to the present. Performance studies needs to consider, and to interpret, that which remains, persists, and returns. Marks are, in the most mundane sense, the archives themselves, which do not disappear unless we ignore them, forget how to work with them, or destroy them.

Mary Carruthers' essay "Rhetorical *Ductus*, or, Moving through a Composition" investigates the problem of absent activity in the performance of actions immanent to physical practices in social life. Carruthers assimilates a rhetorical principle to physical performance in medieval monastic liturgy, invoking the rhetorical concept of the "ductus" to explore the concept of movement that is inseparable from rhetorical composition. Carruthers describes the medieval experience of a composition as an active performance of memory constituting increasingly organized and disciplined motion: in the journey through the piece (or prayer), wandering becomes walking becomes dancing, as sound and motion are brought together in a community of meaning. Her study of the performativity of rhetoric implies that it is difficult, if not impossible, to understand performance as disappearance rather than as absence, for "ductus," although "without specific subject matter," is "something in the work itself." Carruthers' essay, like the one that follows by Annette Richards, focuses on the movement described by the historian's own process of interpretation. This movement is one from past to present, one that unsettles the notion of authenticity and of a clear reference point in historical time as origin. Both essays reflect on the concerns of the collection as a whole with absent bodies and the textual and artistic procedures meant to recuperate or account for them. These themes are, therefore, both historically interested and historiographically motivated. Since the 1980s notions of authenticity in historical music and dance practice have been increasingly problematized, as projects of reconstruction are faced with complex issues of interpretation.[11] *Acting on the Past* seeks in part to establish further theoretical grounding for interpretation, whether of particular performance modes, or of cultural performance,

and points in turn to performances within which critical insight and artistic reflection join. Annette Richards' essay, "C. P. E. Bach's Free Fantasy and the Performance of the Imagination" turns to a late eighteenth-century musical genre grounded in improvisation, one in which compositional artifice is aimed at creating the illusion of instantaneous invention-in-performance. C. P. E. Bach is the central figure, the "original genius," in a culture where performance takes precedence over text. Like an oration, the fantasia foregrounds temporality and persuasion, as the unstable and exciting exchange between performer and listener subverts formal narrative control. Performativity in this case is the domain not of the improviser alone, but of the listeners who are called upon to perform their own interpretations of fantasy. Richards' essay shows how the fantasia by definition escapes historically fixed, authentic performance practice.

A performative genre such as the fantasia invites a reconsideration of the relation between text and performance. Richard Schechner has pointed to the 'subjunctive mood' of performance texts, the "as if" of those texts which, with each performance, are always subject to revision.[12] But as the performance undermines textual authority, the text may in reverse affect the creative process itself. As Adorno comments, "notes are of course more than just directions for performance: they are music objectivized as text."[13] The immediate effect of the musical text is to "freeze" dynamic motion, to negate time in the work: the successive events of a piece of music are "held spellbound in simultaneity, in stasis"—and yet, paradoxically, that stasis allows for the complex patterning that constitutes dynamic musical form. John Butt's essay "Performance on Paper" explores the uncertain status of the musical score and its historical contingencies. Illustrating how even apparently complete texts cannot be assumed to convey monolithic authority, Butt suggests that, in their mediation between present and past, they bear a polyvalent and ambiguous relation to performance. While the other essays in this collection present historical interpretation as performance and as performative, Butt reminds us that historical performance is itself interpretation, remapping the boundaries between production, reproduction, improvisation, and imagination.

The essays in the third and final section, "Re-Enactments," examine performativity in performances past and present, and unveil their underlying historicity. Carolyn Dean's essay "The Ambivalent Triumph" investigates the subversive dissonance between the visible and the invisible, as past is folded onto the (also by now past) present in the performing subaltern body from the sixteenth to the eighteenth centuries. The dominant Spanish colonial powers in Peru sustained the project of eradicating Andean Indian culture with performances that incorporated Inka festival elements and constantly made present the Andean past. Native bodies deployed to enact dramas of conquest and integration fostered a troubling dilemma for the conquerors; whereas the "vanquished" culture might seem "incorporated" according to previous inter-

pretations, and thus in some sense stilled, Dean shows that it was in fact "composited." This conjunction of history and culture continues in modern Cusco as the Corpus Christi festival is revived and restaged annually in a paradoxical assertion of traditional Andean culture. The performance of alterity in colonial Cusco was a performance of conversion, conquest, and resistance all at once; Dean's depiction of ambivalence in the eyes of the Spanish beholder points to a complex performance: visible and invisible, absent but also present.

The power of performance (especially in dance and music), figured as the seductive power of the sensual over the rational, is covertly, indeed sometimes overtly, gendered. Performances entice like Sirens, whose music, in the myth of Odysseus, is itself performative—for their song is a curse that induces men to suicidal action. The hero Odysseus is able to thwart the power of the song only by tying himself to the mast of his ship; by immobilizing himself, and thereby reducing himself to the status of passive listener, he renders the musical performance impotent: the Sirens' song is objectified and therefore, paradoxically, achieves the status of art.[14] If text-based scholarship has tended to suppress the dynamic performance in favor of the frozen, notated work, positing a silent art object divorced from its sounding representation, Susan McClary's essay "Gender Ambiguities and Erotic Excess in Seventeenth-Century Venetian Opera" writes the singing body back into history, simultaneously raising questions of transfer and reflection between past and present performances of sexualities.[15] McClary describes the dizzying conflict between potency and authority constituted by the problematic figure of the castrato, the deliberately twisted focus of erotic desire closely akin to the androgynous late-twentieth-century rock star. Rather than appear as a predecessor, however, the castrato raises questions of a negative model, one whose impact has all but receded from history, and yet can be salvaged and investigated by the historian.

In a tour de force of transhistorical criticism, James Miller's essay "Christian Aerobics" explores the repression of erotic excess in physical tropes that have survived over nearly two millennia. These tropes, which originally constituted the Catholic saltator's physical training as described in the texts of Saint Ambrose and Saint Augustine, echo uncannily in a contemporary practice in Christian fundamentalist aerobic videos, at once a commodified performance and a moral allegory of the religious right keeping in shape. Movement and sexual politics, the presentation and representation of queer identity are collapsed into one another by the historian's performance. Miller's essay provides a virtuosic demonstration of what can be achieved as a result of new theoretical and methodological interactions among performance, archival research, and cultural and aesthetic theory.

Considering the diversity of critical constructs deployed in *Acting on the Past*—autopsy, figural inversion, recovery as prosthesis, performativity, ductus, fantasia, notation/recording, composite, erotic excess, and afterlife—"historical" performance clearly must imagine not a single authentic original but

multiple possibilities upon which to base interpretation and reconstruction. By considering performance both as theoretical abstraction and as historically specific instance, investigating performance in and for its absence (performance in history) as well as historicized presences (contemporary performances that present—foster as actual—past acts), the collection as a whole presents an exploration of bodies and sounds as conveyors of formally determined, ideologically imbued actions. These practices—absent not only because they are far from us, but because they were always both visible and invisible, audible and inaudible—constitute a new field of study, which this volume introduces. What compels scholars of performance to confront the past now? *Acting on the Past* submits that the problem of the past has long been an underexplored and undertheorized domain of performance studies. When the past becomes a performative category, theory rushes in with new interpretive configurations for anthropology and history. The absence of past performance is marked by its flagrant returns or re-enactments, visible and audible evidence that revises our ever changing sense of the disappearing immediate.

NOTES

1. See the Oxford English Dictionary, s.v. "theory": "A looking at, viewing, contemplation, speculation, theory, also a sight, a spectacle."

2. Richard Schechner, *Between Theater and Anthropology* (Philadelphia: University of Pennsylvania Press, 1986), 50 (our emphasis).

3. Hayden White, *Tropics of Discourse: Essays in Cultural Criticism* (Baltimore: Johns Hopkins University Press, 1978), 245.

4. That which by definition disappears is considered to escape memory, and therefore history (even with a small h): "The performative utterances of negativity cannot be absorbed by History." Peggy Phelan, *Unmarked: The Politics of Performance* (London: Routledge, 1993), 165.

5. This is Richard Schechner's definition of performance. See Schechner, *Between Theater and Anthropology*, 35.

6. Elin Diamond, *Performance and Cultural Politics* (London: Routledge, 1996).

7. Joseph Roach, *Cities of the Dead: Circum-Atlantic Performance* (New York: Columbia University Press, 1996). Other influential recent collections that include chapters reaching back at least to the eighteenth century are Elin Diamond, ed., *Performance and Cultural Politics*; Susan Foster, ed., *Choreographing History* (Bloomington and Indianapolis: Indiana University Press, 1995); Della Pollock, ed., *Exceptional Spaces: Essays in Performance and History* (Chapel Hill: University of North Carolina Press, 1998); Janelle Reinelt, ed., *Crucibles of Crisis. Performing Social Change* (Ann Arbor: University of Michigan Press, 1996); and Peggy Phelan and Jill Lane, eds., *The Ends of Performance* (New York: New York University Press, 1998).

8. A first sign of movement toward historicization is clear in Marvin Carlson's *Performance: A Critical Introduction* (London: Routledge, 1996). Carlson not only historicizes the field of performance studies, but also challenges the obligatory reference of contemporary performance art to the historical avant gardes.

9. The work of Judith Butler in the philosophy of speech act theory has probably

been the most influential in the field of performance studies in recent years. See her *Gender Trouble: Feminism and the Subversion of Identity* (London: Routledge, 1990).

10. Jacques Derrida, "Signature Événement Contexte," in *Marges de la philosophie* (Paris: Editions de Minuit, 1972). This essay is translated by Samuel Weber as "Signature Event Context," in *Limited Inc* (Evanston: Northwestern University Press, 1988).

11. For more on the question of authenticity in music and dance, see Laurence Dreyfus, "Early Music Defended against Its Devotees: A Theory of Historical Performance in the Twentieth Century," in *The Musical Quarterly* 69, no. 3 (Summer 1983): 297–322; and Mark Franko, "Repeatability, Reconstruction and Beyond," in *Theatre Journal* 41, no. 1 (March 1989): 56–74. For more general discussion of authenticity and performance, see Richard Taruskin, *Text and Act: Essays on Music and Performance* (Oxford: Oxford University Press, 1995). See also Simon Frith, *Performing Rites: On the Value of Popular Music* (Cambridge, Mass.: Harvard University Press, 1996), esp. chapter 10.

12. Richard Schechner, *Between Theater and Anthropology*, 37.

13. Theodor W. Adorno, *Quasi una fantasia*, trans. Rodney Livingstone (London: Verso, 1992), 296.

14. See Max Horkheimer and Theodor W. Adorno, *Dialectic of Enlightenment*, trans. John Cumming (New York: Continuum, 1991).

15. For perhaps the most influential writing on this problem in musicology, see Susan McClary, *Feminine Endings: Music, Gender and Sexuality* (Minneapolis: University of Minnesota Press, 1991); Ruth A. Solie, ed., *Music and Difference: Gender and Sexuality in Musical Scholarship* (Berkeley: University of California Press, 1993); and Philip Brett, Gary Thomas, and Elizabeth Wood, eds., *Queering the Pitch: The New Gay and Lesbian Musicology* (New York: Routledge, 1994). In his *Performing Rites*, Simon Frith suggests that "The danger—the threat posed by music and dance to aesthetics—is not so much the absence of mind as the presence of the body. The ideology of the musical work leads, as we've seen, to a repression of the sensual" (260).

I. Absent Bodies Moving through Time

2. The Somatics of the Past: Helen and the Body of Tragedy

1. The Photographic Moment

IN EADWEARD MUYBRIDGE'S *Animal Locomotion*, photographic plates are sequentially arranged to convey the discrete moments that constitute a single motion: "Seven hundred and eighty-one plates, containing more than 20,000 figures of Men, Women, and Children, Animals and Birds, all actively engaged in walking, galloping, flying, working, jumping, fighting, dancing, playing at base-ball, cricket, and other athletic games, or other actions incidental to every-day life, which illustrate motion of the play of muscles."[1]

These illustrations of bodily motion in stop-action photographs present a paradox. Less apparent in film and animation, but obvious in the child's flip-book, the paradox resides in the fact that fluid motion can be simulated by the projection of arrested moments following one another at specific intervals of time.[2] One ostensible purpose of Muybridge's experiment was to demonstrate the distinction between motion in life and motion in art or, more precisely, how the static moment of the photograph offers a corrective to that of a painting or sculpture. Thus, one motivating principle in his work is to credit scientific accuracy at the expense of artistic or mimetic representation.[3] In Muybridge's scheme, the isolated moment—fixed in the past but heralding a future in the final frame—promises both the fullness and the perpetuity of motion. To extend this conclusion, his photographs project a scientific and progressive model of history as a series of truthful visual moments following and predicting one another in past time. In short, Muybridge's "chronographic apparatus," perfected in the subsequent advent of film and video, constructs the past as a visual phenomenon.[4] This visible history is obviously distinct from, but has elements in common with, traditional narrative history.[5] Both sorts of history are the products of a process of selection and deletion; as a series of photographic or filmed moments, the photographic record depends upon this process both at the time of shooting and at the (later) time of editing. The truth claims of historical narratives rely on the availability and perceived accuracy of "sources" and upon the historian's selective judgment.[6]

But these similarities do not obscure the fact that there is an immediacy at-

taching to photographic history that is missing from traditional narrative history. Muybridge's desire to expose a reality that is otherwise lost to view and/or distorted in the work of art is symptomatic of this immediacy. Its source is the photograph's perceived relationship to the "real" and the credibility attaching to visual technologies as a means of preserving events; the distinguishing characteristic of the photographic moment is its simultaneity with the moment of the event it records. Thus, whereas written historical accounts are produced retrospectively in a process of inscribing past events, the photographic record is produced prospectively insofar as the taking of the picture necessarily produces the historical event to which it will later testify. Of course, photographs and films are themselves artifacts that can be used in a retrospective accounting of the past. But by virtue of its role in preserving a lived instant, the photographic moment seems to be always already archival. No matter whether we divide photographs (or films) into genres such as the art photograph, the documentary photograph, or the occasional photograph, the photographic moment is always and ideally a visual record of an event, a person, and/or an object in the past.

In this view of history, the camera has achieved the status of an eyewitness or *autoptes*, which, at least since Herodotus, has been the dominant arbiter of truth in European historiography.[7] But unlike what the human informant or eyewitness says he has seen, what the camera has "seen" is not so clearly subject to the insufficiency of human perception and memory.[8] This is not to deny that both the camera and informant see from a certain point of view, but from its inception a constituent feature of the discourse of photography has been the camera's ability to correct and enhance technologically the informant's visual memory of the past. As a consequence, the dominant mode of history as a series of narratives to be read—narratives ideally enabled by the visual memory of the *autoptes*—has been replaced by an emerging mode of history as a series of pictures to be seen. As Benjamin observes, "With Atget, photographs become standard evidence for historical occurrences, and acquire a hidden political significance."[9] But the notion that photographic autopsy provides "evidence for historical occurrences" is a feature of the fact that photographs *create* the past as pictures of prior events. This act of creation is the source of their political significance.

My purpose here is not to provide a comprehensive theoretical account of photography as a historical medium. Rather, I want to suggest how the trope of autopsy in the Western discourse of history informs the discourse of performance. Toward this end, the photographic model of past events invites a reconsideration of the relationship between history and representation, which I hope will illuminate the project of this volume. I begin with the general premise that, beginning with Muybridge's photographs of bodies in motion, the photograph and then the motion picture foreground the fact that the human body as a corporeal object of visual observation exists in history as a nec-

essary absence. It is this absence—what might be called the predicament of history as the representation of a past reality—that the photograph seeks to remedy.[10] If the black-and-white still photograph expresses a desire to restore presence to that body, then its "moving," "talking," and "in living color" descendants testify to the intensity of that desire. Thus, while the development of motion pictures out of still photography and the development of narrative or fiction film out of projected moving images may seem natural, film's "turn to narrative" cannot simply be explained as the consequence of its unique destiny.[11] Rather, the notion that "every shot tells a story," as André Gaudreault puts it, is the basis of the value of photography and film as history; they visualize and then animate the human body in order to tell a story about the past.[12]

If the photographic record creates the past, as suggested above, it also paradoxically produces the body of history *as* an absence. Or perhaps more accurately, it produces that body as a phantom. For in the act of restoring or reanimating bodies in past time photographic technologies, exemplified in Muybridge's early experiments, only reveal their lack of corporeality. And if photography and film are the modern (and postmodern) manifestations of this view of history as an animated past, the premodern theater—beginning with Greek tragedy—anticipates this view. The analogy I am suggesting between theatrical and photographic representation is not meant to further the argument that early or "primitive" film was somehow theatrical.[13] Nor is it based on the fact that film studies and performance studies share theoretical frames of reference.[14] These bases of comparison between film and theater are relevant as *effects* of the larger proposal I want to make, namely, that the principles governing the role of photography and film in constructing and verifying past events are historically linked to ontological and epistemological debates that take theatrical performance as their model. In this postphotographic era, Muybridge's photographs illustrate the claim that a sustaining mechanism of historical representation is the disavowal, that is, the recognition and denial, of an always absent body.[15] As a founding feature of what I am calling the somatics of the past this disavowal is also embedded in the discourse of Western performance practices.[16] The discussions of dramatic *mimesis* in Plato and Aristotle give this discourse its decisive shape. But the disavowal of the absent body on which it depends finds its most vivid expression in drama itself. In Euripides' *Helen*, Helen's two bodies epitomize the way in which the absent body of history and the desire for visible evidence are enacted in performance.

2. *The Platonic Script*

Made up entirely of the first-person speeches of Socrates and his interlocutors, the Platonic dialogue is generally explained as illustrative of the philosopher's epistemology; it renounces the claim that knowledge or truth can be imparted

by an authoritative ego.[17] The efficacy of this position is open to debate; I am more interested in how this perceived renunciation contributes to the somatics of the past in the context of Plato's so-called antitheatrical prejudice.[18] As the subjects of Plato's dialogues, Socrates and his interlocutors are historical figures, that is, they have known referentiality outside the dialogues. And, of course, Plato, writing in the fourth century B.C.E., had known the living Socrates.[19] Whether or not Socrates and his interlocutors actually said what they say in the dialogues is not the point of this observation. Rather, it helps situate Plato's preference for first-person speeches within a genealogy of text-based representations of "real" or historical persons.

But more to the point, Plato's use of the dialogue form must be contextualized within the related Platonic critiques of writing and *mimesis*, the latter represented in its purest form by tragedy and comedy. The problem with allowing tragedy and comedy in the city, according to Socrates, is that they encourage the ideal citizen to give up his unique political role and imitate anything and everything, including animals, women, and slaves (*Republic* 395a1–397b2). On the surface, this criticism seems to be ironically situated in the dialogues since Socrates' formal description of tragedy and comedy is also uniquely descriptive of the dialogues themselves: each is a form of *mimesis* with no narration (*diegesis*) in between (*Republic* 394a7–c5). As a result, Socrates' attack on first-person *mimesis* in the *Republic* casts a shadow on the medium in which Plato presents him; he implicitly censures Plato's mode of political and philosophical exposition. One of the effects of this strategy is to imbue the Socratic persona with agency or autonomy.

The Platonic critique of writing (*grammata*) constitutes a similar and related encounter between form and content. The premises of this well-known critique are set out in the *Phaedrus*, where Socrates describes the effect of the written text as follows:[20]

> When anything is written down, the entire speech [*pas logos*] is tumbled about everywhere among those who may or may not understand them, and it does not know to whom it should speak, and to whom not; and it is maltreated and unjustly abused, it needs the help of its father; it is unable to defend or help itself. (*Phaedrus* 275d9–e5)

The indiscriminate and dangerous behaviors that result from allowing dramatic *mimesis* in the city are here echoed in the indiscriminate "tumbling about" of written words. Socrates does not call written speech a form of *mimesis* in the *Phaedrus*, but he does agree with Phaedrus that it is an image or simulacrum (*eidolon*) of "speech that is alive and animate" (*logon zonta kai empsuchon*, 276a8–9); he also compares it to a painting (*zographia*, 275d5). As an inscription of verbal articulation, the dramatic script is perhaps the most conspicuous example of the mimetic structure of writing as Socrates describes it here; when spoken by actors the script most closely approximates speech that is "alive and animate."[21]

The implications of this proposition deserve more attention than I can give them here.[22] But I want to make two points. First, Plato's critique of dramatic *mimesis* is linked to his critique of writing, where writing specifies the inscription of voice (cf. *Republic* 394c2, quoted above). And second, the effect of this critique is a nostalgic logocentrism rooted in what Derrida refers to as "the absolute proximity of voice and being."[23] It is the loss of this proximity and its political consequences that connects and condemns writing and dramatic *mimesis* in Socrates' arguments, even though these arguments are not brought together in the dialogues.

In making these arguments against drama (as the *mimesis* of first-person speech) and writing, the Socratic persona challenges the writer of the dialogues (call him Plato).[24] And as an effect of this challenge, Plato denies the lost proximity of Socrates' "voice and being"; Socrates seems to speak for himself in the absence of "Plato's" speaking for himself.[25] But this strategy does not rehabilitate tragedy and comedy as mimetic practices; in fact, the Platonic dialogue's formal similarity to a dramatic script only obscures the obvious differences between the two. Most conspicuously, these differences have to do with production values, that is, with the fact that the dialogues are not performance texts and that they are written in prose instead of verse (the latter is the mode of Greek tragedy and comedy).[26] This is not the place to rehearse the long defended but tenuous binary opposition between verse as a product of oral culture and prose as a product of literate culture.[27] Greek history, philosophy, and drama are all products of fifth-century literate culture and this circumstance is the necessary precondition for Socrates' critique of writing. The fact that the prose writers of history and philosophy write in opposition to the verse genres (epic and drama) may be a reflection of this binary. But the point I want to make is that insofar as the Platonic dialogues are comprised of nonvisualized first-person speeches in prose, they are closer to the speeches in historical narrative than they are to the speeches in a drama. In other words, these similarities contrastively define dramatic *mimesis* as not philosophy and not history.[28]

In saying that the dialogues are more like the speeches in history than in drama, I am not denying the fact that ancient drama has historical elements; Greek comedy is peopled with contemporary Athenians and tragedies occasionally take contemporary events for their plots.[29] But these historical references only emphasize how drama is *not* like history. This is because the historical elements in comedy or tragedy are effectively dehistoricized by the genre's visual apparatus. This conclusion can be illustrated by the figure of Socrates. As a dramatis persona in the plays of Aristophanes, for example, Socrates obviously has referentiality in Athenian social life and his existence as a social subject informs his function as a dramatic character. But that existence does not mean that he is a historical agent—or what might better be called a *historiae persona*—in the drama. Dramatis personae are realized and

defined by a fully mimetic performance practice that includes verbal and visual impersonation. In contrast, the personae of Greek history are realized most vividly in written speeches without the visual element that Aristotle, in referring to dramatic *mimesis*, calls *opsis* (see below). As a methodological and evidentiary gambit, the effectiveness of historical autopsy—enacted in the written report of the eyewitness—in fact depends on the *absence* of *opsis* or visible representation. It is in this respect that the Platonic dialogues are more like the speeches in history than those in drama and that, as a result, the dialogues are provisionally rescued from falling victim to the Socratic critique of dramatic *mimesis* and, if to a lesser extent, the critique of writing.

I suggested above that incongruities between the form and content of the dialogues have the effect of imbuing Socrates and—by extension—his interlocutors with a kind of autonomy. Framed within the temporal and spatial confines of ancient Athens, their speeches also assume a writer who saw and heard them talking, even if he does not say so *in propria persona*. Insofar as historical autopsy or eyewitnessing is an *effect* of writing, the Platonic dialogues exemplify what might be called an *implied* form of autopsy.[30] As an *autoptes*, and a writer of first-person speeches (like the speeches in narrative history), Plato animates Socrates not as a mimetic figure, but as a historical agent, with the result that the living body and voice of the dead Socrates are the longed-for aftereffects of Plato's texts. This Platonic mode of writing is in fact in opposition to the fully mimetic or visible impersonation of events and/or speeches that describe dramatic performance. Exposed to the visual and aural scrutiny of a heterogeneous audience, the dramatic script "tumbles about" in public without the "help of its father." In short, when the personae in a dramatic performance walk and talk in the theater they enact the failure of autopsy as the written report of an eyewitness and as the trope of history.

Developed in an era that follows that of the fully developed theater in Athens, the Platonic text is like a theatrical script with the conspicuous exception that it has dispensed with, even overtly rejected, theater's visual element.[31] As a result, it becomes ironically paradigmatic of the desire for bodily presence (as the motivating source of narrative history) and of its necessary absence. At the same time, Plato's dialogues inaugurate premodern theater history as a history of scripts and the body in performance as an ever receding absence.

3. Aristotle and the Plot of History

Although Aristotle is commonly credited with providing a corrective to Plato's overt opposition to theatrical performance, he too is implicated in this history of absence. Embedded in the *Poetics*, that is, in the context of setting out the formal features that distinguish the best sort of tragedy, Aristotle offers theoretical and formal explanations for the distinction between history and poetry (or

fiction). History, he says, is an account of what *has* happened (*ta genomena legein*, *Poetics* 1451b4), while poetry is an account of what *may* happen according to plausibility or necessity (*hoia an genoito kai ta dunata kata to eikos e to anangkaion*, *Poetics*). History relates particular events (*ta kath' hekaston legei*, *Poetics* 1451b7), while poetry relates general or "universal" ones (*mallon ta katholou*, *Poetics* 451a37–b7). The former are illustrated by "what Alcibiades did or suffered" (*Poetics* 1451b11), the latter by the legendary plots of tragedy. Thus, the difference between history and poetry for Aristotle is the difference between what Alcibiades did and suffered and, for example, what Oedipus did and suffered. But the significance of this distinction has less to do with these specific examples than with the fact of the distinction itself, that is, with the fact that Aristotle defines history in opposition to tragedy (or fiction). We can credit Aristotle with establishing the naturalness of this opposition in the history of European ideas.

Aristotle differentiates history from poetry or *poiesis* in general, but he is talking primarily (if not exclusively) about tragic poetry in the *Poetics*.[32] The question then becomes why does Aristotle offer a definition of *history* as a means of contrastively defining and valorizing *tragedy*? On the one hand, it serves Aristotle's purpose of analyzing tragedy as a specific genre; he can say what tragedy is by saying what it isn't. And he can say that it is worth analyzing. But the primary work of formal or generic analysis in the *Poetics*, or wherever it occurs, is to hide the ideological work of the objects under observation. When he elevates poetry by the figure of litotes (poetry is not history) Aristotle seems to protest too much, although the fact that so few ancient tragedies are based on historical subjects is evidence for this prejudice in practice. The plots of the best tragedies, says Aristotle, "are concerned with a few houses, such as those of Alcmaeon, Oedipus, Orestes, Meleager, Thyestes, Telephus, and those others who have done or suffered something terrible" (*Poetics* 1453a18–22). In other words, they deal with families from what we would call Greek legend. Thus Aristotle wants to posit two distinct modes of representing past events, one historical and one theatrical. But notice that he describes the figures of tragedy in terms almost identical to those that describe Alcibiades as the figure of history: both have acted and suffered (*epathen*, 1451b11; cf. *pathein*, 1453a22).

Aristotle's implicit proposition that history is tragedy's "other" is based first of all on a spatio-temporal difference. History represents a prior actuality manifested in the bodily activities of unique individuals like Alcibiades. Tragedy (or fiction) represents a conflation of past and future time which Aristotle expresses in the optative mood ("the sort of things that might happen," *hoia an genoito*) and in which individuation is replaced by replication; it has to do with plausible and repeatable acts rather than with actual and ostensibly unique ones. But Aristotle admits that "there is no reason why some events that have actually happened should not conform to what is probable or neces-

sary" (*Poetics* 1451b30–32). In other words, historical or actual events can be the proper subject of tragedy if they are not idiosyncratic and if they are replicable by virtue of the principle of universality. But what is "probable or necessary," that is, what *may* happen, is obviously the *effect* of repeated representations, not their cause. Thus what is "universal" is created retrospectively by virtue of those representations. In spite of these inconsistencies, however, Aristotle maintains a hierarchical distinction between history and tragedy, which he describes as "more philosophical and more serious" than history (*philosophoteron kai spoudaioteron, Poetics* 1451b5–6). But this protestation only reveals the currency of the counterclaim that as an account of "what has happened," history has a superior claim to truth. The obvious champion of this notion is Thucydides, who juxtaposes his own historical account of past events with the inferior (because less truthful) accounts of the poets.[33]

Aristotle defines tragic performance as "an imitation not of men but of an action and of life" (*Poetics* 1450a16–17). And throughout the *Poetics* he insists that the *mythos* or plot, by which he means the arrangement of the events or actions, is the first principle or "soul" (*psyche*) of tragedy (*Poetics* 1450a38).[34] The metaphor is obviously appropriate insofar as the soul is essential for human life in Greek thought. But if the plot is the soul of tragedy then what is its body? The ancient Greek soul is an inner and invisible attribute, one defined as separable from and superior to the body. Calling the plot the "soul" of a tragedy thus works to efface the ancient theater as a site of performances embodied in the actors, the chorus, and the presence of an audience. Later in the *Poetics*, Aristotle will maintain outright that "the power of tragedy exists even without the performance at public cost and the actors" (*Poetics* 1450b18–20) and that the proper effect of tragedy can be experienced "without seeing" the performance but simply by "hearing the events" (*Poetics* 1453b3–7).[35] In short, Aristotle's definition of tragedy as an "imitation of an action and of life" is disengaged from what is arguably tragedy's most distinctive formal feature, the visible spectacle that Aristotle in fact lists as one of the genre's six essential elements (*Poetics* 1450a9–10). If the plot is the "soul" of tragedy, and if *opsis* or visible spectacle is incidental to that plot, then tragedy is reduced to a verbal account of events that is not a script, but a third-person narrative.[36]

When Aristotle says that the histories of Herodotus would still be a work of history even if they were put into verse (*Poetics* 1451b2–4), the opposite is also presumably true: that if a tragedy were to be put into a prose narrative it would still be a form of tragedy (*Poetics* 1453b3–7; cf. *Poetics* 1451b27–29). But at the same time, the distinction between "what may happen" and "what has happened" is vague in the *Poetics*, because the proof by which one may ascertain what "has" happened is left out of the equation. As Aristotle himself says, what "has" happened may conform to what "may" happen. As it turns out tragic plots *are* about "what has happened"; the tragic poets prefer names that already exist precisely because "what has happened is possible" (*Poetics* 1451b4–20).[37]

These "already existing" or "well-known" names (*gnorima*) are, of course, Alc-
maeon, Oedipus, Orestes and the like. As names that "already exist" (*ta geno-
mena onomata*) they are coincident with events that "have already happened"
(*ta genoma*). In other words, the shared participle (*genomena*) makes Alc-
maeon, Oedipus, and Orestes into what Aristotle would define as the names
of *historical* figures, like Alcibiades. The significance of this fact lies not in
whether Aristotle and his contemporaries believed that Oedipus was a unique
figure in history or that the Trojan War actually happened; they clearly did be-
lieve that these personages "existed" and that these events "happened." Rather,
its significance lies in the fact that Aristotle is unable to maintain the distinc-
tion between history and tragedy (or fiction) with which he began. In particu-
lar, his dismissal of *opsis* demonstrates how visible representation is the prob-
lematic variable in performance genres. It is relevant that Aristotle's own works
(like Plato's) are themselves closer to history than to tragedy and that Aristotle
implicitly aligns himself with historians and against poets as a means of estab-
lishing his own credibility; in taking the *opsis* out of tragedy and disavowing
the body in performance, Aristotle asserts his role as an authority on tragedy
and as a writer.[38]

4. *Euripides' Revision of the Past*

Aristotle's attempt and final failure to establish the difference between history
and tragedy (or fact and fiction) still haunts us in the postmodern age. Aristo-
tle leaves behind a blurred vision of what constitutes both genres and one that
demands an attempt at revision where the term (re-vision) retains its double
meaning: "to see again" and "to correct." I use a visual metaphor because it is
the visible element of tragedy, performance, that Aristotle dispenses with even
as he attempts to describe what tragedy is in the *Poetics*. The effect of this re-
jection of visible *mimesis* in the *Poetics* (as in Plato's dialogues) is an implicit
validation of autopsy (the eyewitness report) as the proof of historical veracity.
 In the Greek tradition, the question of the relationship between visual per-
ception and historical truth is persistently "revised" in the figure of Helen of
Troy. This revision finds its culminating expression in Euripides' *Helen* (412
B.C.E.) in which Helen has *two* bodies, a "real" one that remained chaste in
Egypt during the Trojan War and a false but identical *eidolon* or cloud image
that betrayed Menelaus and went to Troy with Paris (*Helen* 31–36). The prem-
ise of two Helens in three places at the same time (Troy, Egypt, and the The-
ater of Dionysus in Athens) is a hyperbolic example of the disavowal of the
absent body as a defining feature of representations of the past.
 When Euripides staged his *Helen* he was confronted with several compet-
ing stories about her.[39] The essential points of contention are Helen's culpa-
bility and her whereabouts during the Trojan War. According to Homer, of

course, she went to Troy with Paris, an act that initiates the Greek literary and historical traditions. The lyric poet Stesichorus (seventh century B.C.E.) is credited with sending her *eidolon* or image to Troy; Herodotus concludes that Helen stayed in Egypt during the war (*Histories* 2.112–20). Euripides follows a combined Stesichorean-Herodotean version in which Helen's *eidolon* or image went to Troy while the "real" Helen remained in Egypt. In Euripides' presentation, this hybrid version is made more complex by the theatrical medium in which it takes shape. When the audience and characters came face to face (or mask) with what Aristophanes refers to as this "new Helen" (*Thesmophoriazousae* 850), they faced the difference between the "real" (Euripidean) Helen and her "false" (Homeric) image, between a true and a false story, between fact and fiction, and between expectation (given familiarity with epic and/or previous dramatic productions) and experience. In short, *Helen* confirms the formative role played by Helen's persona in the conflict between autopsy and visual *mimesis*.

 In the epics of Homer, Helen is already emblematic of the problematic relationship between visual perception and truth-telling. In the *Odyssey*, she pours Egyptian drugs into the wine of Menelaus, Peisistratus, and Telemachus, drugs that have the power to make men forget painful events—such as the death of parents, siblings, or children—that they have seen "with their eyes" (*ho d' ophthalmoisin horoito, Odyssey* 4.226).[40] As the drugs take effect, Helen tells her guests: "Listen to me and take delight. For I will tell you things that are plausible [or likely]" (*kai muthois terpesthe; eoikota gar katalexo*, 4.238–39). She then tells a story in which she alone had recognized and aided the disguised Odysseus on his spying mission to Troy; she had changed her mind and wished to return to Greece and to her former husband, Menelaus. On the level of plot, her speech of repentance is made for the benefit of Menelaus who sits beside her; this is the story of the "true" wife in the male imaginary. But Menelaus immediately contradicts her account of the way things were in Troy. According to him, she had attempted to ruin the ambush of the Greeks inside the wooden horse by making her voice "sound like the voice of the wife of each of the Argives" (4.279). Hearing her voice, the warriors were eager to answer her and, in effect, to give themselves away. So there are already two Helens in the *Odyssey*, one repentant and the other simply guilty. But each depends on Helen's own mimetic talents or on her ability to recognize them in others (such as Odysseus).

 These mimetic acts comprise the test of plausibility in Helen's account where plausibility is necessary if *muthoi* or stories are to provide pleasure (*muthois terpesthai*, 4.238). The pleasure of *muthoi* is here specified as the ability to forget painful sights that one has "seen with one's own eyes." As we have seen, Aristotle will apply a similar test of plausibility to the *muthoi* or plots of tragedy in contrasting them to historical narratives (*kata to eikos*, *Poetics* 1451a38; cf. Helen's *eoikota*). And for Aristotle too pleasure and plausi-

bility are related to the distinction between fiction and fact, where the latter can be defined as "what one has seen with one's own eyes":

> Things which in themselves we view with pain [*luperos horomen*], such as [when we see] the forms of the lowest animals and of dead bodies, we view with delight [*chairomen*] when we see their likenesses [*eikonas*] faithfully rendered in every detail. (*Poetics* 1448b10 ff.)

This passage describes the effect of *mimesis* or likenesses as similar to the effect of taking Helen's drugs; in both cases, likenesses provide a pleasurable, if tenuous and temporary, relief from the effect of seeing painful events or objects in what we would call real time. Definable as an aesthetic effect, this pleasure is made possible by denying the truth claims of autopsy. In other words, the visible as pleasurable *mimesis* is contrastively defined by the visible as historical evidence.[41] Aristotle describes the proper effect of tragic *mimesis* in particular as the *catharsis* or purgation of pity and fear. A metaphor taken from medical terminology, *catharsis* often follows the administering of drugs or *pharmaka*. Tragic *mimesis* described in the *Poetics* and Helen's drugs described in the *Odyssey* thus seem to have the same effect: both substitute pleasure for pain and both depend upon a distinction between an actual visual reality and a virtual visual reality, where the latter is likened to a drug-induced state. Remembering Aristotle's rejection of *opsis* in the *Poetics*, this positive visual analogy seems somewhat strained. But at the same time it shows how autopsy, defined as "what one has seen with one's own eyes," is contrastively defined by *mimesis*, the source of a pleasurable virtual reality. These contrasting definitions are anticipated in Helen's epic persona and are the subject of subsequent stories about her.

Homer's Helen is a source of both visual pleasure (her "terrible" beauty) and visual distortion: she both attracts men's eyes and poses a threat to their ability to see reality clearly. In Plato's *Phaedrus*, Socrates tells how the lyric poet Stesichorus had said something slanderous about Helen, had been struck blind, and had recognized the reason for his blindness. He immediately made a palinode in which he said that Helen never went to Troy, and then regained his sight (*Phaedrus* 243a). In this story, blindness is the punishment for an ostensibly false or distorted version of Helen's story, but the restoration of the poet's sight is the occasion of another visual anomaly. For if the "real" Helen wasn't at Troy, who or what was? Helen's counterfeit but lifelike *eidolon* is invented to answer that question and constitutes perhaps the most startling re-vision of the Greek past, one that corrects Homer in the process of chastening Helen.[42] The *eidolon* is not mentioned in the *Phaedrus*, so that Socrates' story of the poet's blindness cannot be tied to the invention of the image. Nonetheless, that story demonstrates how Helen's persona is a source of poetic production (the palinode) and, if less conspicuously, that it is somehow connected with the claims of autopsy. If we ask what makes blindness the appropriate penalty

for having slandered Helen, the answer has to do with the truth-value of visible evidence. Connected with a revised version of Helen's story (that she did not go to Troy), the deprivation and restoration of the poet's sight signify a relationship, however ambiguous, between the ability to see and the authority to write about the past.

A similar act of re-vision occurs in Gorgias' *Encomium to Helen* (fifth century B.C.E.). The ostensible purpose of the *Encomium* is to defend Helen against the charge of having deserted Menelaus for her Trojan lover, Paris. It is said to have been Gorgias' demonstration speech, a "showpiece" delivered to prove his rhetorical brilliance and, as a consequence, to attract (male) students. According to Gorgias, Helen "worked the greatest passions of love, and by her one body (*heni de somati*) she brought together many bodies of men greatly minded for great deeds" (chapter 4).[43] Gorgias proposes to absolve Helen of guilt by depriving her of any agency in the story of her abduction. It wasn't her fault, he says, if the gods or necessity made her do it, if she was abducted by physical force, if she was persuaded by words, or if she was conquered by love (chapter 6). The complexity of Gorgias' speech cannot be dealt with in any detail here but two points relate to the present discussion. First, this chastening gesture denies any active desire to Helen; she is conquered by force or by words or by love as a city is conquered by an enemy. Second, Paris' role as the persuasive abductor and desiring subject is somewhat ironically taken over by the writer/sophist himself (i.e., Gorgias). When he says that Helen was carried off by persuasive words "just as if she had been constrained by force" and that the one who persuaded her by force "acted unjustly" (chapter 12), Gorgias implicitly defends himself against these charges; *he* must be a just persuader who does not use force.[44] In the end, the true object of desire is the written speech itself; whoever takes it or "carries it off" (i.e., whoever becomes Gorgias' student) will have power over his peers. In short, the subject of Gorgias' defense of Helen is the sophist's authority as a writer.[45]

The *Encomium* is also concerned with the value of visible evidence, as described in the fourth and most elaborate proposition (chapters 15–19):

> I shall now go on to the fourth cause in a fourth discourse. If it was love that did these things it will not be difficult to escape the charge of error that is alleged. For we see not what we wish but what each of us has experienced: through sight the soul is stamped in diverse ways . . . Moreover, whenever pictures of many colors and figures create a perfect image of a single figure and form they delight in the sight. How much does the production of paintings and the workmanship of artifacts furnish pleasurable sight to the eyes (*thean hedeian parescheto tois omassin*)! Thus, it is natural for the sight sometimes to grieve, sometimes to delight. Much love and desire for many objects is created in many minds. If then the eye of Helen, pleased by the body of Alexander [Paris] gave to her soul an eagerness and response in love, why should this cause amazement? If love, a god, prevails over the divine power of the gods, how could a lesser one be able to reject and refuse it?

As in the *Poetics*, the products of *mimesis* (i.e., paintings) provide the test case for the pleasurable effects of what one sees with one's eyes (*Poetics* 1448b10 ff., quoted above).[46] Here what Helen sees with her "eye" is a proof of her innocence. As a feature of that proof, however, the implicit comparison between Paris' body and a statue suggests how visible *mimesis* is a source of subversion. The founding feature of Helen's story, her betrayal of Menelaus, is here subsumed under the spell of a visual erotics that is compared to the effect of *mimesis*. What Helen is said to have seen provides the visible evidence for Gorgias' arguments, but these arguments are compromised by the implication that what she sees is a *mimesis*—a virtual and not an actual reality. I don't mean to imply that there is some actual reality about Helen to be confirmed in the *Encomium*. Only that, once again, her persona is the subject of the conflict between autopsy and *mimesis*. Gorgias ends by calling his encomium a "plaything" (*paignion*, chapter 21). That a speech in defense of Helen is also a plaything for the sophist is not a contradiction, but a testament to the futility of arguing for Helen's innocence.[47] It is therefore not surprising that Gorgias does not mention the story of the *eidolon* in his speech, even to refute it. While it would provide Helen with an airtight defense, the duplicate Helen also overshadows the appeal to written persuasion that is the centerpiece of the sophist's art.

Gorgias is also credited with the following enigmatic description of tragic performance:[48]

> Tragedy was growing and being celebrated, and affording wonderful verbal and visual pleasure for the men of that time by providing deception through the stories of men's sufferings, just as Gorgias says, "The one who deceives is more just than the one who does not and the one who is deceived is wiser than the one who is not deceived. The deceiver is more just because he has done what he has promised, while the one deceived is wiser because to be easily taken in by the pleasure of words is a sign of good sense (or of sensitivity)." (DK 82.B23 = *De gloria Atheniensium* 5)

We may dismiss as a rhetorical or sophistic tour de force the assertion that tragic deceit (*apate*) is a vehicle for justice and wisdom. But at the same time, the fragment suggests the existence of an antitheatrical prejudice based on the premise that the tragic playwright *is* unjust because he deceives and his audience *is* unwise because it is deceived. If the fragment predates Plato and Aristotle, it is one of the earliest theoretical assessments of Greek tragedy outside the comedies of Aristophanes.

It may be going too far to suggest that Gorgias' defense of tragic deception and his defense of Helen are somehow related, except to say that each defends what is presumed to be indefensible. Gorgias' preoccupations do converge, however, in Euripides' *Helen*, in which the question of Helen's body as visible

evidence is linked with the persuasiveness of theater as a visible medium. One demonstrable proof of this link is that while the "real" Helen occupies center stage, the *eidolon* is never seen—she is only talked about by characters who say they saw her in Troy. In this respect, the *eidolon* is a product of autopsy (as the report of a visible phenomenon) but one that conspicuously undermines its truth-value.[49] In Aristotelian terms, the fake cloud image is all plot or *muthos* while the "real" Helen is all spectacle or *opsis*.[50] As a result, the ontological situation of the two Helens puts pressure on the truth claims of autopsy while it also emphasizes the visible effect of dramatic *mimesis*: the "real" Helen is obviously an actor in costume and mask. In sum, the claim that the Helen on stage is the real thing while the Helen in Troy was an insubstantial copy illustrates how dramatic mimesis is defined in opposition to autopsy. At the same time, Helen and her *eidolon* are the twin signifiers of the disavowal of the absent body as a necessary condition of dramatic performance.

Keir Elam speaks of three distinct bodies on the theatrical stage, one fictional (that of the speaking or listening dramatis persona), one physical (that of the actor), and a third, "virtual" body of the actor "*as indicated in the text.*"[51] *Helen* presents an interplay between these three in the ambiguous relationship between Helen's name (*onoma*) and her body (*soma*; cf. 66, 588, 1100). When Helen says, "My name can be in many places, but not my body" (588), her statement is belied by the intervening body of the actor as indicated in the text. As a theatrical persona, Helen's body *can* be in many places by virtue of the bodies of the actors who impersonate her in various productions. But unlike other dramatic characters who appear over and over again in Greek drama (Agamemnon or Oedipus or Electra), Helen and her *eidolon* overtly signify the ontological and epistemological predicament of theatrical performance. As an *eidolon*, "Helen" is a name without a substantial body. But the *eidolon* necessarily assumes the existence of the real or authentic body of which it is a copy. In Elam's terms, "Helen" refers both to a fictional and a physical body. In short, the real and fake Helens recognize and deny the absent body of history.

Euripides presents the visible likeness of Helen as a suppliant at an Egyptian tomb, a woman who had never gone to Troy, a chaste and dutiful wife who is, in fact, warding off the advances of another man. In the opening monologue of the play, she says she is going to tell "all the truth of what has happened to me." This includes the new version of her story, the story of the cloud-image fashioned by Hera and sent to Troy with Paris (*Helen* 31–36). As a formal device, and one that Euripides uses often, this explanatory monologue creates what has been called a virtual audience.[52] That audience can be understood to be the actual spectators in the theater or an audience imagined by those spectators. In either case, the speech of Helen conjures that audience when it refers to the scenic apparatus of the stage. The speech begins with the lines, "These are the beautiful virgin streams of the Nile" (1) and "I am called

Helen" (22). Of course, the historical audience may already know these facts of locale and character from the title of the play, from the costume and mask the actor is wearing, and/or from Egyptian props and scene-painting. But the notion of the virtual audience helps us recognize the referential or deictic gesture of the actor who says, in effect, "I am called Helen by virtue of this mask and costume," and "These are the beautiful virgin streams of the Nile" by virtue of these props and painted backdrop. As an effect of Helen's opening speech or monologue, the audience's visual attention oscillates between the "real" body of Helen and Helen as a dramatis persona, and between her place in Egypt and the place occupied by the actor on the Athenian stage.[53]

This oscillation continues in the episodes that follow. In the first, Teucer, brother of the great Homeric hero Ajax, makes his appearance before the new Helen. He thinks that the woman before him is Helen but just as quickly says that he thinks she is not (68–82). He tells her that he saw Helen dragged from Troy by Menelaus with his "own eyes, no less than I see you now" (118). To Helen's questions about the veracity of what he had seen, he replies, "I myself saw her with my eyes and [when the eyes see] so does the mind" (122). At this point, Teucer cannot recognize the true (Euripidean) Helen because he had seen that false (Homeric) Helen.[54] To this holdover from the Homeric past, the visual staying power of the epic disables his ability to recognize the "truth" made visible in the theatrical presentation. On the one hand, Teucer's speech testifies to the power of autopsy to guarantee an account of the past (he believes what he says he saw). On the other hand, the mimetic or visible recreation of that past on stage compromises that guarantee.

Teucer comments that the woman he sees before him has Helen's body but not her heart (*phrenes*, 160–61).[55] In general, overt references to a character's body put an added burden on the theatrical representation. In *Helen*, this burden is increased by the implied incommensurability between what Helen says (the indicator of her internal heart or *phrenes*) and what she looks like, that is, on an incommensurability between her mind and her body. A similar incommensurability describes the distinction between an actor and his role. Helen alludes to this distinction when she wishes that her beauty had been rubbed out "like a painting" so that she might enjoy the good reputation she rightly deserves:

> My life is monstrous and so are the things that have happened to me. Some on account of Hera, others on account of my beauty. I wish that I had been rubbed out like a painting and that I could start again with an appearance uglier than this beautiful one. (*Helen* 260–63)

Helen's beauty on stage is clearly an effect of the mask and costume worn by a male actor. But as a consistent signifier of Helen's persona, it can never be rubbed out, not even by the conventions of dramatic *mimesis*. The famous beauty contest or "contest of form" (*krisis morphes*, *Helen* 26; cf. 677) between Hera, Aphrodite, and Athena is the foundational moment of the Trojan War

narrative, when Paris chooses Aphrodite as the most beautiful goddess and Aphrodite rewards him with Helen, the most beautiful of mortal women. Thus, Helen's visible form (her *morphe*) is the ever desirable prize in the Ur-narrative of erotic conquest and the discourse of the truth about the past.[56]

With the entrance of Menelaus and the scenes of recognition and escape that follow, the false Helen or *eidolon* disappears from Euripides' play before she ever appears on stage. But at what cost and with what result? Along with the recognition that the Trojan War had been fought not for nothing (as is sometimes said) but for Helen's image, the ragged Menelaus represents the distortion and dissolution of the heroic or epic narrative. Told by the Egyptian gatekeeper that "Zeus' daughter, Helen," is in the king's palace (470) Menelaus is incredulous and asks whether there can be two Zeuses, two Helens, two Tyndareuses. The difficult answer to these questions comes when Menelaus comments that the body of the woman before him is like Helen's, but that certainty eludes him (577). Helen then asks (the audience as well as Menelaus): "What better teacher shall you have than your own eyes?" Menelaus can say only that his eyes are sick, since he has another wife (i.e., the *eidolon*) hidden in a cave (581; cf. 575). Like Menelaus', the audience's perception of Helen on the stage is complicated by the enduring—if necessarily absent—presence of that epic Helen.

In Euripides' *Trojan Women*, produced three years before *Helen*, the familiar Helen of the Homeric epics takes the stage with no indication that she is anyone but who she appears to be. Her elaborate self-defense in that play includes no reference to an *eidolon*. As we look back from *Helen* to the *Trojan Women*, the new Helen—as Aristophanes calls her—comes as a shock. Does Euripides recant that earlier version, as does Stesichorus? Is *Helen* Euripides' palinode? A theatrical recantation means not only taking back what had been said in the earlier play, but also what had been seen. In contemporary Western theater we are accustomed to seeing different actors in the same role and are not concerned when the same character looks different in different performances. The situation in a conventional masked drama such as Greek drama is complicated by the expectation that a character's appearance will be similar if not identical from one production to another. There is evidence that typical or standardized masks were used in the Greek theater, so we can imagine that a similar or identical "Helen" mask and costume were used both for the *Trojan Women* and for *Helen*.[57] If so, the "good" Helen of the later production may have looked very much, if not exactly, like the "bad" Helen of the former. And in retrospect the "bad" Helen of the *Trojan Women* becomes the *eidolon* of *Helen*. Of course, the true Helen of *Helen* is no more substantial or real than the *eidolon*: both are created out of a costume and mask worn by an actor. Together, then, the two plays add to that palimpsest of multiple Helens that resists the authenticity of any "real" Helen.[58] At the same time, Helen can be both a tragic persona and an *eidolon* because she never changes; she is al-

ways and forever the beautiful Helen. This assertion of temporal constancy, replicated in a visible form that never changes, is another aspect of the idea that visible *mimesis* contradicts the evidence of history. It is true, of course, that as a written artifact, history never changes; this is one facet of Socrates' critique of writing in the *Phaedrus*. But as the trope of history, autopsy refers to the visible verification of a lived instant, an instant whose singularity is verified by the eyewitness.

At *Trojan Women* 892, Hecuba tells Menelaus that Helen "seizes men's eyes" (*hairei gar andron ommata*) and in *Helen* we see the full impact of this statement. Ever replicable and always the same, Helen and her phantom twin seize men's eyes but deny the claims of autopsy; it is never possible to distinguish the true Helen from her false *eidolon*. This impossibility illustrates Aristotle's final failure to distinguish between history and poetry just as it illustrates the allure of the photograph as a true or authentic visible picture of the past. Like Helen's replicable body, the body on film is not bounded by time or space but is characterized by its ability to be seen or projected in numerous places at once; this ease of replication is fundamental to the social and economic explanations for the dominance of film as a cultural artifact. The desire for Helen's body is simultaneously a desire to make the past "real" and to rescue it from its ever receding absence. In this way, Helen's two bodies anticipate the photograph's implicit claim to autopsy as the visible proof of past events. But because the *eidolon* is never a product of *opsis* in Euripides' play, because it is never seen on stage, its absence illustrates how the absent body of history is a founding feature of the body in performance.

NOTES

A version of this essay was presented as a lecture at Wellesley College in 1995. I wish to thank the faculty and students who attended and offered valuable comments, with special thanks owed to Carol Dougherty. I am also grateful to Deborah Boedeker, Mark Franko, Bill Nichols, and Catherine Soussloff for sharing their expertise.

1. Quoted from Edward J. Nygren and Frances Fralin, eds., *Eadweard Muybridge, Extraordinary Motion* (Washington, D.C.: The Corcoran Gallery of Art, 1986), 5.

2. Muybridge's "zoopraxography" is arguably the precursor to the motion picture. See Richard Bartlett Haas, *Muybridge: Man in Motion* (Berkeley and Los Angeles: University of California Press, 1976); Kevin MacDonnell, *Eadweard Muybridge: The Man Who Invented the Moving Picture* (Boston: Little, Brown, 1972).

3. On Muybridge's work as a "quest for the initially unseeable 'truths' of . . . motion," see Linda Williams, *Hard Core, Power, Pleasure, and the "Frenzy of the Visible"* (Berkeley and Los Angeles: University of California Press, 1989), 37–43 and passim. Cf. Ron Burnett, *Cultures of Vision: Images, Media, and the Imaginary* (Bloomington: Indiana University Press, 1995), 78–81, on the analysis of still frames from a film.

4. "Chronographic apparatus" is Williams' useful term. See Williams, *Hard Core*, 41.

5. As a genre, history generally constitutes "high political history." The term is used by Keith Thomas in his review of Adrian Wilson, ed., *Rethinking Social History: English Society 1570–1920, and Its Interpretation* (Manchester University Press, 1994). The review appears in the *Times Literary Supplement*, October 14, 1994, 8.

6. See Michel Foucault, *The Archaeology of Knowledge*, trans. Alan Sheridan (London: Harper Colophon, 1972); Roland Barthes, "The Discourse of History," in *Comparative Criticism: A Yearbook*, ed. E. S. Shaffer (Cambridge: Cambridge University Press, 1981); Michel de Certeau, *The Writing of History* (originally published as *L'écriture de l'histoire*, Paris, 1977), trans. Tom Conley (New York: Columbia University Press, 1988); Paul Ricoeur, *History and Truth*, trans. Charles A. Kelbley (Evanston: Northwestern University Press, 1965); Hayden White, *Metahistory: The Historical Imagination of Nineteenth-Century Europe* (Baltimore: Johns Hopkins University Press, 1974), and his *The Content of the Form: Narrative Discourse and Historical Representation* (Baltimore: Johns Hopkins University Press, 1990). See also the essays in James Chandler, Arnold I. Davidson, and Harry Harootunian, eds., *Questions of Evidence: Proof, Practice and Persuasion across the Disciplines* (Chicago: University of Chicago Press, 1994).

7. On autopsy in the historical sources, see Herodotus 2.29, 34; 3.115; 4.116; cf. 8.79, 80; Thucydides 1.22.; 5.26. Cf. Homer, *Odyssey* 8.491. See François Hartog, *The Mirror of Herodotus: The Representation of the Other in the Writing of History*, trans. Janet Lloyd (Berkeley: University of California Press, 1988), chapter 7, "The Eye and the Ear," for a discussion of autopsy in Greek historiography. Also, Charles W. Hedrick, Jr., "The Meaning of Material Culture: Herodotus, Thucydides and Their Sources," in *Nomodeiktes: Greek Studies in Honor of Martin Ostwald*, ed. R. Rosen and J. Farrell (Ann Arbor: University of Michigan Press, 1994).

8. Cf. Walter Benjamin, "The Work of Art in the Age of Mechanical Reproduction," in *Illuminations, Essays and Reflections* (New York: Schocken Books, 1968), 234: "[F]or contemporary man the representation of reality by the film is incomparably more significant than that of the painter, since it offers, precisely because of the thoroughgoing permeation of reality with mechanical equipment, an aspect of reality which is free of all equipment."

9. Ibid., 226. Cf. Roland Barthes, *Camera Lucida*, trans. Richard Howard (New York: Noonday Press, 1981), 79, discussed by Burnett, *Cultures of Vision*, 41.

10. Cf. Burnett, *Cultures of Vision*, 48:
Inevitably the time of the viewing is the time of the photograph, and although we may then decide to legitimize or validate its historical authenticity, we have not returned to the moment when it was taken. This is for Barthes and for Sartre the crucial axis for a profound sense of loss. Rather, I would suggest, the feelings of loss contribute to the process of interpretation. The loss is one of the sites of subjective intervention. The history being referred to is the history being made.

11. The quotation is from Thomas Elsaesser, ed., with Adam Barker, *Early Cinema: Space, Frame, Narrative* (London: British Film Institute, 1990), 5. He identifies two problems in traditional film theory: "[T]he first is the cinema's turn to narrative as its main form of textual and ideological support, and the second is the industrialization and commodification of its standard product, the feature film." What Elsaesser calls the "turn to narrative" is a turn to what André Gaudreault calls a second level of narrativity; see his "Film, Narrative, Narration: The Cinema of the Lumière Brothers," in Elsaesser, *Early Cinema*. See also Tom Gunning, "'Primitive' Cinema: A Frame-Up? Or, The Trick's on Us," in Elsaesser, *Early Cinema*.

12. The quotation is from Gaudreault, "Film, Narrative, Narration," 68.

13. It has been argued, for example, that the single-shot perspective of early film

reproduced the theatrical proscenium. See Elsaesser, *Early Cinema*, 13, with notes 20–22. See also Gunning, who critiques "the myth of early film as a simple reproduction of the pre-existing art of theatre (minus the voice)" ("Primitive Cinema," 97).

14. See, for example, Jill Dolon, *The Feminist Spectator as Critic* (Ann Arbor: University of Michigan Press, 1988), 14.

15. Cf. Moira Gatens, *Imaginary Bodies: Ethics, Power and Corporeality* (London and New York: Routledge, 1996), 33, on Freud's definition of disavowal as "a process which allows both denial and acknowledgment to operate simultaneously."

16. Cf. Benjamin, "The Work of Art," 231–32, who quotes Pirandello on the film actor: "[H]is body loses its corporeality, it evaporates, it is deprived of reality, life, voice." Benjamin argues that in contrast to the film actor, the theater actor "identifies himself with the character of his role" and, it seems, denies the lost corporeality of which Pirandello speaks.

17. See Charles Griswold, *Self-Knowledge in Plato's* Phaedrus (New Haven and London: Yale University Press, 1986), esp. 219–27.

18. For a discussion of the Platonic antitheatrical prejudice, see Jonas Barish, *The Antitheatrical Prejudice* (Berkeley, Los Angeles, and London: University of California Press, 1981).

19. The dating of the dialogues is controversial. If Plato's convention was not to use living persons as characters, the dialogues must have been written after 399 B.C.E., the year of Socrates' death.

20. A detailed account of the Platonic critique of writing in the *Phaedrus* is beyond the scope of this essay; the bibliography is extensive. See Griswold, *Self-Knowledge*, esp. chapter 6, "Dialogue and Writing."

21. Cf. Jennifer Wise, *Dionysus Writes: The Invention of Theatre in Ancient Greece* (Ithaca and London: Cornell University Press, 1998), who argues that writing is the precondition of the dramatic genres in Greece. This book became available too late for a full consideration of its arguments here.

22. Griswold, *Self-Knowledge*, 219–26, argues that the writing Socrates condemns is "the treatise form" as the inscription of a system of thought.

23. Jacques Derrida, *Of Grammatology*, trans. Gayatri Chakravorty Spivak (Baltimore and London: Johns Hopkins University Press, 1974), 11–12.

24. Cf. Griswold, *Self-Knowledge*, 219: "Plato's decision to write shows that he does not agree with Socrates' position (as presented in the *Phaedrus*) on the matter; else he would have followed in the latter's steps in this regard." Socrates is said to have written nothing.

25. Cf. Griswold, *Self-Knowledge*, 223: "Plato's anonymity reflects his pedagogical awareness of the danger his authority poses to his student's growth."

26. Plato's dialogues may have been "performed" in the sense that they were read aloud. But they are not performance texts in the manner of dramatic scripts.

27. See Rosalind Thomas, *Literacy and Orality in Ancient Greece* (Cambridge: Cambridge University Press, 1992), for a corrective to this binary opposition. Arguments on behalf of this opposition are put forth in Eric Havelock, *The Literate Revolution in Greece and Its Cultural Consequences* (Princeton: Princeton University Press, 1982) and *The Muse Learns to Write: Reflections on Orality and Literacy from Antiquity to the Present* (New Haven and London: Yale University Press, 1986). I discuss Havelock's arguments in *Acting Like Men: Gender, Drama, and Nostalgia in Ancient Greece* (Ann Arbor: University of Michigan Press, 1998), chapter 2.

28. I do not mean to elide the important differences between Plato's speeches and those in narrative history. Unlike the dialogues, the speeches in history are more or less monologic set pieces interspersed within the narrative at large (the *diegesis*). An obvious

exception to this historical practice is the Melian dialogue in Thucydides (*History* 5.85–114).

29. Aeschylus' *Persians* is the only extant example of a tragedy about a contemporary event. Others existed, but the plots of tragedy were primarily about legendary "houses," as Aristotle says (*Poetics* 1453a18–22).

30. Cf. Griswold, *Self-Knowledge*, 222: "If one takes Platonic anonymity or silence seriously, as one must, then the problem receives a radical solution: since *Plato* does not say anything in his own name in the dialogues, there are no statements *by Plato* to be attacked or defended." The assumption that Plato's "anonymity or silence" denies authority to the dialogues as a system of thought is compelling, although it does not fully account for the incongruities between the form and content of the dialogues (i.e., the critique of writing), as Griswold shows. If we accept the implied *autopsy* of the Platonic writer who, in Thucydides' terms, implicitly promises to "stay as close as possible" to what Socrates and his interlocutors really said (*History* 1.22.1), we face the possibility of Platonic authority.

31. Cf. W. B. Worthen, "Disciplines of the Text/Sites of Performance," *The Drama Review* 39, no. 1 (1995): 13–29.

32. Aristotle mentions scenes from the epic poems, for example, at *Poetics* 1460a11 ff., but only to contrast them to what is fitting for the tragic poet to imitate.

33. Thucydides, *History* 1.21.

34. Cf. Aristotle, *De Anima* 402a6: "The soul is the first principle of living beings." This passage is mentioned by Gerald F. Else, *Aristotle's Poetics: The Argument* (Cambridge, Mass.: Harvard University Press, 1957), and quoted by D. W. Lucas, *Aristotle: Poetics*, (Oxford: Clarendon Press, 1968), ad loc.

35. Cf. Lucas, *Aristotle*, on 1450b18: "Aristotle is emphatic (cf. 53b4, 62a12) that the 'effect' of tragedy does not depend on its being performed."

36. Aristotle's dismissal of *opsis* can be called a founding feature of the history of theater studies as a branch of literary studies. See Keir Elam, *Shakespeare's Universe of Discourse: Language-Games in the Comedies* (Cambridge: Cambridge University Press, 1984), 50: "The drama had become (and largely remains) an annex of the property of literary critics, while the stage spectacle, considered too ephemeral a phenomenon for systematic study, had been effectively staked off as the happy hunting ground of reviewers, reminiscing actors, historians and prescriptive theorists."

37. Made-up names (*pepoiemena*) are allowable but this is an exception to the rule, even though Aristotle thinks the rule is too strict (*Poetics* 1451b19–26).

38. The *Poetics* includes what can be called historical data about the early formation of tragedy and comedy (1448a29–b3). In the argument I'm making, however, this isn't the necessary criterion by which Aristotle aligns himself with historians. It should be mentioned also that the authorship of the *Poetics* is problematic. See Lucas, *Aristotle*, ix–xi, on the transmission of the text. My arguments do not depend on the fact that Aristotle actually wrote the *Poetics*; attribution to Aristotle is conventional and used for convenience.

39. For a comprehensive discussion of Helen in Greek literature, see Norman Austin, *Helen of Troy and Her Shameless Phantom* (Ithaca: Cornell University Press, 1994). See also Nancy Worman, "The Body as Argument: Helen in Four Greek Texts," *Classical Antiquity* 16, no. 1 (1997): 151–203. On Euripides' play, see Charles Segal, "The Two Worlds of Euripides' *Helen*," *Transactions of the American Philological Association* 102 (1971): 553–614.

40. If a man were to drink her potion, Helen says, "no tear would fall down [his] cheeks" (223). This scene is a proleptic reference to *Odyssey* 8, where, without the benefit of Helen's drugs, Odysseus *does* weep when he hears Demodocus sing of the Greeks' sufferings during the Trojan War (*Odyssey* 8.83–95; cf. 8.486–92).

41. Cf. Burnett, *Cultures of Vision*, 49, on the incommensurability of aesthetics and history, although he does not deal specifically with history as a genre.

42. On the evidence for Stesichorus' *Palinode*, see my "Helen and the Discourse of Denial in Stesichorus' Palinode," *Arethusa* 26 (1993): 51–76, and the sources cited there. It is not certain whether Stesichorus is the inventor of the *eidolon*.

43. The translation is that of George A. Kennedy in Patricia P. Matsen, Philip Rollinson, and Marion Sousa, eds., *Readings from Classical Rhetoric* (Carbondale: Southern Illinois University Press, 1990), 34–36.

44. This line is uncertain but the comparison of speech to physical force seems secure. For the Greek text, see H. Diels, *Die Fragmente der Vorsokratiker*, 6th ed., revised with additions and index by W. Krantz (Berlin: Weidmann, 1952), 82B11.

45. Cf. Susan Gruber, "'The Blank Page' and Female Creativity," *Critical Inquiry* 8 (1981): 246.

46. The atomists explained that images (*eidola*) emanate from both the seen object and from the observer and that these meet to form a solid impression or stamp (*tupousthai*) in the air, which then enters the pupil of the eye. See G. S. Kirk, J. E. Raven, and M. Schofield, eds., *The Presocratic Philosophers: A Critical Survey with a Selection of Texts*, 2nd ed. (Cambridge: Cambridge University Press, 1983), 428–29. On images "engraved on the mind," see Froma Zeitlin, "'The Artful Eye': Vision, Ecphrasis, and Spectacle in Euripidean Theatre," in *Art and Text in Ancient Greek Culture*, ed. S. Goldhill and R. Osborne (Cambridge: Cambridge University Press, 1994).

47. See Ann L. T. Bergren, "Language and the Female in Early Greek Thought," *Arethusa* 16 (1983): 85.

48. There is no convincing evidence, despite various attempts to prove the contrary, that Gorgias was particularly interested in tragedy in general or in any play or playwright in particular. He is said to have first gone to Athens in 427 (Diodorus 12.53) but we do not know what plays were performed in the Spring of that year nor if Gorgias was in Athens at the time of the tragic festival. The only evidence that suggests he had knowledge of a particular play is Plutarch's statement (Diels/Krantz, *Die Fragmente* 82.B24) that he called Aeschylus' *Seven against Thebes* "full of Ares." But the fact that Aeschylus, as a character in Aristophanes' *Frogs* (1021), makes this same observation about his own play, undermines Plutarch's reliability.

49. Cf. J.-P. Vernant, *Mortals and Immortals: Collected Essays*, ed. F. I. Zeitlin (Princeton: Princeton University Press, 1991), 168: "The *eidolon* manifests both a real presence and an irremediable absence at the same time."

50. Debates about the reliability of sensory perception, especially *opsis*, are common in the writings of the Presocratics and Sophists. See, for example, the following passages in Diels/Krantz, *Die Fragmente*: Heraclitus, C1.23 (1.188, 15); Democritus B11 (2.140, 145ff.); Empedocles B2; Gorgias B11 (2.293, 8, 12ff.); Antiphon, the Sophist B1 (2.338, 2); Anaxagoras B21, 21a (2.43, 6–18).

51. Elam, *Shakespeare's Universe*, 50.

52. Although it is not exclusively Euripidean, the opening monologue is considered a particularly Euripidean convention. See Richard Hamilton, "Prologue, Prophecy and Plot in Four Plays by Euripides," *American Journal of Philology* 99 (1978): 277–302. On the monologue form, see also Harry Berger, *Imaginary Audition: Shakespeare on Stage and Page* (Berkeley: University of California Press, 1989), 95–103.

53. This doubleness is expressed also in the two conflicting stories Helen tells of her birth. Her father, she says, is Tyndareus . . . but there is another story that Zeus, disguised as a swan, had made love to her mother, Leda (17–18). She may, therefore, be the daughter of Zeus . . . "if this story is clear" (21). In his *Encomium*, Gorgias also mentions the confusion over Helen's paternity (Diels/Krantz, *Die Fragmente* 82B11.3).

54. Froma Zeitlin speaks of the "double vision" that "rules [Euripides'] play in every way." See her "Playing the Other: Theater, Theatricality, and the Feminine in Greek Drama," *Representations* 11 (1985): 88. This important essay is now available in revised form in Zeitlin, *Playing the Other: Gender and Society in Classical Greek Literature* (Chicago: University of Chicago Press, 1995).

55. As a Greek persona, the female is defined in opposition to the male, who is "beautiful and noble," and whose external beauty guarantees his internal virtue.

56. *Morphe* (shape, form, appearance) has a wide semantic range in the play. It is used of Zeus' disguise as a swan (19), of Callisto in the shape of a wild beast (378), of Menelaus' rough physical appearance that prevents him from being recognized by Helen (545, 554) and, in the final tag of the play: "Divinity takes many shapes" (*pollai morphai ton daimonion*, 1688). Bergren, "Language," recalls "the shape shifting *metis* of Nemesis, the mother of Helen in the *Cypria*, who resisted *harpage* [ravishment] by Zeus by transforming herself into one dread creature after another (*Cypria* 8)."

57. See Arthur Pickard-Cambridge, *The Dramatic Festivals of Athens*, 2nd ed. (Oxford: Clarendon Press, 1968), 177 ff; also Niall W. Slater, "The Idea of the Actor," in John J. Winkler and Froma I. Zeitlin, eds., *Nothing to Do with Dionysos? Athenian Drama in Its Social Context* (Princeton: Princeton University Press, 1990), 389–90.

58. A similar situation obtains of course if the two Helens looked substantially different. See Worman, "Body as Argument," 180–200 for an extended reading of Helen's persona in the *Trojan Women*.

3. Figural Inversions of Louis XIV's Dancing Body

THE HISTORICAL IMAGINATION for performance studies begins in the present, its impetus deriving from present acts loosely referred to as reconstructions. In this essay I take two images of Louis XIV as dancer, performed in different media, and at different stages of his life, to explore the way the voyage to an absent past from a reconstructed one is complemented by an analogous movement between two points in time *within* the past. There are four bodies moving through time here, three of which are internal to "the past" itself at its different stages. The "present" body's movements are ghosted by this array of phantasmatic entities. I wish to bring the issues of presence and representation into play with the predicament of pastness: the fact that some authentic performance appears to be inscribed beneath reconstructions. In this process, I reinscribe French poststructuralist theory into the seventeenth century as a way of rendering interpretive scope to danced movements that cannot be resolved into a simple identity or a simple unity.

Consider two views of baroque dance by the dancer Jean-Christophe Paré. In a 1987 production of Lully's *Atys* by Les Arts Florissants, Paré impersonates Louis XIV costumed as Apollo from *Le ballet de la nuit*. As broadcast on the PBS documentary *Dancing*, the segment highlights the Sun King's legendary influence over dance history: as the narrator says, Louis XIV was "ballet's first star." Paré, himself a former Paris Opéra star who defected to the Groupe de Recherches Chorégraphiques de l'Opéra de Paris (GRCOP), the Paris Opéra's experimental wing, performs Francine Lancelot's choreography brilliantly styled to technically modernize the king's historical presence.[1] What results in *Atys* is a somewhat romanticized version according to which charisma is expressed by the lyrical rendering of baroque technique. One would hardly guess by this performance that Louis danced the rising sun in *Le ballet de la nuit* to augment his own political power, unless that power were conceived on a purely charismatic level. Indeed, baroque dance tempts the historian to imagine royal charisma outside the sphere of the profane and the everyday. Court ballet was an exceptional art.

Yet advances in the decoding of period notation in the last few decades have made abundantly clear the fact that baroque dance was a complex *discipline*: it was profane, rational, and it required routine. Moreover, Louis XIV's charisma, to the extent he had it, was institutionalized, inherited, and bureaucratized, as Max Weber would say.[2] Hence the high level of technicality in baroque dance. The king's movements were confined within a limited set of technical possibilities and variations on those possibilities. The complex coordination of twisting wrists, flicking hands, and rotating elbows, which complexities are in almost syncopated relation to an equally complex pumping up and down of the legs, transfer of weight from foot to foot, and skimming in patterns through space, all represent the technological character of that style of dancing. Anyone who has studied baroque dance in the studio under the teacher's watchful eye can testify that it allows little or no place for spontaneity. The royal body dancing was made to represent itself as if remachined in the service of an exacting coordination between upper and lower limbs dictated by a strict musical frame. It was an early modern techno-body.

In *Entrée d'Apollon*, conceived, choreographed, and danced by Paré to a contemporary score by Franco Donatoni, Paré adapts historical vocabulary to an original scenario in which he calls that technology into question in the course of the dance. Sections of the choreography are direct citations from Feuillet's *Entrée d'Apollon*, originally written for Lully's *Le triomphe de l'amour* (1681). Both Feuillet's notation and Pecour's extant version of the same dance recall versions choreographed for Louis XIV earlier in the seventeenth century by Pierre Beauchamps.[3] Originally entitled *Ombra*—suggesting both shadow and specter: shade—and premiered at the Café de la Danse in Paris in 1991 for the tenth anniversary gala of Lancelot's baroque company "Ris et Danseries," this contemporary solo may have startled its audience by deviating from the original source. Paré wears a modern pair of pants, a long-sleeved shirt, a dark skullcap, and black gloves without fingers. Paré's baroque arm and hand movements accelerate frantically, only to subside into listlessness. The choreography stages an expiration of vitality as if the historical figure, barely evoked, crumbles into dust rather than radiating solar heat. The dance ends with the figure descending to the floor and pivoting precariously on one knee. Paré's remarkable technical facility allows one to savor every difficulty of the dance spun out with great ease. But, at the same time, this is a dance almost solely about that technique; it has no concern for charisma. This solo deconstructs baroque dance as a dance of power by applying a choreographic analysis of historical material to the performance of that material in an altered context. Paré removes the romantic animus from the dancer and replaces it with emphasis on the technological character of the dancing itself.

The juxtaposition of these two images—the theatricalized reconstruction and the analytic deconstruction—reveals the way in which each anamorphoses the other. My contention is that we can better understand the relation of dance

to power in the distorted reflection each version holds up to the other. To think this way is to see theory at work in the body, but the body we aesthetically visualize is an absent one, a fully realized body of history that exists for us only in projections and distortions that multiply in the space between original and copy. In his pioneering study *The King's Two Bodies*, Ernst Kantorowicz identified the functional modes of the king's presence as the body politic and the body natural, and assumed the body politic's transcendent identity on the basis of the body natural's obedient support. The king is "human by nature and divine by grace."[4] I take Paré's *Entrée d'Apollon* to say that a relationship between body politic and body natural only occurs inasmuch as it fails. In royal ballet both body politic and body natural were danced figures, that is, visual impressions resulting from physical movement. Drawing my theoretical motive from Paré's two dances, I shall call this movement of baroque power figural inversion. This whole essay moves within and through such figural inversions. They have four coordinates: the absent past event (presumably dead) is resurrected with the help of theory which, over time, itself loses force or influence, leaving behind it the physical remnants of its reasoning, its dance.

1

Let us take an example of figural inversion occurring within the monarch's lifetime. In 1653, at age fifteen, Louis XIV danced the role of Apollo in *Le ballet royal de la nuit*. In the ballet's final scene, he entered as the rising sun infiltrating and dispersing night's somber shadows. His costume, similar to Paré's in *Atys*, was stitched with light-refracting golden thread (figure 1). Here was the body politic as expressed in baroque dance and performed by the king himself. Sixty-two years later, in 1715, Hyacinthe Rigaud painted a portrait of an aging Louis XIV who had long since retired as a dancer from the stage (figure 2). Yet the king stands in a dance pose and displays a pair of exquisitely stylized, dancerly legs. Two images, then, of Louis XIV: the young dancer drawn in a costume sketch as the Sun (King), and the aging monarch posing as the young dancer. The first is a gesture of dance toward power, a manifestation of political will on the stage. The second is a gesture of power toward dance, which is now out of power's reach. Each image supplements the other, mirroring its counterpart to complete an impossible whole where dance and power coalesce, and history is embodied.

Rigaud's portrait of Louis XIV has frequently been thought to contain an ideological/aesthetic reasoning about the royal body. Louis Marin's analysis of the portrait acknowledges that the king, although well past his prime, is presented in the portrait as, if not dancing, still a dancer.

> The king does not walk, yet he is not motionless either; he does not advance, nor does he stand perfectly still. He poses, he marks a pause within the pose, within a suspended instance that fashions something like a corporeal ideality.[5]

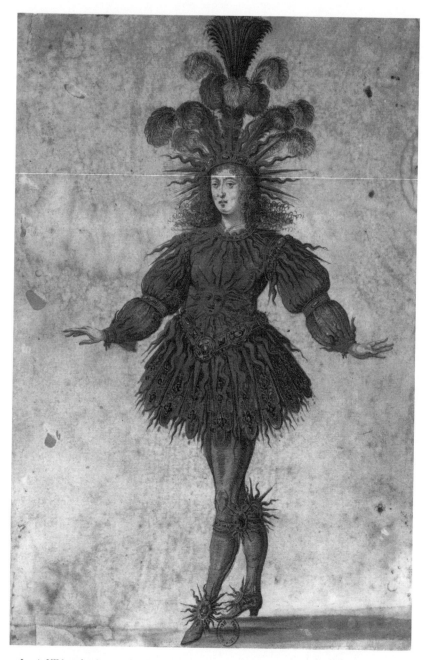

1. Louis XIV as the Sun in the final moments of *Le ballet royal de la nuit* (1653). Cliché Bibliothèque Nationale de France, Paris.

2. (*facing page*) Louis XIV after Hyacinthe Rigaud (circa 1705). J. Paul Getty Museum, Los Angeles.

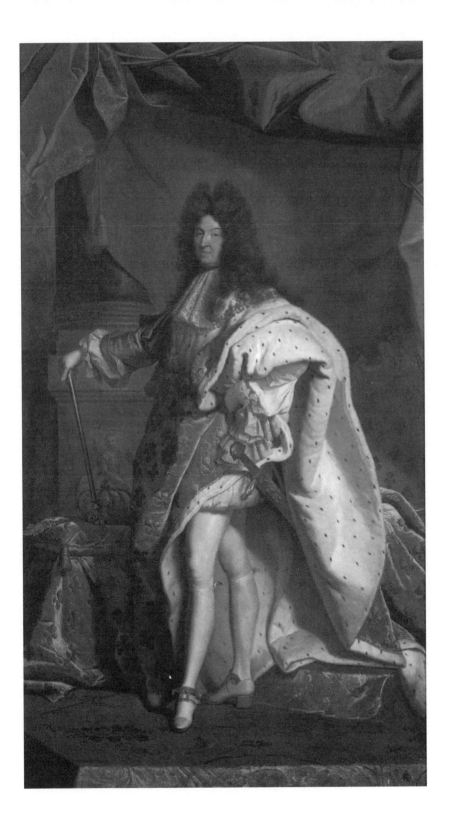

The tension Marin describes between movement and pose could be attrib-
uted to an aspect of the baroque dance aesthetic: *fantasmata*, understood as
the ability of stillness to mimic flight, and conversely of precipitous motion to
be quickly resolved into stillness. *Fantasmata* designated a styling of move-
ment in its functional attitude.[6] For Marin, the king's legs transform his body
natural into dance in order to abnegate (deny) that same body natural by sus-
pending it (not destroying it or negating it). Thus, attention to the dance sub-
text of the portrait cleaves the body natural from the body politic:

> The referential body's rights to be an exceptional individual are negatively con-
> tested and transformed into an ideal, in order to be presented as the ethical,
> political, and theological paradigm of the absolute Monarch over and against
> the real king.[7]

Given that the subject of dance is indubitably present, can the portrait not also
be said to comment on the role of dance in kingship from the beginning of
Louis' personal reign? The king's performance project, begun in 1651 at the
age of thirteen, was abandoned approximately twenty years later in the early
1670s. Rigaud's portrait, painted fully thirty-five years after Louis' retirement
from the stage, reflects nostalgically on that past. There is a discrepancy be-
tween the king's aging face and his youthful, androgynous legs. Those legs
seem hardly able to support the mass of his upper body, which in turn supports
the material paraphernalia of wealth and power. At the same time, the king's
upper body is not all eternal body politic: his jaws sag, suggesting the mouth's
erosion caused by operations to his nasal passages and the loss of his teeth.
While his legs show a buoyant balance between muscle and bone, his face
lacks the same definition of contours; it is encased in flesh. In contrast to all
the signs of wealth draped across his upper body, his legs, sheathed in tight-
fitting silk, represent the king's bodily presence, the energy and sexual power
of his kingship. They are also indubitably the legs of a dancer standing in the
dance pose codified by Feuillet in 1701 as the fourth position (figure 3).[8] They
are, in fact, the very legs of the costume sketch of Louis as Apollo executed
twenty years earlier.

Let us consider this schism between the king's upper and lower body as a
schism between body natural and body politic as well as one between youth
and age. We shall see that a figural inversion joins these two sets of categories.
The king's dancing legs seem frozen in a timeless moment because they are
part of a past, whereas his face is subject to time's corruption in the portrait's
present. His lower body presents the apotheosis of his body natural as undying,
whereas his upper body figures the decay of the body politic as if it were natu-
ral. This portrait seems to invert the two-body doctrine: the undying "politic"
half—subject or seat of the royal gaze—declines physically and grows passive,
whereas the "natural" mortal half—object and body consumed by the viewer's
glance—escapes time. Ermine competes with legs for visual consumption,
and the king's eyes seem to observe the viewer's pull toward his lower body.

Quatriéme Poſition.

3. The fourth position, codified by Raoul Auger Feuillet in *Chorégraphie ou l'Art de Décrire la Dance* (1701).

The portrait proposes a theory of royal performance: the king's dance destabilizes the very paradigm that official representations of his person in other media are mostly designed to construct, yet the portrait also redefines his power as a result of that destabilization. It could be formulated as the conflict between a *gaze*—the look of the royal person emanating from the upper body and bestowing light on the beholder—and a *glance*—his body itself, and particularly his lower body, put on display. Facing the portrait, we are drawn as beholders into the sagittal circuit of his gaze despite fitful glances at his legs.[9] The portrait's tensions between upper and lower body weigh the king's omnipotent gaze against his audience's clandestine and mobile glance: they weigh law and rule against desire and aesthetics. In other terms, the portrait addresses contradictions between physical display and the myth of royal omnipotence, contradictions inherent in the project of royal ballet, and thus in the project of monarchical ideology in general.

René Demoris interprets royal omnipresence as the king's uncanny ability to *see* more, and with greater penetration, than others do.[10] The king's gaze signifies his omniscience. He transforms that faculty of vision into omnipotence (figure 4). This knowledge, deriving from and ultimately anchored in a power of vision is where, explains Demoris, "the body-State and the physical body of the king are conjoined."[11] The king's body could *be* the state only through a fantasy of exhaustive physical occupation in which the royal body shows up "everywhere," but is located nowhere. In this way, the royal body became identified with a physical abstraction always in some measure contra-

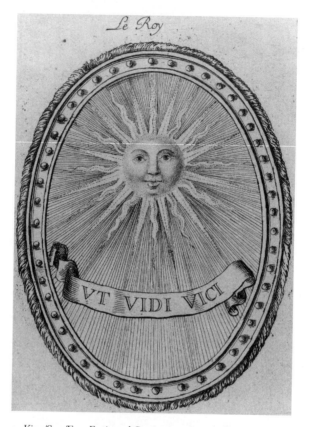

4. King/Sun/Eye. *Festiva ad Capita Annulumque Decursio, a rege Ludovico XIV principibus, summisque aulae proceribus* (Paris: Regia, 1670). Getty Research Institute, Research Library.

dicted by its local performance.[12] Norman Bryson theorizes the gaze as that which "seeks to confine what is always on the point of escaping or slipping out of bounds."[13] But even if the omnipotent gaze were staged by and on the king's body, that body could still only imperfectly perform a "body-everywhere." The royal body in performance is also apprehended by glances, a fundamentally disorderly mode of perception, which, as Bryson notes, "proposes desire, proposes the body in the *durée* of its practical activity."[14] Awareness of this constitutive "defect" of performance suggests one reason the king was cast in the role of the sun. As Apollo or the sun he dances that which cannot be displayed but, to the contrary, enables display. His first appearance as Apollo concluded *Le ballet royal de la nuit* (1653), in which a nighttime scene that had persisted throughout the piece was succeeded by the arrival of day, heralded by the rising sun. Upon entering, Louis XIV proclaims: "I have come to give form and

color to objects."[15] His entrance fuses his own performance activity with the punctual perception of the stage as a totality. In each of its instants his performance is identified with the self-enabling of a spectacular perception, and in this way constitutes the glance's erasure. If the royal spectacle were not enough, the royal gaze itself erases the glance: it mesmerizes and thus prevents the perception of its own task in real time. This is the site at which it generates charisma.

Despite these strategic paradoxes, the king's physical presence was far from ideologically inadmissible. On the contrary, flattering accounts of his inimitable technique indicate the desirability of his dance as *praxis*: despite conventional trappings, Louis' movement derived its effectiveness less from symbolic allusions than from uniquely performed actions with immediate appeal. Flattering appraisals of Louis' mesmerizing perfection—"such radiance and light"—short-circuit the performative process out of which aesthetic perceptions emerged.[16] Yet, his personal style—his charisma—was not present only in his "danse noble" passages such as Apollo. Prior to his appearance as the sun he performed as an Hour, a Game, A Will o' the Wisp, a Curious Person, and a Fury in the same ballet. In most of these secondary and sometimes comic roles, his royal identity was acknowledged in the *récit*, the spoken or sung text accompanying his dance. But the secondary roles also reveal that the glance, rather than the gaze, was integral to court ballet's official project. A *Gazette* account of *Le ballet de la nuit* emphasizes how the king's figure materializes from his serial appearance in a variety of roles:

> [The ballet was] composed of forty-three *entrées*, all so rich, both in their innovative qualities, the beauty of their *récits*, the magnificence of machines, the superb pomp of the costumes and the grace of all the dancers, that the spectators would not have perceived the best if those—in which our young monarch became known beneath his clothes just as the sun makes itself known through the clouds that sometimes veil its light—were not marked with a particular character of radiant majesty, which made us note the difference.[17]

The king's actual presence, hidden within the proliferation of dazzling qualities, "glances" through that paraphernalia and is clearly noted only *differentially* with respect to his surroundings. Such incidental triumphs make no claims on a gaze structure. The onlooker is, in fact, exhorted to *notice*, practically to extract what transpires from a visual homogeneity where the king is barely (re)marked. Even the basest role, so to speak, could be transformed into an expression of distinction, and therefore of power, by the king.

It is as true of portraits of kings, Demoris notes, that "Every symbolic representation is questionable because it does not denote a unique body."[18] Symbolism is gradually supplanted by a tendency to verisimilitude and resemblance. Live performance easily accommodates some such apprehension of the real (of uniquely being there), but such pragmatic presence can also hamper the magical operations of royal symbolism. Any appeal to individual, and hence

private, emotions dilutes the manipulation of this social imaginary. "The real," notes Marin in his analysis of Rigaud's portrait, "is an obstacle to the ideological functioning of the King's portrait."[19] The real constitutes an appeal to authenticity as an isolated referent. It is charismatic in Weber's sense.

The seemingly double requirement—to be both omnipresent (omniscient) and specifically located—corresponds functionally to the gaze, the dancing king's gaze in its ability to encounter, mesmerize, and, if need be, blind our look, and to his empirical body passively on display as randomly caught in our glance. The spectatorial function of the gaze is to return a look, whereas the glance occurs when the viewer's look strays from the face to less privileged areas of the body such as the legs. This straying and returning is the "baroque" quality of official spectacle. Moreover, the king's tendency to invert himself is suggested both by the range of mundane roles he danced contrasted with his supposed apotheosis as the sun. His body politic is natural (alive) but his body natural is dead, and therefore, eternal. Royal ballet inverted the two-body theory.

2

How does poststructuralist theory help us to pose this challenge to the hegemony of Kantorowicz's thought on the monarch? The poststructuralist turn in French cultural critique of the 1960s began with an examination of seventeenth-century power, force, and representation. Both Michel Foucault and Louis Marin inaugurated critical oeuvres with their respective analyses of Port-Royal sign theory;[20] likewise, Jean Baudrillard's references to baroque culture, if less rigorously scholarly, were also frequent in his first books. This essay measures early poststructuralist theory against the example of baroque dance, specifically that of Louis XIV in his ballets. It perceives a continuity between physical performance of the distant past and critical theory of the not-so-distant past. I choose these respective domains of performance and theory not only because I think critical theory should be applied to performance history, but because the encounter of history and theory elucidates baroque inversion, the interpretive figure of this essay.

Foucault has said, "We need to cut off the King's head. In political theory that has still to be done."[21] By this he meant that we should stop studying sovereignty as law or prohibition and see it rather as discipline and knowledge. Baroque dance offers just such an entry into the study of sovereignty, constituting not so much a prohibition as a discipline and a knowledge. It provides us with an apprehension of the king's body that is not theological but cultural. Although Foucault does not discuss dance, he does address the king's physical presence as a performance of power. Let us briefly examine his approach.

Discussing public torture or execution as a spectacle in the first part of *Dis-*

cipline and Punish, Foucault proposes a model of seventeenth-century monarchical power in which that power is fully present as action.[22] This action brings the king's physical presence together with sovereignty or law as prohibition. The displayed suffering body, an "anchoring point for the manifestation of power," indexes power in a spectacle of pain. Even in the king's personal absence, punishment does not *represent* but rather is said to *present* the king. Foucault both emphasizes the importance of the body natural and limits the mode of its operations. Monarchical power "is not *represented*," asserts Foucault, but "recharged in the ritual display of its reality as 'super-power.'"[23] Super-power is demonstrated in actual force. "This superiority," he further specifies, "is not simply that of right, but that of the physical strength of the sovereign beating down upon the body of his adversary and mastering it."[24] The subordination of representation to presence or recharging marks an analytical tendency to stress monarchical power as force over power as representation.[25] In Foucault's account, power is force performed. Its efficacy derives from the visibility of its impact on bodies, and the ritual quality of its agent.

Foucault's model of monarchical power, in which "the king's physical presence was necessary for the functioning of the monarchy," invites comparison with other sorts of performances in which the king's physical presence was required: court ballets and royal festivities.[26] Prospecting for models of power adequate to baroque political performance, one is led to consult Louis Marin's extensive work on "the present presence of a 'now' of the king."[27] Marin's perspective differs from that of Foucault because Marin subordinates presentation to representation, and makes of the king's live performance a "rehearsal" for other forms of representation, which themselves constitute his power. The king's live performance for Marin is a risk taken to heighten the prestige of other representations in which he is physically absent. By dancing in ballets,

> [T]he king puts on stage, mounts in space, and risks ritually and gratuitously the order of his place, the monument of his glory and his symbolic body in the spaces of the royal diversion, as if to give, in and through the spectacular framework that constitutes it, a superpotential to the power of his representation, a superpotential to his representation itself. In this sense, the prince's fête is a *rehearsal* that founds the king's representation.[28]

The king's performance is, in fact, both a "founding" rehearsal and a counter-rehearsal: one that risks practice rather than practices risks.

Foucault and Marin both create a place for a consideration of the powers inherent in the king's performative presence. Foucault's model, despite its welcome focus on the possibilities of present actions, overloads force and thus cannot be extended to a viable theory of spectatorship. Spectacle theory cannot be extrapolated from the reception of punishment, even if the common effect of both torture and dance is political subjection. On the other hand, Marin's "performance as a rehearsal for actual representation" theory subordinates the body natural to the body politic in the manner of Kantorowicz, but

also slyly offsets Kantorowicz's binary. It is this move away from such a binary on Marin's part that inspires this essay.

In *Portrait of the King*, Marin interjects a situationist or Baudrillardian analysis into his study of royal power: "The king is only truly king, that is, monarch," he writes, "in images. They are his *real presence*."[29] It is this representation that the king's performance rehearses, and through which the body politic becomes simulacral. Indeed, Marin tells us that the king's power is a simulacrum with no substantive existence outside its own representations.

To be effective, the monarch's performance demands its spectacular setting or "constructed place" of "factually real illusion."[30] Jean Baudrillard's discussion of stucco as a building material in the creation of architectonic counterfeit will be useful here for our understanding of the king's power as a dancer:

> Stucco is wed to all forms, imitates everything—velvet curtains, wooden cornices, charnel swelling of the flesh. Stucco exorcises the unlikely confusion of matter into a single new substance, a sort of general equivalent of all the others, and is prestigious theatrically because it is itself a representative substance, a mirror of all the others.[31]

Baudrillard evokes a stage setting in which one material, stucco, can perform all the others. This one basic material not only is fashioned into the semblance of many shapes and forms, but also counterfeits the different building materials that underlie these imitations. He comments on baroque spectacle as the creation of a parallel if unreal world whose illusory totality and seamless closure upon itself are formally unassailable. But rather than alchemy, this is mirage.

Inversely, and from a contemporary perspective, Baudrillard equates the baroque experience with the aesthetic scandal of period furniture in a modernist interior. In his early work, which is closest to that of situationists like Debord, Baudrillard locates the modernist exercise of power in the media and interior design.[32] The authentic baroque antique that clashes with a highly designed and homogeneous modernist environment is, for the critic, a sign of failed authenticity, in that it seeks to regain a "reference to the real, [as] an *obligation*." So, we have two theories of the baroque effect in Baudrillard, one stressing an illusory totality, the other an isolated critique. The first implies an aestheticist vision of the past not unlike Paré's performance in *Atys*; the second delineates a contemporary phenomenon explainable with reference to that history, and as such bears comparison with Paré's *Entrée d'Apollon*. Let us call the first interpretation theological and the second cultural. The theological refers to the king's presumably all-seeing but, in fact, decaying upper body in the Rigaud portrait, whereas the cultural refers to his youthful legs, and in particular, to the red-heeled shoes in which his feet are sheathed.

The cultural baroque fails to sustain the criterion of authenticity implied by its own ostensible critique: it is an isolated intervention. The theological baroque, for its part, inverts the situation: its illusory authenticity is manufac-

tured not by singular example but through a counterfeit environment: like the stucco stage setting, the theological interpretation is a totalizing fiction. This situation mirrors that of the king as both physically located and omnipresent. Theological and cultural interpretations of the king's body are inverted reflections of a single, if split or anamorphetic, condition, which Baudrillard emblematizes as "angels of baroque stucco whose extremities meet in a curved mirror."[33] The stucco angels—inverted reflections of two facing figures—produce through their reflection the simulacrum of four figures in three dimensional space. Similarly, Paré's two dances reflect each other in that *Atys* figurally inverts technique into power, while *Entrée d'Apollon* inverts power into technique.

3

Poststructuralist theory has presented us with the tools to think about the performance of royal power as a historical reality. The reason for this is that an unacknowledged simulacral element takes on a constitutive role in the historical situation. To some degree, Kantorowicz is displaced by this simulacrum. Let us go forward from the idea of Baudrillard fleshed out by Marin and press further questions. How does the figural inversion of the theological and the cultural function *in* the historical past? The king's performance of ballet can figurally invert the rationality of state functioning (raison d'état) into the wealth (that is, the objectification of value) that supports it. This realization in its turn inverts an accepted perspective on the two-body theory. Imagine the situation as follows: civil servants regulated government internally;[34] the military expanded government's scope beyond borders; and royal dancers (especially the king himself) inverted these functions,[35] expanding power within (performative conquest) and regulating foreign perception of monarchy in opulently illustrated festival books exported abroad.[36] The king's body itself, "un Objet si rare," was the apparitional mode of political economy.[37]

Daniel Dessert has theorized seventeenth-century luxury objects as transformable merchandise; "immobilized in forms of artistry and prestige," aesthetic objects, predominantly gold and silver plate, could also be converted into cash.[38] The body politic mobilizes cash, whose convertibility into power is referenced by the king's body in motion. The king's performance generated a cultural capital readily convertible into political power. His body was not really *an* object, however rare, but *the* object, not an example *of*, but the very underlying "material" *in* prestige—its gold or its stucco—and consequently the source of value in prestige. By the same token, prestige itself, the product of baroque political economy, was reducible to the material fact of the king's body. This abstract status of the king's body as the material source of prestige speaks to Louis' theatrical impact as a dancer. In addition to being a real body

performing fictional roles in court spectacle, Louis XIV was both the physical source and the general abstract equivalent of all prestige.[39] As such his body supported an excessive charge of presence, even as it was visibly and simultaneously drained of specific content. The paradox is the following: to be an abstract equivalent his sign value was decreased, his materiality heightened. We can reimagine the power of his dance, not as a representation, but as a presence that behaves nonetheless as a sign. His dancing epitomized power's vacuousness, its status as image.

The body natural and the body politic, to return to Kantorowicz's terms, are not stable or fixed entities in themselves, but rather performative and thus continuously self-constituting ones. The spectacle of the king's dancing stages the movement of value itself in its two material manifestations: as raw source and as crafted art object, objects of the glance and gaze respectively. The baroque inversion materializes value as an object-sign and simultaneously refigures the object-sign back into its source materials. The baroque trope is perennially inverted and inverting, such that materiality refigures itself as symbol, and symbol as materiality: neither were transcendent. This movement of figural inversion is what Louis XIV performed in and by his dancing, and the relationship of his dancing to political power can be traced within that movement.

NOTES

I am grateful to Louis Marin for having challenged me some years ago to write on the Rigaud portrait of Louis XIV. A residency at the Getty Research Center for the History of Art and the Humanities during 1994–95 allowed me to undertake research and writing. Earlier versions of this chapter were presented at the Getty Research Center, the NEH Pre- and Early Modern Studies Faculty Seminar at the University of California, Santa Cruz, and the Stanford Opera Symposium, Stanford University. I am grateful for the critical responses of Randy Starn, Harry Berger, Jr., Karen Bassi, Catherine M. Soussloff, Mary-Ann Smart, Annette Richards, Joseph R. Roach, Timothy Murray, the anonymous reader of Wesleyan University Press, Christine Bayle, and for the kindness of Jean-Christophe Paré in allowing me to view a video of *Entrée d'Apollon*. Responsibility for the views in this essay remains entirely my own.

1. Paré's work on baroque dance started on the Paris Opéra stage with Lancelot's *Quelques pas graves de Baptiste* (1985). My description of Paré's performance in *Atys* is based on a live performance seen at the Brooklyn Academy of Music in May 1989. It premiered in France in 1986.

2. "Charismatic authority is thus specifically outside the realm of every-day routine and the profane sphere. In this respect, it is sharply opposed both to rational, and particularly bureaucratic, authority, and to traditional authority, whether in its patriarchal, patrimonial, or any other form. Both rational and traditional authority are specifically forms of every-day routine control of action; while the charismatic type is the direct antithesis of this." Max Weber, "Charismatic Authority and Its Routinization," in *Max Weber on Charisma and Institution Building: Selected Papers*, ed. S. N. Eisenstadt (Chicago: University of Chicago Press, 1969), 51.

3. See Fiona Garlick, "Dances to Evoke the King: The Majestic Genre Chez Louis XIV," in *Dance Research* 15, no. 2 (Winter 1997), 16–18.

4. See Ernst H. Kantorowicz, *The King's Two Bodies: A Study in Medieval Political Theology* (Princeton: Princeton University Press, 1957), 87. For a critique of the two-body theory, see Alain Boureau, "Un obstacle à la sacralité royale en Occident: le principe hiérarchique," in *La royauté sacrée dans le monde chrétien (Colloque de Royaumont, Mars 1989)*, ed. Alain Boureau and Claudio Sergio Ingerflom (Paris: Editions de l'école des hautes études en sciences sociales, 1992), 29–37. Thanks to Jacques Revel for calling my attention to this volume.

5. Louis Marin, "The Portrait of the King's Glorious Body," in *Food for Thought*, trans. Mette Hjort (Baltimore: Johns Hopkins University Press, 1989), 205.

6. The term was first used in print by the fifteenth-century Italian dancing master Domenico da Piacenza in his treatise *De arte saltandi e choreas ducendi*. See my *Dance as Text: Ideologies of the Baroque Body* (Cambridge: Cambridge University Press, 1993), 25–30.

7. Marin, "The King's Glorious Body," 209.

8. See Raoul Auger Feuillet, "Des positions," in *Chorégraphie ou l'art de décrire la dance* (1701; rpt., Bologna: Forni, 1970), 7. The *entre-chat trois volé* is still called a "royal" in traditional ballet classes because of the jump's legendary status as the king's invention.

9. Twentieth-century movement analyst Rudolf von Laban used the term *sagittal* to signify a plane of movement toward and away from the viewer.

10. René Demoris, "Le corps royal et l'imaginaire au XVIIe siècle: Le portrait du Roy par Félibien," in *Revue des sciences humaines* 44, no. 172 (October–December 1978): 9–30. See also Louis Marin, "La guerre du roi," in *Le récit est un piège* (Paris: Minuit, 1978), 67–115.

11. Demoris, "Le corps royal," 23.

12. Ibid., 17.

13. Norman Bryson, "The Gaze and the Glance," in *Vision and Painting: The Logic of the Gaze* (New Haven: Yale University Press, 1983), 93. Evan Alderson was the first to point out the applicability of Bryson's theorizing for dance in "The Structure of Attention in Dance: The Gaze and the Glance," in *Progress and Possibilities: CORD 20th Annual Anniversary Conference Proceedings, October 9–11* (New York: CORD, 1989): 5–12.

14. Bryson, "The Gaze and the Glance," 122. The gaze and the glance correspond to two related issues in dance: (1) to the time of "being there" perceptually necessary to the creation of any effect or image building in dance; (2) to the fact that all effects (images) are created in dance before our very eyes, that is, to the fact that they are not images but figures. Despite the existence of a framing proscenium arch, the gaze cannot be focused in performance to the same degree as it can in painting. It is in the nature of dance spectatorship to look elsewhere, sidewise, and to perceive within the frame myriad details that cannot have been suspended by a gaze aesthetic.

15. "Je viens rendre aux objets la forme et la couleur." "Le ballet royal de la nuit," in Victor Fournel, *Les contemporains de Molière* (Geneva: Slatkine Reprints, 1967), vol. 2, 404.

16. "Que d'éclat et de lumiére." J. Loret, *La muze historique* (Paris: 1857), 1:348. This description is of Louis' appearance as Apollo in *Le ballet royal de la nuit* (1653).

17. Renaudot, *Gazette* (1653), cited in Charles I. Silin, *Benserade and His Ballets de Cour* (Baltimore: Johns Hopkins University Press, 1940), 215.

18. Demoris, "Le Corps Royal," 26.

19. Marin, "The King's Glorious Body," 207.

20. See Michel Foucault, Introduction to Antoine Arnauld and Claude Lancelot, *Grammaire générale et raisonée* (Paris: Paulet, 1969), iii–xxviii; and Louis Marin, *La critique du discours: Sur la "logique de port-royal" et les pensées de Pascal* (Paris: Minuit, 1975). Marin said that *La logique de Port-Royal* was "placed at the forefront of philosophical modernity" by Noam Chomsky's *Cartesian Linguistics* (1966), Foucault's work, and others. See "Interview," in *Diacritics* (June 1977) 7: 49.

21. Michel Foucault, *Power/Knowledge: Selected Interviews and Other Writings, 1972–1977*, ed. Colin Gordon (New York: Pantheon, 1980), 121.

22. Michel Foucault, "The Spectacle of the Scaffold," in *Discipline and Punish: The Birth of the Prison*, trans. Alan Sheridan (New York: Vintage, 1979), 55.

23. Ibid., 57.

24. Ibid., 49.

25. "The ceremony of the public torture and execution displayed for all to see the power relation that gave his force to the law." Foucault, "The Spectacle of the Scaffold," 50. This is the fundamental difference for Foucault between "sovereign" power, which is visible, and "disciplinary" power, which is invisible. For a further discussion of power and force in the king's dancing, see Mark Franko, "The King Cross-Dressed: Power and Force in Royal Ballets," in *From the Royal to the Republican Body: Incorporating the Political in Seventeenth- and Eighteenth-Century France*, ed. Sara E. Melzer and Kathryn Norberg (Berkeley and Los Angeles: University of California Press, 1998).

26. Foucault, "Body/Power," in *Power/Knowledge*, 55.

27. Marin applies this phrase to the king's participation in the 1664 fêtes. See his "The Magician King, or the Prince's Fête," in *Portrait of the King*, trans. Mette Hjort (Minneapolis: University of Minnesota Press, 1988), 198.

28. Marin, *Portrait of the King*, 197–98 (translation amended, emphasis added).

29. Ibid., 8. Transubstantiation for Marin is the transitive and reflexive crux of the neoclassical sign. See his *La critique du discours*.

30. These are both phrases employed by Guy Debord in *The Society of the Spectacle* (Detroit: Black and Red, 1983), n.p., section 189.

31. See Jean Baudrillard, "L'ange de stuc," in *L'échange symbolique et la mort* (Paris: Gallimard, 1976), 78–81. For an English version, from which I have drawn the above quote, see Baudrillard, "The Stucco Angel," in *Simulations*, trans. Paul Foss, Paul Patton, and Philip Beitchman (New York: Semiotext[e], 1983); the quote appears on page 88.

32. See Baudrillard, "Requiem for the Media" and "Design and Environment," in *For a Critique of the Political Economy of the Sign*, trans. Charles Levin (St. Louis: Telos, 1981). For Baudrillard, modernist interior design relays a decisive function of historical spectacle. Spectacle, too, creates a total environment bearing on the ideological properties of housing.

33. Baudrillard, "The Stucco Angel," 92. Baudrillard returns almost verbatim to the stucco angels when criticizing Foucault's historical conception of power: "An entire cycle [of linear revolution] is ending," he writes; "it has already curved upon itself to produce its simulacrum, like stucco angels whose extremities join in a curved mirror." Baudrillard, *Forget Foucault* (New York: Semiotext[e], 1987), 50. It is Foucault's failure to deal with power's signifying capabilities that founds Baudrillard's critique.

34. French nationalism, writes Pierre Legendre, is "indissociable from a cult of Administration." See his *Trésor historique de l'Etat en France: L'Administration classique* (Paris: Fayard, 1992), 9. This volume is an expanded version of his earlier *L'Administration du XVIIIe siècle à nos jours* (Paris: PUF, 1969).

35. The connection between dance and the military has already been noted by Joseph R. Roach: "Louis XIV, whose personal devotion to ballet is well known to the-

atre historians, held the first mass revue of formations in close-order drill in 1666 . . . Historians should not suppose that these specialized technologies, ballet and close-order drill, remained isolated as local networks of subjection and control." See Roach, "Theatre History and the Ideology of the Aesthetic," in *Theatre Journal* 41, no. 2 (May 1989): 164.

36. Festival books become royal policy only during the first decade of Louis' reign, with Félibien's *Les plaisirs de l'Isle Enchantée* (1673) and *Relation de la feste de Versailles* (1668). See Helen Watanabe O'Kelly, "Festival Books in Europe from Renaissance to Rococo," in *Seventeenth Century* 3 (1988): 181–201; and Marie-Claude Canova-Green, "Mises en texte du spectacle du pouvoir," in *La politique-spectacle au grand siècle: Les rapports franco-anglais* (Paris: Papers on French Seventeenth-Century Literature, 1993).

37. Part of the text displayed on Louis' device presented at the start of the fêtes de Versailles in 1664 and reported in Félibien's account, *Les plaisirs de l'Isle Enchantée* (1673). On the connection of devices to the seventeenth-century theater state, see Mario Praz, *Studies in Seventeenth-Century Imagery* (Rome: Edizioni di Storia e Letteratura, 1964).

38. Daniel Dessert, *Argent, pouvoir et société au grand siècle* (Paris: Fayard, 1984), 29–31.

39. This is a paraphrase of Guy Debord on the spectacle as "the general abstract equivalent of all commodities." See his *Society of the Spectacle*, section 49. See also section 34: "The spectacle is *capital* to such a degree of accumulation that it becomes an image."

JOSEPH ROACH AND

SHELBY RICHARDSON

4. Writing the Breast, Performing the Trace: Madame d'Arblay's Radical Prosthesis

QUIETLY SEATED, limbs all but motionless, voice matter-of-fact, actress Carol MacVey talks her audiences into deep shock. Many gasp. Some cry out. She pauses briefly to accommodate their responses, and then she softly continues, her voice uninflected by pathos, for "theatrical" affect would be redundant here. Her most palpable expressions arise from the subtle but excruciating changes in the rhythm of her breathing: some deep and slowly exhaled, others sharp and quick, her breaths seem to embody the memory of indescribable pain. These audible suspirations already mark the written cadences of the prose text she speaks, but their impact is intensified during the climactic moment of the performance because MacVey's breath seems to be the only one in the theater that is not being held. Only when an audience member faints is her monologue interrupted. The show is the "History of Medicine," directed by Theodora Skipatares and adapted from a variety of historic documents by dramaturg Art Borecca. MacVey's text is a letter dated March 22, 1812, in which the eighteenth-century novelist Fanny Burney (Madame d'Arblay [1752–1840]) recounts the experience of having her breast surgically removed without anesthetic.

Fanny Burney's "mastectomy letter" has drawn considerable attention from historians of medicine and of eighteenth-century literature. Our desire to revisit it here responds to the challenge posed by the editors of this volume: "Absent performative 'events' have conceptual, imaginary, and evidential as well as actively reproductive bases. They are especially characterized by movement between present and past, one in which archive and act, fragment and body, text and sounding, subject and practice, are in provocative interaction." We want to suggest how such events are rehearsed, staged, and revived in the interstices of imaginative anticipation and affective memory by acts of writing as well as by other corporeal practices. To review the circumstances under which Burney produced the letter, which she enclosed in an envelope entitled "Account from Paris of a terrible Operation—1812," is to become acutely aware of writing itself as a bodily performance. Her arm maimed by the radical ampu-

tation, the author lifted her pen and put it to paper in the face not only of traumatic memory but also of continuing physical pain. Writing of her loss, however, torturous though that activity was for her, clearly played a role in what many today would call her "recovery."

The network of ideas activated by the word *recovery* helps to define our understanding of "absent performative events." Cognate to *recuperation* and *recoupment* with their literal meaning of "cutting back" or "retrenching," *recovery* can mean "a return to a normal state," but only in its most improbably optimistic usage. More realistically it conveys the idea of compensation for a loss, the recuperative action of which recalls the moment of separation and the memory of continuing absence. For good and obvious reasons, the loss of a breast is doubly charged as unrecoverable. Evoking the moment of the infant's separation from its mother, mastectomy violently removes the organ culturally coded to exude erotic meaning as well as a host of related yet conflicting emotional associations for the adult.

"Recovery" in such a case must involve an imaginative process of supplement, of substitution, of replacement—a *prosthesis* in its historical grammatical sense as well as its practical medical usage: "the replacement of a missing part of the body by an artificial one." The historical meaning of *prosthesis* descends from a rhetorical figure, introduced from Greek into English "Elocucion" by Thomas Wilson in his *Arte of Rhetorique* of 1553. In performing the figure of a prosthesis, a speaker supplies an additional syllable at the beginning of a word to conform its meaning to a revised context or substitutes a syllable for one that has been "cut."[1] In this sense, a rhetorical prosthesis is similar to both *supplement* and *trace* as Jacques Derrida employs those terms, in that a prosthesis is an addition that appears as the reminder of an absence. "Writing," notes Derrida, "supplements perception before perception even appears to itself [is conscious of itself]. 'Memory' or writing is the opening of that process of appearance itself. The 'perceived' may be read only in the past, beneath perception and after it."[2] In his excursus beyond Freud's "Note on the Mystic Writing Pad" (the "pad" is a child's toy that retains the palimpsestic trace on a wax slate after the inscription itself has been torn away), Derrida would extract the Freudian unconscious trace from the "metaphysics of presence" by describing it, as one might describe a prosthetic appliance, as "the erasure of selfhood, of one's own presence." "[The trace] is constituted," Derrida continues, "by the threat or anguish of its irremediable disappearance, of the disappearance of its disappearance."[3] Writing may be the scene of an "irremediable disappearance," but prosthesis celebrates the artifice of its substitution for an absent original—hence the historic tendency to decorate artificial limbs. Performance attempts to occupy similarly privileged places of surrogated presence. Actors double "originals" and elaborate them in the certainty of their absence. The perception of the illusions they create might be compared to those communicated by the severed nerves at the terminus of an amputation. These will

evidently produce the vivid experience of sensations—a "phantom" pain or maddening itch in the foot of a leg missing above the knee—that emerge from an absent limb. An example of such a communication from a specific performance would be the agonized rhythm of Fanny Burney's breaths that come to Carol MacVey from the lines of a letter describing an event that occurred in 1811. The sensations of two women born centuries apart seem to converge in a ghostly trace, reversing the expected relations of prosthesis: living organs and limbs stand in for dead ones. Examining Burney's mastectomy letter as both a text and a performance of an absent event, we will exfoliate a process of loss and apparent recovery. This process aims at healing through a prosthesis that involves writing, utterance, and gesture—"Elocucion." In particular we will show how Burney's novel, the relatively neglected *The Wanderer; Or, Female Difficulties* (1814), recollects and revises her surgical and postsurgical performances. We thereby propose to explore a dynamic relationship between speech and writing, presence and absence, through which intimate loss is summoned into visibility by expression even in the face of its ultimate unrecoverability. We are speaking of recovery not as restoration, then, but as redress.

Any examination of this subject would be impossible without the extensive research of Joyce Hemlow, who first published the account, and Margaret Anne Doody, whose impressive biographical studies provide most that is known of Burney's life and works.[4] Julia Epstein's evocative essay "Writing the Unspeakable" has also proved invaluable to our project, though our approach moves beyond her central concern with "body as text."[5] Rather than becoming text, the writing body recovers and resumes its position as a performing, active body; body as text, on the contrary, suggests a passivity incompatible with Burney's continued attempts to seize control (of mind and body) through revision and rewriting of memory and experience. Also important to our discussion is Kay Torney's exploration of the psychological implications of Burney's loss in her essay "Fanny Burney's Mastectomy," and more recently, John Wiltshire's essay "Fanny Burney's Face, Madame D'Arblay's Veil," which addresses both Burney's mastectomy account and life at court, and so combines the story of her "embodied life" with a review of her medical history.[6]

In 1811, at the age of fifty-nine, Burney was forced to undergo a mastectomy without the aid of anesthetic (she was prescribed only a "wine cordial"), a procedure she describes in gruesomely accurate detail in a letter addressed to an audience of select family members and friends entitled, "A Mastectomy." Although the letter was written over a four-month period, she returned to it at various times during her life, a process Epstein discusses in detail: "all of these acts of writing—revising, recopying, preserving, turning to familial authorship —serve as coding mechanisms by which Burney translates surgical privacy into literature and the dread-provoking body into language."[7] The movement from body to language serves also to construct the trace. As Derrida writes, "traces produce the space of their inscription only by acceding to the period of

their erasure . . . they are constituted by the double force of repetition and erasure, legibility and illegibility."[8] Burney, through rewriting or revising her experience of torment into an enduring historical document, is able partially to erase this experience from the surface of her mind. She thereby transposes real experience onto literary construction and so defies the procedure's potential to provoke psychological annihilation. Burney instead uses "repetition" and the creation of a fixed record of her experience as a means of releasing her anguish.

The letter next focuses on the author's forced absence from society because of her ailment. The words she uses to invoke her feelings are revealing; she begins,

> *Separated* as I have now so long—long been from my dearest Father—BROTHERS—SISTERS—NIECES, & NATIVE FRIENDS, I would spare, at least their kind hearts any grief for me but what they must inevitably feel in reflecting upon the sorrow of such an *absence* to one so tenderly *attached* to all her first and for-ever so dear and regretted ties—nevertheless, if they should hear that I have been dangerously ill from any hand but my own, they may have doubts of my perfect *recovery* which my own alone can obviate.[9]

Torney notes that for Burney, "all physical pain has become the pain of separation, all separation from loved ones feels like the pain of amputation."[10] However, Burney's use of words associated with amputation (separation, absence, attached) also suggests an attempt to outline the recovery from her loss, which she plans for herself through writing. The language used in this introduction symbolizes Burney's ultimate project to fill up the absent space left from her operation with language, or, in this particular case, with correspondence, and in doing so figuratively to recover a part of herself. The letter was prefaced by the following injunction: "Breast operation / Respect this / & beware not to injure it!!!" (6:597). Here Burney describes the actual account of her operation as if it were an individual, and, as such, subject to injury or its own "amputation" through unwanted editing. As an author, Burney asserts control over her text and thereby ironically emphasizes her inability to maintain control over her body during her own surgical procedure.[11] This assertion, combined with the letter's painfully meticulous description of the operation and the events leading up to it, therefore provides essential and therapeutic augmentation of Burney's eventual *recovery*. The author is driven to report as accurately and thoroughly as possible, despite the admitted futility of language to recreate fully the pain and horror of her surgery; she thereby draws the audience into her remembered experience and at the same time eases her pain through its distribution.

Burney finally learned that an operation would be necessary only through the appearance of her husband after he had spoken to the physicians: "He also sought to tranquilize me—but in words only; his looks were shocking! his features, his whole face displayed the bitterest woe. I had not, therefore, much

difficulty in telling myself what he endeavored not to tell me—that a *small* operation would be necessary to avert evil consequences!" (6:600 [emphasis ours]). Misled by doctors as to the duration and extent of the operation, her questions concerning the procedure unanswered, Burney becomes increasingly suspicious: "[the doctor] uttered so many charges to me to be tranquil & to suffer no uneasiness, that I could not but suspect there was room for terrible inquietude" (6:600). The physicians' later attempts to soothe her fears only aggravate the situation further:

> M. Dubois had pronounced "il faut s'attendre a souffrir, Je ne veux pas vous Trompez—Vous Souffrirez—vous souffrirez *beaucoup!*—" Mr. Ribe had *charged* me to cry! to withhold or restrain myself might have seriously bad consequences, he said. M. Moreau, in ecchoing this injunction, enquired whether I had cried or screamed at the birth of Alexander—Alas, I told him, it had not been possible to do otherwise; Oh then, he answered, there is no fear!—What terrible inferences were here to be drawn! (6:604–5)

Despite her well-founded apprehension, Burney finally agreed to undergo the procedure. And yet, she writes, "I felt the evil to be deep, so deep, that I often thought if it could not be dissolved, it could only with life be extirpated. I called up, however, all the reason I possessed, or could assume, & told them —that if they saw no other alternative, I would not resist their opinion & experience . . ." (6:603). These legitimate concerns about the actual performance of the operation and her chances for survival were compounded by the prolonged deferrals involved in the event's preparation, first a delay of weeks and finally of hours. Burney describes this time as "a dreadful interval . . . I had no longer anything to do—I had only to think—TWO HOURS thus spent seemed never-ending . . . I would fain have written . . . but my arm prohibited me" (6:609).

Burney's apprehension is also greatly increased by the realization that despite promises that "an Arm Chair would suffice," the head surgeon instead specifies that "two *old mattresses* . . . and an old Sheet" will prove necessary (6:610). This change in plan suggests both the primitive facilities available to even the best surgeons of the time, and also a more extensive and bloody procedure than Burney had previously believed. As Hemlow notes, "the mastectomy was attended with severe bleeding from severed arteries," bleeding treated by "the assistants [who] press their fingers on any arteries that bleed freely" (6:609). Burney seems to guess the reasons for this change in instructions, noting that "I now began to tremble more violently, more with distaste & horrour of the preparations even than of the pain" (6:609–10). After much suspense, Burney is surrounded by the physicians, described only as, "7 men in black" (6:610). She voices her displeasure to her reader: "I was now awakened from my stupor—& by a sort of indignation—Why so many? & without leave?—But I could not utter a syllable" (6:610). Burney is denied both the "robe de Chambre" she had hoped to retain and female companionship

(though at her insistence one female attendant remained); of the latter denial she later wrote, "Ah, then did I think of my Sisters!—not one, at so dreadful an instant, at hand, to protect—adjust—guard me" (6:610).

Before the operation begins, Burney's face is veiled, a "cambric handkerchief" spread over her, a curtain drawn over the scene of mutilation. However, this precaution is apparently not taken for the protection of the patient but rather for the comfort of the surgeons. In fact, the cambric functioned effectively for the surgeons by disguising the horror of their victim, while Burney remained horribly aware of the approaching torment: "I refused to be held; but when Bright through the cambric, I saw the glitter of polished Steel—I closed my Eyes. I would not trust to convulsive fear the sight of the terrible incision" (6:611). The excruciating anticipation Burney experienced, though unintentional, may appropriately be compared to the dynamics involved in an act of torture; Elaine Scarry, in her exploration of testimony reported by victims of torture, notes that "[the account] almost invariably includes descriptions of being made to stare at the weapon with which they are about to be hurt."[12]

This tension is further heightened by the patient's dawning realization that more than removal of the actual lump is intended: "through the Cambric, I saw the hand of M. Dubois held up, while his fore finger first described a straight line from top to bottom of the breast, secondly a Cross, & thirdly a circle; intimating that the WHOLE was to be taken off" (6:611). Despite her protestations, during which she "threw off [her] veil" in order to address her captors more directly and to explain that the pains "sprang from one point, though they darted into every part," Burney is ignored (6:612). The doctors cover her again, and repeat the configuration as if she were unable to see their movements; as Wiltshire notes, their use of the handkerchief is designed to "obliterate Burney as subject, to banish her from the order of speech and language."[13] Burney, objectified by her surgeons, has temporarily lost control over the fate of her body and is here denied even the minimal relief language and communication might afford in preparing herself for the horror to ensue. After the ritual is repeated and "again I saw the fatal finger describe the Cross—& the circle," Burney accepts the impending torment: "Hopeless, then, desperate, & self-given up, I closed once more my Eyes, relinquishing all watching, all resistance, all interference, & sadly resolute to be wholly resigned" (6:612). When the operation begins, with it starts further description of this loss of language and self: "Yet—when the dreadful steel was plunged into the breast—cutting through veins—arteries—flesh—nerves—I needed no injunctions not to restrain my cries. I began a scream that lasted unintermittingly during the whole time of the incision—& I almost marvel that it rings not in my Ears still! so excruciating was the agony" (6:612). The sensitivity of the wound is so great that even the air proves to be a weapon against her: "When the wound was made, & the instrument withdrawn, the pain seemed undi-

minished, for the air that suddenly rushed into those delicate parts felt like a mass of minute but sharp & forked poiniards, that were tearing the edges of the wound" (vi, 612). Burney's control over both body and mind is relinquished in her moment of agony; only her flesh attempts defiance as next, "I felt the instrument—describing a curve—cutting against the grain, if I may say, while the flesh resisted in a manner so forcible as to oppose & tire the hand of the operator" (6:612). The parts of the body become nearly indistinguishable as all senses are subjugated to the overwhelming pain experienced, as Burney here describes: "I attempted no more to open my Eyes,—they felt as if hermetically shut, & so firmly closed, that the Eyelids seemed indented into the Cheeks" (6:612).

Even in the midst of such agony, however, Burney continues to be tormented by suspense. The operation is described as seemingly endless, and it becomes if possible even more terrible as "again all description would be baffled—yet again all was not over . . . I then felt the Knife <rack>ling against the breast bone—scraping it!" (6:612). Senses are at this point so heightened that Burney is able to perceive motions separate from her body: "I literally *felt* [M. Dubois' finger] elevated over the wound, though I saw nothing & though he touched nothing, so indescribably sensitive was the spot—[he] pointed to some further requisition—& again began the scraping!" (6:613). She states: "I bore it with all the courage I could exert & never moved, nor stopt them, nor resisted, nor remonstrated, nor spoke" (6:613). After the operation, as Burney is carried out of the room, she describes not her own pain but that of her physician and friend, Doctor Larrey: "his face streaked with blood, & its expression depicting grief, apprehension, & almost horror" (6:614). Here Burney distances herself from her own pain by focusing on that of another, describing the pain of the actual audience in the operating theater to her own reading audience.

The connection between the loss of the author's breast and the ensuing injury to the arm with which the author wrote is an intimate one. Although Burney describes in detail the abandonment of language and self she experienced during her surgery, this loss of control is belied by the very letter which reports the event. Burney resumes control as she writes, literally rebuilding muscle and tissue with each painfully constructed word and sentence. The author creates a fixed and enduring version of her experience as she perceived it and/ or wished it to be perceived, while at the same time she relives and erases a portion of her pain through the cathartic experience of writing—writing becomes an act of simultaneous creation and destruction. The erasure becomes not only a death but a rebirth, as her continual revisitation and revisioning of the painful scene becomes a consoling redressive act. A prominent gap in Burney's diary entries exists during this period (September 1809–January 1812), though letters prove she was able to correspond; the interruption suggests the author's need to share her experience with an audience through its dramati-

zation (and later fictionalization in *The Wanderer*) in order to cope with her painful memories. Though earlier, in November 1806, she refers to the suspected cancer as a "Breast attack" (6:565), there is little reference to the operation after the mastectomy letter in either her letters or journals. An exception is a reflective note written in her journal in the summer of 1812 concerning her friend Mrs. Waddington: "she little knew my then terrible situation:—hovering over my head was the stiletto of a surgeon for a menace of a Cancer" (6:707).

Writing acts as a cathartic means of imaginatively re-creating the physical body through a "body" of work. The compulsive nature of Burney's writing (extensively researched in Epstein's *Iron Pen* especially in reference to Burney's *Camilla*) suggests not only the repression and deathlike erasure of the self proposed by Derrida but a rejuvenation or regrowth as well. The physical body is revisioned by the creative outpouring involved in Burney's fictive return to her moment of loss and so the event is imaginatively reconstructed as the physical body cannot be. Through this process of reconstruction, the compilation of real and fictional events becomes more than a trace or supplemental presence; it becomes an active physical presence, resulting in the creation of a virtual prosthesis. Though the breast is not physically replaced, the wound is healed as words and language irritate and then fill up the absent physical space. Even Burney's carefully constructed punctuation accentuates the pain of her experience and allows the letter to stage its own performance; for, as her commas and dashes create both brief and extended pauses, the text itself seems to actually breathe. The words of the text survive long after the author's physical body is gone (in both the mastectomy letter and in Burney's fictional representation of her medical experience in *The Wanderer*), leaving their own trace, but perhaps most powerfully resulting in renewed physical presence through Burney's representation on the stage in Carol MacVey's performance.

Derrida notes that "there is no writing which does not devise some means of protection, to protect against itself, against the writing by which the subject is himself threatened as he lets himself be written: as he exposes himself."[14] Burney is willing to expose herself to an intimate audience of family and friends, but she maintains an aversion to a more public performance of this very private event. In *The Wanderer*, therefore, the mask of fiction functions as a means of self-protection; it is a disguised method of revelation that also acts therapeutically. As Derrida suggests, "it is no accident that the metaphor of censorship should come from the area of politics concerned with deletions, blanks, and disguises of writing . . . the apparent exteriority of political censorship refers to an essential censorship which binds the writer to his own writing."[15] Burney practices this "essential censorship" while at the same time allowing an audience to glimpse her terror and pain; she gains relief through willing self-exposure, in direct contradiction to her forced exposure at the hands of the male surgeons. In both the mastectomy letter and in *The Wanderer*,

Burney gains power through this overwriting exercise, for though "the trace is the erasure of selfhood, of one's own presence,"[16] it is also for Burney the potential erasure of pain. This erasure, rather than resulting in "repression," in Burney's case provides a space for imaginative freedom and possible (if partial) recovery.

Ellis, the heroine of Burney's *The Wanderer*, arrives in England disguised as a nameless foreigner of unknown ethnic origin, her limbs darkened with paint and her face concealed by bandages. The only clue to her real identity as the noble heiress "Juliet" is her impeccable speech, bearing, and "beautifully white and polished teeth." Upon arrival in England this anonymous figure soon abandons her disguise and reveals her beauty, prompting an irate employer to ask, "Will it be impertinent, too, if I enquire whether you always travel with that collection of bandages and patches? and of black and white outsides? or whether you sometimes change them for wooden legs and broken arms?"[17] Unlike her fictional heroine, Burney is able to reconstruct her body only through the act of writing—an act of performative prosthesis.

The Wanderer was published in 1814, although the author spent the two prior decades writing it. Burney's work to complete the novel, then, encompassed all stages of the illness, including her initial encounter with breast disease, eventual operation, and the beginnings of her recovery. In fact, the author returned to work on the novel almost immediately after surgery, in defiance of her pain. In the winter of 1813 Burney complained to her brother of the lasting effects of her operation: "I am a slave to care & precaution, or an instant sufferer: for the least cold—damp—extension of the right arm, bending down the chest,—quick exertion of any kind,—strong emotion, or any mental uneasiness, bring on either short, acute pangs, or tolerable, yet wearing and heavy sensations."[18] Burney's justifiable preoccupation with her medical experience is reflected in *The Wanderer* in the dramatic representation of Elinor's first suicide attempt (Elinor is Ellis' rival for Harleigh, the male protagonist of the novel and the object of their affections). Though Doody has made brief reference to this scene and its "echoes" of Burney's mastectomy, further exploration suggests a deeper significance for our project.[19] The scene provides a moment in which the drawing of the *trace* is defined, for, as the author's medical and professional pain is revisioned, Burney's fictive and real experience are inextricably intertwined. Through Elinor the author visually presents a "Breast attack," as Elinor's female body literally and dramatically attacks itself, while the greatly suffering Ellis experiences the author's own pain and terror in a notably theatrical setting.

In this scene, central to *The Wanderer*, Ellis becomes the reluctant star of a musical recital, which was proposed to relieve the considerable financial distress in which her precarious position as "incognita" leaves her. The anxiety of Burney's heroine and her unsuccessful attempts to maintain tranquility as she faces her theatrical ordeal replicate those of the mastectomy letter's "trem-

bling" author as she prepared for her own operation. Her heroine's aborted performance also inevitably recalls the acutely uncomfortable physical display Burney's surgical procedure necessitated. After multiple delays, Ellis is unable to practice for her recital, "her voice and her fingers were infected by the agitation of her mind" (355). Burney's own ailment prevented her from the relief writing might have provided her immediately before the surgical procedure; as she notes, "I would fain have written . . . but my arm prohibited me."[20] Both Burney and her heroine are shocked by "instruments": in Burney's own case, "the sight of the immense quantity of bandages, compresses, spunges, Lint—Made me a little sick:—I walked backwards and forwards till I quieted all emotion, & became by degrees, nearly stupid—torpid, without sentiment or consciousness." In the novel, Ellis is described entering the theater: "in this shattered state of nerves, the sound of many instruments . . . made her start, as if electrified . . . the strong lights dazzled [her eyes]" (357). The "trembling" heroine reluctantly approaches the stage on which she is to perform to the sound of the audience's "violent clapping" (358). However, Ellis is immediately aware of an unusual, theatrically costumed figure watching her, whom she instantly suspects may have some "latent motive or purpose": "His dress and figure were . . . remarkable . . . The whole of his habiliment seemed of foreign manufacture; but his air had something in it that was wild, and uncouth; and his head was continually in motion" (357–58). At this point the tone of Burney's mastectomy letter resonates remarkably, as Ellis is "struck with the sight of her deaf and dumb tormenter; who, in agitated watchfulness, was standing up to see her descend; and whose face, from the full light to which he was exposed, she now saw to be masked; while she discerned in his hand, the glitter of steel" (358). Here Burney offers a virtual recreation of her foreign surgeons, described as deaf and dumb to her complaints. Ellis is horrified to see in the hand of her tormenter the "glitter of steel," so like the "glitter of polished Steel" Burney viewed, "Bright through the cambric."

Soon realizing her performance has been prevented by the appearance of the cross-dressed and lovesick Elinor and certain she has come "to perpetrate the bloody deed of suicide," Ellis is "agonized with terror" (358). Ellis' reaction conveys her fear and also reflects Burney's own response to pain, "her voice refused to obey her; her eyes became dim; her tottering feet would no longer support her; her complexion wore the pallid hue of death, and she sunk motionless to the floor" (358–59). Elinor, on the other hand, has no such qualms about public performance, dramatically shouting as she reveals herself, "Turn, Harleigh, turn! and see thy willing martyr!—Behold, perfidious Ellis! Behold thy victim!" (359). She completes her performance by "plunging a dagger into her breast" (359). Burney situates herself between the fainting Ellis and the dramatic Elinor, admitting her passive role as suffering patient while at the same time reclaiming her body through an act of writing that produces the dramatic actions of Elinor. Yet this potentially recuperative oppor-

tunity for the author is belied by the self-destructive potential evident in Elinor's theatrical suicide attempt. Burney seemingly tries to evade similar self-destruction through her noble attempt to, essentially, write herself a new breast. However, this goal is simultaneously acknowledged as a practical impossibility when her moment of physical loss is depicted in this dramatic and violent re-creation of the destruction of self. As the scene continues, Burney attempts to overcome this disparity by recreating her individual self as many, thereby creating characters to share with her the pain of an experience simply too overwhelming for one individual to contain.

The reaction of the audience to this scene of violence is divided by gender. The women in the audience are described as "hiding their faces, or running away" as Elinor's "blood gushed out in torrents" (359). The men in the audience, "though all eagerly crowding to the spot of this tremendous event, approaching rather as spectators of some public exhibition, than actors in a scene of humanity" (359–60). Harleigh alone has the presence of mind to call for both a surgeon and "an armchair for the bleeding Elinor" (360). At this point it is revealed that the victim's sister Selina, like Burney during her own operation, "had made one continued scream resound through the apartment, from the moment her sister discovered herself" (360). When a "surgeon of eminence" (not unlike Burney's own sympathetic Dr. Larrey), just happens to be on hand to stop the "effusion of blood," he is initially prevented by Elinor herself who "would not suffer the approach of the surgeon; would not hear of any operation, or examination; would not receive any assistance" (360). Before fainting, Elinor states: "I come to die: I bleed to die; and now, even now, I talk to die!" (361). Unlike Burney, Elinor maintains control over both her body and her voice; Elinor's protests against medical treatment are (at least temporarily) respected, and she is even offered the armchair Burney was denied during her own operation. It is only after Elinor loses consciousness that her wound is dressed and Ellis is able to quit the "apartment where this bloody scene had been performed" (362). Then, as when she finally resolved, "[her] self-given up," to submit to her operation, Burney describes Ellis' reaction to Elinor's performance: "her sufferings, indeed, for Elinor, her grief, her horrour, had set self wholly aside, and made her forget all by which but a moment before she had been completely absorbed" (362).

The physical violations enacted in Burney's description of her operation are revised and complicated by the performance included in the novel. Burney chooses to divide her surgical experience among the scene's characters, portioning out her pain and exerting the control she lacked during the operation. She emphasizes the *trace* through this repeated revision and recreation, thereby evading repression; each form of writing Burney selects is both a theatrical display and a means of gaining control over the public violation of the private body. Burney transforms her wounded and incomplete physical body into an active writing body, a place of performance. Epstein suggests that, "in

medicine, the body becomes spectacle; in imaginative prose, the writer's language repossesses the theater."[21] But Burney repossesses her body through her writing; through the "trace" the "operating theater" becomes her own imaginative theater in which the experience of pain is revised, distributed, and shared. In *The Wanderer*, years of painful experiences, linked by the reincarnation of words and phrases, are expelled in one violent and dramatic exhalation, mesmerizingly reproduced through performance and remembered with the screams that linger and echo through time.

An affectionate caricature, thought to represent Fanny Burney and drawn by a member of her family, possibly her cousin Edward Burney,[22] crystallizes the issue of prosthesis as postsurgical performance. It depicts the novelist as a steam-powered android (figure 5). The dominant additions to her human form are a crowning smoke stack, spouting fumes, and a mechanical arm attached by an improbable system of pulleys and pistons to her brain. Kinesthetically, woman and mechanized appendages move in synchrony. The whole body leans forward and the level gaze bores straight ahead, expressive of confident motion in one direction, as one might expect from a locomotive engine, the overskirt and petticoats following in train. The caricature poignantly imputes the stolid invulnerability of a machine to the precise point of fleshly articulation, at the sensitive juncture of arm and breast, that provided the source of Burney's most exquisite suffering. The circular shape that defines the prosthetic shoulder joint might be thought to memorialize the absent breast, fixed above the angular lines that outline the profile of its surviving twin and inserted into the cavity that now houses the inner gears of the writing mechanism. That mechanism affirms the existence of Madame d'Arblay's radical prosthesis, but her words endow it with motion and meaning.

To create the kinesthetic idiom of "Still/Here" (1994), a dance-drama that confronts disease and mortality, choreographer Bill T. Jones conducted a series of workshops with people who had been diagnosed with life-threatening illnesses. He asked them "to define yourselves without words, to picture your lives [and your deaths] as you would want the world to know them . . . What I want is everything you are feeling right now—your life in one simple gesture."[23] From the life stories condensed into gestures that came from deep within the workshop participants, Jones built his choreography on the bodies of trained dancers, who stood in kinesthetically for the original informants. Among these informants was actress Carol MacVey, who narrated the scene of her diagnosis:

> I came to the hospital for a check up. I had no reason to suspect. I wasn't ill. There's no history in my family. I had a mammogram. Then the doctor said, "There's something suspicious looking." I looked up at the wall, and there was a sign that said, "Nineteen Out of Twenty Mammograms are Great." And I thought, "Just my luck."

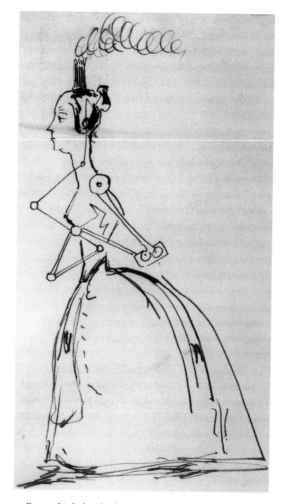

5. Pen and ink sketch of a mechanical woman by a member of the Burney family. Berg Collection of English and American Literature, New York Public Library.

When Bill T. Jones invited MacVey to express her feelings in gesture, she added speech to her physical movements, which consisted of wide swinging and reaching motions of her arms, fingers clenching, then extending: "I have this opportunity—to make something while I'm doing it. To create something free. [Breath] Why am I suffering? Maybe I'm blessed. [Breath] Maybe if I could just be free, I could stir it up. [With increasing vehemence in vocal tone and gesture] Stir it up! Stir it up! [Sharp breath] Just stir it up!"

MacVey's performance speaks of loss and recovery in the terms we have

used to describe Burney's acts of writing. Her use of the words *make* and *create* suggests that she imagines her body and mind as instruments of prosthetic manufacture. She suggests that the body she was born with is not exactly the only one she will ever have. Her embodiment of her own narrative for Bill T. Jones is more physicalized than her recitation of the mastectomy letter, but these two performances are linked by the expressiveness of her breathing. In each case, breathing communicates fear, loss, pain, anger, and ultimately determination. We believe that the "opportunity" of which MacVey speaks on this public occasion resembles the opportunity that Burney seized in writing and rewriting the scene of her loss—the opportunity for redress. In the face of "irremediable disappearance" of "presence," Burney and MacVey, like Bill T. Jones, use the occasion of embodied performance to assert before witnesses that they are—to a large extent, though not entirely—still/here.

NOTES

1. Quoted in David Wills, "1553: Putting a First Foot Forward (Ramus Wilson Pare)," in *Human, All Too Human,* ed. Diana Fuss (New York: Routledge, 1996). See also the *Oxford English Dictionary,* s.v. "prosthesis."
2. Jacques Derrida, *Writing and Difference,* trans. Alan Bass (Chicago: University of Chicago Press, 1978), 224.
3. Ibid., 229.
4. See Joyce Hemlow, ed., *The Journals and Letters of Fanny Burney (Madame D'Arblay),* 12 vols. (Oxford: Clarendon Press, 1975); and Margaret Anne Doody, *Frances Burney: The Life in the Works* (New Brunswick, N.J.: Rutgers University Press, 1988).
5. See Julia Epstein, "Writing the Unspeakable: Fanny Burney's Mastectomy and the Fictive Body," in *The Iron Pen: Frances Burney and the Politics of Women's Writing* (Madison: University of Wisconsin Press, 1989).
6. See Kay Torney, "Fanny Burney's Mastectomy," in *Border Crossing: Studies in English and Other Disciplines,* ed. John Barnes (Bundoora, Australia: La Trobe University Press, 1991); and John Wiltshire, "Fanny Burney's Face, Madame D'Arblay's Veil," in *Literature and Medicine During the Eighteenth Century,* ed. Marie Mulvey Roberts and Roy Porter (London: Routledge, 1993).
7. Epstein, "Writing the Unspeakable," 60.
8. Derrida, *Writing and Difference,* 226.
9. Hemlow, *The Journals and Letters of Fanny Burney,* 6:598 (our emphasis); subsequent page numbers in the text refer to this edition.
10. Torney, "Fanny Burney's Mastectomy," 81.
11. Torney also notes this reaction; describing the letter as "a desperate final strategy," she suggests that "when actual self-protection is impossible, Fanny Burney adopts the patient's last psychic resort, enacting a symbolic placement of one's vulnerable parts somewhere loved and safe." "Fanny Burney's Mastectomy," 81.
12. Elaine Scarry, *The Body in Pain: The Making and Unmaking of the World* (New York: Oxford University Press, 1985), 27.
13. Wiltshire, "Fanny Burney's Face," 257.
14. Derrida, *Writing and Difference,* 224.

15. Ibid., 225.

16. Ibid., 230.

17. Fanny Burney, *The Wanderer* (Oxford: Oxford University Press, 1991), 45. Subsequent page numbers in the text refer to this edition.

18. Hemlow, *The Journals and Letters of Fanny Burney*, 7:72.

19. See Doody, *Frances Burney*, 343–44.

20. Ibid., 6:609.

21. Epstein, "Writing the Unspeakable," 82.

22. Ibid., 137.

23. This and the following two quotes are from Bill T. Jones and Carol MacVey in Bill Moyers PBS Special: "Still/Here" (1994).

II. From Authenticity to Performativity

5. Like a Performance: Performativity and the Historicized Body, from Bellori to Mapplethorpe

THE FIELD OF performance studies has traditionally understood "performativity" as a sort of theatrical essence inherent in, but not necessarily transparent to, performance practices, whether these take place in traditional theatrical contexts or not.[1] Recently, the pressures from outside performance studies on the concept of "performativity"—from fields such as literary theory and philosophy—have made themselves felt in interpretations of "performance acts," just as they have long been felt in interpretations of "speech acts." Andrew Parker and Eve Kosofsky Sedgwick express their view of the theoretical power of the concept for performance studies by stating: "performativity has enabled a powerful appreciation of the ways that identities are constructed iteratively through complex citational processes."[2] "Performativity" contributes to the current explorations of "identity formation" occurring in many disciplines, specifically by revealing the possibility of language to speak autonomously—without the determination of traditional notions of authorship and creativity. Ideally, "performativity" reveals the contingency of subjectivity itself, thereby creating critical alternatives for the interpretation of performance.

Given the widespread influence over the last twenty years of the sociological and anthropological critiques of performance on performance studies, which have insisted on the complex social *context* as primary to interpretation, the value of "performativity" for a critique of performance appears to make sense.[3] Performances, as complex citational processes taking place in complex social contexts, might be viewed—in a deceptively simple parallelism—as ideally "performative."[4] The accepted complexity of performance's contexts would now seem to have found an equally complex means through which meaning is understood to be conveyed. Such an understanding of "performativity" as a complex social action engaged with both context and language, gesture, and the body in space (as it must be if identity is being constructed) suggests a compelling attractiveness to the field of performance studies. There remains, however, the danger—found also in its earlier usage there—that per-

formativity's "presence" in performance could be taken to be universal, immanent, and nonspecific. I shall discuss this danger below.

In this essay I want to probe this newer, interdisciplinary concept of "performativity" for signs of its effectiveness for the interpretation of historical performance. Specifically, I am interested here in a kind of historical performance in which the body is of paramount importance: marble figure sculpture. In the rhetorical context of the performative and in the mimetic regime of visual representation in early modern Europe, marble figure sculpture might be called an "art act"—indeed the preeminent or ideal "art act," inasmuch as it seeks to represent, mimic, and refer to the whole body, its gestures, and being in actual space. Furthermore, it does so with an insistence on the *materiality* of the represented body attractive to both the concepts of "art" and "performativity." *Scoltura* achieves its materiality as a result of: (1) its three-dimensionality; (2) its adherence to a mimetic regime of representation of the body; (3) its extrinsic and intrinsic characteristics relative to painting, the other representational art, in the art theory of the early modern period; (4) its overt reference to the past in the early modern period through the re-presentation of visible classical models, subjects, and techniques.[5] In the sense of the terms used in the title of the introductory essay to this volume, *Actualizing Absence*, marble sculpture actualized the presence of the performing historical body as no other medium, until the invention of photography, could.[6] I want to establish this important claim for early modern figure sculpture before I engage with the theoretical concept of "performativity."

The primary aim of sculpture, to actualize the body in space, led to formulations about the origins of the medium that reach back to Greek times.[7] Sculpture was seen as the earliest of the arts because its materials and techniques were closest to nature and its natural forms. Leon Battista Alberti, the early Renaissance humanist, implicitly states this in the first section of his treatise on sculpture:

> I believe that the arts of those who attempt to create images and likenesses from bodies produced by nature, originated in the following way. They probably occasionally observed in a tree-trunk or clod of earth and other similar inanimate objects certain outlines in which, with slight alterations, something very similar to the real facts of Nature was represented. They began, therefore, by diligently observing and studying such things to try to see whether they could not add, take away or otherwise supply whatever seemed lacking to effect and complete the true likeness.[8]

In the eighteenth century, Johann Joachim Winckelmann repeated this origin myth of sculpture in his introduction to *The History of Ancient Art*, the first history of classical sculpture.[9] In this discourse on the origins of sculpture in the early modern period, its very materials, particularly marble, were given an "ethnogeology"—a history of wood and stone in which naturally occurring characteristics were established solely on the basis of their visual

correspondence to the human form—which we find as early as Pliny's *Natural History*.[10]

Marble figure sculpture in the context of the visual tradition in the early modern period (ca. 1350–1800) sought to represent, mimic, and refer to the body *in the past*. In this way it was like the ideal kind, or genre, of painting known in early Italian art theory as *istoria*, the enactment of a worthy and illustrious story through the actions of the body.[11] However, whereas the primary aim of painting in the early modern period can be said to have been the representation of a historical narrative, sculpture's sole aim was to portray both through expression and gesture the human figure in the round. Thus, around 1450 Alberti could write:

> If I am not mistaken, the sculptor's art of achieving likeness is directed to two ends: one is that the image he makes should resemble this particular creature, say a man. They are not concerned to represent the portrait of Socrates or Plato or some known person, believing they have done enough if they have succeeded in making their work like a man, albeit a completely unknown one. The other end is the one pursued by those who strive to represent and imitate not simply a man, but the face and entire appearance of the body of one particular man, say Caesar or Cato in this attitude and this dress, either seated or speaking in court, or some other known person.[12]

Finally, the point most often made about marble sculpture in early modern art theory was that in its very process, the subtraction of the material from itself, it referred to its essence, an inner core understood as the idea of the thing to be represented that the artist holds in his mind. For example, in 1568 Giorgio Vasari expressed the quality of the absoluteness of the medium of sculpture as representation: "Sculpture is an art which by removing all that is superfluous from the material under treatment reduces it to that form designed in the artist's mind."[13] In this sense, sculpture by virtue of its very medium obtains a purity but also a quality of abstraction; figure sculpture comes closest to the externalization of inner experience or thought because it is derived by elimination of superfluous matter. This medium, therefore, can be said to epitomize representation in a way that no other medium can. It is the literalness of the congruence of the three—marble, the process of subtraction, and the subject of depiction (the body, itself present as being in the past, i.e., re-presented)—that makes sculpture paradigmatic of representation itself in the early modern period.

Furthermore, this burden of "representationality," as we might call it, was historically determined by the existence of antique marbles, called *statua*, for use beginning in the Renaissance as models of emulation. Whether fragmentary or whole, these ancient figure sculptures were copied by students in drawings, which were then used more creatively at a later stage by the mature artist as inspiration. These marbles gained further authority because of the written accounts of ancient sculpture in the Greek and Roman historical sources that

had been perused carefully by the humanists since the fourteenth century.[14] For these reasons we can say that ancient sculpture's representationality was emphasized both textually and visually throughout the period. Its citational strength, so apparent in contemporary art and art theory, gained from its location in both visual and textual instantiations.

Our understanding of the function of representation in the early modern period should also be a factor in regarding sculpture's role, as a medium, as paradigmatically "representational." Jacques Derrida reminds us that at the center and periphery of a Cartesian notion of representation stands "the self, here the human subject, which is the field in this relation, the domain and the measure of objects as representations, its own representations."[15] As the medium used to represent the body exclusively, sculpture came to refer at its most literal to the embodied self. In the seventeenth century, a sculpture could be said to be a "speaking" likeness or, similarly, a marble sculpture could be said to be more like the sitter than the actual man. In 1665 Paul Fréart de Chantelou reports just such an assessment of the early *Portrait of Monsignor Montoya* by Gianlorenzo Bernini (1598–1680):

> The Cavaliere told us that one of the first portraits he did was of a Spanish prelate called Montoya. Urban VIII, then still a cardinal, came to see it, accompanied by various prelates who all thought it was a marvelous likeness, each outdoing the other in praising it and saying something different about it; one remarked, "It seems to me Monsignor Montoya turned to stone," while he remembered another said with great gallantry, "It seems to me that Monsignor Montoya resembles his portrait."[16]

In this way sculpture incorporated the sitter or figure represented as its human subject while at the same time, as I have said, referring most essentially and abstractly to the "idea that the artist holds in his mind." The result, quite clearly stated in the seventeenth-century sources, was that contemporary sculpture that was deemed successful succeeded in blurring distinctions between original and copy. For example, in his biography of his father, Gianlorenzo, Domenico Bernini writes in regard to the *Portrait of Montoya*:

> And he brought this work to such a conclusion—one of such spirit and verisimilitude—that whosoever took delight in regarding it with attention and was forced to choose between the Original and the Copy—or which between the two was the fake or the real—would say that, represented like this, the Statue had no need of animation in order to appear alive.[17]

Thus, by the late seventeenth century, those who favored painting in the comparison of the arts of painting and sculpture would resort to color as the rebuttal to sculpture's authority over "form."[18] Sculpture's adherents retorted that even when a man becomes pale he keeps the same features "just as the Sculptor can find likeness in white marble."[19]

We have seen that in this period sculpture could be said to incorporate a dual subjectivity: that of the creator/artist whose idea rests in the marble and

whose hand is revealed in the manipulation of it, and that of the sitter or figure whose essence has been embodied in the stone. It is this duality of subjectivity embedded in sculpture that pertains to "performativity." With the historical background established, let us return to the congruency of the meanings between what I have called "art acts"—performance or marble sculpture—and what many have called "speech acts."

Such an understanding of the status of performance and sculpture in speech act theory relies on the reformulation by Derrida in the essay, "Signature Event Context," of the concept of "performativity" found in J. L. Austin's *How to Do Things with Words.*[20] Derrida's important discussion of Austin and the stakes he raised for the interpretation of texts, speech, and performance form the heretofore insufficiently explored basis of the contemporary use of the concept of performativity. The reason is clear. Derrida presupposes all communications—oral, gestural, written—as homogeneous. Communication is "a homogeneous element through which the unity and wholeness of meaning would not be affected in its essence. Any alteration would be accidental."[21] In this way, Derrida contradicts Austin's earlier exclusion of performance from "performative utterance." In *How to Do Things with Words*, Austin disallowed utterances "said by an actor on the stage."[22] From our perspective today, some twenty-five years after Austin and in the wake of a contextualist performance studies, it may well seem like an extreme denaturalization of theater—of theatrical speech and the theatrical body—to have insisted on its banishment from the realm of "performativity."[23] However, until Derrida questioned the grounds of Austin's exclusion and his characterization of these "*etiolations* of language" spoken in performance as "non-serious," performance theory remained oblivious to the concept "performativity." After "Signature Event Context," every performance could be considered a communication; significantly, Derrida uses the term "expressive communication" in the essay.[24] The qualifying adjective holds great importance for both performance and art. Expressivity and discussions of media, particularly the distinctions between media, go hand in hand in twentieth-century art theory.

In addition to considering performance a communication, Derrida insisted on the "representational character of the written communication—writing as picture, reproduction, imitation of its content."[25] Representation is the essential characteristic of the communication as far as Derrida is concerned. In its most classical formulation, as Derrida writes: "Representation regularly *supplants* [*supplée*] presence."[26] For Derrida, this turns us toward the "act" of enunciation as much as it makes us aware of the utterance. In this sense we must understand the representational character of the communication—oral, gestural, written—not in terms of imitation or mimicry but as containing the present, the speaker, and the addressee. That these aspects of the communication are always part of it pertain centrally to our understanding of performance and art of all kinds. In reference to the latter, David Summers put it this

way: "The words 'representation' and 'representationalism' obviously and literally contain the term 'present': and they thus also presuppose the presence of something as well as the presence of someone by whom and to whom representation is made."[27] This understanding of representation has determined our history of art, the major interests of which have been the relationship of "the art object" (material and existing in our present) to both the creator/artist and/or the spectator/market.[28]

Derrida's interest in the presence in the representational character of communication lies, characteristically for him, in its apparent opposite, *absence*, which he theorizes as "a continuous and homogeneous reparation and modification of presence in the representation."[29] This understanding of "absence" as an *activity* of the presence *in* representation allows Derrida to address a key aspect of performative language according to Austin: its iterability—what Derrida calls its repeatability. For Austin, iterability denotes the performative utterance and no other. For Derrida, iterability is an aspect of the representational character of all communication (performance, art, writing) without which it could not *be*.[30] Thus, according to Derrida, all communication can be potentially or in actuality "performative."

For the historical representation or the historian interested in past performances, the stakes involved in Derrida's understanding of "performativity" lie here: "My communication must be repeatable—iterable—in the absolute absence of the receiver or of any empirically determinable collectivity of receivers . . . A writing that is not structurally readable—iterable—beyond the death of the addressee would not be writing."[31] If we are to understand performance as performative, then we must, according to Derrida, admit that it cannot be erased if it is to *be* performance. Absence refers not to the absent referent, which, in any case, can only be referred to. Instead, absence dynamically refers to the speaker's and possibly the audience's absence because they are caught up in the (re)presentation.

According to Derrida, then, the iterability of any communication cannot be erased if it *is*, or, put more historically, if it has truly occurred. Iterability raises the issue of temporality and brings us up against the commonplace or naturalized understanding of performance as an original that took place *then* and, therefore, was *by its very nature* always erased. If we hold with Derrida's careful reformulation of Austin's "performativity" we cannot agree with Peggy Phelan's understanding of the ontology of performance: "Performance's only life is in the present. Performance cannot be saved, recorded, documented, or otherwise participate in the circulation of representations *of* representations: once it does so, it becomes something other than performance."[32] Phelan's absolute performance may allow room for the body and subjectivity in the present, as she insists that it does, but there is no space in this performance for history. In Derrida's formulation, however, *all* communications exist as a presence that is known only through iteration. Subjectivity, therefore, may not

govern performativity. Rather, as Judith Butler writes, "If a performative provisionally succeeds . . . then it is not because an intention successfully governs the action of speech, but only because that action echoes prior actions, and *accumulates the force of authority through the repetition or citation of a prior and authoritative set of practices.*"[33] Today's iteration gives way to the performance or the art of the past.

Although Derrida does not explicitly include "art" in his list of performatives, I have proceeded here as if art were understood to belong to the category of "communication." Furthermore, when the concept of art has been explored philosophically in the field of aesthetics, it becomes clear that our culture's understanding of art relies precisely on this Derridian formulation of "iterability." As Richard Wollheim has argued, the concept of art contains within it the assumption of the continuity of an audience who will accept the status of the object from the past as art in the present, and who will, often unconsciously, view its functioning in the present in terms different from those given to it in the past, nonetheless insisting on the authority of its status as art.[34] Furthermore, as Wollheim has stated, the concept of art cannot be understood to be socially determined in the abstract, but rather requires "a more intimate link between the social and artistic phenomena than mere correlation."[35] He suggests that understanding art as "essentially historical" would be the only way to explain the way that it is constituted.[36] Pushing Wollheim's argument perhaps further than he might like, it is precisely because art is constituted that it must be historical. Or, with a Derridian gloss, it is precisely because the communication is iterable that it must be able to refer to the past. These characteristics of the concept of art as explored by Wollheim converge with Derrida's more rhetorically nuanced understanding of the communication.

Finally, Judith Butler recognized that Derrida's critique of Austin did not only reclaim action for all communication, precisely by insisting on the iterability of performances—in other words, his critique of Austin did not only make the apparently de-naturalized performance "natural" or potentially normative again. Derrida's critique also brought forward into critical consciousness the realization of how *unnatural* the seemingly most natural acts can be, thereby making possible Butler's famous critique of the performativity of gender.[37] As she says, performative acts within theatrical contexts are like or similar to natural acts in any other context, and it is only the extreme naturalization of each—the loss of their "cultural meaning"—that has allowed them to appear distinct from each other.[38] The political power of "performativity" follows from this point of view: if apparently natural acts such as gender are constituted, that is, "performative," then changing these acts may be possible. She writes: "In its very character as performative resides the possibility of contesting its reified status."[39] So too, it would seem, taking performance as the "natural" term here, performance could be or may well have been misunderstood in the past as unconstituted—unnatural in its naturalness, or "non-

serious" in its seriousness. Performances may have been misunderstood to have been immutable, fixed, and incapable of being changed. Such performances may have been standardized or made normative to such an extent that an ontology of performance could be theorized from this "existence."

The canonical *locus* for this kind of normative discourse on the visual arts succeeds by establishing the essential characteristics of the visual arts through the method of distinguishing ancient marble figure sculpture from other, textual arts, preeminently poetry. In his famous essay on an ancient Hellenistic sculpture, *Laocoön: An Essay on the Limits of Painting and Poetry* (1766), Gotthold Lessing found the essence of the visual arts to be both the deployment of a body in space and a simultaneous apprehension of the parts of that figure by the viewer.[40] Lessing considers ancient sculpture's characteristics to be exemplary and normative, but the specific term for the medium disappears in favor of a term that can stand in for the visual arts in general.[41] It may now seem "natural" to call sculpture painting, in part because of Lessing's status in art criticism but, according to Butler's view, it is precisely at times like this, when specificities become generalized in discourses that apparently distinguish and discriminate, that we should watch for "a loss of cultural meaning."

In history we would look for evidence of the immutable performance in criticisms or theories of performance that imposed rigid models, resisted change, and insisted on the feint that what is understood here today by the concept of performativity was a sign of the unnatural (or the overly natural), the unmediated (or Austin's "parasitic"), the unreal (or Austin's "non-serious"). If we accept Butler's understanding of Derrida's performative, we may say that the concept existed in the past but that it was undesirable or unrecognizable. As such, we should expect performativity to have been legislated out of performance, apparently absent or missing, although its traces have often been found by historians.[42] Similarly, during the course of Wollheim's argument about the concept of art, it becomes clear that it existed in the past but has not consistently been theorized as constituted—that is, historical. Wollheim's preeminent example of the absurdity of such thinking—what he calls a "Presentational theory"—is Kant, who "stipulated that we should free ourselves from all concepts when we approach art."[43] This is still a broadly accepted commonplace about the concept of art. If this kind of absurd critical situation sounds suspiciously like classicism, we should not be surprised, and our historical example of marble figure sculpture will take us directly to the heart of this sort of discourse on art.

First, however, we must return to the place of the body in the concept of the performative because, except as an aspect of the active absent present, it is not prominent in Derrida's understanding of the concept. Significantly for performance studies, the body, especially sexuality, becomes primary in Butler's understanding of performativity, as it also must be for the concept to prove useful to understanding the "staged body" and the "ritualized body,"

whether in the present or the past.[44] Butler has explained that her understanding of the body as the site of performativity relies on the phenomenological philosophy of Merleau-Ponty, which gives us "the doctrine of constitution that takes the social agent as an *object* rather than the subject of constitutive acts."[45] For Merleau-Ponty, Butler, and others, this is a body on which culture acts as much as it itself performs. To understand this acted-upon body, it must be historicized, particularized, and specific. Butler explores the gendering of this body using an understanding of the constitutive performative gleaned from phenomenology and speech act theory.

The Body and Sculpture

For our purposes here, those concerned with the historical performance and performativity in history, we should be clear that with this understanding of the body there can be no universal, immutable type, just as there is no universal and unchangeable performance. We might say that this is the body with a difference and one that has always been constituted. In concrete, material terms, the temptation may be to oppose this kind of performative body to the classical type of the heroic male, whether nude as in Michelangelo's *David* of 1512 (Florence, Galleria dell' Accademia), or clothed as in Orfeo Boselli's *St. Benedict* of the mid-seventeenth century (Rome, Church of Sant'Ambrogio). The male figure of this type was the primary subject of marble sculpture in the early modern period; it was understood to be universal, immutable, and ideal. In like manner, the performative, constituted body might be seen to be the opposite of, say, the *Belvedere Antinous* (Rome, Musei Vaticani), a Roman copy of a Greek original thought by some to be by Praxiteles and, since its discovery in 1543, used by artists and critics alike, as *the* example of the perfection of ancient marble figure sculpture (figure 6).[46] But we should be careful here to understand all bodies—and following Butler perhaps especially those once determined ideal—as performative, as the result of constitutive acts. In the case of *Belvedere Antinous*, the constitutive performative act is the sculpture, and, as I shall demonstrate below, we can understand its performativity only through the ways in which the figure—the represented body—is performed upon in history.

Once placed in this performative frame, we can see how the ideal male body is played out in different historicized situations through the medium of marble figure sculpture dominated by a regime of classicism. We can specify the political power with which this particular performativity endows the classical male body and the theory that ensues from it. This representation of the male nude body, discovered in 1543, has been performed upon over the next four centuries both visually, in works of art and photographs, and textually, in art history writing and criticism. *Belvedere Antinous* has been the site of the

performance of a variety of masculinizations, several of which I will explore here.[47] This demonstration of performativity and its components will allow us to test the critical concept in the interpretation of the historical "art act."

Let us begin in the contemporary period so that we can appreciate more easily the political power that performativity carries with it. The overt citation of the *Belvedere Antinous* by the photographer Robert Mapplethorpe in his

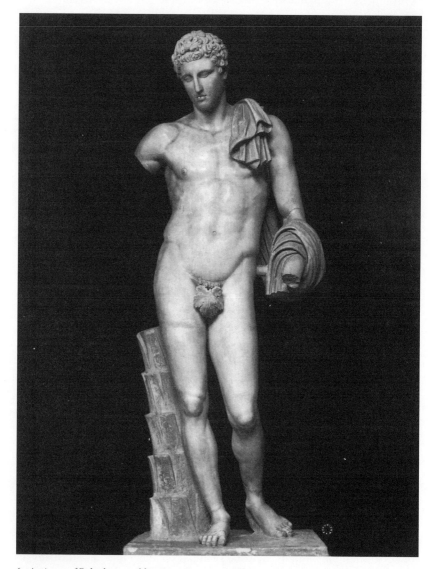

6. *Antinous of Belvedere*, marble. Alinari/Art Resource, NY. Vatican Museum, Vatican State.

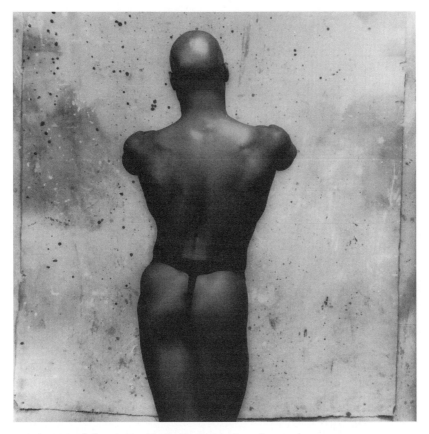

7. Robert Mapplethorpe, *Ken Moody*, black and white photograph. Ken Moody, 1983 Copyright © 1983 The Estate of Robert Mapplethorpe.

1983 photograph *Ken Moody* insists on the original site of representation by portraying the figure from the back, thereby emphasizing the in-the-round quality of the sculpture (figure 7). The arms are truncated, thereby reminding us of the fragmentary quality of the original marble. In the reinscription of Ken Moody as *Belvedere Antinous*, Mapplethorpe performs the sculpture through additive and subtractive measures. He shaves the head of the figure, de-classicizing it so that it assumes the same tonalities and reflective possibilities as the rest of the body. He dresses the body in a thong that bisects vertically the cheeks of the buttocks and horizontally the torso of the figure. As a kidding reference to the fig leaf normally seen on the front of the classical male nude, the thong itself also marks the forbidden orifice in the representation of male homosexuality. Not only does this ornament enhance the sexuality of the figure by marking the naked backside, it also enhances the classical contrap-

posto pose of the figure, in which the *Belvedere Antinous* and its purported artist, Praxiteles, were said to have excelled, thus remarking upon the critical importance that this gesture of the figure sculpture has carried since the early modern period.[48]

Finally, Mapplethorpe has substituted here the representation of a black male body for the male body in white marble that is *Belvedere Antinous*. This apparently subversive move rearticulates issues of medium between the depiction of the body in marble sculpture and in black-and-white photography. Moreover, it allows us to question the canonicity of images in the European classical tradition as color-coded and insidious. But, as bell hooks argues in her catalogue essay for the *Black Male* exhibition, this body "reinscribe[s] and perpetuate[s] existing structures of racial and/or sexual domination" by reifying racist stereotypes because the "public response privileges this work."[49] In contrast, according to my enframement of Mapplethorpe's *Ken Moody* in the performance of *Belvedere Antinous*, such reification pertains to the way in which the performative functions in the historicized representation. This reification may or may not be intentional on the part of Mapplethorpe, its privileging by the public may or may not be "purposive" on Mapplethorpe's part.[50] *Ken Moody* performs; Ken Moody and *Belvedere Antinous* are performed upon. Whatever it once was—and we shall investigate a text from the historical moment closer to the discovery of the ancient marble—*Belvedere Antinous* has become *Ken Moody*.

So too, has it become a Nubian warrior in the photograph by Leni Riefenstahl from her book *The Last of the Nuba* (1973) (figure 8).[51] The *Primitivism* show of 1984 at the Museum of Modern Art in New York brought out a critique of the appropriation of primitive art to the European tradition as model, inspiration, or blood kin in ways that denied or ignored native and indigenous conceptions of what the objects on display might be or do.[52] Riefenstahl's use of *Belvedere Antinous* purports a realistic ethnography of a people in Africa not desired by Mapplethorpe's *Ken Moody*, which was destined for the gallery or museum wall. This performance of the marble figure sculpture masks its originary context as "art act" through insertion in the field of anthropology. Riefenstahl herself has contributed to this masking by expressing surprise that anyone could see her pictures of the Nuba as part of a continuing celebration of beauty and strength rather than as a humble record of what was there to be photographed.[53] Absence may well be a difficult position from which to make an argument, but we can understand this powerful iterative presence precisely in the acts of masking and denial that Riefenstahl has performed upon her figures. Support for this understanding of the citation comes from the criticism of Riefenstahl's project by anthropologists: her photographs of the Nuba have been discredited as legitimate ethnographic practice.[54] In their performativity they require legislation, even censure.

With the example of Riefenstahl's photographs of the Nuba, we might say

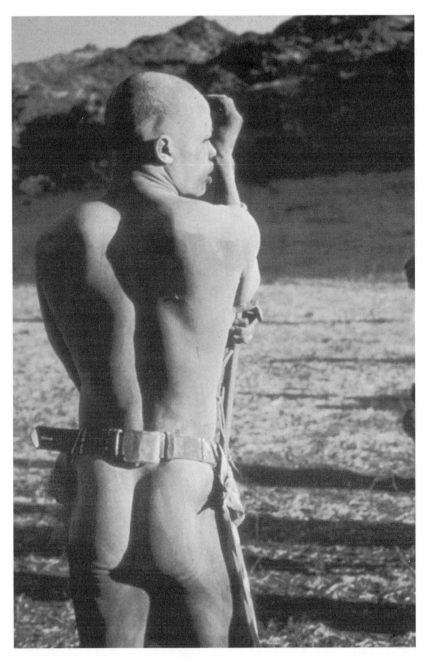

8. Leni Riefenstahl, *A Wrestler from the Zariba*, in Riefenstahl, *The Last of the Nuba*.

that in the academic context at least, performativity may well be a more comfortable concept when it finds a decorous or proscribed context. When *Belvedere Antinous* performs *Ken Moody* it may be subversive, but when the sculpture performs the *Nuba* it becomes outrage. Ethical considerations pertaining to disciplines and their conventions and rules of professional conduct may in part explain why performativity as a concept has found a certain difficulty gaining entrance.

The Textually Performing Belvedere Antinous

Finally, let us turn to 1672, a most important moment for our understanding of the performativity of *Belvedere Antinous* because this is when the visual and textual representations converge. The statue can be found prominently illustrated in Giovanni Pietro Bellori's *Le vite de' pittori, scultori e architetti moderni* (The lives of the modern painters, sculptors, and architects), a book extremely influential for both art history and aesthetics.[55] Bellori's book formed the basis of a classical canon of art elaborated upon over the next two centuries. Bellori presents a complex history of modern art made up in the main of a series of twelve biographies of artists, all of whom were dead by the time Bellori published his book. These are preceded by (1) a dedication to Colbert, minister to the court of Louis XIV; (2) an "Address to the Reader"; (3) a "Table of Contents of the *Vite*"; (4) a *discorso* (sometimes translated as "a discourse") with the title, "L'idea del pittore, dello scultore, e dell'architetto scelta dalle bellezze naturale superiore alla natura" (The idea of the painter, the sculptor and the architect chosen from the natural beauties superior to nature). Following the individual biographies of the artists are four pages of illustrations, measurements, and explanations of *Belvedere Antinous*, said to be taken from the thought of the painter Nicolas Poussin, friend of Bellori and subject of the final biography in the book. Following *Belvedere Antinous* are excerpts from Poussin's treatise on painting. The various sections of the book are all fascinating in their own right and as separate genres that converse with each other, but we shall focus here on the illustrations of *Belvedere Antinous* and the *discorso*, in which Bellori further explains his views on antique sculpture. These two parts of the book, the visual and the textual, complement and support each other's claims.

We should keep in mind that throughout the book Bellori proceeded "according to a principle determined by criteria of evaluation."[56] His goal was not one of comprehensiveness, like the earlier books containing collections of artists' biographies that he criticizes in the "Address to the Reader," but one determined by the very same principles of judgment determining art that he recommends his readers follow.[57] We find Bellori's judgment operating in the lengthy and detailed descriptions of art works he considers significant, the

attention he paid to the illustrative matter in the book, and in the care he took in assembling the oeuvre of the artists he does discuss.

Let us examine the visual instantiation first (figures 9–12). The figure is shown in two engravings, from the front (*veduta di faccia*) and from the side (*veduta di profilo*), on separate pages, each of which faces an explanation of the measurements indicated with letters and lines on the image. It should be pointed out that the very process of engraving has caused *Belvedere Antinous* to be represented in the engravings in reverse, a change little noted in discussions of Bellori but certainly significant if we are to understand these two images as iterations of the ancient sculpture. It was of course well known at the time that the engraving process resulted in a reverse image unless a correction for the technology were made, but evidently such a change was not deemed necessary. The exact replication of *Belvedere Antinous* cannot be the point of these images, although the authority of the sculpture remains intact.

Instead, the representations of *Belvedere Antinous* privilege the proportions and measurements of the figure, not its subject matter or its style (i.e., the visible marks of the hand of the artist). These measurements are indicated by letters on the edge of the contours of the figures in the engravings. Proportion is further emphasized in both views by the different architectural backgrounds against which the figures are set. In both cases, these are classicizing structures in a severe style constructed of large, regular rectangular blocks that anchor the figure—the body—to a system of linearity and regularity. In the frontal view of *Belvedere Antinous*, the wall captures the body in its corner. The prominent cornice bisects the figure horizontally, calling attention to the interest of this area of the body, which is expanded upon in the facing text.

In the profile view of the figure the architecture depicts a set of steps, which leads directly to the groin of the figure. The proportions of the figure, indicated by letters, literally descend the body in a triplet; at the front of the torso, at the back of the thigh, at the front of the calves. Again, the prominent cornice at the top of an attached pilaster is placed behind the figure and rises only as far as the top of the head, functioning to pull the figure upright. Similarly, the shadow projected on the wall behind the figure flattens and elongates our understanding of its slightly foreshortened appearance.

In these engravings *Belvedere Antinous* is bisected, brought into the order of the architecture, and delineated with letters that refer to texts on the facing page. These representations are not an illustration of a body, embodiment, or action. They are lessons on how to make order of *Belvedere Antinous*. Classical sculpture is put into the context of proportion and regulatory conduct to be consumed by the modern artist and connoisseur, the ostensible readers of Bellori's book. If the illustrations of *Belvedere Antinous* represent the idea of classical sculpture in Bellori's book, as scholars have argued, then ancient sculpture has been disciplined to bring it into conformity with an aesthetics of regulation based on judgment that pervades the rest of Bellori's book.

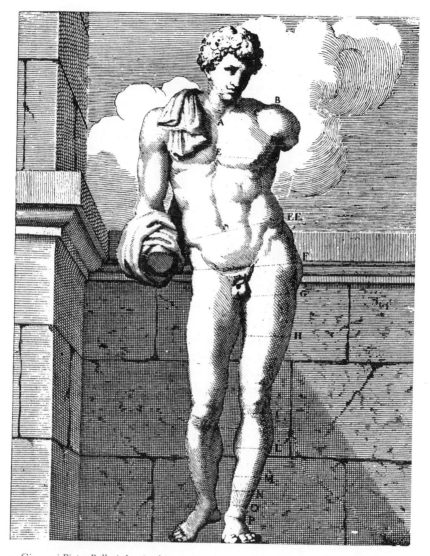

9. Giovanni Pietro Bellori, *Le vite dei pittori* . . . (Rome, 1672). Engraving of the statue of *Antinous* seen from the front.

Given the theoretical priorities visited upon *Belvedere Antinous* in Bellori's book, it comes as no surprise that his discussion of the role of judgment and antiquity found in "The Idea," as well as its placement before the biographies that comprise the larger part of the book, have been interpreted as polemical gestures on the author's part. Giovanni Previtali regards Bellori's views in the essay as unoriginal inasmuch as they came from those circulating earlier in

Mifure fopra la ftatua d Antinoo veduta di faccia.

D *Alla fontanella* **A.** *fino all'eftremità della clauicola nella congiun-tione fua coll'acromion, & offo del braccio fegnato* B *vi e vna_ tefta.*

Dalla fontanella **A.** *fino al principio del mufcolo deltoide fegnato* C. *vt è tanto quanto dal detto* C. *fino alla piegatura* D.

Dalla detta piegatura D. *tanto fimilmente fino al caporello .*

Dal caporello vi è il medefimo fino alla foffa dello ftomaco fegnato E. *il medefimo dal deltoide fegnato* B. *fino alla piegatura* D.

Di maniera che in quefto fpatio di membra vi fono cinque mifure tutte_ vguali fradi loro.

Quella parte che ι di là sù fino alla congiuntura del membro, occupa due_ tefte in q uefta maniera : dalla foffa del petto fino alla prima eneruatio-ne, o fibra nel ventre fuperiore fia vna terza, e tre duodecime . La fe-conda eneruatione, che è terminata per l'vmbilico, hà vna terza & vna duodecima, & il tutto fà vna tefta. Dall'vmbilico fino all'eftremità del pettignone : quefta parte è diuifa come la fuperiore, cioè per la prima eneruatione del ventre inferiore, quanto quella del fuperiore , & il mede-fimo dal pettignone come della feconda eneruatione del fuperiore che vi farà vn altra tefta di fronte ; fotto le linee d'vn profilo all'altro vi fo-no due tefte .

F E *Vna tefta , e due terzi , & vna ventefima d'vna tefta , e quattro quintefime .*

F *Vna tefta , meno vna ventefima e tre quarti .*

G *Due terzi meno vna duodecima .*

H *Hà il medefimo .*

I *Due quarti , e la metà d'vna ventefima .*

L *Due terzi .*

M *Vna terza e due duodecime .*

N *Due quinte .*

O *Vna terza .*

P *Vna terza , & vna duodecima .*

Il collo del piede vna terza.

Per il più largo del piede poco men di due terzi .

Da vn caporello all'altro vna faccia , e fei ventefime .

Mi

10. Giovanni Pietro Bellori, *Le vite dei pittori* . . . (Rome, 1672). Measurements of the statue of *Antinous* seen from the front.

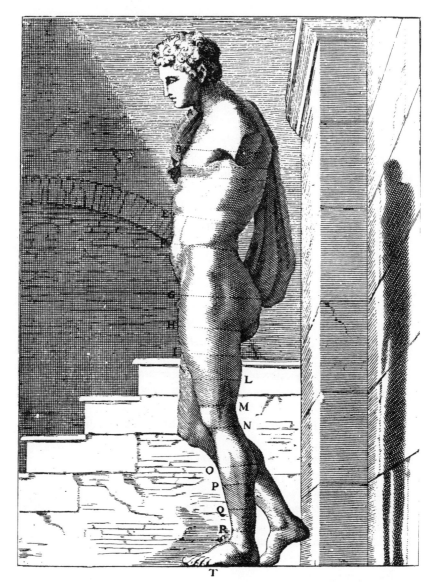

11. Giovanni Pietro Bellori, *Le vite dei pittori* . . . (Rome, 1672). Engraving of the statue of *Antinous* seen in profile.

458

Mifure fopra la veduta di profilo della ftatua d'Antinoo.

A. *Tre quintefime.*
B. *Vna faccia vna terza, e la metà d'vna duodecima.*
C. *Vna faccia e due quinte.*
D. *Vna faccia e noue ventefime.*
E. *Vna faccia e due ventefime.*
F. *Vna faccia & vna feſta.*
G. *Vna faccia e due quinte.*
H. *Vna faccia e due ventefime.*
I. *Vna faccia & vna ventefima.*
L. *Due terzi, vna duodecima.*
M. *Due terzi.*
N. *Due terzi manca vna duodecima.*
O. *Due terzi.*
P. *Vna terza, e due duodecime.*
Q. *Vn terzo, & vna duodecima e mezza.*
R. *Noue ventefime.*
S. *Tre quinte.*
T. *Vna tefta, e tre quinte.*
La lunghezza del piede tutto è quanto dalla fua pianta alli gemelli, & da ge-melli alla fommità del ginocchio,

12. Giovanni Pietro Bellori, *Le vite dei pittori* . . . (Rome, 1672). Measurements of the statue of Antinous seen in profile.

the seventeenth century in the revisionist and conservative circles of Monsignor Agucchi, Bellori's teacher.[58] According to Previtali, this art "theory in its Renaissance formulation proposed a third way between the contrary extremes of the fantastic idea of Mannerism and a naturalism without judgment"; the first characteristic of the painting of Michelangelo Merisi da Caravaggio, and the second, of the sculpture of Bernini.[59] According to Previtali, this classical aesthetic reduced the naturalists to a marginal position in the academy and in society in general by launching a polemic against the "license and ardent liberty of the youngest artists."[60]

This was accomplished in large part through the kind of criticism Bellori brought to bear on antique marble sculpture. Drawing on the nomenclature of Neoplatonism and earlier art theory, Bellori called the goal of art "The Idea," and rejected Caravaggio "for being too natural in painting likenesses."[61] Similarly, he cited the authority of the Greek sculptor Lysippus, who "reproached the vulgarity of the Sculptors who made men as they are found in

nature, and prided himself for forming them as they should be, following the advice given by Aristotle to Poets as well as Painters." This overt statement of policy resulted in a less visible one, the relative denigration of modern sculpture in comparison to painting and to antique sculpture. Bellori accomplished this denigration by insisting on the absolute value of antique sculpture, and the impossibility of an adequate iteration of it in the present.

In *Le vite*, "The Idea" merits its own title page, which states that Bellori originally delivered this *discorso* at the Accademia Romana di San Luca (the painter's academy) on the third Sunday of May, 1664.[62] That he calls the essay or lecture a *discorso* is extremely significant in terms of its content and polemical purpose, for the term had a specific meaning at the time. According to the *Vocabolario degli Accademici della Crusca* (1691), *discorso* means: "An operation of the intellect with which one strives to understand a thing perfectly, by means of conjecture or by its principal marks."[63] Thus, the meaning of *discorso* iterates the contents of "The Idea," a discussion of those aspects of ancient sculpture that make it the perfect model for the present. The definition of *discorso* corresponds exactly to the art critic Filippo Baldinucci's definition of *idea* found in the 1681 *Vocabolario toscano dell'arte del disegno*: "The perfect knowledge [*cognizione*] of the intelligible object, acquired and confirmed by doctrine and usage."[64]

Although it has not been noted in the literature on Bellori, surely his erudite contemporaries would have been aware of the iteration between the terms of *l'idea* and *il discorso*. The "performativity" potentials of the text are underscored in these iterations. For example, Bellori writes iteratively:

> It remains to be said that since the Sculptors of antiquity used the marvelous Idea, as we have indicated, a study of the most perfect antique Sculptures is therefore necessary to guide us to the emended beauties of nature and with the same purpose direct our eyes to contemplate the other outstanding masters.[65]

We should recall that according to Derrida it is this iterability that allows a performative to succeed. Just as Bellori's "Idea" is mirrored in the meaning of *discorso*, so too the imitation of ancient sculpture should constitute the art of the present. This position, as Previtali suggests, is not without polemical intent. However, in order to ascertain the political stakes in Bellori's book more specifically than has been done previously we need to do more than gesture to the return of Renaissance humanism, as well-known art historians have done.[66] Bellori's appropriation of a humanist view of antique sculpture must be historicized with a certain degree of specificity in order to understand its iteration in "The Idea."

For this reason I turn now to Niccolo Machiavelli's *Discourses on the First Decade of Titus Livy*, the best known *discorsi* in Italian literature in Bellori's day as well as our own. Machiavelli's book, written after his exile in 1512, is a long discussion on the perfect republic—a tyrannical republic as most of his

recent critics have recognized.[67] Although based on its Latin source, Machiavelli presents a purely Renaissance conception of how men in the present should imitate the past in order to achieve their political purposes. As such it is both theoretical and practical in intention, just as Bellori's book is. While Machiavelli presents us with political theory, Bellori presents us with art theory, yet both authors intend that their methods should persuade their contemporaries to action. In Machiavelli the desire to persuade is clearest in the prefaces to the first and second books, in which he discusses his esteem for antiquity and the value for the present of imitating it. Likewise in Bellori's book, it is the *discorso* ("The Idea") and "The Letter to the Reader" that precedes it that exhort the reader to value antiquity so that they can reach good judgment in the present.

There can be little doubt that Bellori imitated the structure and the content of Machiavelli's prefaces because they provide a Renaissance *exemplum*, by way of a Roman historian, of an approach completely consonant with his own. More significantly, in the preface to the first book, Machiavelli begins with an ancient sculpture. He gives sculpture to his readers as the preeminent example of how, through imitating the antique, they can succeed in the present.

> Considering thus how much honor is awarded to antiquity, and how many times — letting pass infinite other examples — a fragment of an ancient statue has been bought at a high price because someone wants to have it near oneself, to honor his house with it, and to be able to have it imitated by those who delight in that art, and how the latter then strive with all industry to represent it in all their works.[68]

Machiavelli goes on to compare this exemplarity with the lack of imitation of the antique found in other areas of contemporary life. In this way, ancient sculpture is elevated as the paradigmatic example not only from the past (antiquity) but also for the political present. Thus, he writes:

> and seeing, on the other hand, that the most virtuous works the histories show us, which have been done by ancient kingdoms and republics, by kings, captains, citizens, legislators, and others who have labored for their fatherland, are rather admired than imitated — indeed they are so much shunned by everyone in every least thing that no sign of that ancient virtue remains with us — I can do no other than marvel and grieve. And so much the more when I see that in the differences that arise between citizens in civil affairs or in the sicknesses that men incur, they always have recourse to those judgments or those remedies that were judged or ordered by the ancients. For the civil laws are nothing other than verdicts given by ancient jurists, which, reduced to order, teach our present jurist to judge. Nor is medicine other than the experiments performed by ancient physicians, on which present physicians found their judgments. Nonetheless, in ordering republics, maintaining states, governing kingdoms, ordering the military and administering war, judging subjects, and increasing empire, neither prince nor republic may be found that has recourse to the examples of the ancients.[69]

Finally, Machiavelli ties the strength that these examples hold for the present to a knowledge of history, thereby reinforcing his own project of the glossing of Livy. He goes on:

> This arises, I believe, not so much from the weakness into which the present religion has led the world, or from the evil that an ambitious idleness has done to many Christian provinces and cities, as from not having a true knowledge of histories [*vera cognizione delle storie*], through not getting from reading them that sense nor tasting that flavor that they have in themselves.[70]

According to Thomas Green, Machiavelli's purpose in writing is to "perform (*operare*) things desirable for the common good, and the content of his labor will be those achievements filled with *virtù*, those 'virtuosissime operazioni' wrought (*operate*) by ancient kingdoms and republics."[71] Bellori echoes this purpose of the performance of a history in his "Letter to the Reader."

Two things emerge here from a close reading of Machiavelli's *Discourses* in the context of Bellori's *discorso* and his project in the entire book. First, that Bellori sought in Machiavelli the authority for a view of ancient sculpture that extended its significance well beyond the realm of art. This appropriation, certainly by Bellori's day, must be termed conservative. Second, that in Machiavelli he found the "cure" to what he viewed as the relative decline in art brought about by a lack of imitation of the antique. This cure was history writing itself. The purpose of Bellori's book, for the most part a series of biographies of artists chosen for their exemplarity rather than for reasons of a chronological thoroughness or fame, can be found in Machiavelli's text. Like Machiavelli, Bellori sought to rectify a decline through recourse to antique *exempla*. We need not accept, then, Panofsky's view of a dissonance between the philosophical content of "The Idea" on the one hand, and the biographical *vite* on the other.[72]

Bellori's concept of history rests on antique sculpture and the recognition that it allows for the constitution of an ideality that extends in meaning well beyond the then current realm of art, both in its absolute perfection and in its lack of what we understand by historicity. In Bellori, contemporary sculpture could not give way to the art of the past; rather, the very performativity of ancient sculpture represented an ideality that related only to the present. Like Phelan's view of performance, which I have also characterized as absolute, Bellori's view of sculpture cannot allow contemporary sculpted figures to "participate in the circulation of representations *of* representations" and remain sculpture.[73] Instead of accepting Bellori's view, as later neoclassicists did, I want to argue that ancient sculpture gives us more than itself, just as *Belvedere Antinous* represents more than itself. We have seen with the examples of *Ken Moody* and Riefenstahl's photo of the Nubian warrior that when the performative concept is used to interpret *Belvedere Antinous*, aesthetic dimensions in the historical example inflect "performativity." These aesthetic dimensions entwine with any historical use of "performativity" in the interpretation of per-

formance and/or "art acts." What we understand by "the aesthetic" may in fact be, as we have seen in the case of marble figure sculpture, the effect of the power of the performative—its disciplinings and regulation. The strength of the aesthetic lies in its apparent or naturalized strength—analogous to Austin's view of performance as "non-serious"—an apparent ontology for art as pure presence rather than particular historical acts.

Performativity exposes ancient sculpture, particularly in the important instance of Bellori's use of it, to the possibility of a political interpretation of the art theory in which it is found. It is exactly and only with this imposition of antique sculpture into the political that we understand its omnipresence as a model in European art and its function as proscription in the realm of the performative. Ancient sculpture persists against such an understanding in part because, as we have seen, iteration carries with it the past into the present, and part of that past is the absolute position theorized for ancient sculpture by Bellori.

Furthermore, the performative ideality of classical sculpture always constructs an ideal body that can be measured and repeated with an infinite variety of permutations that always refer back to the antique original.[74] Its repetition, both in practice and in art criticism, established the concept of the modern history of art where the "true" body—the body that refers only to Nature—became the nonrepeatable original, certainly the forbidden in much of high art. One might think of the rise of the pornographic image in the nineteenth century in this context.[75] The pornographic body came to be seen as not only overly natural, but also, to use Austin's terms of prohibition in the performative, as parasitic upon the ideal body, as "non-serious" compared to a classicizing art—that is, "like a performance."

The final status of the medium of marble sculpture in the mature stages of modernity (somewhere around 1900) was its complete disappearance as a legitimate art medium. This betrays the success of the imposition upon the medium of the ideality of a performativity modeled on the antique. There was no longer any need to legislate through models; the concept of art had become absolute, at least *theoretically* absolute, as in the philosophy of Hegel.[76] We saw this beginning with Bellori. The medium of marble sculpture had become unnecessary, because its precepts had been naturalized into the concept of art.

In the early decades of the twentieth century, change in art—some would even argue, in sculpture—would come with new "hybrid" media, "the readymade." For this transformation we must look to the radical political and aesthetic agenda of dada and Marcel Duchamp. Significantly for my argument here, art historian Thierry de Duve has argued that Duchamp understood the readymade to be "art about painting even before it is art about art."[77] While there are legitimate grounds on both sides of the debate about which of the traditional representational arts Duchamp sought to challenge with the ready-

made, it is perhaps more comfortable to understand that without the figure as the subject, the readymade could only be about a concept of art. We have, after all, seen that both painting and sculpture required the figure in all early modern definitions of these media. Rosalind Krauss sees the readymade as sculpture, inasmuch as she argues that all twentieth-century sculpture concerned itself primarily with the abstract concepts of time and space, and not the body.[78] Interesting in this regard, as Krauss points out, the readymade did not actually affect the outcome of the medium of sculpture until the birth of conceptual art in the 1960s.[79] This conceptual art was to be the foundation for postmodernism in visual culture, where the aesthetics of performance appear as the "natural" term.

I have argued that Bellori's citational gesture of *Belvedere Antinous*—his insistence on art about art—launches a performative gesture that continues through Riefenstahl and Mapplethorpe, among many others. It results in a naturalization of art and the representation of the body that marks the very performativity of this act. The ideal, as evidenced in classical sculpture, becomes the natural term for art, while the real or natural becomes scandal or pornography. Iteration has its effect on the very ideal of performance, allowing the seemingly spontaneous and noniterative to stand outside history and time as "a performance," while naturalizing what is cited and iterated as a mythic timelessness. Both gestures efface the importance of performativity in Derrida's sense of the term as the historical location in which specific citations take the forms of speech, art acts, and performance alike.

NOTES

I am very grateful to the editors of this volume and to Bill Nichols and Steven Z. Levine for their comments on earlier versions of this essay. Some of this material was presented as a paper in the conference "Art History in the Age of Bellori," American Academy in Rome, November 1996. I appreciate the comments that Mathias Winner, Philipp Fehl, and Jennifer Montagu made at that time. I am grateful to Aaron Kerner for his assistance and to the Samuel H. Kress Foundation and the University of California Academic Senate Research Funds for supporting the activities required to produce this essay.
English editions are given whenever possible.

1. Marvin Carlson, *Performance: A Critical Introduction* (Routledge: London and New York, 1996), provides a useful summary of the different understandings of "performance." An account of the concept of performativity—its usage in and significance for the arts, humanities, and social sciences—remains to be written.

2. Andrew Parker and Eve Kosofsky Sedgwick, eds., *Performativity and Performance* (New York and London: Routledge, 1995), 2.

3. The foundational texts for this approach to performance were Victor Turner, *The Human Seriousness of Play* (New York: Performing Arts Journal Publications, 1982); idem, *The Anthropology of Performance* (New York: Performing Arts Journal Pub-

lications, 1986); and Richard Schechner, *Between Theater and Anthropology* (Philadelphia: University of Pennsylvania Press, 1985).

4. This view is expressed in Elin Diamond, ed., *Performance and Cultural Politics* (London and New York: Routledge, 1996), 5: "The point is, as soon as performativity comes to rest on *a* performance, questions of embodiment, of social relations, of ideological interpellations, of emotional and political effects all come to the fore."

5. By 1504 the term *scoltura* referred to both marble sculpture and bronze casting. In this regard, see Pomponio Gaurico, *De sculptura*, Florence, 1504. Filippo Baldinucci, in *Vocabolario toscano dell'arte del disegno* (Florence, 1681), 15, defined *scultura* as: "Arts with which the artist takes material from material, making appear that which is in his mind, imitating both natural and artificial things and those that can be." This should be compared with his definition for painting, *pittura*: "An art with which the artist joins or adds material to material, making appear that which is in his mind, imitating natural, artificial, and possible things." Emphasis added.

The qualities that were assigned to marble figure sculpture in the early modern period, which I have listed here, are adumbrated in the lengthy debates known now as the *Paragone*, or the comparison of the arts of painting and sculpture. For an extensive discussion of these debates in the sixteenth century, see Leatrice Mendelsohn Martone, *Paragoni: Benedetto Varchi's 'Due lezzioni' and Cinquecento Art Theory* (Ann Arbor: UMI Research Press, 1982); and Claire J. Farago, *Leonardo da Vinci's Paragone: A Critical Interpretation with a New Edition of the Text in the Codex Urbinas* (Leiden, Netherlands: Brill, 1992).

6. Geoffrey Batchen, *Burning with Desire: The Conception of Photography* (Cambridge, Mass.: MIT Press, 1997), sees painting as the medium that photography replaced, but the material presence of the body in the theory of sculpture resonates strongly with the early writing on photography and its relationship to the body. In regard to exactly the same period in France when we find the invention of photography, James Rubin has argued that Edouard Manet's paintings are performative, but were not recognized as such at the time: "Manet brutally dragged [painting] into the modern age, and in so doing visually acted out the ideology of modernity." See James Rubin, *Manet's Silence and the Poetics of Bouquets* (Cambridge, Mass.: Harvard University Press, 1994), 22. According to Rubin, this "new performative mode" of Manet can be located in the materiality of the painting and was a "transformative performativity." In this latter sense it differs from performativity as I find it in the early modern period in general and in sculpture specifically. It is *this* earlier performativity that Manet and modernity sought, unconsciously and consciously, to change. I am grateful to James Rubin for his thoughtful discussion of these topics.

7. On Greek views of the origin of Greek sculpture, see the excellent study by Alice Donohue, *Xoana and the Origins of Greek Sculpture* (Atlanta: Scholars Press, 1988).

8. For the original Latin text and the English translation, see Leon Battista Alberti, *On Painting and On Sculpture*, ed. and trans. Cecil Grayson (London: Phaidon, 1972), 121.

9. Johann Joachim Winckelmann, *History of Ancient Art*, trans. G. Henry Lodge (New York: Frederick Ungar, 1968), 1:30:

Art commenced with the simplest shape, and by working in clay,—consequently, with a sort of statuary; for even a child can give a certain form to a soft mass, though unable to draw anything on a surface, because merely an ideal of an object is sufficient for the former; whereas for the latter much other knowledge is requisite; but painting was afterward employed to embellish sculpture.

10. Pliny the Elder, *Natural History*, book 34. I am indebted to Alison Leitch for sharing her knowledge of this ethnogeologic discourse on marble with me both in con-

versation and through her article "The Life of Marble: The Experience and Meaning of Work in the Marble Quarries of Carrara," *Australian Journal of Anthropology* 7 (1996): 235–57. On the tradition of marble working and its distinct culture in Italy, see the seminal work by Christiane Klapisch-Zuber, *Carrara e i maestri del marmo (1300–1600)*, trans. from the French by Bruno Cherubini (Modena: Poligrafico Artioli, 1973).

11. The classic formulation of *istoria* can be found in 1435 in the treatise on painting by the Florentine humanist Leon Battista Alberti; see Alberti, *On Painting and On Sculpture*.

12. Alberti, *On Painting and On Sculpture*, 123. There are occasions in early art theory where the terms *painting* and *sculpture* are used interchangeably. A useful summary of the various discussions of the interchangeability of the terms and their meanings can be found in David Summers, *Michelangelo and the Language of Art* (Princeton: Princeton University Press, 1981), 250–61. The seventeenth-century art theorist Franciscus Junius used the term *pictura* to refer to the representational arts. His editors explain it thus: "The academic tradition depends on this use of *pictura*. It makes it possible to bestow upon sculpture in the round a grandly narrative function." Franciscus Junius, *The Painting of the Ancients/De Pictura Veterum According to the English Translation (1638)*, ed. Keith Aldrich, Philipp Fehl, and Raina Fehl (Berkeley: University of California Press, 1991), 1:liii n. 70. I do not find the term *pictura* when used this way to the exclusion of "sculpture" to be as commonplace as do the editors.

13. Giorgio Vasari, *Vasari on Technique*, ed. G. Baldwin Brown, trans. Louisa S. Maclehose (New York: Dover, 1960), 143.

14. J. J. Pollitt, *The Ancient View of Greek Art: Criticism, History, and Terminology* (New Haven: Yale University Press, 1974).

15. Jacques Derrida, "Sending: On Representation," *Social Research* 49 (Summer 1982): 307.

16. Paul Fréart de Chantelou, *Diary of the Cavaliere Bernini's Visit to France*, ed. Anthony Blunt, annotated by George C. Bauer, trans. Margery Corbett (Princeton: Princeton University Press, 1985), 125.

17. Domenico Bernini, *Vita del Cavalier Gio. Lorenzo Bernino* (Rome, 1713), 16 (my translation).

18. This is the important argument made on color and painting by Roger de Piles in the second *Conversation sur la connaissance de la peinture* (Paris, 1677). See James Rubin, "Roger de Piles and Antiquity," *Journal of Aesthetics and Art Criticism* 34 (Winter 1976): 157–63.

19. Bernini, *Vita*, 30 (my translation).

20. J. L. Austin, *How to Do Things with Words*, 2nd ed., ed. Marina Sbisa and J. O. Urmson (Cambridge, Mass.: Harvard University Press, 1975); Jacques Derrida, "Signature Event Context," in *Limited Inc*, trans. Samuel Weber (Evanston: Northwestern University Press, 1988).

21. Derrida, "Signature Event Context," 3.

22. Austin, quoted in Parker and Kosofsky Sedgwick, *Performativity*, 3. The same passage can be found quoted in Derrida, "Signature Event Context," 16.

23. Parker and Kosofsky Sedgwick, *Performativity*, 6–16, explore what they call "the nature of this perversion" but they do not explore further Derrida's critique.

24. Derrida, "Signature Event Context," 5. Derrida's understanding of the "expressivity" of communication is less worked out in his essay than many other aspects and deserves further consideration than I can provide here.

25. Ibid., 5.

26. Ibid. *Supplée* can also mean supplements (as a verb).

27. David Summers, "Representation," in *Critical Terms for Art History*, ed. Robert S. Nelson and Richard Shiff (Chicago: University of Chicago Press, 1996), 3. See also

W. J. T. Mitchell, "Representation," in *Critical Terms for Literary Study*, ed. Frank Lentricchia and Thomas McLaughlin (Chicago and London: University of Chicago Press, 1990).

28. I have discussed the history of the first relationship—of the object to the creator/artist—in my book *The Absolute Artist: The Historiography of a Concept* (Minneapolis: University of Minnesota Press, 1997).

29. Derrida, "Signature Event Context," 5.

30. Ibid., 7. Derrida refers here to the ontological level at which his understanding of iterability must operate: "It is at that point that the *différance* [difference and deferral, *trans.*] as writing could no longer (be) an (ontological) modification of presence." Later in the essay (18–19), he elaborates further, particularly in reference to Austin's understanding of motivation or intention:

> *Différance*, the irreducible absence of intention or attendance to the performative utterance, the most "event-ridden" utterance there is, is what authorizes me, taking account of the predicates just recalled, to posit the general graphematic structure of every "communication." By no means do I draw the conclusion that there is no relative specificity of effects of consciousness, or of effects of speech (as opposed to writing in the traditional sense), that there is no performative effect, no effect of ordinary language, no effect of presence or of discursive event (speech act). It is simply that those effects do not exclude what is generally opposed to them, term by term; on the contrary, they presuppose it, in an asymmetrical way, as the general space of their possibility.

31. Ibid.

32. Peggy Phelan, *Unmarked: The Politics of Performance* (London and New York: Routledge, 1993), 146. Understanding Derrida in this way, we also cannot accept Sue-Ellen Case's critique of "queer performativity" in favor of "lesbian performance" in *The Domain-Matrix: Performing Lesbian at the End of Print Culture* (Bloomington and Indianapolis: Indiana University Press, 1996), 11–34. Case's argument relies on understanding performativity as purely textual, something Derrida, Butler, and others do not posit, as we have seen. Case argues that performativity "resides" in the author, whereas Derrida, Butler, and others understand the iterative and re-iterative process to affect author, reader, spectator, consumer, and even, in Butler's case, institutions. Case desires to keep the visual and performance away from textuality and theories of texts, in order to maintain a radical material culture, one in which "lesbian performance" triumphs "at the end of print culture."

33. Judith Butler, "Burning Acts—Injurious Speech," in Parker and Kosofsky Sedgwick, *Performativity*, 205.

34. Richard Wollheim, *Art and Its Objects*, 2nd ed. (Cambridge: Cambridge University Press, 1980), esp. 63–74.

35. Ibid., 150.

36. Ibid., 151.

37. Judith Butler, "Performative Acts and Gender Constitution: An Essay in Phenomenology and Feminist Theory," in *Performing Feminisms: Feminist Critical Theory and Theater*, ed. Sue-Ellen Case (Baltimore and London: Johns Hopkins University Press, 1990); idem, *Bodies That Matter* (New York and London: Routledge, 1993), esp. 223–42.

38. Butler, "Performative Acts," 272.

39. Ibid., 271.

40. On Lessing's significance for the history of modern sculpture I have benefited greatly from Rosalind Krauss, *Passages in Modern Sculpture* (Cambridge, Mass., and London: MIT Press, 1977), 1–6.

41. Gotthold Lessing, *Laocoön: An Essay on the Limits of Painting and Poetry*,

trans. Edward Allen McCormick (Baltimore and London: Johns Hopkins University Press, 1984), 6: "I should like to remark, finally, that by 'painting' I mean the visual arts in general; further, I do not promise that, under the name of poetry, I shall not devote some consideration also to those other arts in which the method of presentation is progressive in time." The major contradiction in Lessing's *Laocoön* is that he refers to all of the representational arts by the word "painting" even though he explores at length the sculptured depiction of Laocoön and his sons in comparison to literary representations of them. In German the terms used for "painting" and "art" particularly highlight the absence of sculpture, usually referred to in German as *Bildhauerkunst*: "Noch erinnere ich, dass ich unter dem Namen der Malerei die bildenden Künste überhaupt begreife" (Gotthold Lessing, *Gesammelte Werke* [Leipzig: Tempel, n.d.], 6:6). On Lessing's criticism of Winckelmann and his view of the limits of painting, see the remarks by the editors in Junius, *The Painting of the Ancients*, lxxvi–lxxviii.

42. On the "trace" and the importance of the "re-marked moment" of performance that "enables the memory its presence incurs to be a memory for some politics," see Mark Franko, "Mimique," in *Bodies of the Text: Dance as Theory, Literature as Dance*, ed. Ellen W. Goellner and Jacqueline Shea Murphy (New Brunswick, N.J.: Rutgers University Press, 1995).

43. Wollheim, *Art and Its Objects*, 70.

44. See especially Judith Butler, *Bodies That Matter*.

45. Butler, "Performative Acts," 270.

46. For a full account of the critical reception of this sculpture, see Francis Haskell and Nicholas Penny, *Taste and the Antique: The Lure of Classical Sculpture 1500–1900* (New Haven and London: Yale University Press, 1981), 141–43.

47. In important studies Thomas Crow and Abigail Solomon-Godeau have argued that the art of the French Revolution saw an increased "masculinization" of content and form. See Thomas Crow, *Emulation: Making Art in Revolutionary France* (New Haven: Yale University Press, 1995); and Abigail Solomon-Godeau, "The Other Side of Vertu: Alternative Masculinities in the Crucible of Revolution," *Art Journal* 56 (Summer 1997): 55–61. This construction of masculinization in visual culture appears to have begun with the construction of the ideality of the male body in the sixteenth century.

48. David Summers, "Contrapposto: Style and Meaning in Renaissance Art," *Art Bulletin* 59 (1977): 336–61.

49. bell hooks, "Feminism Inside: Toward a Black Body Politic," in *Black Male: Representations of Masculinity in Contemporary American Art*, ed. Thelma Golden for Whitney Museum of American Art (New York: Abrams, 1994), 136.

50. I use the term *purposive* in the same sense as Kant uses it in *Critique of Judgment* to emphasize that his postulation of "purposiveness" on the part of the artist and the work of art is a historical phenomenon. It should not therefore be used anachronistically and cannot work in a performative context.

51. Leni Riefenstahl, *The Last of the Nuba* (New York: Harper & Row, 1973).

52. Catherine M. Soussloff and Bill Nichols, "Leni Riefenstahl: The Power of the Image," *Discourse* 18 (Spring 1996): 24.

53. *Die Macht Der Bilder (The Wonderful, Horrible Life of Leni Riefenstahl)*, 1993, dir. Ray Muller. Riefenstahl's own words in the film cited here belie this position.

54. See James Faris, "Southeast Nuba: A Biographical Statement," in *Anthropological Filmmaking: Anthropological Perspectives on the Production of Film and Video for General Public Audiences*, ed. Jack Rollwagon (New York: Harwood, 1988); and idem, "Signification of Differences in the Male and Female Personal Art of the Southeast Nuba," in *Marks of Civilization: Artistic Transformations of the Human Body*, ed. Arthur Rubin (Los Angeles: Museum of Cultural History, UCLA, 1988).

55. Giovanni Pietro Bellori, *Le vite de' pittori, scultori e architetti moderni* (Rome, 1672). See the facsimile edition published by Broude International, 1980. On Bellori's prominence in art history, see Julius von Schlosser, *La letteratura artistica: Manuale delle fonti della storia dell'arte moderna*, trans. Otto Kurz, 3rd ed. (Florence: La Nuova Italia Editrice, 1977), 463–64. See also Kenneth Donahue, "Bellori, Giovanni Pietro," in *Dizionario biografico degli italiani* (Rome, 1965), 8:785 ff. and the excellent introduction by Giovanni Previtali in Giovanni Pietro Bellori, *Le vite de' pittori, scultori e architetti moderni*, ed. Evelina Borea (Turin: Einaudi, 1976).

56. Von Schlosser, *La letteratura artistica*, 465.

57. Here we can recall Giovanni Previtali's view, in Bellori, *Le vite*, ed. Borea, xxxii, that the issue of choice or selection is central not only to Bellori's theory of art, but also to the literary text as a whole. Bellori's arrangement of the extensive front matter, his ordering of the individual biographies, his inclusion of frontispieces for each biography and the *discorso*, the four pages of measurements and illustrations of the ancient statue of *Antinous*, and the excerpts from Poussin's theory of painting, support the theoretical precepts found in his protocols to the reader. See also, Elizabeth Cropper, "'La più bella antichità che sappiate desiderare': History and Style in Giovan Pietro Bellori's 'Lives,'" in *Kunst und Kunsttheorie 1400–1900*, ed. Peter Ganz, Martin Gosebruch, Nikolaus Meier, and Martin Warnke (Wiesbaden: Otto Harrassowitz, 1991).

58. The context of Bellori's thought in "The Idea" is an incredibly thorny problem and the topic of vociferous debate among art historians. Previtali's introduction provides a good analysis of the situation in Bellori, *Le Vite*, ed. Borea, xxxiv–xl.

59. Previtali, in Bellori, *Le Vite*, ed. Borea, xxxviii.

60. Ibid., xxxviii–xxxix.

61. Bellori's treatise on "The Idea" is reproduced and translated in Erwin Panofsky, *Idea: A Concept in Art Theory*, trans. Joseph S. Peake (Columbia: University of South Carolina Press, 1968), 154–75. The lines quoted here and following appear on 159.

62. For the chronology of Bellori's activities at the Accademia, see Bellori, *Le Vite*, ed. Borea, lxi–lxiv.

63. *Vocabolario degli Accademici della Crusca* (Florence: Accademia della Crusca, 1691), 2:537: "Operazion dello 'telletto, colla quale si cerca d'intendere una cosa perfettamente, per mezzo di conghietture, o di suoi principi noti" (my translation).

64. Baldinucci, *Vocabolario toscano*, 72.

65. Panofsky, *Idea: A Concept in Art Theory*, 171.

66. See Previtali in Bellori, *Le Vite*, ed. Borea, xxxviii–xxxix and Panofsky, *Idea: A Concept in Art Theory*, 105–11. Previtali locates Bellori in the context of Renaissance humanism, while Panofsky locates Bellori in the context of Neoplatonism and also sees his aesthetics as more original than Previtali does.

67. See the introduction by Mansfield and Tarcov in Niccolo Machiavelli, *Discourses on Livy*, trans. Harvey C. Mansfield and Nathan Tarcov (Chicago: University of Chicago Press, 1996), xvii–xlvii.

68. Machiavelli, *Discourses*, 5: first book, preface, 2.

69. Ibid., 5–6: first book, preface, 2.

70. Ibid., 6: first book, preface, 2.

71. Thomas M. Green, "The End of Discourse in Machiavelli's *Prince*," in *Literary Theory/Renaissance Texts*, ed. Patricia Parker and David Quint (Baltimore: Johns Hopkins University Press, 1986), 68.

72. Recently Elizabeth Cropper and Charles Dempsey have also rejected Panofsky's understanding of "The Idea," but on grounds different from those presented here; see Elizabeth Cropper and Charles Dempsey, *Nicolas Poussin: Friendship and the Love of Painting* (Princeton: Princeton University Press, 1996). See also von Schlosser,

La letteratura artistica, 465–66 and 511–20, who exemplifies the view of a dissimilarity between the *Idea* and the *Vite*. The similarities on points of theory between the *Idea* and the *Vite* are explained at length by Elizabeth Cropper, *The Ideal of Painting: Pietro Testa's Düsseldorf Notebook* (Princeton: Princeton University Press, 1984), 162–75.

73. Phelan, *Unmarked*, 146.

74. Dempsey and Cropper, *Nicolas Poussin*, discuss this notion of how the antique model functions in Poussin's work and its relevance to Bellori's theory.

75. For insights on the rise of the pornographic image in nineteenth-century photography, I am grateful to a lecture by Kelly Dennis given at Cowell College, University of California, Santa Cruz, 1995.

76. G. W. F. Hegel, *The Introduction to Hegel's Philosophy of Fine Art*, trans. Bernard Bosanquet (London: Kegan Paul, 1886), 18.

77. The influence of Marcel Duchamp and dada on the concept of art and sculpture cannot be overemphasized. On Duchamp and his radical aesthetic, see Thierry du Duve, *Kant after Duchamp* (Cambridge, Mass.: MIT Press, 1996), 166.

78. Krauss, *Passages in Modern Sculpture*, 4–6.

79. Ibid., 103: "Indeed, it was not until the 1960's that Duchamp's concern with sculpture as a kind of aesthetic strategy and Brancusi's concern with form as a manifestation of surface assumed a central place in the thinking of a new generation of sculptors."

6. Rhetorical *Ductus*, or, Moving through a Composition

IN THEIR DESCRIPTION of the purpose of this collection, Mark Franko and Annette Richards called for the development of new methodological tools the better to analyze the difficult subject matter of the historian of performance. I am not a performance historian, but I hope in this essay to suggest that a concept little known now but of considerable importance in ancient and medieval rhetoric—the concept of *ductus*, or directed movement—may fruitfully be recovered for use by historians of all the arts. Performance is, after all, one of the traditional five aspects of rhetoric: the basic situation of performance is also that of the rhetorical occasion, and the marriage of rhetorical and performance studies is, historically, a lasting one. The period of time I will examine is the late fourth until the ninth centuries in Europe, the founding age of monasticism. It is the monastic context, with its emphasis upon praying constantly, and thus its need to invent and perform prayer both individually (in meditational reading) and communally (in the performance of liturgy) that made the richest use of the inventive concept of *ductus*, aligning it to the fundamental meditative trope of the monastic "way" of prayer.

Rhetoric can provide an especially useful tool, for its categories were developed to teach and describe the various technical aspects of a craft whose product was precisely an event or occasion of some sort. This occasion is the focus of any rhetorical analysis, and its components are (to use Aristotle's categories) *logos, ethos,* and *pathos*—the composed work itself, the artist's presentation, the audience's receptive involvement. These three are the active ingredients —nay, participants—in any complete artistic event, whether that be liturgical dance, musical performance, the reading of a literary work, or communal meditative prayer within the plan and ornamental programs of a building. Their importance in a particular event may vary, but all three are always present in some way or other. In ritual processions, performers and audience may be largely the same, as individuals participate in the communal liturgy. Those individuals who "only" witness come to constitute communally what we properly call the audience, forged by the occasion into an agent of the event. Even

silent reading, the medium of meditation, is thought of as a performance by the reader (or viewer or listener in other arts), actively and intentively memorizing, responding, recalling, and seeing and hearing inwardly. One should always keep in mind that music and dance were fundamental parts of a rhetorical education, a constant source of many of the craft's basic tropes and models for itself—as was architecture. Indeed, the earliest theorizing of the various arts, including poetry and music, took many of their categories from rhetoric, as we will soon see.

Rhetoric provides method unconstrained by subject matter. It was Plato who first, disparagingly, observed this and Aristotle says the same, though without prejudice. Rhetoric, Aristotle noted, is a craft, like cabinetry or singing or painting. Historians of rhetoric are often defensive about this, for a discipline without specific subject matter is also a discipline without real theory, that is, an analytical methodology determined by coherent ideological goals and performed upon a distinct subject matter. Examples of the latter among the human sciences would be economics, sociology, most forms of history, and psychology. The methods of rhetoric can be used for any ideological goals, on virtually any subject matters; this is one reason why rhetoric has always been suspected of being intellectually immoral, for the immorality of a craftsman is attributed to his craft itself (though rarely is the same argument made for a moral practitioner). And ever since Plato excoriated Gorgias for teaching no subject (unlike philosophy, which taught the nature of "the good" and "the true"), rhetoric has been, and continues to be, suspected of having no place in the academy.[1] Many of its academic practitioners in the modern university have taken to concentrating on what "scientific" subject matter it does seem to have, namely the textbooks and handbooks of technical rhetoric used in school. But no craft fares well intellectually when its students find themselves only explicating its handbooks—consider how dry and pointless cooking would seem were it studied entirely in terms of the textual relationships among recipe books, and no one went near a kitchen!

Despite Socrates' ironies concerning its merits, by the late fourth century B.C.E., rhetoric stood at the heart of Greek and Roman *paideia*, the course or way of education via the seven liberal arts, whose goal was to produce "a good citizen speaking masterfully." This seeming paradox is best accounted for by Cicero, who observed that "nothing is so essentially human as conversation which is beautifully constructed and never ill-informed in subject matter." Because rhetoric has no subject of its own, its methods and categories can be applied to all that is human and that involves conversations.[2] *Logos*, the crafted subject matter, is but one of the ingredients in any occasion understood rhetorically; the others, composer-performer and audience-performers, are required to complete it. A rhetorical approach to any of the arts will deal with how a work functions socially within continuing human conversations (often contentious, of course), and will refuse to make of a work, the *logos*—whether score

or poem or script or image—an object separate from those who made it as composers and performers, and those who received it and continue to do so over time.

In this essay, the terms I will chiefly concentrate on, *ductus*, its synonym, *tenor*, and two related subterms, *color* and *modus*, map the complex dance of *logos, ethos,* and *pathos* within and throughout a complete work. They are also terms that have a long career in musical composition and performance. They refer to the most apparently ephemeral of performance phenomena and the least amenable to academic study, its affects and moods (the modern words that most closely approximate the meanings of *color* and *modus*).[3] Yet by understanding and learning to use these ancient concepts, we can provide ourselves with powerful tools for talking about the whole "occasion" of performances.

As a technical term, *ductus* was defined first in the fourth-century textbook of the Christian rhetorician, Consultus Chirius Fortunatianus, whose work reflects the pedagogy of rhetoric that Augustine also knew and taught.[4] The *ductus* is what we sometimes now call the flow of a composition. *Ductus* is an aspect of rhetorical arrangement, but it is the movement within and through a work's various parts. Indeed, *ductus* insists upon movement, the con*duct* of a thinking and feeling mind on its *way* through a composition.[5]

The noun *ductus* in classical Latin often meant "command" or "direction," especially in a military context; this was also the meaning of a verb formed from this noun, *ducto, ductare* (not to be confused with the verb *duco, ducere* [lead], whose past participle, *ductus* gave rise in the first place to the fourth declension noun we are now discussing).[6] In both the *Oxford Latin Dictionary* and in Lewis and Short's dictionary of Latin (whose citations, unlike those of the *OLD*, include a few later Latin writers like Augustine), the primary meaning of *ductus* is given as "command."

But there are other meanings of this noun, which convey, even from the time of the Roman Republic (first century B.C.E.), more generalized meanings of controlled and directed movement, compatible with the basic meaning "to draw, to lead" of the verb from which it derives. *Acquae ductus* (aqueduct) is, literally, "the conveyance or directing of water." The facial expression of distaste now called a *moue*, in which the lips are drawn tightly together, was a *ductus labiorum*. The word could be used for a drawing or outline, or a linear graph or line. It could also refer to the action of pulling or drawing: Valerius Maximus, whose compendium of *dicta et facta memorabilia* (sayings and events worth remembering) enriched the mental store of authors from antiquity through the late Middle Ages, used the word to refer to a draught or drawing-in of fishes.[7]

The idea of producing directed movement is also basic to the word's use in rhetoric. Although not defined as a separate textbook term before Fortunatianus, the concept was certainly known to Quintilian. Analyzing a sentence from Cicero's second Philippic oration, he praises the masterly use of word

order by which the orator humiliates Mark Antony without saying anything actionable. He describes how Antony "in conspectu populi Romani vomere postridie" (in the sight of the people vomited on the next day) (*De institutione oratoria* 9.4). The particularly contemptible weakness Antony showed not only by vomiting publicly but on *the day after* a binge is the point Cicero makes: Quintilian admires how "totius ductus hic est quasi mucro" (the *ductus* of the whole [sentence] is here like a knife-point [in the final word *postridie*]).[8]

So *ductus* is the way(s) that a composition guides a person to its various goals, both partial and overall. This meaning is apparent in another use Quintilian makes of the concept, this time using a verbal form of the root, *duct-*. In the preface to his third book, he speaks of other writers on the subject of rhetoric, all of whom shared the same goal (of making the subject clear) but each of whom constructed different routes to that goal, and drew their disciples along those various ways: "diversas . . . vias muniverunt atque . . . induxit sequentes" (they constructed their various ways [through the subject] and . . . [each] drew along his pupils [in his own route]).[9]

Even when he speaks of how a subject matter must be analyzed into parts and distributed into its places within a dispositive scheme, Quintilian uses a verb compounded from the same root, *di-duc-ere*: "not only must the whole matter be analyzed [*diducenda est*] into its questions and topics, but these parts themselves require to be arranged in their own order too."[10] Sometimes translated as "treatment" (as in "the treatment of a subject"), *ductus* conveys a greater sense of motion than the English word *treatment* does. As the fifth-century rhetorician Martianus Capella (who borrowed extensively from Fortunatianus) says, *ductus* is the *tenor agendi* or basic, sustained direction of a work, which flows along, like water in an aqueduct, through whatever kinds of construction it encounters on its way.[11]

This meaning of *ductus* became important in medieval rhetoric. It is used practically to characterize methods or modes of presenting material, and with the development of this meaning the continuing influence of late fourth-century rhetoric seems particularly clear. At times it seems to mean something like what we think of as literary genre. Thus, the author of a fifth-century allegorical commentary on the Psalms speaks of how, in a particular psalm, the Lord uses a pastoral *ductus* for his audience, one suitable for those who have the care of people's souls, rather than one for a recondite audience.[12] The phrase *ductus rationis*, "the way of reason," became fairly common as a pedagogical usage in the Middle Ages; it was used by Saint Augustine. And a thirteenth-century teacher of rhetoric and poetics at the University of Paris, an Englishman named John of Garland, defined the act of intellectual invention itself in these terms: "[the process of] invention means to come to [*in-venire*] a conception of an unknown thing by the guidance of an appropriate plan [*ductu proprie rationis*]."[13] The word *reason* did not mean in this context what it now does, for the compositional *ratio* or scheme was more like a map or schematic

plan—a sort of blueprint of the kind a medieval master builder might make before beginning work. It did not have the connotations that five hundred years of academic philosophy and science have since given it. Indeed John of Garland's near-contemporary, Geoffrey of Vinsauf, describing how to compose a poem, counsels a literary composer to make a schematic *ratio* in his mind of his whole composition in detail before he ever sets anything in writing. In this way, he says, poets must learn from architects how to invent a new work.[14] Yet the particular scheme he uses as his example is not an imaginary building plan (though those were commonly used) but an imagined map, like the schematic, circular maps of the world known to medieval students as *mappaemundi*.

The word Fortunatianus uses for the initial plan that a composer must have in his or her mind when beginning a work is *consilium*, related to the concepts of "council" and "consult." A composer initially consults his own learning, experience, and judgment, as any master craftsman would. This mental *consilium* takes shape in the work as its *ductus*, but—Fortunatianus stresses—while the mental plan directly expresses the author's own volition and judgment, the *ductus* is something in the work itself.[15] This may seem to be an obvious point, but it is a crucial one for any audience or other kind of performer to understand. The work in and of itself directs movement; it does not merely express the author's intentions. In other words, the composition (Aristotle's *logos*) also is an active agent in an occasion perceived rhetorically, not a (more or less) transparent expression of the author-director, or symbol of something other than itself, or unformed matter for an audience to do with as it solipsistically likes. The work also *is*, like a child that is born: *nascor*, "born," is the verb Fortunatianus uses to describe the relationship of authorial plan to compositional *ductus*—and all parents should know that, once born, a child is a distinct being with agency of its own.

The movement among a composition's parts is not uniform; it can and should vary. Fortunatianus pays most attention to this feature, though the qualities and degrees of variation are evident also in Quintilian's use of the word and its compounds. According to Fortunatianus, there are five kinds of *ductus*: simple, subtle, figurative, oblique, and mixed.[16] These are distinguished by how direct and easy a path you make for your audience—whether you let them just step along with no obstacles, or whether you want them to work a bit, to look beneath or through your words to another agenda you may have. This is the matter to which Fortunatianus devotes the most attention. His examples are taken from legal proceedings, and they demonstrate how the nature of the charges and the aims of one's client (and oneself) will determine what sorts of figures and colors one may wish to use to persuade the judges. But the comments made apply far more widely than to the particular matter of legal cases. As one must keep in mind, the principles of rhetorical craft apply to situations, not subjects, for rhetoric has no subject of its own.

Ductus is born of constant deliberation and various choices, says Fortunatianus.[17]

Fortunatianus admits that the more usual name for what he distinguishes as types of *ductus* is "figures" (*figurati*) but he dislikes, he says, lumping such variety of movement together in a single term (and he also has reserved *figuratus* for one of his modes of *ductus*). Of interest here is that Fortunatianus evidently recognizes that the variations in movement and direction he is analyzing are among the figurative or ornamental properties of a work. Such "ornaments" are functionally and situationally understood. Thus, switching to an "oblique" mode acts as a signal that the "direction" of the work is characterized by a divergence between what is apparently being said and what is meant, in the same way as does an oblique figure like irony or allegory. Stylistic ornaments have both *vis* or "energy level" (fast or slow, measured or lively) and function or *raison d'être* (*ratio*) in the overall scheme.[18] Differences among the ornaments, according to Fortunatianus, are accounted for by variations in these two qualities. Notice how the function of an ornament within the overall work, and not how it expresses or "imitates" something else, determines its character.

What marks out the variation in route(s) of the overall *ductus* are the figures, modes, and colors of the way. Fortunatianus reserves the term *modus* for the movement of particular parts of the composition, *ductus* for that of the whole. Martianus Capella uses the word *color* where Fortunatianus uses *modus*: evidently in this context they were synonyms. Since *colores* is a term most commonly used (including by Martianus Capella) for the ornaments of rhetoric, the figures and tropes of style, its adoption by Martianus Capella in connection with way-finding is significant, for it suggests that to Martianus the ornaments played a key marking function for finding one's way, *ductus*, through a literary composition.

In the monastic Middle Ages, the period from the fifth through eleventh centuries, the way of meditation was initiated, oriented, and marked out especially by the schemes and tropes of Scripture. Like sites plotted on a map, these functioned cognitively as the "stations" of the way, to be stopped at and stayed in mentally before continuing. They could also serve as route indicators, "this way" or "slow down" or "skim this quickly" or "note well." All figurative language can function for a reader in this way, but for monastic composition, the "difficult figures" were particularly important intellectually, providing what Saint Augustine called *obscuritas utilis et salubris*, "productive and health-giving difficulty."[19]

If we adopt for a moment the central figure in the concept of rhetorical *ductus*—that of flow and movement, as through an aqueduct—we can think of the ornaments in a composition as causing varieties of movement in thought: steady, slow, fast, turn, back up. They not only signal how something is to be taken (like a pathway)—whether straight (literally) or obliquely (meta-

phorically or ironically)—but also can indicate temporal movement, like time signatures in written musical composition. Compositional *ductus*, moving in colors and modes, varies both in direction and in pace, after it takes off from its particular beginning (the all-important *status* or station "where" one starts) toward its target (*scopus*). A stylistic figure or "image" signals not just a subject matter (*res*) but a "mood" (*modus, color*), plus an "approach" (another meaning of *modus*) and a reading tempo or "measure" (the root meaning of *modus*).[20] Movement within and through a literary or visual piece is performed, as it is in music and dance. Choice is involved for the author in placing ornaments in a work, and choice for an audience in how to "walk" among them. And as in all performances, variation from one occasion to another is a given.

An essential first step of cognitive invention is thus recollective cogitation. To begin to make meaning at all, one's memory must be hooked up and hooked in to the associational play of the mind at work. That is the essential function of any ornament, and it explains why many of the basic features of the ornaments also are elementary principles of mnemonics: surprise and strangeness (for example, metaphora, metonymy, allegoria, oxymoron, and, in art, grotesquery), exaggeration (hyperbole and litotes), orderliness and pattern (chiasmus, tropes of repetition, various rhythmic and rhyming patterns), brevity (ellipsis, epitome, synecdoche, and other tropes of abbreviation) and copiousness (all tropes of amplification), similarity (similitude), opposition (paradox and antithesis), and contrast (tropes of irony). All of these characteristics are essential for making mnemonically powerful associations.

And they are all also deliberately playful and surprising, for mnemonic and recollective techniques have all relied heavily on emotion as the quickest and surest way to catch the mind's attention. The besetting vices of meditative thought were mental torpor and sloth, and distraction or *curiositas*. Both of these are failures to concentrate one's mind. "Cellula quae meminit est cellula deliciarum" (the little cell which recollects is a little chamber of pleasures), wrote a late-twelfth-century teacher of rhetoric, Geoffrey of Vinsauf.[21] These ideas were all ancient and medieval mnemotechnical commonplaces, that the human mind tires easily, is easily bored, easily distracted. To counteract this, the craft of thinking requires energizing devices to put the mind in gear and to keep it interested and on track, by arousing emotions of fear or delight, anger, wonder, and awe.[22] We can think of *color* as emotional hue, of *modus* as emotional type: these together characterize the role of various figurative and other kinds of ornament in "way-finding." And recognizing that they each have distinctive *color* and *modus* means that we can recover some at least of the emotional, affective rationale of a work through paying particular attention to the ornaments that map it out, both in themselves and—most important for the journey-like aspect of the work—in relationship to one another.

Fourth-century rhetoricians introduced a third term, *scopus*, into their dis-

cussion. This term is also important in meditation. *Skopos*, a Greek word, is literally the target of a bowman, the mark toward which he gazes as he aims; it derives from a Greek verb meaning "to look." For Fortunatianus, *scopus* meant "goal," that to which the *ductus* and *via* lead. The modern use, as in "the scope of an argument," derives from the Latin rhetorical term. A composition that has no scope may or may not be extended, but it certainly has no evident emotive and persuasive goals—it is just a mess.[23] The notion of *scopus* (to use its Latin form) emphasized identifying a goal as a first step in composing: "what are you aiming for?" Its corollary was to identify where you were starting from, the "state of the question" or its *status* (Greek *stasis*). Knowing where you were starting from and where you wanted to go, the next step was to identify your *ductus*. Notice how the whole procedure is modeled as a journey from one place to another, via a route. It is no accident that the cognitive *rationes* imagined as outlines for all sorts of artistic compositions so often took the preferred forms of buildings or maps, terrestrial or celestial. So these are the terms that describe aspects of the movement of any composition: *status*, *ductus*, *modus*, and *scopus*. They differ, Fortunatianus says, "in that *modus* is the *ductus* in each part of the composition, and *scopus* is that which the whole *ductus* renders."[24]

Monastic practice and late Greco-Roman rhetoric, that of the so-called second Sophistic, enjoyed a symbiotic, if seemingly improbable, relationship. This relationship was not at all one-sided. Historians have long emphasized how the founders of monasticism, people like John Cassian and Augustine of Hippo (contemporaries in the late fourth century C.E.), were formed by their late antique rhetorical educations.[25] Less emphasized, but just as important, is the way in which early monastic practice, especially with its stress upon the way of composition in prayer, shaped and carried to the Middle Ages some fundamental aspects of what became the medieval crafts of rhetoric. For example, Boethius (writing in 523 C.E.) invokes the rhetorical conception of *ductus* in this speech of Lady Philosophy's from *The Consolation of Philosophy*, words that later came to be much quoted: "I will fasten wings to your mind by which it may raise itself on high so that, having pushed aside your wavering, you may turn again safe and sound by my course [*meo ductu*], by my path, and by my conveyances."[26]

But it is in Augustine's writings that rhetorical *ductus* and the meditational "way" most closely connect. When Augustine thinks about the process of meditation, he models it as a route. Such a model is central to his notion of conversion as a procedure of changing orientation and way-finding, as though within a topography of locations, among which there are a variety of routes. A notion of compositional *ductus* informs how Augustine writes about meditation in *De doctrina christiana*, modeling it as a turning (of direction) in fear, and then climbing through emotional stages on a mental ladder from fear to joyful tranquility:

Above all the work [of reading Scripture] requires that we be turned by fear of God toward knowing His will . . . this fear may inspire in us thoughts and imaginings of our mortality and our inevitable future death, and, as the hairs on our flesh stand up, may affix all the wrigglings of our pride to the wood of the cross . . . [The second step is piety, the third knowledge, the fourth strength of purpose, the fifth mercy, and then] he ascends to the sixth step, where he cleanses that eye by which God may be seen, as much as He can be by those who die to the world insofar as they can . . . And now however much more certain and not only more tolerable but more joyful the sight of a [divine] light may begin to appear, nonetheless still *darkly* and *in a mirror* it is said to be seen, for it is approached more *by faith* than *by sight* when in this world *we make our pilgrimage*, although we have our *conversation in heaven*.[27]

The seventh step of this ladder is wisdom, and "from fear to wisdom the way extends through these steps."

Spatial and directional metaphors are essential to the conception of the "way" of monastic meditation, as is well known. The rhetorical concept of *ductus* emphasized way-finding by organizing the structure of any composition as a journey through a linked series of stages, each of which has its own characteristic flow (its "mode" or "color"), but which also moves the whole composition along. And the "colors" or "modes" are like the individual segments of an aqueduct, carrying the water, yes, but changing its direction, slowing it down, speeding it up, bifurcating, as the water moves along its "route" or "way." For a person following the *ductus*, the colors and modes act as stages of the way or ways to the *scopus* or destination. Every composition, visual or aural, needs to be experienced as a journey, in and through whose paths one must constantly *move*.

The connotation of movement along a path seems to have become emphasized in the word *ductus* through the early monastic centuries. It was always implicit, as we have seen, but during the early Middle Ages *ductus* became used as a synonym for the word *via*, which always meant "path." This is clear in the following citation from Bede's early-eighth-century commentary on the book of Tobit (Tobias, in Latin). The particular verse under discussion (5:7) refers to "the path which leads to Media [the land of the Medes]," a land to which Tobias has promised his blind father to go, but to which he does not know the way (*via*, in the Latin Bible). At that point in the story, Tobias meets a lovely young man who promises to guide him on his way, and who is the angel Raphael in disguise. Bede uses the word *ductus* where the Vulgate uses *via*.[28] Bede's commentaries became elementary texts in monastic Bible study for later centuries, and undoubtedly helped to establish the meaning of "path" for *ductus*. Over the centuries, the word thus lost an exclusive meaning of "command," especially in the sense of military command, a direction one must exactly follow, and became identified with something that, as a metaphor, was (to some extent) more freely chosen, and more susceptible to particular adaptations of its "colors" and "measures" by others using the "way."

One of the commonest and most basic models of the monastic way is that of the tabernacle or temple. I cannot here go into its complex history as a mandala-like meditational form.[29] But a maplike, architectural-style plan of this (then nonexistent) scriptural structure seems to have been in use even in earliest monasticism as a schematic for guiding meditation. We now are so accustomed to thinking of maps as static and abstracted representations of already known subjects, that we can hardly think of a map or other plan as requiring that the viewer move mentally about in the space it defines in order to use it. Yet in exegetical traditions the "place of the Tabernacle" (as Augustine called it) was pictured with varying perspectives, at times from a bird's eye and at other times from one or several restricted points of view.[30] Indeed, the invention trope of "the place of the Tabernacle" requires movement through and within its structure as though one were walking about in a material building.

In his comments on Psalm 41, preached first as a sermon to a listening congregation, Augustine paints a literary picture of the tabernacle. This psalm was regarded as being about contemplation, that was its matter or gist, a subject heading it would commonly have been filed under in any monk's mental quotation store. It begins "As the hart panteth after the water-brooks, so my soul panteth after thee, o God." Verse 5 mentions the tabernacle: "These things I remembered, and poured out my soul in me: for I shall go over into the place of the wonderful tabernacle, even to the house of God: With the voice of joy and praise; the sound of one feasting."[31]

Augustine comments that, "He who has His highest house in a hidden place, also has on earth His tabernacle." This tabernacle is the church, and in this place is discovered the way by which one can go up to the house of God. He continues:

> When I [had remembered and] poured out my soul within me in order to touch my God, how did I do this? "For I will enter [*ingrediar*] into the place of the Tabernacle." These words suggest that I will first blunder about [*errabo*] outside the place of the Tabernacle seeking my God . . . Then, when I [enter in] there indeed will I gaze upon many things in the Tabernacle. Faithful men are the Tabernacle of God on earth; I admire in them their control over their members, for not in them does sin reign by obedience to their desires, . . . but they offer through their good works to the living God; I marvel at the disciplined physique of a soul in service to God. I look again upon the same soul obeying God, distributing the benefits of his position, restraining his desires, banishing his ignorance . . . I gaze also upon those virtues in my soul. But still I walk about in the place of the Tabernacle. And I cross through even that; and however marvellous the Tabernacle may be, I am amazed when I come right up to the house of God . . . Here indeed is wisdom's water fountain [cf. Psalm 41:1], in the sanctuary of God, in the house of God . . . Ascending the Tabernacle, [the Psalmist] came to the house of God. Even while he looked upon the parts of the Tabernacle he was led up to the house of God, by following a certain sweetness, I know not what inner and hidden delight, as though some kind of *organum* sounded

sweetly all through the house of God; and all the while he might walk about in the Tabernacle, having heard a sort of interior music, led by sweetness, by the pleasure of the *ductus*, removing himself from all the noise of body and blood, he made his way up to the house of God. For thus he remembers his way and his *ductus*, as though we had said to him: You are gazing upon the tabernacle in this world; how have you come to the hidden place of God's house? "With the voice," he says, "of joy and praise, with the sound of one celebrating a festival" . . . From that eternal and perpetual feast, there sounds I know not what song so sweet to the ears of my heart; as long as the noisy world does not drown it out. To one walking about in that Tabernacle and considering the wonders of God for the redemption of the faithful, the sound of that festivity quiets the ear and carries off the hart to the water fountains.[32]

Augustine treats the phrase *locus tabernaculi* as a mnemotechnical place, a background. To go up to the place of the tabernacle thus becomes, in Augustine's meditation on the phrase, a mnemotechnical walk about the structure, seeing the various "things" that are gathered within it, placed like groups of actors in scenes, or "active images" in "places," to use the language of memory craft. Within the tabernacle, Augustine says, "is found [*invenietur*] the way [*via*] by which one may proceed to the home of God."

For a living human being here, who is seeking God in the context of a pilgrim-church, the "way" begins outside, wandering in error, moving through "the place of the Tabernacle," to the ascent up to "the home of God." There are thus three distinct locations in Augustine's structure, three mnemonic *loci*: outside, tabernacle, and *domus Dei*, a common phrase in the Psalms, but one that in this context particularly resonates, recollectively, with its use in Ezekiel's description of the visionary Jerusalem temple-citadel (Ezekiel 43:10).

Augustine is very clear that only by walking about and looking at the parts or *membra* of the tabernacle can the soul come to God's house. Augustine was certainly familiar with the rhetorical concept of *ductus*. But in this complex text, the handbook notion realizes an extraordinary literary richness. The master trope is of movement channeled by a construction, contrasted to wandering aimlessly and formlessly outside. This need for orderly movement through places is caught in Augustine's use of *ductus*, which at its core denotes an ordered, directed motion—such as practiced movement of human limbs. As Augustine, now implicating himself in the experience of the Psalmist, walks about the tabernacle, following some internalized route of joy-directed movement, the soul's eye modulates into the soul's ear listening to a sort of ("quasi") *organum* or musical instrument, and the walking becomes more like a dance, some choreographed movement (that is how I would understand *ductus* in this context). As he walks/dances through the tabernacle, *strepitus*, "noise," is replaced with harmony, as wandering was replaced by walking purposefully and then by a kind of dancing.

Thus, when Augustine uses *ductus* in his meditation on the "locus tabernaculi," he evidently thinks of it as movement within a composition, and as

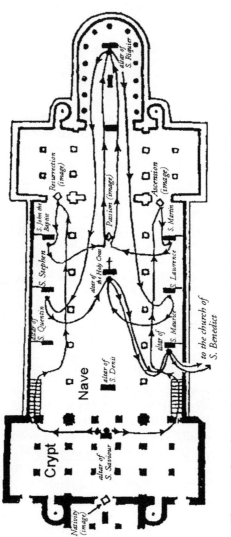

Crypt

Nave

altar of
S. Saviour

Nativity
(image)

altar of
S. Denis

altar of
S. Quentin

S. Stephen

S. John the
Baptist

Resurrection
(image)

altar of
the Holy Cross

Passion (image)

altar of
S. Maurice

S. Lawrence

S. Martin

Ascension
(image)

to the church of
S. Benedict

altar of
S. Riquier

13. The route of one liturgical procession performed in the Carolingian abbey of Centula-Saint-Riquier, France. After C. Heitz, "Architecture et liturgie processionnelle."

such, contained and oriented by its structure. Yet it is movement that the viewer also adapts or "domesticates," to use another concept developed in monastic meditational craft.[33] Augustine chooses his pace, where he will look first and in what order, and the *ductus* of the construction eventually becomes the "way" he follows, like an internal music that leads him on. As Augustine ponders the idea here, compositional *ductus* is only to a limited extent a matter of the author's original choices or "approach"; the work itself has *ductus* that, while it expresses authorial choices (one hopes well), also invites its audiences to choose their *ductus* within its possibilities. And if they do not, they will simply remain in confused wandering, "outside the place of the Tabernacle."

A very common if specialized use of the word refers to scribal *ductus*, the precise combination of hand movements that produced the calligraphic pen strokes that scribes learned for drawing the various letters. This meaning was present in the word in antiquity. But like many of the crafts the monks practiced, it was also moralized and "ethicized" as a way, *ductus*, of prayer. For example, the twelfth-century monk Rupert of Deutz wrote that the Greek letter Υ (upsilon) was said by "certain of the wise" to be like the life of man, "because beginning with one stroke it forks into two paths."[34] Thus what to us is fixed and static—the shape of a letter—in this culture was understood as inherently dynamic and full of movement, because letters were created from choreographed patterns of hand motions and not simply picked out from prefabricated shapes.

I would like finally to suggest how the concept of *ductus* nourished not only meditation but also the public rhetoric of the liturgy "mapped" within the architectural complexes (conventionally likened to the tabernacle and temple) of the monastic church and cloister. Carol Heitz has written persuasively about some ways in which processional liturgies determined, in several respects, the articulation of space within Carolingian and pre-Romanesque monastery churches.[35] His work is too rich to be easily summarized here, but one example will perhaps give an idea of his analysis. At the late-eighth-century monastery of Saint-Riquier, there were three churches of varying size, joined by long galleries, the whole complex forming an obtuse triangle. Documents have survived from the eleventh century, describing various liturgies that took place within this complex: they involved elaborate, journey-like processions by choirs of monks through the main church of Saint-Riquier, and from one church to another. In these processions, the altars of the main church and its porch became the stable markers of a variety of such liturgical journeys. Figure 13 shows the route of one of these processions through the largest of the churches of Saint-Riquier; the chronicler's descriptions make clear that such a procession would then have continued into the other, smaller churches.

In addition to the altars, four pictures also marked out the main *loci* of the "way." Heitz describes them:

Images, *imagines*—stations for prayer—marked out the liturgical itinerary . . . The first of these, that of the Nativity, was placed in the porch, above the entry door in the crypt of the Savior . . . The three other *imagines* were found in the nave and transepts, more or less aligned. In the center, behind the altar of the Holy Cross, was the image of the Passion of Christ. To the north, doubtless at the end of the aisle, the Resurrection; to the south, in the same position, the Ascension.

Various liturgies used all these *loci* in a variety of ways. The procession shown in figure 13 started in front of the Nativity picture in the porch, then split into two choirs, which moved along each side of the nave to the corresponding *imagines* of the Resurrection and the Ascension, and then across the church to meet in the central *locus* of the altar of the Holy Cross surmounted by the Passion. From there the monks went east, still in two choirs, into the apse, to the altar of Saint Riquier himself, west again to altars on opposite sides of the nave, met again at the altar of the Holy Cross, and then left the church by the south door, first pausing to chant the office of the dead at the altar of Saint Maurice. All this while, of course, they were engaged in communal prayer. Their abbot clearly understood the whole complex as, in effect, a single structure whose decoration (both the altars and the mural paintings) afforded a simple map of background "places," within which he could invent an extremely complex set of varying *ductus*.

The way the *imagines* were used at Saint-Riquier confirms that using images and all the other *colores* of ornament entails more than just meditating on some particular *content* that they represent. The pictures in this church were reminders of particular content of course, but their more important function was as way-markers and especially as way-*makers*. Whether or not the abbot had Augustine's commentary on Psalm 41:5 in mind (and he may well have, for it was familiar material) he perfectly realized its intent. The processions in Saint-Riquier show in a particularly rich way how the multiple *ductus* afforded by location-based memory schemes could be woven into the very fabric of monastic buildings, which could then act as a flexible and variously adaptable stage or platform (Latin *scaena*, English *scene*) for inventing new compositions.

Perhaps I can now make a few general observations about the usefulness of the concepts I have developed here to the analysis of historical performance. First, the composed work is regarded as "open": it is a *ratio* to be "made familiar" within actual, specific occasions. Because no occasion can ever be exactly like any other, every repetition of a work will differ—and that is as it should be. Moreover, because such an occasion, understood rhetorically, is a complex, varying texture of work, composer-performer, and audience-performer, no one of these ingredients can be privileged over the others, and all alike are necessary agents in the whole affair. A composition—in sound or paint or stone or ink—is the *logos* or *ratio* for a conversation of author and audience, containing within itself a *ductus* that outlines the path of that conversational journey. This path is "scored" by the varying *modi* and *colores* which play over and

around and within its continuing movement (*tenor*). They mark out the "places" or "locations" that link up the "way," but they also provide cues and clues regarding the kind of movement and direction both performer and audience may take. In this process, memory plays the key cognitive role. Indeed one should probably think of monastic and late classical art primarily as an art of *mneme*, rather than one of *mimesis* or representation, especially as that word is now used. The desert monks called their meditational way "mneme theou" or "the memory of God." The questions raised about a work by *mneme* are different from those raised by *mimesis*. They stress cognitive uses and the instrumentality of art over questions of how well it "holds a mirror up to nature." *Mneme* produces an art for thinking about, for meditating upon, and for "gathering," a favored monastic metaphor for the activity of *mneme theou*, deriving from the pun in the Latin verb *legere*, "to read" and also "to gather by picking," like picking bouquets of flowers—hence also the ancient metaphor of the flowers of reading. An art of tropes and figures is an art of patterns and pattern-making, and thus an art of *mneme* or *memoria*, of cogitation and recollective thinking. To observe the obvious, tropes cannot exist unless they are recognized. That is a function of people's memories and shared experiences, including their education. Tropes and figures are as much social phenomena as they are linguistic ones, and in rhetorical craft they were considered to have ethical, communal instrumentality. Memory is always *performed* in rhetoric, by the composer whose mind invents the work and presents it to the audience, which both recognizes and re-cognizes it, and within the ever fruitful work itself, which is constantly remade and re-membered as its audiences travel along its varying paths.

N O T E S

1. Plato's two important dialogues on rhetoric are *Gorgias* and *Phaedrus*, though of the two *Phaedrus* represents his mature thought on the subject of good rhetoric. It is wrong to state, as some historians have, that Plato abjured rhetoric as immoral: recognizing that rhetoric is a craft of speaking well, he argues for the importance of the ethical education of the craftsman. The social and ethical ideals pertaining to ancient rhetorical practice may be best expressed by Plato's *Phaedrus*, read in conjunction with Cicero's *Brutus* and *De oratore*.

2. Richard McKeon, "Rhetoric in the Middle Ages" (1942; rpt. in *Critics and Criticism*, ed. R. S. Crane [Chicago: University of Chicago Press, 1952]), traces the greatly diverse subject matters to which the method of rhetoric was applied in the Middle Ages. He concludes "if rhetoric is defined [by modern "scientific" historians] in terms of a single subject matter—such as style or literature or discourse—it has no history during the Middle Ages," but, he continues, all the arts of the Middle Ages would profit from being considered in terms of rhetoric, rather than continue to be constrained by anachronistic modern definitions of (academic) discipline. Unfortunately McKeon's counsel has not been much heeded in the intervening fifty-five years since it was first published. Quintilian defined the goal of rhetorical education as producing "vir bonus

dicendi peritus" (a good man masterly in speaking); this maxim was quoted as a commonplace by Fortunatianus at the start of his treatise on rhetoric (fourth century). Augustine's version of this was that the life of a Christian orator "should itself be a kind of bountiful speech" (*ut sit eius quasi copia dicendi forma uiuendi*) (*De doctrina christiana* 4.29; ed. J. Martin, Corpus Christianorum Series Latina 32 [Turnhout, Belgium: Brepols, 1962], 165). The quotation from Cicero is *De oratore* 1.8.32: "quid esse potest . . . magis proprium humanitatis quam sermo facetus ac nulla in re rudis" (ed. and trans. E. W. Sutton and H. Rackham for the Loeb Classical Library [London: Heinemann, 1942–48]). Aristotle's basic definitions of rhetoric and the categories I am focusing on in this essay are in his *Rhetoric*, trans. George Kennedy (New York: Oxford, 1991), 1.1–2.

3. The English word *mood* actually derives from an Anglo-Saxon word meaning "mind," *mód*, but the Latin-derived and Anglo-Saxon–derived words, fairly close in certain of their meanings, soon came to overlap in these areas; see the *Oxford English Dictionary* (henceforth OED), s.v. "mood."

4. Fortunatianus' exact dates are not known, but he preceded Martianus Capella, who borrowed from his work and who wrote about rhetoric in the 430s (Augustine died in 430). Fortunatianus' theory of *ductus* is described as "unusual" by George A. Kennedy, *Classical Rhetoric and Its Christian and Secular Tradition* (Chapel Hill: University of North Carolina Press, 1980), 105; *ductus* was certainly first categorized and theorized by him and his contemporaries. Fortunatianus' rhetoric was usually copied in the Middle Ages together with a work on rhetoric then attributed to Augustine; thus, it shared the aura of the master. In addition, Fortunatianus was named by Cassiodorus as a master of rhetoric, especially on *memoria* and delivery. See J. Miller et al., *Readings in Medieval Rhetoric* (Bloomington: Indiana University Press, 1973), in which appears a portion of Fortunatianus' discussion of *ductus* (somewhat misleadingly translated as "approach"). All quotations are from the Latin text of Fortunatianus in *Rhetores latini minores*, ed. Carolus Halm (Leipzig: Teubner, 1863), 81–134.

5. An analysis of the thirteenth-century musical concept *conductus*, with interesting relationships to the more generalized root word (*ductus*), is in Nancy Van Deusen, *Theology and Music* (Leiden: Brill, 1995), 37–53; see also Margot Fassler, *Gothic Song* (Cambridge: Cambridge University Press, 1993), 18–30, on what she calls "the nature of liturgical commentary" in the musical trope as it developed in the eleventh and twelfth centuries.

6. That *ductus* is a fourth declension masculine noun means that by late antiquity this form looked the same in the singular and plural of the nominative case, the genitive singular, and the accusative plural, thus allowing for some word play with its forms.

7. See the *Oxford Latin Dictionary* (hereafter OLD), s.v. "ductus," for these various meanings and citations. See also the citations, s.v. "ductus," in the *Thesaurus linguae latinae* (Leipzig: Teubner, 1907).

8. Quintilian, *De institutione oratoria* 9.4.30 (cf. 4.2.53): "it is also possible to make the flow of the matter [*ductus rei*] credible, as is done in comedy and farce. For some things naturally have such sequence and coherence, that if you have told the first part well, the judge will expect what comes next all by himself." Here *ductus* has to do with narrative credibility. The word shows up again in some thirteenth-century technical discussions: see Paolo Bagni, "L'*inventio* nell'ars poetica latino-medievale," in *Rhetoric Revalued*, ed. B. Vickers (Binghamton, N.Y.: Center for Medieval and Renaissance Studies, 1982). The text of *De institutione oratoria* (abbreviated in these notes as *Inst. orat.*) is cited from the edition and translaton of H. E. Butler for the Loeb Classical Library (London: Heinemann, 1922).

9. Quintilian, *Inst. orat.* 3.1.5.

10. Ibid., 7.10.5: "Non enim causa tantum universa in quaestiones ac locos didu-
cenda est, sed haec ipsae partes habent rursus ordinem suum." Notice that Fortuna-
tianus' distinction between *ductus* as the movement of the whole and *modus* as the
movement of each particular part is implicit in this advice from Quintilian.

11. Martianus Capella, *De rhetorica* (*De nuptiis mercuriae et philologiae*, 5.470):
"Ductus autem est agendi per totam causam tenor sub aliqua figura servatus" (*Ductus*
is the course of action through the whole cause, held to underneath whatever figure of
speech [one may be using for the moment]). All citations are from the edition of Halm,
Rhetores latini minores, 451–92. The word *tenor* is from the verb *teneo*, "hold": it was
used in rhetoric to refer to the sustained argument of a work (see *OLD*, s.v., and "Du
Cange" (*Glossarium mediae et infimae latinitatis* [Graz, Austria: Druck, 1954]), s.v.
"tenor," 2). There seems, however, to have been some confusion in antiquity about its
etymology, and thus about the affinities of its "proper" (that is, its root) meaning. Quin-
tilian states that "old writers" spelled the word *tonor* and derived it from Greek *tonos*,
"tone, pitch." A meaning of *tenor* in classical Latin is "tone" (*OLD*, s.v., 5), and Quin-
tilian (but not Cicero) refers *tenor* to metrical pitch and accent (*Inst. orat.* 1.5.22). It is
of considerable interest that a number of rhetorical categories turn up from an early
time in writings on music. This is not surprising, since music was one of the liberal arts
and the meters of poetry were taught as part of harmony; see, for example, the discus-
sion of "harmony" in Martianus Capella's *De nuptiis*, bk. 9, trans. W. H. Stahl and
R. Johnson in *Martianus Capella and the Seven Liberal Arts*, 2 vols. (New York: Co-
lumbia, 1977); Martianus' teaching on music is summarized in 1:202–27. Latin prose,
from antiquity through the Carolingian period, employed a rhythmic form called *cur-
sus*, metrical syllabic units used at the close of sentences and clauses to carry the work
along. These were obviously among the "signatures" of the *ductus*. And the termino-
logical affiliation of rhetoric and music may also have to do with the great influence of
Stoic philosophy (and Pythagoras) upon the development of Hellenistic and Roman
education.

12. Commentary on Psalm 99:3 in *Theodori Mopsuesteni expositio in psalmos*, ed.
L. de Coninck, Corpus Christianorum Series Latina 88A (Turnhout, Belgium: Bre-
pols, 1977), 326. This commentary was originally written in Greek by Theodore of
Mopsuestos, with a contemporary (fifth-century) translation of it made in Latin by at
least two different clerics. It was quite influential in the early Middle Ages.

13. John of Garland, *Parisiana poetria*, ed. T. Lawlor (New Haven: Yale University
Press, 1974), 8: "invenire est *in* ignote rei noticiam ductu proprie rationis *venire*." On
the notions of early university rhetoric teachers concerning invention, see Bagni, "L'in-
ventio." Augustine used the phrase in his controversial work *Contra Iulianum*; he says
that "gentiles" (that is, the ancient pagans—in this case the Stoic philosophers and his
revered master, Cicero) came to their knowledge of divine law solely "ductu rationis."
Here the idiom has a meaning more like our "reasonable" or (common) "sensible," as
distinguished from "revealed." Many of these uses of the noun *ductus* I was able to
glean from a computer search for the form *ductu-* using CETEDOC CLCLT, release
2 (Turnhout, Belgium: Brepols, 1994).

14. I have written extensively about the crucial role of mental previsualization in
composition as taught both in ancient rhetoric and in the practice of monastic medi-
tation from the fourth century onward, in both *The Book of Memory: A Study of Mem-
ory in Medieval Culture* (Cambridge: Cambridge University Press, 1990) and *The Craft
of Thought: Meditation, Rhetoric, and the Making of Images, 400–1200* (Cambridge:
Cambridge University Press, 1998). I discussed an imaginary "map" and other forms for
composing in my essay "The Poet as Master Builder," *New Literary History* 24 (1993):
881–904. Geoffrey of Vinsauf's *Poetria nova*, in which he describes a preferred method

of composition that relies importantly on mental imaging as a technique for composition, is most readily available in an English translation by M. F. Nims (Toronto: Pontifical Institute of Medieval Studies, 1967).

15. "How is *consilium* distinguished from *ductus*? In that the *consilium* is a matter of [the author's] choice, and *ductus* is part of the work itself. Likewise in that the *ductus* develops from the plan, not the plan from the *ductus*." (*Consilium a ductu quo differt? quod consilium voluntatis est, ductus ipsius orationis. Item quod ductus ex consilio nascitur, non consilium ex ductu.*) Fortunatianus, *Artis rhetoricae libri tres*, 1.7 (Halm, 86.31–33).

16. Ibid., 1.5–6 (Halm, 84–86); cf. Martianus Capella, *De rhetorica* (*De nuptiis* 5.470), Halm, 463–64.

17. Fortunatianus, *Artis rhetoricae libri tres*, 1.7 (Halm, 86.24): "ductus ex consilio nascitur, consilium autem non omnium semper est unum" (the *ductus* is born from the plan, but the plan is not always the same overall).

18. "Hos omnes ductus plerique quo nomine vocant? figuratos. Nos ergo quare nominibus separamus? quoniam singuli ductus diversa et vi et ratione consistunt nec debent uno nomine nuncupari, quorum et vis et ratio non una est." Fortunatianus, *Artis rhetoricae libri tres*, 1.7 (Halm, 86.14–17).

19. The phrase is used by Augustine, *De doctrina christiana*, 4.8.22.7–8 (Corpus Christianorum Series Latina 32, p. 131). An important essay on the inventive power of obscure language is D. Kelly, "Obscurity and Memory," in *Vernacular Poetics in the Middle Ages*, ed. L. Ebin (Kalamazoo: Medieval Institute, 1984); see also W. Kemp, "Visual Narrative, Memory, and the Medieval Esprit du System," in *Images of Memory*, ed. S. Küchler and W. Melion (Washington, D.C.: Smithsonian Institution Press, 1991).

20. *Modus* basically meant "measure." Students of music are probably best acquainted with the idea of musical "modes," classified by differing tempi, emotional effects, and ways of performing. These related meanings from music are also present in the rhetorical use of *modus* in the fourth century.

21. Geoffrey of Vinsauf, *Poetria nova*, line 1972 in *Les arts poétiques de xiie et xiiie siècles*, ed. E. Faral (1923; rpt., Paris: Champion, 1958).

22. I developed these observations at much greater length and with many more examples especially in chapter 3 of *The Craft of Thought: Meditation, Rhetoric, and the Making of Images, 400–1200* (Cambridge: Cambridge University Press, 1998).

23. See *OED*, s.v. "scope," n2. *Skopos* is also an important term in the advice on meditation given in John Cassian's *Conferences*, which became standard reading in medieval monasticism. For more on this, see both *The Craft of Thought*, chapter 2, and my essay, "Reading with Attitude: Remembering the Book" in *The Book and the Body*, ed. D. Frese and K. O'Brien O'Keeffe (Notre Dame, Idaho: Notre Dame University Press, 1997).

24. Fortunatianus, *Artis rhetoricae libri tres* 1.7 (Halm, 86.29–30): "modus est ductus in parte orationis, scopus autem id quod omnis efficit ductus." Cf. Martianus Capella, *De rhetorica* 5.471 (Halm, 464.16–17): "color in una tantum parte, ductus in tota causa servatur."

25. John Cassian was bilingual in Latin and Greek, and described his conversations with some of the early desert monks in Egypt on meditation and the contemplative life in his *Colloquies* (or "conversations"); he also wrote a handbook on the monastic life called *Institutiones* (or "fundamentals"). Both became basic books in later monasticism, despite the fact that Cassian was tainted with the heresy of "semi-Pelagianism" for some of his opinions. He left the eastern Mediterranean for the West to found monasteries in Marseilles and Provence. John Cassian lived ca. 365–ca. 435; Augustine lived 354–430. Good introductions to the lives of these two central figures include

O. Chadwick, *John Cassian*, rev. ed. (Cambridge: Cambridge University Press, 1968) and P. Brown, *Augustine of Hippo* (Berkeley: University of California Press, 1967); see also H. Marrou, *Saint Augustin et le fin de la culture antique* (Paris: Boccard, 1938).

26. Boethius, *Consolatio philosophiae* 4.1.35–38.

27. Augustine, *De doctrina christiana* 2.7.62–63 (Corpus Christianorum Series Latina 32, p. 38). The italicized words in the quotation are recollected from the Bible.

28. Beda Venerabilis, "Expositio in librum beati patris Tobiae," 5.18 (D. Hurst, ed., Corpus Christianorum Series Latina 119B, 7): "Dicit ipse de ductu ad Medos: Et alias oues habeo quae non sunt ex hoc ouili, et illas oportet me adducere" ([The Lord] says about [the phrase,] "the road to Media": And I have other sheep which are not of this flock, and I must gather them) (John 10:16). A letter composed in 1181 by the monk Guibert of Gembloux (near Namur in Belgium) describes a sort of pilgrimage he made to various places associated with Saint Martin of Tours; he calls his route "peregrinationis ductus" (a pilgrim's path). *Epistolarium Guiberti*, 9.470; ed. A. Derolez, Corpus Christianorum Continuatio Medievalis 66 (Turnhout, Belgium: Brepols, 1988), 142.

29. I discuss this history in *The Craft of Thought*.

30. The use of varying perspectives within a single work of art is an old tradition in the West. E. Revel-Neher has discussed this in reference to early (third- through seventh-century) Jewish and Christian representations of the Temple in "Du Codex Amiatinus et ses rapports avec les plans du Tabernacle dans l'art juif et dans l'art byzantin," *Journal of Jewish Art* 9 (1982): 6–17; and J-P. Antoine discusses varying perspectives in early Italian Renaissance mural painting in "Mémoire, lieux et invention spatiale dans la peinture italienne des xiiie et xive siècles," *Annales ESC* 48 (1993): 1447–69.

31. This is the reading of the Douay translation of the Latin Bible, similar to the one Augustine used. Modern English Bibles have a somewhat different reading of this text.

32. Augustine, *Enarrationes in Psalmis* 41.8.4–6; 9.1–24, 35–46, 58–62 (ed. E. Dekkers and J. Fraipont, Corpus Christianorum Series Latina 38 [Turnhout, Belgium: Brepols, 1956], 465–66). An English translation of much of this passage can be found in Dom Cuthbert Butler, *Western Mysticism* (1922; rpt., New York: Harper, 1966), 22–24.

33. I discussed the idiom of "domesticating" and "familiarizing" one's reading (in the sense of making it part of one's mental "family") in *The Book of Memory*, esp. 162–70.

34. Rupert of Deutz, *De sancta trinitate et operibus eius*, "In Genesim" 4.29.1348–50 (ed. H. Haacke, Corpus Christianorum Continuatio Medievalis 21 [Turnhout, Belgium: Brepols, 1971], 315): "Proinde et quidam sapientium saeculi uitam hominis Υ graecae litterae similem dixerunt quae ab uno ductu incipiens finditur in biuium." The observation was attributed to Pythagoras; it was included in the influential commentary on Virgil's *Aeneid* composed in the late fourth century by the grammarian Servius.

35. C. Heitz, *Recherches sur les rapports entre architecture et liturgie à l'époque carolingienne* (Paris: SEVPEN, 1963), and "Architecture et liturgie processionelle à l'époque préromane," *Revue de l'art* 24 (1974): 30–47.

7. C. P. E. Bach's Free Fantasy and the Performance of the Imagination

THE LATE-EIGHTEENTH-CENTURY free fantasia was remarkable both for its intensity and its evanescence. As improvised performances, fantasias had no preexisting text that could conjure up their recreation, and they were necessarily fleeting, leaving no record to form the basis for reconstruction. Yet contemporary accounts, such as Charles Burney's famous description of a fantasy performance by Carl Philipp Emanuel Bach, attest to the compelling, inspired brilliance of the free fantasia and to its status as the highest form of keyboard art: "After dinner . . . [Bach] played, with little intermission, till near eleven o'clock at night. During this time, he grew so animated and *possessed*, that he not only played, but looked like one inspired. His eyes were fixed, his under lip fell, and drops of effervescence distilled from his countenance."[1] Yet the inherent ephemerality of this musical art has contributed to its virtual erasure from modern histories of the period. Peggy Phelan's vivid account of performance art offers an apt description of the fantasia's position: "Without a copy, live performance plunges into visibility—in a manically charged present—and disappears into memory, into the realm of invisibility and the unconscious where it eludes regulation and control."[2] The fantasia evades the control of history and slips into the imagination.

The vanished fantasy performances (the improvisations) of the late eighteenth century maintain a spectral presence for the historian in texted, "composed" fantasias, but even eighteenth-century commentators were quick to point out that these may misrepresent the enterprise of fantasia. The surviving compositions entitled "fantasia" bear an equivocal relation to the improvisations of a musician such as C. P. E. Bach, who was hailed as the genre's greatest artist and a genius in composition, performance, and spontaneous invention; in evaluating the fantasia, an emphasis on composed text at the expense of performance would threaten to distort the genre. Indeed, the free fantasia blurs the boundary between text (composition) and instantaneous performance (improvisation), just as performance of a composed piece of music mediates between body (the physical present) and text (the trace that

points to absence and invokes memory). The genre problematizes the locus of the musical work, asking whether it resides in the notated piece or in its performance—in its "congealed written state" or "the fluid state [that] signifies," to borrow Adorno's formulation.[3] Adorno suggests that "informal" music such as improvisation is fundamentally incompatible with the process of writing: "The complex forms by means of which succession is internally organized as such would be inadequate for any improvised, non-written music-making."[4] The effect of the free fantasia's liminality has been to marginalize the genre in modern histories of late-eighteenth-century music; despite the vibrant presence of the fantasia in the late-eighteenth-century repertoire and its centrality to the period's critical discourse, twentieth-century music historians have tended to shy away from "informal" music such as this, which problematizes the role of the texts upon which such history is based.

The evasion in the eighteenth-century fantasia (to which Adorno is obliquely referring) of the usual techniques of musical development has contributed to the neglect of the genre in twentieth-century musicological narratives. Our usual model for understanding late-eighteenth-century music is in terms of form—motivic, thematic, harmonic patterning; the paradigmatic plot of sonata form in particular is held up as the template against which to hear and "understand" the music of the period. Sonata form, its structures based on repetition and return, directly engages the memory of the listener, measuring past event against present. The fantasia, by contrast, is epitomized by deliberate evasion of clear harmonic trajectories, period structures, and formal design. Performed without regular meter, the free fantasia has no barlines; a mosaic of rhapsodic, quick-changing effects, it boasts extravagant shifts of harmony and sudden changes of texture and dynamic level. In the fantasia, points of formal articulation are deliberately concealed, and the whole effect is one of intentional irregularity—in its expression of the divine inspiration of the musician, the fantasia is concerned less with notions of progess and return than with digression itself.

A music, like improvisation, that is purely performative, or that, like the written fantasia, derives its status as the "highest level of composition"[5] from its prioritization (fetishization, even) of performance, makes little sense when analyzed in purely formal terms, as so many formalist attempts have proven.[6] When such analysis has failed to find its version of coherence in the fantasia, the genre has been dismissed as marginal—but the critic who wishes to hear form (as it might appear on paper) misses a "hearing" of the fantasia that might reflect more closely the eighteenth-century listener's experience of fantasy performance.[7]

As an improvisatory genre the free fantasia privileges performance over composition; its freedom and extravagance, highly prized in the late eighteenth century, were predicated precisely on its immediacy, as the act of performance granted license to range well beyond the rules of formal composition. Indeed,

C. P. E. Bach, in the first volume of his influential treatise on keyboard performance, *Versuch über die wahre Art das Clavier zu spielen* (1753), suggested that the fantasia's rootedness in performance, which accounts for its resistance to modern analytical strategies, was the secret of the genre's appeal. In Bach's theory, music's ability to move the listener is a function less of the intrinsic structure of composition than of the ephemera of musical performance. Indeed, while Bach states that the purpose of good playing is "to make the ear conscious of the true content . . . of a composition," and to convey something "coherent" to the listener,[8] in a surprisingly extreme formulation, he goes on to imply that "content" and "coherence" reside in the act of performance itself, the exchange between listener and player, rather than in the abstract musical material (the text):

> Just as ugly grimaces are inappropriate and harmful, so fitting expressions are useful in that they help the listener to understand our intention. Those opposed to this show are often incapable of doing justice, despite their technique, to their own otherwise worthy compositions. Unable to bring out the content of their works, they remain ignorant of it. But let someone else play these, a person of delicate and sensitive insight who knows the meaning of good performance, and the composer will learn to his astonishment that there is more in his music than he had ever known or believed. Good performance can, in fact, improve and gain praise for even an average composition.[9]

Bach's statement here reflects the contemporary notion of *Empfindsamkeit*, which focuses on the body's participation in communicating emotion and empathy. He yokes musical meaning to the performance itself, and suggests that it is the work of the performer to supplement the notated score with such essential elements as physical gestures—a rather surprising idea to those of us taught to remain impassive while performing, and a colorful challenge to anyone concerned with reconstructing historical performance practices.

Bach prioritized performance, with its accompanying appeal to the physical, and he identified fantasia, freed from the coercion of form, as the locus of pure musical expression. In his book *Musical Form and Musical Performance* (1967), Edward Cone has articulated a certain strain of musicological anxiety over the physicality of performance: "Of course," he writes, "one often does hear exciting interpretations that build up so much energy that the overflow is imparted to the audience, which has to respond by immediate clapping; but I wonder whether these performances are not, for that very reason, a bit meretricious." Cone cites Leo Stein's suggestion "that music requiring bodily motion on the part of the listener for its complete enjoyment, like much popular dance music, is by that token artistically imperfect." Perhaps, Cone comments, "the same principle can be applied to performance."[10]

In this essay I suggest that the performance-saturated fantasia, far from being empty and possibly meaningless as the object of historical study, can attest to an especially active imaginative engagement between the late-eighteenth-

century listener and the musical performance. This is music that, as the imagination, or fantasy, of the greatest improvisers was sublimely embodied in sound, required the listener to engage in his (or occasionally her)[11] own imaginative performance to make sense of the seemingly confused soundscape. It carries important repercussions for how we might listen to the echoes of those performances today and informs the critical acts both of recreating the fantasy performances themselves and of writing the history of the period.

The free fantasia's flirtation with chaos was a cause for concern among Bach's contemporaries, some of whom found such stuff bizarre, contrived, even incomprehensible. Bach was not immune in his own day to the kind of formalist criticism that has been leveled against him in this century: critics in both Germany and England worried that his style was bizarre and fantastic and that it tended toward pathological excess. The Mannheim Kapellmeister Johann Georg Vogler's diagnosis for what he saw as the undue artificiality of Bach's style lay in the composer's inability to check his fantastical imagination: "between simplicity and dullness, variety and confusion, between a high flight, original brushstrokes and fancy, caricature, bizarre nonsense, i.e., between musical fantasy and a high fever there is all the difference in the world."[12] Self-indulgence is the sickness, formal coherence, as Vogler points out elsewhere, the cure. For Johann Nikolaus Forkel, an admirer of C. P. E. Bach and biographer of his father, the musical fantasist was, likewise, a feckless daydreamer, his "disorderly" music the antithesis of the "artful" music of a "brilliant and characterful man." But "natural, disorderly" music is not only aimless and ineffective, it is unkempt and barbaric, a kind of "crude, uncivilized animal."[13] The absence of a clear and ordered sequence of emotions in the fantasia rankled Forkel's well-controlled sensibilities. Forkel's attitude toward this music reveals itself most directly in an essay on Bach's famous F-minor sonata (published in the third *Kenner und Liebhaber* collection, 1781), in which Forkel defines the musical genre "sonata" as the coherent arrangement of the impassioned utterances of the artist, an order subverted by the fantasia. Indeed, the fantasia, characteristically located on the margins of a rationalist discourse, is figured here as the accidental by-product of a failed sonata:

> Without order and a suitable sequence, or gradual progression of our emotions, either toward strengthening or lessening, there is obviously no real artistic expression. Without it our impassioned depictions become ravings [*Schwärmereyen*], mostly without meaning or power, and only very rarely somewhat tolerable fantasias.[14]

That Forkel should grudgingly admit the possibility of "tolerable" fantasias is an indication of the uncertainty of his position as well as the centrality of the genre, since to dismiss the fantasia outright would be too eccentrically reac-

tionary. Yet for the most part, Forkel sees the artist who is tempted to veer away from the formal constraints of the sonata as one who swerves off into the random and incoherent digressions of the fantasia—and in its transgression of legitimate formal order, the fantasia's chaotic spontaneity threatens madness, fever, and dreams.

But in a positive inversion of such critical formulations, the theorist Daniel Gottlob Türk explained that the musical fantasy bears a contorted and blurred relation to "normal" musical discourse, like a dream to reality. This is exemplified by the improvised cadenza:

> Perhaps the cadenza could be compared not inappropriately with a dream. We often dream through actual experienced events in a few minutes, which make an impression upon us by their most lively sensations, but are without any coherence or clear consciousness. Thus also with the cadenza.[15]

In his *Klavierschule* (1789), which borrows heavily from Bach's *Versuch*, Türk privileged the freedom of the improvisation over the need for order in meaningful musical discourse and stressed that the value of the free fantasia lay precisely in the fact that it was of the moment, not the product of premeditation or something subsequently improved by artifice: paratactic and continually shifting, the fantasia is indeed the antithesis of conventional composition. But vague and fragmented as it is, the spontaneous performance is all the more vivid and memorable.

All too often, of course, dreams disappear and are forgotten; it was this transience, the fantasia's escape from memory, that particularly troubled enthusiasts of the free fantasia. The continual and paradoxical process of simultaneous creation and disappearance in the fantasia's performance highlighted the problematic distinction between the improvised and the notated fantasia. The difficulty, for those who saw the fantasia as the highest form of musical art and reveled in its poetic instability, lay in fixing a music that is ephemeral without robbing it of its unique freedom. In the article on the fantasia in Johann Georg Sulzer's *Allgemeine Theorie der schönen Kunste* (1771–74), the author described the intensity and brilliance of improvised fantasias, which are invented in the "fire of inspiration"; yet while he praised their instantaneity, he lamented their impermanence:

> The fantasias of great masters, particularly those which are played from a certain profusion of feeling and in the fire of inspiration are often, like the first sketches of a sketcher, works of exceptional power and beauty, which could not be achieved in a calm state of mind.
>
> It would consequently be an important matter if one had a means to write down the fantasias of great masters.[16]

Fascination with the fantasia's ephemerality lies at the heart of Sulzer's comparison between the fantasia and the sketch, and it is a comparison that carries broad implications for the interpretation of both the gaps and digressions of the fantasia itself, and of the partial role of the score in representing the fantasia.

In an attempt to preserve fantasias from their instantaneous absence (the genre's hallmark) a machine had been constructed that purported to be able to make exact transcriptions of improvisations.[17] An invention of the midcentury, exhibited in 1753 at the Royal Academy of Sciences in Berlin, the Fantasy Machine was described even decades later by writers such as Sulzer who were obsessed with the idea that this machine might be able to effect an immediate transformation of performance into text, thus bypassing the potential distortions of memory and self-criticism.[18] An account of the Berlin project published in 1770 attests to contemporary fascination with the mysterious impermanence of the improvised performance:

> [This is] indeed an important invention for music, which can imperceptibly, without the artist's troubling himself about it, bring to the paper as many musical thoughts, beautiful sudden ideas, and wonderful pieces that a quick-witted harpsichordist improvises, and can therefore, so to speak, catch in midair and hold tight the most beautiful pieces of music, which otherwise vanish before the ears as they are being made, more quickly than beautifully colored bubbles before the eyes.[19]

John Creed, the English inventor of an earlier plan for such a machine, presented to the Royal Society in London in 1747, had encapsulated the paradox of the project's aim to fix the free (the paradox, also, of the composed fantasia) with his claim that with the device the "most transient Graces" could be "mathematically delineated."[20] This machine was conceived both to record improvisation and to aid invention—ideas could be sketched out with it, to be refined later into careful composition—but in what amounts to a curious conflation of musical performance and composition the ultimate composition figures here as the most free and spontaneous improvisation.

The Berlin version of Creed's machine was widely commented upon and was tried out (in 1753, the publication year of Bach's *Versuch*) by several well-known musicians, probably including Bach.[21] But despite Sulzer's claim that it could "accurately transcribe everything that was played, even the smallest ornament,"[22] the consensus appears to have been that the machine was not a success. Although the notes of the improvisations played on it may have been accurately transcribed, the Fantasy Machine failed to record the nuances of performance: it could produce only pale imitations of free improvisation, from which all fantastic elements had been erased. As the critics noted, in its failure the Fantasy Machine highlighted the dubious relation between the note-text of a fantasia and its performance—a disjunction that the editor of the influential *Magazin der Musik*, Carl Friedrich Cramer, had hinted at in his comments on the two fantasias published in C. P. E. Bach's fifth collection for *Kenner und Liebhaber* (1785):

> Those who haven't heard the Kapellmeister [Bach] for themselves can get *some idea* of [his improvisation] from these Fantasias, although this idea always remains deficient, if one compares them to the real performance of the improviser, which, if it were fully notated, few, perhaps none, could execute properly.[23]

Not only would these printed pieces lack a crucial element of the free and accidental present in Bach's actual performance, but those performances themselves (the improvisations), could never be rendered exactly on the printed page.

The composed fantasia, as the imitation of an improvisation, may be considered tautological, even fraudulent. Borrowing Sulzer's comparison between the fantasia and the sketch, however, the theorist Heinrich Christoph Koch suggested that to "write" a fantasia was not simply to create a counterfeit; instead, the process of composition itself could in fact be just such a spontaneous and transgressive performance, an improvisation with pen and paper rather than musical instrument:

> One also gives the name *fantasia* to pieces actually composed, in which the composer binds himself neither to a definite form nor to a totally clearly connected order of ideas etc.; since the Ideal brought forth by Genius loses not the least of its first liveliness through the further working-out toward a more strictly ordered whole, these pieces very often contain far more prominent and striking traits than a piece composed according to forms and other necessary characteristics of a perfected whole. It is a similar case with sketches in painting, where likewise through the execution and completed depiction of the painting, many of the finer traits of the Ideal that are still present in the sketch get lost.[24]

In this case, the brilliant spark of inspiration is retained in the casual roughness of the (notated) result, its looseness of syntax, freedom of form, and sketch-like immediacy.

Both Sulzer and Koch noted how both the improvisation and the painter's sketch preserve a closer identity to the original ideas of the artist than a work produced in a more careful and studied fashion. The sketch is like the performed (that is, improvised) fantasia, but unlike the fantasia, it needs no recording machine. The fleeting temporality of its performance precludes completion, and its very "sketchiness" allows a free range to the imagination of the viewer who can enter into and fill out the work itself. Indeed, while sketches were seen as the most truthful representation of the imagination of the artist, they invited the viewer to use his/her own imagination to supply the details. The English pioneer of landscape sketching, William Gilpin, suggested, for example, that the rough sketch of a master "has sometimes an astonishing effect on the mind; giving the imagination an opening into all those glowing ideas, which inspired the artist; and which the imagination *only* can translate."[25]

In his famous *Discourses*, Sir Joshua Reynolds noted that "from a slight, underdetermined drawing, where the ideas of the composition and character are . . . only just touched upon, the imagination supplies more than the painter himself, probably, could produce." But danger lurked in the ambiguity of the

sketch, its promiscuous invitation to the viewer's imagination. Reynolds continued with a caution: "We cannot . . . recommend an undeterminate manner or vague ideas of any kind, in a complete and finished picture . . . Science and Learning must not be sacrificed and given up for an uncertain and doubtful beauty."[26] Another contemporary warning goes further:

> As useful as sketches are, artists, certainly young ones, must use them with sobriety, in order not to accustom themselves to the mistaken and fantastic. The artist must protect himself from the seduction of the thousand vague and irrational ideas that sketches suggest to him. He must examine with great rigor his libertine ideas at the moment that he establishes his composition.[27]

The fear of overindulgence in fantasy at the expense of reason, and its concomitant quasi-erotic effect on the body, is as tangible here as it is in the critiques of the musical fantasia by Forkel and Vogler.

In fact, the keen interest expressed by Sulzer and others in the 1770s and 1780s in the Fantasy Machine of the 1750s (which was destroyed by fire only a few years after its invention and exhibition) may well have been prompted not only by the increasing prominence of the fantasia, but also by the renewed critical debate over these issues as it was articulated in the literature on sketching, especially sketching landscape, in these decades. One such text, Alexander Cozens' A *New Method of Assisting the Invention in Drawing Original Compositions* (1785), gained considerable notoriety in both England and Germany, and directly addressed the evanescent productions of an artist's fantasy.[28] Cozens' method was designed, like the Fantasy Machine, to preserve spontaneity and truth while recording the ideas of the artist—for a great composition, "how perfect soever in conception, grows faint and dies away before the hand of the artist can fix it upon the paper or canvas." Indeed, Cozens promised an "instantaneous method of bringing forth the conception of an ideal subject fully to the view (though in the crudest manner)."[29]

Cozens recommended the rapid and energetic execution of blots—black amorphous masses, which, like musical improvisations, exploit accident while being by no means entirely accidental. The blot is a "production of chance, with a small degree of design." It provides a freely expressive way of creating an outline of the artist's idea, one that can then be worked up into a more conventional drawing or painting; the blot is not simply a random confusion, for the process is governed by a controlling idea (see figures 14 and 15). Blotting, Cozens claims, is "the speediest and the surest means of fixing a rude whole of the most transient and complicated image of any subject in the painter's mind."[30] Yet, given that a single blot may serve a number of finished paintings, the blot may be considered not only a recording device but also an aid to invention, a type of sketch that, in its indeterminacy, stimulates the imagination of the viewer.[31] Indeed, Cozens' own mounting and signing of some of his blots suggests their self-sufficiency as works of art, like the apparently random and sketchy improvisations of great musicians.[32]

14. Alexander Cozens, *New Method*, plate 40. Beinecke Rare Book and Manuscript Library, Yale University.

15. Alexander Cozens, *New Method*, plate 2. Beinecke Rare Book and Manuscript Library, Yale University.

In fact, Cozens casts his whole project as an exercise for the imagination: by describing a process of conjuring coherent forms from apparently indistinct shapes, Cozens presents his blots as ambiguous creations designed to allow multiple interpretations. The epigram from Shakespeare with which Cozens introduces the essay likens the New Method to a freely fantastical game of seeing shapes in clouds:

> Sometime we see a Cloud that's dragonish,
> A Vapour sometime like a Bear, or Lion,
> A tower'd Citadel, a pendant Rock,
> A forked Mountain, or Promontory,
> With Trees upon't, that nod unto the World,
> And mock our Eyes with Air.[33]

And indeed the New Method contains an extended series of cloud studies, at first glance rather out of place among its concluding examples of blots (see figure 16). The openness of clouds to interpretation is like that of sketches, or music without words—or "incomplete" fantasias. As William Gilpin noted, the sketch that has not been "worked up" into something more complete is open to multiple readings, as the spontaneity of its invention and execution necessarily incurs a risky (or rich) lack of closure. While seeing shapes in clouds might signal a pathological delirium, clouds could also offer a heightened reality, where the spectacle of fantastic metamorphoses was played out in the theater of the imagination.[34]

The blurred and blotted business of the performance and interpretation of musical fantasies cohered, in the second half of the eighteenth century, around one famous piece: the free fantasia in C minor (H. 75) published by C. P. E. Bach in 1753 as a model for improvisation to accompany his Versuch. Indeed, this piece figured as the touchstone for subsequent contributions to the genre, as well as for critical discussion of musical fantasy, well into the nineteenth century. In 1763 the poet Heinrich Wilhelm von Gerstenberg made an experimental "analysis" of this famous C-minor fantasia; Gerstenberg's project subsequently became the subject of a long essay by Carl Friedrich Cramer published in 1787.[35] Cramer, professor of Greek and oriental languages at Kiel, was thoroughly conversant with contemporary English and German aesthetics and criticism, and his discussion of Gerstenberg's experiment describes a fascinating process of fantasia interpretation; it is a critique that records both contemporary fascination with the production of musical fantasy, and, crucially, argues for fantasy interpretation as itself a performance. Gerstenberg had set two alternative dramatic texts to the C-minor fantasia, both of which are meditations on mortality and the troubled exit from the physical world offered by suicide: one is a freely adapted version of Hamlet's monologue "To be or not be" (Sein oder nicht sein), the other presents Socrates preparing to

27) The same as the last, but darker at the bottom than the top.

28) All cloudy, except one large opening, with others smaller, the clouds lighter than the plain part, & darker at the top than the bottom.
The Tint twice in the opening, and once in the clouds.

25) The same as the last, but darker at the bottom than the top.

26) All cloudy, except one large opening, with others smaller, the clouds darker than the plain part, & darker at the top than the bottom.
The Tint twice over.

16. Alexander Cozens, *New Method*, plates 25–28. Beinecke Rare Book and Manuscript Library, Yale University.

drink poison (see figure 17). Perhaps not coincidentally, Cozens' epigram to the *New Method*, taken from Shakespeare's *Anthony and Cleopatra*, addresses the same subject matter: considering suicide, Anthony imagines himself to be as ephemeral as cloud patterns, now a visible form, soon to disappear.

Cramer explains Gerstenberg's experiment as an attempt to illustrate the hermeneutic problems and potential of the newly ascendant instrumental music (music without words), a response to the question "whether pure instrumental music in which an artist had expressed only the dark passionate conceptions that lay in his soul might also be susceptible to a clear definite analysis?"[36] It perhaps seems ironic that the argument Cramer presents here for the value of "absolute" music should rely on the festooning of the fantasia with two verbal texts, but Cramer rationalizes this aspect of the project: he apologizes for the addition of constraining and overly specific words to the free fantasia, the most open and freely instrumental of genres, and argues instead for what the texts represent of the fantasia's hermeneutic potential on a more thematic level.[37] The idea is encapsulated in a single image, embedded in an obscure passage, as follows:

17. C. P. E. Bach, *Free Fantasia in C minor* (H. 75), with added texts by Heinrich Wilhelm von Gerstenberg. *Flora*, ed. C. F. Cramer (Hamburg, 1787). By Permission of the British Library (D. 776).

> Out of all the flights and leaps, never coercible by meter or rhythm and moving
> through every region of modulation, of these cloud formations, [the critic's]
> plastic genius lifts out here a nose and there an eye, like the lesbian Tragelaph,
> and assembles for you such a shape of deep emotion that certainly another
> could not be so clear, although the wise will be rewarded if they take the trou-
> ble to—*study*—it.——and *one* shape is not enough![38]

Cramer figures the fantasy as a multivalent cloudscape, and the work of the in-
genious interpreter as that of discovering shapes in clouds. Having explained
that this fantasia is the expression of Bach's "unfettered imagination," Cramer
describes how Gerstenberg has engaged in an idiosyncratic fantasy perform-
ance of his own, giving "unrestrained flight to his own sublime imagination."[39]

Cramer presents the constant shifts and changes of the fantasia not as
empty ravings but as a fabulous cloudscape full of potential meanings. Indeed,
he emphasizes multiplicity of interpretations—"one shape is not enough."
Not only does the analogy with seeing shapes in clouds focus on the activity of
the listener in "performing" his own work of fantasy, it allows for the discovery
of multiple meanings in the fantasia, without compromising the essential free-
dom of the genre by imposing a rigid interpretative framework on it. Cramer
conceives of the spontaneous, performative fantasia as meaningful, not in
terms of the formal coherence advocated by Forkel, but in a new way, in
which, as the imagination of the artist works with as little mediation as possible
to produce a shifting and transitory soundscape, the resultant gaps allow the
listener to perform his own imaginative work of interpretation. It is precisely
the irregularities, disappearances, and absences of the performance itself that
allow a dialogic engagement between performer and listener, a conversation
whose ellipses are silently filled by those taking part.

My narrative, then, is one of absences—of the disappearing fantasy per-
formance, the absent eighteenth-century fantasizing body, and of the gaps
within the fantasy that are a necessary concomitant of its spontaneous inven-
tion-in-performance (or written imitation of this act). But there is yet another
vanishing act to consider here. Cramer's interpretation of the fantasia as a
multivalent cloudscape has itself disappeared from the recent critical litera-
ture on the genre. In his detailed commentary on this key fantasia text,
Eugene Helm, the distinguished C. P. E. Bach scholar, gives Cramer's essay
on Gerstenberg's "experiment" in English translation—yet he omits the para-
graph I have quoted above, whose absence is signaled by an ellipsis.[40] I won-
der whether the omission may be due to the difficulty and, at first sight,
obscurity of the passage's bizarre reference to clouds; perhaps it has something
to do with the odd body parts, here a nose, there an eye, of the unknown "les-
bian Tragelaph." Perhaps the allusion to Lesbos baffled the critic and tempted
him to suppress the passage altogether.

The omission of the Tragelaph from the critical discourse on the fantasia
is itself curiously appropriate, however. This strange creature is central to

Cramer's interpretation, for the Tragelaph is a figure of classical mythology, half stag and half goat, which functions in classical philosophy as a standard metaphor for the unreal.[41] Amalgamating his classical allusions, Cramer situates this polymorphous monster on the Isle of Lesbos, presumably thus referring to the "Lesbian rule" mentioned by Aristotle in the Nichomachean Ethics, a flexible measuring stick that can be made to conform to any shape. Aristotle writes:

> . . . all things are not determined by law, [indeed] about some things it is impossible to lay down a law, so that a decree is needed. For when the thing is indefinite the rule also is indefinite, like the lead rule used in making the Lesbian moulding; the rule adapts itself to the shape of the stone and is not rigid, and so too the decree is adapted to the facts.[42]

In Cramer's formulation, then, the fantasia, neither straight, fixed, nor predetermined, is to be celebrated for its richly varied and brilliantly shifting topography, one which the listener is expected to confront without a fixed template of aesthetic assumptions. Far from being empty and incoherent, it is music rich with its own forms, however unstable they may be. For this eighteenth-century critic the imaginary takes shape at the heart of the fantasia's discourse, as live performance disappears into memory, and memory metamorphoses into imagination.

The fantasy has remained obscure perhaps because it challenges the musicologist to a new kind of listening, an unruly one that demands a free-ranging imagination; a genre of intense emotions, morbid reflections, and, not least, libidinous updrafts, it promises the sublime but threatens chaos. While the issue of indeterminacy was central to the contemporary debate over the fantasia, fantasy characteristics themselves were constantly described, both positively and negatively, as intrinsic elements of contemporary instrumental music. If the free fantasia, which has no clear thematic working-out, no meter, and no clear formal structure, could be meaningful despite its apparent incoherence, then so too could "abstract" instrumental music. Extrapolating from Cramer's interpretation of Bach's C-minor fantasia, the way in which the fantasia enacts musical meaning may be taken as a model for other kinds of instrumental music in this period. Where late-twentieth-century analytical techniques emphasize formal coherence and downplay surface discontinuities, Cramer (an initiate in the Bach circle) valued the contingent and disruptive as opportunities for imaginative play by the listener. Indeed, Cramer advocates a fantastical listening that establishes individually constructed meaning precisely through a creative intervention on the part of the listener.

 In his critique of the "authentic" performance movement, Richard Taruskin has extensively questioned a fixation on the past at the expense of the present, countering the notion that restoration, re-imagining something old, is

necessarily more valuable than creating something new (in the performance of "old" music).[43] Resituating the fantasia within a broader conception of the eighteenth-century musical imagination offers the present-day performer and listener the opportunity for a new and lively engagement with this music. Forkel's distrust of such "daydreams" and "visions" prefigured modern musicological distrust of fantasy and those elements of musical discourse that resist notation. Perhaps, though, the intrinsic instability of the free fantasia might offer us—as it offered educated listeners of the period—an unruly and rewarding way to hear anew both the free fantasia and the "ordered" masterpieces of the late-eighteenth-century canon.

NOTES

1. Charles Burney, *The Present State of Music in Germany, the Netherlands and the United Provinces* (London, 1773; rpt. New York: Broude Bros., 1969), 2:270.

2. Peggy Phelan, *Unmarked: The Politics of Performance* (London: Routledge, 1993), 148.

3. Theodor W. Adorno, *Quasi una Fantasia*, trans. Rodney Livingstone (London: Verso, 1992), 296. See also Lydia Goehr, *The Imaginary Museum of Musical Works* (Oxford: Oxford University Press, 1992); and Richard Taruskin, *Text and Act: Essays on Music and Performance* (New York and Oxford: Oxford University Press, 1995).

4. Adorno, *Quasi una Fantasia*, 295–96.

5. "den höchsten Grad der Komposition." Johann Samuel Petri, *Anleitung zur praktischen Musik*, rev. and enl. ed. (Leipzig, 1782), 266.

6. David Schulenberg, for example, writing on the C-major fantasy from C. P. E. Bach's fifth *Kenner und Liebhaber* collection, attempts a formal analysis, but ends up admitting that its "more mysterious parts" consist of "little more than one thing after another"; coherence, he concludes warily, resides in a principal of progression by non sequitur, which "stretches the idea of formal connections to its limits." The implication is that this is music of dubious artistic merit, if not an outright failure. See David Schulenberg, *The Instrumental Music of Carl Philipp Emanuel Bach* (Ann Arbor: UMI Research Press, 1984), 157.

7. In a reconsideration of this question, Karol Berger has suggested that notions of form for late-eighteenth-century listeners were neither thematically based (the late-nineteenth- and earlier twentieth-century view), nor harmonically based (our more usual reading of structures such as "sonata form"), but that instead an "archeology of hearing" based on H. C. Koch's *Versuch einer Anleitung zur Composition* (1787) reveals such listeners to have relied on "the experience of punctuation," the articulation of a composition into a "hierarchy of parts." While this offers a compelling model for listening to structures such as the classic concerto, it is less useful for the free fantasia, in which "punctuation" is deliberately obscure, even arbitrary. But one might take Berger's analogy with narrative a little further, and relate the fantasia discourse to deliberately digressive eighteenth-century (anti)narrative strategies such as those of Lawrence Sterne. See Karol Berger, "Toward a History of Hearing: The Classic Concerto, a Sample Case," in *Convention in 18th- and 19th-Century Music: Essays in Honor of Leonard Ratner*, ed. Wye J. Allenbrook, Janet M. Levy, and William P. Mahrt (Stuyvesant, N.Y.: Pendragon Press, 1992).

8. "Worinn aber besteht der gute Vortrag? in nichts andern als der Fertigkeit, musikalische Gedancken nach ihrem wahren Inhalte . . . dem Gehöre empfindlich zu machen." C. P. E. Bach, *Versuch über die wahre Art das Clavier zu spielen* (Berlin: Henning, 1753; rpt. Wiesbaden: Breitkopf & Härtel, 1986), 1:117.

9. "So unanständig und schädlich heßliche Gebährden sind: so nützlich sind die guten, indem sie unsern Absichten bey den Zuhörern zu hülfe kommen. Diese letzern Ausüber machen ungeachtet ihrer Fertigkeit ihren sonst nicht übeln Stücken oft selbsten schlechte Ehre. Sie wissen nicht, was darinnen steckt, weil sie es nicht herausbringen können. Spielt solche Stücke aber ein anderer, welcher zärtliche Empfindungen besitzet, und den guten Vortrag in seiner Gewalt hat; so erfahren sie mit Verwunderung, daß ihre Wercke mehr enthalten, als sie bewust und geglaubt haben. Man sieht hieraus, daß ein guter Vortrag auch ein mittelmäßiges Stück erheben, und ihm Beyfall erwerben kann." Ibid., 123. Translation based on C. P. E. Bach, *Essay on the True Art of Playing Keyboard Instruments*, trans. William J. Mitchell (London: Eulenburg, 1974), 152.

10. Edward T. Cone, *Musical Form and Musical Performance* (New York: Norton, 1986), 16–17. Cited in Susan McClary, *Feminine Endings: Music, Gender and Sexuality* (Minneapolis: University of Minnesota Press, 1991), 185 n. 15.

11. The eighteenth-century critical literature on the fantasia tends to be gender-specific—the fantasia is considered the music of genius, and as such is generally the domain of men, both as performers and as listeners.

12. ". . . zwischen Einfachheit und Trockenheit, Mannigfaltigkeit und Verwirrung, zwischen einem höhen Schwung, originellen Pinselzug und Fantasie, Karrikatur, bizarres Zeug, ie, zwischen musikalischer Fantasie und einem hizigen Fieber noch ein himmelweiter Unterschied [ist]." Johann Georg Vogler, *Betrachtrungen der Mannheimer Tonschule* (Mannheim, 1780), 3:156.

13. Johann Nikolaus Forkel, "Genauere Bestimmung einiger musikalischen Begriffe: Zur Ankündigung des akademischen Winterconcerts von Michaelis 1780 bis Ostern 1781," in Cramer, *Magazin der Musik* 1, no. 2 (November 8, 1783): 1050. The image of the "primitive" man here (Rousseau's noble savage is apparently not for Forkel) curiously prefigures the Englishman Thomas Busby's juxtaposition of the "uncivilized" with a musical style characterized by the stylistic features of the fantasia. Busby defined "Wild Music" as "the music of uncivilised countries; or compositions characterized more by feeling, and originality of imagination, than by any just or systematic succession of sounds." Thomas Busby, *A Complete Dictionary of Music* (London, 1801): 330, s.v. "Wild Music."

14. "Ohne Ordnung und gehörige Folge, oder stufenweise Fortschreitung unserer Empfindungen, entweder zur Verstärkung oder Verminderung, läßt sich kein wahrer Kunstausdruck denken. Ohne sie werden unsere leidenshaftliche Schilderungen Schwärmereyen, meistens ohne Verstand und Kraft, und nur höchst selten etwas erträgliche Phantasien." Forkel, "Ueber eine Sonate aus Carl Philipp Emanuel Bachs dritter Sonatensammlung für Kenner und Liebhaber, in f moll," *Musikalischer Almanach für Deutschland* (1784), 21.

15. "Vielleicht leiße sich die Kadenz nicht unschicklich mit einem Traume vergleichen. Man durchträumt oft in wenigen Minuten wirklich erlebte Begebenheiten, die Eindruck auf uns machten, mit der lebhaftesten Empfindung; aber ohne Zusammenhang, ohne deutliches Bewußtseyn.—So auch bey der Kadenz." Daniel Gottlob Türk, *Klavierschule, oder, Anweisung zum Klavierspielen für Lehrer and Lernende* (Leipzig, 1789), 312.

16. "Die Fantasien von großen Meistern, besonders die, welche aus einer gewissen Fülle der Empfindung und in dem Feuer der Begeisterung gespielt werden, sind oft,

wie die ersten Entwürfe der Zeichner, Werke von ausnehmender Kraft und Schönheit, die by einer gelassenen Gemüthslage nich so könnten verfertiget werden. "Es wäre demnach eine wichtige Sache, wenn man ein Mittel hätte, die Fantasien großer Meister aufzuschreiben." Johann Georg Sulzer, *Allgemeine Theorie der schönen Künste*, enl. ed., (Leipzig, 1786–87): 2:149, s.v. "Fantasiren; Fantasie."

17. For a detailed account of the machine, see Peter Schleuning, "Die Fantasiermaschine: Ein Beitrag zur Geschichte der Stilwende um 1750," *Archiv für Musikwissenschaft* 27 (1970): 192–213.

18. See Sulzer, *Allgemeine Theorie*, 2:149–50, s.v. "Fantasiren; Fantasie"; Forkel, *Musikalischer Almanach für Deutschland* (1782): 26–27; Forkel's account echoes Burney's in *The Present State of Music*, 213–216; J. von Stählin, "Nachrichten von der Musik in Rußland," in *Beilage zum neuveränderten Rußland*, ed. J. J. Haigold, vol. 2 (Riga, 1770), reprinted in J. A. Hiller, *Musicalische Nachrichten und Anmerkungen auf das Jahr 1770*, 4/2/25 (June 18, 1770): 194–98; and Heinrich Christoph Koch, *Musikalisches Lexicon* (Offenbach am Main, 1802), cols. 1076–77, s.v. "Notenschreibe-Maschine."

19. Von Stählin, "Nachrichten von der Musik in Rußland," 195.

20. John Creed's plans were published in the *Philosophical Transactions of the Royal Society*, vol. 44, part 2, For the Year 1747, (London, 1748), no. 483: 445–50 and table 1. Quoted in Schleuning, "Die Fantasiermaschine," 196.

21. Scheibe and Marpurg were among those who saw it. Burney, citing the opinions of a "great performer," who tried the machine, was most likely referring to Bach himself.

22. ". . . jedes, bis auf die kleinest Manier im Spielen, genau aufzeichnet." Sulzer, *Allgemeine Theorie*, 2:150, s.v. "Fantasieren; Fantasie."

23. "Diejenigen, welche nun den Herrn Capellmeister nicht selbst gehört haben, können sich aus diesen . . . Fantasien *einigen Begriff* davon machen, obgleich dieser Begriff noch immer unvollständig bleibt, wenn man den wirklichen Vortrag des Fantasirenden damit vergleicht, der, wenn er völlig in Noten gesetzt wäre, von wenigen, vielleicht von Niemand, gehörig ausgeführt werden dürfte." Review of "Claviersonaten und freye Fantasien . . . für Kenner und Liebhaber, . . . Fünfte Sammlung," Cramer, *Magazin der Musik*, 2, no. 2: 871–72.

24. "So nennet man das durch Töne ausgedrückte und gleichsam hingeworfene Spiel der sich ganz überlassenen Einbildungs-und Erfindungskraft der Tonkünstlers, oder ein solches Tonstück aus dem Stegreife, bey welchem sich der Spieler weder an Form noch Haupttonart, weder an beybehaltung eines sich gleichen Zeitmaßes, noch an Festhaltung eines bestimmten Charackters, bindet, sondern seine Ideenfolge bald in genau zusammenhängenden, bald in locker an einander gereiheten melodischen Sätzen, bald auch nur in nach einander folgenden und auf mancherley Art zergliederten Akkorden, darstellet." Koch, *Musikalisches Lexicon*, cols. 554–55, s.v. "Fantasie."

25. William Gilpin, *Three Essays:—on Picturesque Beauty; on Picturesque Travel; and, on Sketching Landscape: to Which Is Added a Poem, on Landscape Painting* (London, 1792), 50.

26. Sir Joshua Reynolds, discourse 14 in *Discourses*, ed. Pat Rogers (London: Penguin, 1992), 225–26.

27. "Si utiles que soient les *esquisses*, les artistes, surtout les jeunes, doivent en user avec sobriété, pour ne pas s'accoutumer à l'incorrection et au fantastique. L'artiste doit se garder de la séduction des mille idées vagues et peu raisonnées que ses *esquisses* lui suggèrent. Il convient qu'il examine avec une grande rigeur ses idées libertines au moment d'établir sa composition." Francesco Miliza, *Dizionario delle belle arti del disegno* (1797), s.v. "Schizzo." Reprinted in the article "Esquisse, esquisser" in the *Diction-*

naire des arts of Watelet and Levesque (Paris, 1792). See also Jean-Claude Lebensztejn, *L'art de la tache* (Montélimar, France: Éditions du Limon, 1990), 122–23.

28. Sulzer cites Cozen's *New Method*, as well as its anonymous precursor, *An Essay to Facilitate the Invention of Landskip* (London, 1759), almost certainly also by Cozens, alongside the works of William Gilpin in the bibliography appended to the essay on "Landschaft" in his *Allgemeine Theorie* (revised and enlarged edition of 1786).

29. Alexander Cozens, *A New Method of Assisting the Invention in Drawing Original Composition* (London, 1785), 3, 2.

30. Ibid., 10.

31. Cozens suggested that a number of different people could use the same blot as the basis for their own compositions (useful, no doubt, in the classroom).

32. Cozens had taught his blotting method in the early 1750s at Eton and Christ's Hospital, and numbers of English artists after him used his technique; yet despite Cozens' position as drawing master to the royal children, as well as many aristocrats (including the incorrigibly exotic William Beckford), his system was widely ridiculed, and he himself was dismissed by some wags as "Blotmaster-general to the Town." For more on Cozens, and on his son, John Robert, see Kim Sloan, *Alexander and John Robert Cozens: The Poetry of Landscape* (New Haven and London: Yale University Press, 1952); see also Lebensztejn, *L'art de la tache*.

33. Shakespeare, *Anthony and Cleopatra*, act 4, scene 14, lines 3–8.

34. For a brief survey of attitudes toward seeing images in the clouds, see Lebensztejn, *L'art de la tache*, 95–100.

35. Gerstenberg's "experiment" is documented in detail in Eugene Helm, "The 'Hamlet' Fantasy and the Literary Element in C. P. E. Bach's Music," *Musical Quarterly* 58, no. 2 (1972): 277–96. See also Friedrich Chrysander, "Eine Klavier-Phantasie von Karl Philipp Emanuel Bach mit nachträglich von Gerstenberg eingefügten Gesangsmelodien zu zwei verschiedenen Texten," *Vierteljahrsschrift für Musikwissenschaft* 7 (1891).

36. "Es war gestritten worden, ob auch bloße Instrumentalmusik, bey der ein Künstler nur dunkle leidenschaftliche Begriffe in seiner Seele liegen gehabt, einer Analyse in heller, bestimmtere fähig seyn sollte?" Cramer, *Magazin der Musik* 2, no. 2: 1359; Helm, 287.

37. They provide examples for a notion similar to that expressed by Friedrich Schlegel a few years later in the *Athenaeum* fragments: "Some find it strange and foolish when musicians speak of the thoughts in their compositions . . . but . . . must not pure instrumental music itself create a text of its own?" Quoted in Carl Dalhaus, *The Idea of Absolute Music*, trans. Roger Lustig (Chicago and London: University of Chicago Press, 1989), 107.

38. "Aus allen den nicht einmal in Takte und Rhythmen zwangbaren Schwüngen and Sprüngen dieses durch alle Gefilde der Modulation einherzienden Wolkenbildes, hub sein plastischer Genius, gleich dem lesbischen Tragelaph, heir eine Näse und wieder ein Auge heraus, und fezte Euch so diese Gestalt tiefer Empfindung zusammen, die freylich nicht einem Jeden gleich anschaulich seyn dürfte, aber den Weisen belohnen wird, wenn er sich die Mühe nimmt, sie zu—*studieren.*——Und nicht genug an *Einer* Gestalt!" Cramer, *Magazin der Musik* 2, no. 2: 1359.

39. ". . . der ungebundene Flug seiner erhabenen Einbildungskraft." Ibid.

40. See Helm, "'Hamlet' Fantasy."

41. See Giovanna Sillitti, *Tragelaphos: Storia di una metafora e di una problema* (Naples: Bibliopolis, 1981). Many thanks to Julia Annas at the University of Arizona for this reference.

42. Aristotle, *Nichomachean Ethics*, 1137b 30, trans. W. D. Ross, *The Complete Works*

of Aristotle: The Revised Oxford Translation, ed. Jonathan Barnes (Princeton, N.J.: Princeton University Press, 1984), 1796. I am indebted to Gail Fine and Terry Irwin at Cornell University for this reference, and for helping to unravel Cramer's mysterious allusion to Lesbos.

43. Taruskin, *Text and Act*, 8–9.

8. Performance on Paper: Rewriting the Story of Notational Progress

ANY OBSERVERS of the early music movement may overestimate the degree to which "historically informed" musicians actually foster a distinctive approach to the interpretation of their parts, normally cleansed of every romantic acretion. Indeed, many purists will be shocked on their first visit to the rehearsal of their local baroque or classical band. The conductor will usually give a long list of crescendos and diminuendos to be inserted into the parts, and will provide indications of tempo changes and ornaments. Moreover, the players—in the course of rehearsal—will add their own markings to remind themselves of various issues such as bowings, difficult fingerings, and those places where they must reluctantly resist the cooperative urge of the early music ethos and actually watch the conductor. Our purist will be further disappointed to compare the level of marking in the performers' parts with those of a "mainstream" symphony orchestra. For the most part, the symbols used and the detail of the marking will be similar. Obviously, the relationship of the performance markings with the notes may be different and to some degree more "historically informed"—shorter slurs, closer spaced dynamic nuances, more ornaments—but there would generally be little sense of the performers' intuitively drawing on a large reservoir of historical stylistic awareness with which they spontaneously interpret the original notation.

There might be two explanations for this tendency to mark as many interpretative details as possible in the notation. First, it might reflect the circumstances of the present age: players and singers could rightly claim that they are being required to perform a far wider range of styles than any "original" performer and that modern life is simply too frenetic to facilitate a ready stylistic ambidexterity. Furthermore, many might claim that Western society has moved from a reliance on the power of memory and mental calculation to dependency on written records and detailed notations.

Another side to this might be the influence of recording and broadcasting technology, which requires a greater degree of precision in the details of performance and a consistency from one performance or recorded "take" to the

next. As Robert Philip observes, "The changes in recording and the recording studio have in turn fed back into the concert-hall. If pre-war recordings are remarkably like live performances, many late twentieth-century live performances are remarkably like recordings."[1] Interestingly, Adorno made a similar, if more damning, observation in 1938, precisely during the period that Philip credits with live-sounding recordings. He believed performance style to suffer from the influence of the culture industry and recording technology, to be too concerned with the rationalization of superficialities at the expense of the structural truth of the music:

> The new fetish is the flawlessly functioning, metallically brilliant apparatus as such, in which all the cog wheels mesh so perfectly that not the slightest hole remains for the meaning of the whole. Perfect, immaculate performance in the latest style presents the work at the price of its definitive reification. It presents it as already complete from the very first note. The performance sounds like its own phonograph record.[2]

A second explanation of the tendency to notate interpretative details concerns the concept of autonomous musical works and the notion of the composer as the supreme controller of each work. This undoubtedly accounts in part for the dramatic increase in performance markings added by composers and editors during the nineteenth century, when the concept of the musical work took hold.[3] Not only the basic pitches and rhythms, but also many details of performance interpretation became part of the distinctive character of each work insofar as this was recorded in, or stipulated by, the score. Moreover, such details were often retroactively applied to earlier repertories in the various performing editions of the time. José Bowen, in a study of three of the most significant composer-conductors of the nineteenth century (Mendelssohn, Berlioz, and Wagner), sees the origins of the adherence to a composer's spiritual and notational intentions as lying at the high point of musical romanticism, when composers developed their respect for the intentions of their predecessors partly as a way of justifying a growing sense of their own individuality.[4]

The traditional periodization of music history tends to support this view of the fully formed work solidifying in the nineteenth century, and of the composer taking ever more control over the notation of performance directives in the music. The medieval period was the time when first pitch and later rhythm were notated; in the Renaissance, complex tempo relationships were established; in the baroque, details of expression, tempo, dynamics, ornamentation, and articulation were added to the notation; in the classical period, diminuendos and crescendos came to be prescribed and all expressive directions were notated in greater detail and in greater precision; and, with Beethoven, tempo itself could be established with the aid of metronome marks. The same "story" can be continued to encompass the specification of many other musical and extramusical factors in performance by Wagner, to Stravinsky's belief that the performer need do nothing more than read the notated instructions, to the serialization of dynamic and attack by Messiaen, Babbitt,

and Boulez, and, finally, to tape music, in which both performer and notation are subsumed by the recorded medium.[5]

This story is also bolstered by cultural-materialist interpretations of music history. As early as 1911, Max Weber related developments in music to the increasing rationalization of Western society and the increasing control over nature. He gives particular attention to the development of tempered keyboard tuning and the developing technology of instruments. The progress of notational systems inevitably finds a place in this all-embracing system of rationalization.[6] Weber sees notation as essential to the existence of a complex modern (Western) work, and, indeed, to the very notion of a composer. Although he does not provide a detailed history of the development of notation his concept of progressive rationalization—in which the means toward specific ends become increasingly efficient and precisely calculated—would clearly support the story of notational progress.

Adorno develops this approach in a way that runs forcefully against the ideals of historically informed performance. Musical works change throughout their history; most pertinently, the degree of freedom allowed to the interpreter has progressively diminished during the bourgeois period. While works of music achieve autonomy with the rise of the bourgeoisie at the end of the eighteenth century, the music becomes more rationalized, and any performer freedom that remains becomes arbitrary and no longer part of the creative process and realization of the work. If certain parameters of interpretation in earlier notations were purposely left to chance, this no longer works in the modern age, when the constructive unity of earlier music has been recognized and thus becomes the goal of all performance: "Subjected to more careful observation, older and, above all 'classical' German music—if it is to be realized as its construction presents itself to the eye of today—demands the same strict reproduction as does new music, resisting every improvisational freedom of the interpreter."[7]

As odious as Adorno's standpoint—making the high modernism of his age a historical necessity—might seem today, it remains a perceptive diagnosis of the notational rationalization of music during the last two centuries. Historical performers may have taken a step in the direction of performer freedom and a return to what Adorno saw as the flexibility of the boundaries of production, reproduction, and improvisation that existed before the end of the eighteenth century, but, I suggest, many are still possessed by the urge to notate; even freedoms, even nonrational elements of expression, often have to be added to their performance parts.

Interestingly, performers do not seem universally to have added many markings to their parts until well into the twentieth century—in other words, the period of expanding recording technnology and regular rehearsals. However much Bach added performance directives in his performing parts, the performers themselves seemed to have added little more.[8] A century later, instrumentalists in Donizetti operas seem to have added only cartoonlike annotations

and left even obvious mistakes uncorrected.[9] As Robert Philip has observed, Oscar Cremer (1924) advised violinists not to insert fingering into their parts so as not to inhibit the choices for other players; in the same period concertgoers in Manchester were startled by the uniformity of bow direction in the visiting Berlin Philharmonic.[10] These examples might seem surprising from a late-twentieth-century perspective, particularly given the detail of performance marking in nineteenth- and twentieth-century notation. Perhaps the composer's markings were seen as part of the inviolable work as preserved in notation, and the performer's own interpretation was something contingent, not necessarily to be notated or rationalized. The prescribed markings, at least from the nineteenth century onward, may be there to give the illusion of the completeness and uniqueness of each musical work, their success as performance directives depending on the practical experience of the composer.

Moreover, however much a composer may ostensibly wield supreme authorial control over the production of a musical text, there are going to be many external factors—and indeed other wills—in action. By the late nineteenth century, the golden age of the musical "work," the creation of a definitive score, and, by analogy, the creation of an authorial figure, was a collaborative venture. James Hepokoski's study of the creation of Verdi's last opera, *Falstaff* (1892–94), provides a particularly pertinent example of a composer who lived from an age of singer dominance to one in which the composer exerted supreme control over matters of musical text and performance decisions. It comes at a crucial juncture in the development of the unique musical work:

> From the beginning, the *Falstaff* project celebrated the modern principle of the marriage of art to the economic and legal powers of big business; from the beginning, it was conceived both as something to be received and treated as a "masterpiece" and as something to be marketed aggressively within the norms expected by the modern institution of art music . . . To try to reduce this to a concern with Verdi's intentions alone—with the implication that these intentions may be investigated apart from the collaborative and commercial process with which they were inescapably intertwined—is grossly to misunderstand the multilayered reality of this opera. *Falstaff* was very much a "socially produced" work.[11]

What is most significant about the performance indications in the authorized published score is the fact that two members of the La Scala orchestra, Gerolamo De Angelis and Giuseppe Magrini, were commissioned to edit the performance markings in the orchestral parts. Verdi knew of and sanctioned their participation, although he presumably held the right to modify their work and made suggestions of his own during rehearsal.[12] But clearly the comprehensiveness, rationalization, and plausibility of the performance markings were of prime importance in the definition of the authorized printed score.

The story of notational rationalization should thus not be accepted uncritically. Furthermore, it may lead to the belief that music history has always had the goal of precise performance specification, which was only imperfectly at-

tained in the earlier periods (this is something Adorno was perceptive enough to avoid). This belief may be precisely the reason some "historically informed" performers today might give for covering the performance part liberally with interpretative indications (whether playing from a modern Ur-text or a facsimile of an original source). But it is all too easy to assume that the "goal"—only imperfectly attained in each successive development in notation—was always the same, that composers from Machaut to Josquin to Monteverdi to Corelli to Bach to Mozart all desired (and performed with) the same variety of phrasings, attacks, crescendos, and diminuendos. Moreover, many earlier repertories might be distorted and undervalued if current rules of musical interpretation are applied, in the belief that they constitute a universal system of human expression. The story tends to support the concept of inexorable progress toward the perfected musical work, and, like all grand narratives, it often serves a purpose that is by no means innocent and universally valid.

The idea of the goal of a fully rationalized musical work also implies the notion of an end to the story. In many ways, this end might already have come and gone since tape music must represent something close to the point of ultimate saturation—the point at which both performer and notation can be dispensed with. The end of the story may thus be placed somewhere in the late 1950s, vividly symbolized by the demolition on January 30, 1959, of the Philips Pavilion at the Brussels World's Fair. Edgard Varèse's *Poème électronique* (1958), a masterpiece of *musique concrète*, had been composed to be played in the pavilion, ostensibly designed by Le Corbusier but largely realized by Iannis Xenakis. Sounding from around 325 speakers it was designed to be performed together with a two-minute interlude by Xenakis himself, continuously to successive groups of visitors. That Varèse saw his tape music as representing the ideal medium for a composer's supreme control over his music is suggested by his statement that "Anyone will be able to press a button to release the music exactly as the composer wrote it—exactly like opening a book."[13] However, Varèse was perhaps not so free of the intermediary of performance as his comment suggests; the piece was, after all, written with the simultaneously emerging building also in mind, and—more important—the sound engineers working on the site installed the sound equipment in accordance with the composer's instructions.[14]

Thus with the demolition of the pavilion there is a sense in which this most specific of musical works is rendered incomplete. As Marc Treib suggests:

> In [some] ways . . . the music no longer exists. Conceived and executed for a specific space, and perhaps more importantly, utilizing a specific sound system related to that space, no recorded performance today can equal the sounds experienced within the pavilion . . . no recording can conjure the space as well as the sound . . . Like the building, the full experience of the music can be described as demolished.[15]

This piece is also symptomatic of the breaking point in the story of increas-

ing compositional prescriptiveness in the sense that there were already, at the time of its creation, considerable cracks within its own intense individualization. For a start, it was part of a larger conception ultimately devised by Le Corbusier himself, a twentieth-century *Gesamtkunstwerk* involving architecture, visual display, music and an audience to be "digested" in the stomach-like interior of the pavilion at regular ten-minute intervals. Such were the contingencies of all these technologies in the 1950s that they could not be executed by a single figure: Le Corbusier delegated much of the architectural responsibility to Xenakis; much of the execution and eventual design of the building was in the hands of the builder who had particular experience in concrete structures; Le Corbusier's ideas for the visual display were remodeled and executed by Philippe Agostini; and Varèse (Le Corbusier's personal choice, in opposition to the plans of the Philips Corporation) worked independently, under the sole injunction to provide precisely eight minutes of music to match the length of the visual display. In other words, the work as a whole shows a resistance to the supreme rationalization that Varèse seems to have prized so highly.

There were many other signs of this "decline" in the rational control of musical composition during the 1950s onward. For instance, this period of the strictest serialism was also the time of aleatoric music, where within certain parameters the performer had free rein to determine the course of events (or rather, often left them to chance). The end of the story may also lie in the irony that works exhibiting the strictest serialism sounded, to a horrifyingly large number of experienced listeners, no different in kind from those that were the product of chance. With the demise of tape music and the development toward computers there has been a tendency to return to the sense of a live performance by allowing for more chance factors or spontaneous decisions, and by involving performers to a greater degree in the interpretation of the music. In other words, whatever we might think of its validity in the course of Western music history before the 1950s, the story of increasing notational control has definitely come to an end.

The seeming obviousness of the story might be conditioned by the specific experiences of those concerned in musical production, thought, and scholarship, for whom the ever more precise conventions of notation must be extremely noticeable and, consequently, influential. Umberto Eco, writing outside the music profession, sees the history of music — as of Western culture in general — as working in precisely the opposite direction to that theorized by Weber and Adorno, from more restricted possibilities of meaning and interpretation to increasing openness, culminating in the "work in movement" of the twentieth century. Musical works (precisely those from the 1950s by Stockhausen, Berio, Pousseur, and Boulez) allowing — indeed demanding — the complicity of the performer in their constitution and interpretation are his prime examples of the "open work."[16] Rather than seeing these as a definite break with the tradition of increasing authorial control, as I have so far sug-

gested, Eco sees this stage as the culmination of a long historical progression, one that mirrors changes in the sciences and the prevailing world view. While writings of the Middle Ages admit multiple meanings, by the interpretative standards of the day, these meanings are far from being indefinite or infinite and, indeed, are governed by an extremely authoritarian system.[17] In the baroque era, Eco observes a move away from the "static and unquestionable definitiveness of the classical Renaissance form"; its visual art "induces the spectator to shift his position continuously in order to see the work in constantly new aspects, as if it were in a state of perpetual transformation."[18] Here the observer is actively encouraged to play a part in the creation and understanding of the work. Nevertheless, even this activity was, to a certain degree, governed by convention, and Eco sees a further emancipation with the notion of "pure poetry" developing toward the necessary vagueness and infinite suggestiveness of Mallarmé and the openness of Kafka and Joyce.[19] Eco even sees the strictly serial works of Webern as more open than their predecessors, in the sense that there is a greater amount of "information" and hence, ambiguity, that such works present to the listener.[20] From here it is a small but significant step to the "work in movement," one where the performer (and, by extension, the listener) is required to organize and order certain aspects of the musical discourse.

Eco's macroscopic view of art history may provide a useful foil to the local history of musical performance and its notation, but he might be too facile in directly equating the variability in meaning of an art work with the range of interpretative choices open to the musical performer. By separating the concept of openness of meaning from openness of performance options, we might be able to see them not as unaccountably contradicting one another but as part of a reactive process. Thus the increasing precision of notation may be one of the means musical institutions and composers developed to counteract fear of the increasing openness of artistic meaning; what cannot be fixed in the abstract—indeed what may seem to be increasingly out of control—can perhaps be more closely defined in the particular, notated details. After all, the concept of an individual genius producing individualized musical works brings with it the contradictory notions of exquisite specificity and infinite potential for meaning. Thus we might perhaps consider the extreme specificity of much twentieth-century notation as part of a last-chance effort to preserve the identity of a musical work from the threat—indeed the inevitability—of indeterminacy.

If this is indeed the case, then perhaps we should be wary of equating the increasing complexity of notation purely with the technicalities of performance, something that seems substantiated by the variability of recorded evidence. In other words, the notation of performance details may have a function over and above (and occasionally contrary to) the simple prescription of actual, practical performance. This thought will underlie much of the remain-

der of this essay. I will examine several possible relations between notation and performance—alternative "stories"—that are undervalued by the "story" of notational progress, working toward the general point that we should be wary of treating notation as it has so often come to be regarded in the late twentieth century—namely, as a transparent recipe for performance, one that is almost interchangeable with performance itself.

My first alternative account of the historical relation between notation and performance—not a "story" as such—briefly considers some cases that the first model would tend to undervalue, such as those in which the notation is *purposely* incomplete. Thus this is the case of a composer or scribe leaving details imprecise not because he lacked the notational machinery but because certain details of the piece were variable from one performance to another; imprecision was thus a positive advantage. Here, then, there is not the desire to aim for the perfected, unique, and definitive work, even if, as Adorno would have been quick to point out, there were signs of a unifying rationality within the compositional fabric. Most obvious is perhaps the notion of the figured (or, more often than not, unfigured) bass of the baroque era, something that implies both a standard of harmonic correctness in realization and a supreme adaptability to performing circumstances and the style to be projected. We should note the implications of a handbook such as Niedt's *Musicalische Handleitung zur Variation*, in which a whole suite of pieces (from prelude to gigue) can be generated in notation or performance from a single bass line.[21] With such a supremely practical theory as figured bass—spanning as it does the disciplines of composition and performance—one can readily see how flimsy is the notion of an individualized piece. With one seeming flick of the interpretative switch, that which seems essential to one piece (its bass line and implied chords) can become the basis for an apparently new piece.

One interesting, yet contentious, case of purposely incomplete notation is the issue of musica ficta and recta, particularly in music of the fifteenth and sixteenth centuries. In this era, if we are to believe Reinhard Strohm, there really was a move toward authorial distinction and the perfection of individual works.[22] Yet many significant local inflections of pitch were left unnotated. The degree to which each performing community made consistent choices from the general conventions of musica ficta is moot.[23] As Anthony Newcomb remarks, in an examination of lute intabulations chronologically close to original motets by Gombert, "the . . . variety of possible behavior seems to have been a source of delight rather than dismay . . . Perhaps the process of devising a way out of these puzzle-passages was itself considered a source of delight, another intellectual game for the members of academies of the time, and a test of a musician's *virtù*."[24] Perhaps Margaret Bent's analogy between the application of unnotated accidentals and the conventions of figured bass in the baroque era is useful in alluding to a variable practice with its boundaries of correctness.[25] In fact, the paucity of the notation was doubtless useful, in al-

lowing adaptability between variable performance circumstances, rather than frustratingly ambiguous.

Another area in which notation may have been left purposely vague or at least plain was Italian opera from its inception until well into the nineteenth century. The musical text was often prepared extemely quickly and may have gone through as many versions as there are productions (if not performances). The notation thus had to be designed from the outset with adaptability in mind.[26] Moreover, many elements of performance, most notably the singer's ornamentation, would have been determined by the individual performer and were thus redundant in the notation.

Mozart's notation, however, often looks highly developed and very specific regarding details of ornamentation and expression. Nevertheless, it is increasingly emerging that much of Mozart's operatic writing was conceived with particular singers in mind, that to him his skill lay in making "an aria to fit the singer like a well-made garment,"[27] rather than in creating fixed sequences of immutable arias.[28]

These examples lead to another, more complex, conception of notation, one in which the notation may look detailed and often prescriptive (particularly in a modern, scholarly edition), but where, in fact, it represents only one of several versions of the piece. The piece, as it stands in a "Fassung letzter Hand," may represent only the performing situation for the final version, the ghosts of the performers for whom it was refashioned masquerading in the light of later reception as the composer's ultimate intention. Thus detailed notation, complete with many refinements relating to performance, does not automatically suggest a work that was conceived as a perfect whole from the start, however much it may be co-opted by the ideology of the supremely controlling composer: "In as dynamic a form as early nineteenth-century Italian opera, it is almost always impossible to isolate . . . self-contained categories of authorial intention."[29] As Roger Parker goes on to state, with regard to Donizetti,

> it is rare that one can call any version of a Donizetti opera the "finished" work. One has the impression that most operas were simply suspended, awaiting new revivals, new performers to reanimate the composer's creative faculties. Only with his disablement and death does the story reach a first conclusion; an unequivocal barrier.[30]

There is a further subset of the category in which the notation presents only one possible version of the piece. In this the notation does, in fact, offer precise performance directives, but perhaps with no single performer in mind, and rather by way of example than prescription. Here the danger of applying anachronistic notions of the perfected, immutable work is particularly acute. One prime example might be Monteverdi's sample realization of the vocal part to "Possente spirto" in the commemorative publication of his opera *Orfeo* (1607). Modern singers may often admit that they will follow this version because they

cannot ornament so well themselves, but they would be mistaken to think that Monteverdi's suggestions should be followed to the letter because the composer wished it to go no other way: "The florid version provided by Monteverdi indicated to the singer that the aria was one that required ornamentation, and furnished a model, though one which the singer was by no means bound to follow."[31] Indeed, some seventeenth-century composers offering elaborated versions of simple lines often seem positively embarrassed by their suggestions, which encroached, as it were, on the territory of the performing experts. Michael Praetorius refers to his remarkably sophisticated diminutions in *Polyhumnia caduceatrix* (1619) as if he were merely adding a fashionable accessory.[32]

Many accept that Corelli's ornaments in the Amsterdam publication (1710) of his Violin Sonatas, op. 5 (1700), are examples rather than hard-and-fast prescriptions.[33] However, much the same could be claimed of Mozart's solo piano lines. As Robert Levin reminds us: "Mozart's virtuosity as a pianist was prized above his composing, and his abilities as an improviser stood above both in the public's esteem."[34] To Levin, Mozart's variants of rondo themes "provide invaluable examples of spontaneity captured on the page."[35] He lists several situations that seem to call for elaboration in Mozart's scores.[36] Perhaps Mozart considered different components within a piece to have a different level of "fixity"; as Wye J. Allenbrook suggests, the development sections of concertos — consisting mainly of arpeggios — may represent a specific arena of improvisation, something that belies the entire notion of classical "development."[37]

Another contentious case of the possible ornamentation or alteration of notated lines concerns the lieder of Schubert. As Walther Dürr has noted, Johann Michael Vogl was well known for his free alterations of Schubert's lieder and even induced the composer to make notational changes.[38] While there was sometimes "friendly controversy" between singer and composer, Dürr believes that most disputes would have concerned not whether improvised embellishments were permitted but where they should be applied. So central does Dürr see Vogl's performing versions to the Schubert tradition that he sanctions their inclusion in the appendices of the *New Schubert Edition*. They are not to be reproduced literally in performance, but rather present a model of improvised, "nonessential" alterations.

By positing a distinction (still used in Schubert's day) between the categories of "wesentliche" (essential, indicated by the composer) and "willkürliche" (nonessential, the province of the performer) ornaments, Dürr can allow Schubert's notated works to survive in their individualized glory.[39] Yet by suggesting that Schubert was actually influenced by Vogl's ornaments, he seems to admit that what is by nature inessential, can influence the essential; the "work itself" preserved in the main text of the new edition is perhaps not as impervious to the variations of the appendix as Dürr would like to admit. David Montgomery, fighting a rearguard action, considers things to have gone too far in Schubert performance:[40] he admonishes historical performers for

deviations from the text (including most forms of rubato), and he summarily dismisses Schubert's relationship with Vogl—"it seems most likely that he merely tolerated Vogl's liberties because the singer was an important advocate for his music."[41]

In all, it is hardly surprising that the notion that Mozart's notation might be incomplete and that some apparently "finished" passages in both Mozart and Schubert might have been varied have met with far more resistance than have similar suggestions regarding Corelli.[42] This music as it is notated has simply acquired too privileged a place in Western culture for it to be considered in any way mutable. Mozart's identity as a virtuoso performer has been subsumed by his expanding posthumous identity as a composer, a composer with the authoritarian persona of Wagner, late Verdi, or even Stravinsky. It is indeed difficult to grapple with the received view of these pieces as eternally fixed and "classical"; the more one allows the music to be varied, the more the very essence of what makes this music so supremely admired is destroyed. Yet while the undefiled notation may have been essential for the survival of such music, it may also contain the echo of Mozart the dazzling performer or of Schubert's "friendly controversies" with Vogl. Even without necessarily changing one note, the score can be considered as much the record or echo of performative acts and dialogues as the blueprint of a "work."

In all, there is no particular sense of historical progress in all these categories of notation that is purposely incomplete or provided by way of example. Indeed diverse historical periods may have several points in common. The challenge to understand the relation between the notation and the musical practices with which it was associated is as present in the fields of Mozart performance and nineteenth-century Italian opera as it is in those of musica ficta and continuo realization.

A third approach to the history of notation is, to some degree, the opposite of the first, which tended to see notation as the starting point and controling manifestation of the work and, consequently, the prescription for future performance. In this case, then, the notation comes as a *result* of a performing tradition. Even if it is meant to prescribe later performance, the history of how it got that way is surely significant. This type of notation surfaces even in a composer as late as Messiaen. One of his most refined and notationally complex organ works is the *Messe de la Pentecôte* (1951). According to the composer himself, this was the product of over twenty years of improvising at the church of Sainte Trinité and the energy expended on its notated composition was such that the composer ceased to improvise for several years subsequently.

[My] improvisations went on for a rather long time, until the day I realized they were tiring me out, that I was emptying all my substance into them. So I wrote my *Messe de la Pentecôte*, which is the summation of all my previous improvisations. *Messe de la Pentecôte* was followed by *Livre d'orgue*, which is a more thought-out work. After that, as it were, I ceased to improvise.[43]

This seems to be the classic modernist dilemma of a composer achieving such a perfection and abstraction on paper that his creative urges as a performer were effectively stunted. This work might represent the ultimate clash between the final chapter of the usual story of notational progress with a tradition that allowed more fluid interplay between composition and performance.

There is an increasing number of studies of music before 1500 showing that notation can come not only at the end of the compositional process rather than the beginning, but also after a considerable number of memorized performances have taken place. With the researches of Helmut Hucke and Leo Treitler, most agree that the Gregorian repertory was stabilized in memorized performance before it was notated, and that when notation first came into use, the activities of remembering, improvising, and reading continued side by side. According to Hucke, "the propagation of Gregorian chant in the Empire and the distribution of manuscripts with neumes are not the same phenomenon; they represent two different stages in the spread of chant."[44] As Treitler shows with regard to the Old Roman tradition, notational variants reflect variants that already existed in the improvisatory system.[45] Early notation was always conceived as a matter of choice, not through ignorance, carelessness, lack of skill, primitiveness, or underdevelopment. The notation often provides more information for music that was less familiar to the original performers, resorting to a less informative system for the more familiar aspects of the repertory; it would also serve musicians who were not well versed in the tradition.[46]

Craig Wright has proposed that much of the early polyphonic repertory of Notre Dame was performed without notation because there is a total absence of sources (and of references to them) before 1230.[47] Anna Maria Busse Berger has gone a long way toward substantiating this view. She stresses the importance of memory in general education and particularly in the art of verbal composition, and notes the proximity of literate Parisians of the age, who extolled the virtues of memory.[48] Rather than excusing the cross-references and citations between works in the Notre Dame repertory, she suggests that reference and citation, when done consciously, was a positive virtue in literary composition (where one was encouraged to draw on a large memorized "warehouse of wisdom"). Not only performance, then, but composition itself was intimately connected with memory, the art of invention being the compiling of a collection from one's memory archive. If the end result was written down, this was usually done by dictation (i.e., not by the author) and the product was by no means a finished, immutable piece of music.

These findings suggest that we should not compare sources in order to discern a single, authentic, original that was written down with the direct sanction of the composer. Not only is the notion of "composer" itself rendered more complex in a culture that prides itself on the borrowing and adapting of models, but we should be wary of viewing the notation as the ideal embodiment of a piece. We should, rather, see it as a mnemonic aid and work back-

ward toward an original that existed only in the minds of its original performers and composers.

Rob Wegman has attempted to highlight the specific era, around 1500, during which the distinction became possible between composition as an object and improvisation as a practice.[49] He notes that before this time, performable pieces of music were conceived primarily in terms of event rather than object.[50] Fifteenth-century notation does not necessarily reflect the compositional status of the piece; it serves the purely utilitarian purpose of providing instructions for performing counterpoint and it does not necessarily represent a compositional conception.

As compositions were conceived more as notated objects—a notion Wegman observes as spreading to the general consciousness during the sixteenth century—composers developed increasingly esoteric notation in order to preserve a sense of secrecy, professional demarcation, and protection.[51] However, as I will emphasize later, the recognition of the profession of composer from the last decades of the fifteenth century, a recognition that depends on the notated *res facta*, does not automatically imply that such notation contains precise and limiting directions for the performer; it took on something of a life of its own, obliquely to its function of providing instructions for the performer. Performers, on the other hand, continued to improvise at all degrees of the spectrum of compositional refinement, and, in some locations, were still memorizing enormous liturgical repertories well into the seventeenth century.[52]

My fourth, and final, approach—perhaps the most contentious—draws on all the other approaches but focuses on those cases in which the notation reflects a work that is generally regarded as "complete," in some respect, on paper, but in which the composer in fact allowed, expected, or himself made deviations in performance. This is to be distinguished from the category in which the composer produced an exemplary notation that the performer could alter at will, in that a certain perfection or "finish" was expected in the notation of the music for its own sake, while its performance entailed a different set of conventions, which may, at times, have gone against the perfection of the notated music.

Rob Wegman makes this notion explicit for the notation of Renaissance polyphony: "the notion of contrapuntal 'correctness' . . . may have more relevance on paper than in the actual practice of extemporizing counterpoint (and hence perhaps more to us than to many singers and listeners in the Middle Ages)."[53] Contrapuntal correctness on paper may itself be a symptom of the newfound primacy that the sixteenth century gave to that which was written, the "male principle of language," according to Michel Foucault.[54] It may well have been accepted in the music profession that the "sounds made by voices provide no more than a transitory and precarious translation of it."[55] Perhaps the most significant example of this distinction between what is written and what is heard in performance is the choral music of Palestrina, in

which the notation presents a refined and perfected treatment of dissonance, line, and rhythm (one that has become the paradigm for contrapuntal study). However, there is considerable evidence to suggest that in performance some — if not all — singers improvised around these lines, often negating the contrapuntal "perfection." Graham Dixon draws attention to the numerous primers in vocal ornamentation in the late sixteenth century, Bovicelli, for example, providing a lavishly ornamented version of Palestrina's *Benedicta sit sancta Trinitas* in 1594, the year of the composer's death. Furthermore, one of the leading exponents of vocal ornamentation, Giovanni Luca Conforti, was himself a member of the papal chapel.[56]

Conforti's ornament treatise *Breve et facile maniera d'essercitarsi* is designed to provide (with less than two months work!) the novice singer with the skill a famous singer might have acquired through practice and years of listening to his peers. Conforti hardly ventures into the laws of counterpoint (although, as the title suggests, he does seem to wish to give the reader skills for basic ornamented — but presumably unnotated — composition). Knowledge of the correct consonants on which passage work can be inserted is apparently not necessary, and Conforti merely marks with an X those passages that work over suitable consonances.[57] The method is formulaic in the extreme: those who wish to insert runs need only decide which notes to ornament and then look for ornaments for similar pitches and note values in Conforti's systematic examples (treating, as they do, each ascending and descending interval in turn with countless examples in a wide range of note values). The only rule the singer is exhorted to follow is that dictated by the ear.

Much of Dixon's view of Palestrina performance rests on the assumption that most of his music was sung with single voices, thus enabling singers to perform embellishments with relatively little danger of ungainly clashes. Noel O'Regan has somewhat modified this view by showing that many parts of the mass ordinary were sung with more than one voice to a part, solos being reserved for particular sections. He points to an extremely varied and flexible practice for the performance of non-concertato music: multiple voices for four- to six-voice ordinaries and some motets; single voices for the divided choirs of polychoral music; one-per-part singing for trios and quartets in masses, some motets, hymns, and magnificats.[58] O'Regen also notes that Dixon fails to see the connection between the practice of ornamentation and another — often ignored — practice of performing motets: that in which one or more parts are abstracted from polyphonic motets with the organ substituting for the missing voices. This was accepted practice in Rome long before Viadana's famous publication of sacred concertos in 1600.

While there is no consensus as to what degree of ornamentation was practiced in polyphonic performance of the music of Palestrina and his contemporaries, ornamented performance with organ was clearly an acceptable manner of performance at the time.[59] Furthermore, given such group impro-

visatory practices as *contrappunte al mente*, which were regularly applied to of-
fertory chants and magnificat antiphons,[60] it may not necessarily be the case
that the hypothesis for ornamented performance relies on the assumption of
one-per-part performance. If Palestrina's motets were embellished almost to
the point of being unrecognizable in the versions with organ accompaniment,
the possibility of simultaneous heterophonic embellishment might not seem
so extreme. Certainly Conforti's elaborations of psalm formulae in his *Salmi
passagiati* (1601) and *Passagi sopra tutti li salmi* (1607) suggest that austerity
was not a feature of even the simplest liturgical genres.

In short, it seems that much of the supreme refinement of Palestrina's com-
positional technique was designed more for the eye than for the ear and that
only to reactionary contemporaries such as Artusi did the eye version become
mandatory for the ear; this is the view of Palestrina that has taken hold through-
out most of his subsequent reception. The distinction between compositional
practice and performance at the time of Palestrina can be inferred, somewhat
negatively, from Artusi's famous polemic against the imperfections of modern
music. Artusi suggests that some of the small *accento* ornaments that modern
composers introduce into their music have arisen because "singers do not sing
what is written, but 'carry the voice,' sustaining it in such a way that, when they
perceive that it is about to produce some bad effect, they divert it elsewhere,
carrying it to a place where they think it will not offend the ear."[61] The ear has
been corrupted by sensuous excess, so that it has become acceptable for com-
posers to write music incorporating various "barbarisms."

There are several other examples in music history of music that, in its no-
tated form, has—or has acquired—a particular "purity" that was violated in
its early performance. Corelli provides an interesting parallel to Palestrina, a
century or so later. We can be as certain as possible that Corelli produced
Dionysian performances of at least the slow movements of his violin sonatas.
What is fascinating about the comparison between the original edition of 1700
and ornamented versions in the 1710 print is that the "plain" version does not
look incomplete and contains its own logic of sequence and motivic consis-
tency; the ornamented versions often undo the "finish" by obscuring the
melodic sequences and subverting the supreme rationality of the texture with
unpredictable, irrationally divided runs.

Nevertheless, Corelli's reputation (at least as it stretches into the nine-
teenth and twentieth centuries) has been made not through his performance
but through his notation, a notation that, like Palestrina's, is unusually Apol-
lonian, implying beautifully finished, sonorous pieces of music. The Apollon-
ian view was evidently an "authentic" view of the age, one epitomized by
Roger North's comment of 1728 that "Upon the bare view of the print any one
would wonder how so much vermin could creep into the work of such a mas-
ter . . . Judicious architects abominate any thing of imbroidery upon a struc-
ture that is to appear great, and trifling about an harmonious composition is

no less absurd."[62] It is this view that has most strongly colored Corelli's subsequent reception, one that would prefer to ignore the seeming contradiction between Corelli the Apollonian composer and Corelli the Dionysian performer.

One final example of a composer obsessed with notational perfection, which he may disregard in performance, is provided again by Olivier Messiaen with a piece such as the "Introit" to the *Messe de la Pentecôte*. Here the rhythmic notation is particularly complex and esoteric, apparently the fruit of twenty years of improvisation (as discussed above). In performance of the "Introit," though, the composer seems to have "reverted" to the improvisational mode, largely ignoring the letter of the rhythmic notation.[63] Why then did he not notate the piece in simple values, with a rubric along the lines of "molto rubato"? Presumably because it was the "look" of the piece that counted; it had a particular identity on paper, which—at least to the composer—was not to be followed literally in performance.

The ultimate significance of this final category—notation that is "complete" for its own sake and that is not necessarily to be followed literally in performance—is that it can be applied to many more repertories and compositional styles; indeed, it should perhaps be tested, at least, for virtually any music we encounter. To what extent did each composer take delight in the composition and notation of the music on paper and to what extent was this independent of the practicalities of performance? In Palestrina's era this may have had something to do with a perfected theoretical system of dissonance that could be realized on paper. At the turn of the twentieth century it might have had more to do with details of performance marking, rendering—as it were—the piece more individualized on paper, more precisely defined for copyright purposes. This move was facilitated, if not necessitated, by the number of markings available and the improving technologies of notational reproduction. My approach is thus an antidote to perhaps the most significant change in the history of performance—the mass production of recording and broadcasting that has become ubiquitous since World War II. Only in this age, I contest, has it been possible for performance virtually to reduplicate notation and vice versa; only in this period has exact compliance with notation been widely seen as a virtue, since it is the first time that such a notion has become truly verifiable.

NOTES

1. Robert Philip, *Early Recordings and Musical Style* (Cambridge: Cambridge University Press, 1992), 231.

2. Theodor W. Adorno, "Über den Fetischcharakter in der Musik und die Regression des Hörens" (1938). Translation from Max Paddison, *Adorno's Aesthetics of Music* (Cambridge: Cambridge University Press, 1993), 200.

3. See, for instance, Carl Dahlhaus, *The Idea of Absolute Music*, trans. Roger Lustig (Chicago: University of Chicago Press, 1989); and Lydia Goehr, *The Imaginary Museum of Musical Works* (Oxford: Oxford University Press, 1992).

4. José A. Bowen, "The Conductor and the Score: The Relationship between Interpreter and Text in the Generation of Mendelssohn, Berlioz and Wagner" (Ph.D. diss., Stanford University, 1993).

5. A version of this story is given in James Grier, *The Critical Editing of Music* (Cambridge: Cambridge University Press, 1996), 119–20.

6. Max Weber, *Die rationalen und sozialen Grundlagen der Musik*, appendix to *Wirtschaft und Gesellschaft* (1911, published Tübingen: J. C. B. Mohr, 1921). English translation: *The Rational and Social Foundations of Music*, ed. and trans. Don Martindale, Johannes Riedel, and Gertrude Neuwirth (Carbondale: Southern Illinois University Press, 1958).

7. Paddison, *Adorno's Aesthetics*, 192–97, quotation on 195.

8. See John Butt, *Bach Interpretation* (Cambridge: Cambridge University Press, 1990), esp. 81–83.

9. See Roger Parker, "A Donizetti Critical Edition in the Postmodern World," in *L'Opera Teatrale di Gaetano Donizetti—Proceedings of the International Conference on the Operas of Gaetano Donezetti, Bergamo, 1992*, ed. Francesco Bellotto (Bergamo: Comune di Bergamo, Assessorato allo Spettacolo, 1993); and especially Rebecca Harris-Warrick, "The Parisian Sources of Donizetti's French Operas: The Case of *La Favorite*," in Bellotto, *L'Opera Teatrale*. Parker and Harris-Warrick suggest that singers in Donizetti did mark their parts with ornaments and cadenzas but that the instrumentalists marked nothing of musical importance.

10. Philip, *Early Recordings*, 180.

11. James Hepokoski, "Overriding the Autograph Score: The Problem of Textual Authority in Verdi's 'Falstaff,'" *Studi Verdiani* 8 (1992): 15.

12. Ibid., 18–29.

13. Marc Treib, *Space Calculated in Seconds: The Philips Pavilion—Le Corbusier—Edgard Varèse* (Princeton: Princeton University Press, 1996), 176.

14. Ibid., 197.

15. Ibid., 211.

16. Umberto Eco, *Opera aperta* (Milan: Bompiani, 1962), translated, with additional chapters, by Anna Cancogni with an introduction by David Robey, as *The Open Work* (Cambridge, Mass.: Harvard University Press, 1989), 1–2.

17. Ibid., 5–7.

18. Ibid., 7.

19. Ibid., 7–11.

20. Ibid., 62–63, 95–96.

21. Part 2 (1721) of *The Musical Guide*, trans. and ed. by Pamela L. Poulin and Irmgard C. Taylor (Oxford: Oxford University Press, 1989); see esp. 155–78.

22. Reinhard Strohm, *The Rise of European Music 1380–1500* (Cambridge: Cambridge University Press, 1993), esp. 1–10.

23. For a summary of the issues, see Karol Berger, "Musica Ficta," in *Performance Practice: Music before 1600*, ed. Howard Mayer Brown and Stanley Sadie (New York and London: W. W. Norton, 1989).

24. Anthony Newcomb, "Unnotated Accidentals in the Music of the Post-Josquin Generation: Mainly on the Example of Gombert's First Book of Motets for Four Voices," in *Music in Renaissance Cities and Courts: Studies in Honor of Lewis Lockwood*, ed. Jessie Ann Owens and Anthony M. Cummings (Michigan: Harmonie Park Press, 1977), 225.

25. Margaret Bent, "Musica Recta and Musica Ficta," *Musica Disciplina* 26 (1972): 73–100, esp. 74.

26. See Ellen Rosand, *Opera in Seventeenth-Century Venice: The Creation of a Genre* (Berkeley and Los Angeles: University of California Press, 1991); and Philip Gos-

sett, "Gioachino Rossini and the Conventions of Composition," *Acta Musicologica* 42 (1970): 48–58.

27. Letter of February 28, 1778, quoted in Patricia Lewy Gidwitz, "'Ich bin die erste Sängerin': Vocal Profiles of Two Mozart Sopranos," *Early Music* 19 (1991): 566.

28. See Daniel Heartz, discussion (582–83) concluding Alessandra Campana, "Mozart's Italian *buffo* Singers," *Early Music* 19 (1991): 580–83. For a later example, see Mary Ann Smart, "The Lost Voice of Rosine Stoltz," *Cambridge Opera Journal* 6 (1994): 31–50, esp. 48–50, where she suggests that something of Stoltz's voice remains in Donizetti's notation of her role in *La favorite*.

29. Parker, "A Donizetti Critical Edition," 63.

30. Ibid., 64.

31. John Whenham, *Claudio Monteverdi—Orfeo* (Cambridge: Cambridge University Press, 1986), 69. It might also be possible that Monteverdi was writing down what he recalled from Francesco Rasi's original performance of the role.

32. John Butt, *Music Education and the Art of Performance in the German Baroque* (Cambridge: Cambridge University Press, 1994), 161. See also p. 153 for a similar case.

33. See Neal Zaslaw, "Ornaments for Corelli's Violin Sonatas, op. 5," *Early Music* 24 (1996): 95–115; see esp. 109.

34. Robert D. Levin, "Improvised Embellishments in Mozart's Keyboard Sonatas," *Early Music* 20 (1993): 221.

35. Ibid., 224.

36. Ibid., 230–33.

37. Wye J. Allenbrook, personal communication.

38. Walther Dürr, "Schubert and Johann Michael Vogl: A Reappraisal," *19th-Century Music* 3 (1979): 126–40.

39. Ibid., 127.

40. David Montgomery, "Modern Schubert Interpretation in the Light of the Pedagogical Sources of His Day," *Early Music* 25 (1997): 101–18.

41. Ibid., 104.

42. See also Friedrich Neumann, *Ornamentation and Improvisation in Mozart* (Princeton: Princeton University Press, 1986).

43. Claude Samuel, *Music and Color: Conversations with Claude Samuel/Olivier Messiaen* (1986), trans. E. Thomas Glasow (Portland: Amadeus Press, 1994), 25.

44. Helmut Hucke, "Towards a New Historical View of Gregorian Chant," *Journal of the American Musicological Society* 33 (1980): 437–67, esp. 447.

45. Leo Treitler, "The 'Unwritten' and 'Written' Transmission of Medieval Chant and the Start-up of Musical Notation," *Journal of Musicology* 10 (1992): 131–91.

46. Leo Treitler, "The Early History of Music Writing in the West," *Journal of the American Musicological Society* 35 (1982): 237–79, esp. 261.

47. Craig Wright, *Music and Ceremony at Notre Dame of Paris, 500–1550* (Cambridge: Cambridge University Press, 1989), 333–34.

48. Anna Maria Busse Berger, "Mnemotechnics and Notre Dame Polyphony," *Journal of Musicology* 14 (1996): 263–98, esp. 269; see also her "Die Rolle der Mündlichkeit in der Komposition der Notre Dame Polyphonie," *Das Mittelalter* 1 (1998): 127–43.

49. Rob C. Wegman, "From Maker to Composer; Improvisation and Musical Authorship in the Low Countries, 1450–1500," *Journal of the American Musicological Society* 49 (1996): 409–79.

50. Ibid., 434.

51. Ibid., 470.

52. See Wright, *Music and Ceremony at Notre Dame*, 328, for a reference to memorization at Notre Dame in 1662.

53. Wegman, "From Maker to Composer," 450.

54. Michel Foucault, *The Order of Things: An Archaeology of the Human Sciences* (New York: Vintage Books, 1970), 38–39.

55. Ibid., 38.

56. Graham Dixon, "The Performance of Palestrina: Some Questions, but Fewer Answers," *Early Music* 22 (1994): 667–57, esp. 672.

57. Giovanni Luca Conforti, *Breve et facile maniera d'essercitarsi* (Rome, 1593).

58. Noel O'Regen, "The Performance of Palestrina: Some Further Observations," *Early Music* 24 (1996): 144–54, esp. 149.

59. Ibid., 151.

60. Dixon, "The Performance of Palestrina," 672.

61. Oliver Strunk, *Source Readings in Music History*, vol. 3, *The Baroque Era* (London and Boston: Faber and Faber, 1952–1981), 39.

62. Quoted from Zaslaw, "Ornaments for Corelli's Violin Sonatas," 103.

63. *Messiaen par lui-même*, EMI Classics CDZD 7 67400 2 (1992), *Messe de la Pentecôte* recorded in 1950.

III. Re-Enactments

9. The Ambivalent Triumph: Corpus Christi in Colonial Cusco, Peru

"Be like *us*." The goal pursued is the spread of a hegemonic dis-ease. Don't be *us*, this self-explanatory motto warns. Just be "like" and bear the chameleon's fate, never infesting *us* but only yourself, spending your days muting, putting on/taking off glasses, trying to please all and always at odds with myself who is no self at all. —Trinh T. Minh-ha

FOLLOWING THE Spanish occupation of the Andean city of Cusco—the political and religious center of the Inka empire—in the early sixteenth century, the prolonged, often painful and certainly perverse process of transculturation began.[1] Spaniards attempted to reproduce Iberian culture in their colonies so as to fashion the familiar out of the foreign. And yet, of course, *they* were the foreigners in the Andes. Those of European stock were well outnumbered by indigenous Andeans; the faces and dress of Cusco's citizens insisted on the non-European-ness of Cusco. The buildings of the colonial city in which the colonizers lived, resting uneasily as they did on the solid foundations of Inka masonry or constructed of stones sacked from Inka edifices, were architectonic reminders of the city's Andean heritage. Cusco thus cradled memories of the Inkaic era in its very substance—its citizenry and the materials of which it was built.

All major colonial public celebrations took place in the same plaza that had hosted Inka festivals in pre-Hispanic times. Although public festivities were organized by officials of European descent and were modeled after Spanish celebrations, they frequently incorporated indigenous performances, particularly native songs and dances. In fact, the exhibition of the pagan past became an essential aspect of colonial Christian festivals in Cusco. Thus, indigenous Christian Andeans were transformed into performative pagans for colonial-period celebrations in which their costumed bodies summoned memories of pre-Christian Inkaic times. The festive presence of "pagans" necessarily kept the native past alive in the colonial present. Although the Christian present and the pagan past, once performatively actualized, became inextricably intertwined, they never converged; in fact, in and through festival, the rifts between pagan and Christian, Andean and European, past and present, continually gaped like festering wounds in the colonial body politic.

Festive enactments of the unwritten Inka past inscribed Andean history through and within European performative modes. Framed by the Spanish, Christian festival, performed Inka history was thus created as much as commemorated. Like colonized Andeans themselves, the indigenous past was Europeanized in and through performance, but never became (nor could it become) European. Colonial performative culture, then, perforce enacted the coping strategies of the colonized who responded to the imperative that they be "like" but never *be* the Spanish, Christian colonizer. Recent critiques of postcolonial discourse, such as that by Trinh T. Minh-ha (quoted at the outset), have exposed and explored the ambivalences inherent in (post)colonial culture, particularly on those occasions in which the colonized and the colonizer met and failed to find in each other an affirmation of self. Public festivals in Cusco became particular occasions during which the successes and failures of religious conversion and acculturative efforts—what Trinh characterizes as the "hegemonic disease"—were exposed, debated, and, as we shall see, left forever, necessarily unresolved, for when Andean bodies performed their past, that past could be and was perceived as not only historic, but actual and present.

Spaniards in colonial Cusco commonly referred to Corpus Christi as the Catholic festival most frequently occasioning "paganist" survivals. In fact, several colonial sources suggest that the Inka's Inti Raymi (sun festival), which celebrated the June solstice and the Inka's patron deity, was evoked during Cusco's Corpus Christi through indigenous songs and dances. In colonial Cusco, the Catholic feast of Corpus Christi was the source of both civic pride and perturbation precisely because of the presence of subaltern performers. In part, this paper investigates why native Andeans were invited to perform indigeneity and how Andean festive practices were incorporated into Corpus Christi. Yet, "incorporated" implies absorption and that is not the case; "composited" is a more apt description, for Hispanic witnesses to Corpus Christi celebrations in Cusco quickly began to suspect that native performers were being covertly "idolatrous." That is, they realized that the Spanish Corpus Christi had failed to incorporate Andean bodies. Paradoxically, by insisting on the inclusion of performative difference (Andean costumes, songs, and dances), the colonizer ensured that Cusco's Corpus Christi would be an uncomfortable composite, which drew attention to the failure of their acculturative project. Thus, this paper will also consider the ways in which a performed past can profoundly unsettle the present and alter its trajectories.

The traditional festive format of Spain's Corpus Christi made room for the performance of alterity in the Andes and conditioned the meanings conveyed there. In fact, from its very inception, Corpus Christi, which celebrates the Roman Catholic doctrine of transubstantiation, has specifically incorporated references to non–Roman Catholic beliefs and, frequently, peoples. The Corpus Christi festival was initially instituted in thirteenth-century Europe to

affirm the doctrine, considered essential to the Roman Catholic faith, that held that Christ was embodied in the consecrated Eucharistic host. The festival was intended to counter heretical assertions that the Sacred Host was not the actual (i.e., transubstantiated) body of Christ.[2] In 1551, the Council of Trent (session 13, October 11) issued a decree characterizing the feast of Corpus Christi as a "triumph over heresy" and condemning anyone refusing to celebrate the Blessed Sacrament in procession.[3] Thus the festival was conceived as a joyous celebration of victory not only of the Christian god over sin and death, but of the Roman Catholic Church over heretics.

Saint Thomas Aquinas championed the then new festival of Corpus Christi, devising services that included a procession featuring the display of the host followed by a mystery play in which the doctrine of transubstantiation and its importance were explained. Throughout Europe, local celebratory customs were incorporated into Corpus Christi festivals and thus regional differences manifested themselves. The essential ingredient of Corpus Christi wherever it was celebrated was (and still is) the triumphal procession of the consecrated host through city or village streets.[4] The host was (and is) held in a monstrance —a receptacle designed to display the wafer for adoration. In its festive structure, the traditional celebratory form of Corpus Christi was that of a triumph —a joyous procession heralding a victor, in this case Christ, whose presence was (and is) summoned through transubstantiation into the Eucharistic host.

Spaniards were early celebrants of this "triumph over heresy." Corpus Christi was observed in Toledo in 1280 and Seville in 1282; both of these festivals antedate the Papal Bull of 1311 that made the feast mandatory.[5] Records of early festivals exist for Barcelona (1319) and Valencia (1348 or 1355) as well.[6] Corpus Christi grew to be one of the most important festivals celebrated on the Iberian peninsula in the early modern period. In Seville, for example, Corpus Christi became known as the "Thursday that shines brighter than the sun" (*Jueves que reluce más que el Sol*). In fact, Corpus Christi was frequently the measuring stick by which other festivals were evaluated.[7]

To evoke the "triumph over heresy" in the spirit of the Counter Reformation, most early modern Spanish Corpus Christi processions involved the representation of non-Christian elements over which Christ (in the form of the host) would symbolically triumph. While, according to church doctrine, Christ was actually present, his enemies were actualized through being performed. Sometimes Christ's opposition was in the form of a general symbolic reference to evil like the famous *tarasca*, the dragonlike serpent featured in the Corpus Christi processions of Madrid and other Spanish communities.[8] Not infrequently, however, references were made to historical and/or contemporary political triumphs involving non-Christian peoples. Spanish Christians, dressed as Moors, Arabs, or Turks, would attempt to impede the celebrations; they always failed, of course.[9] Famous battles were often represented by the celebrated *rocas* (or *roques*), processional carts, of Valencia and other

Iberian cities. In the seventeenth century, dancers dressed as Moors accompanied a cart constructed in memory of the capture of Valencia from its Islamic rulers in 1238. Another cart, dedicated to the Archangel Michael, commemorated the *reconquista* ("re-conquest") and was attended by a dance of the "infidels."[10]

The early modern Spanish Corpus Christi festival explicitly linked the state's political and military victories to divine triumphs. Divine will and royal will were inextricably intertwined in festive themes and forms. The Catholic monarchs even established a special endowment to help defray the costs of the Corpus Christi celebration in Granada, the last of the Moorish strongholds to fall to the Christians; a *cédula* of 1501 commanded that the people of that city celebrate the feast of Corpus Christi with "such great displays of happiness and contentment" that they would "seem as though they were crazy" (*la fiesta ha de ser tal e tan grande la alegría y contentamiento, que parezcais locos*).[11] The fervor with which one celebrated Corpus Christi in Granada and elsewhere in post-*reconquista* Spain was held to reflect one's fidelity not only to Christianity, but to the Spanish crown. Because the "defense" of Catholic Christianity legitimized offensive measures—that is, "conquest"—the triumph of the Corpus Christi was understood as the triumph of those who celebrated Corpus Christi. Many Spanish celebrations of this feast featured choreographed performances that were (and still are) militaristic in nature. Dancers often appeared as combatants; angels and demons, Samson and the Philistines, and Christians and Moors are just a few of the warring factions presented in early modern Spanish celebrations of Corpus Christi.

An oppositional framework encompassing both global and local politics structured the celebration of Corpus Christi everywhere it was observed. Celebrants were cast as victors, while those who did not revere the consecrated host were the absent, yet often performatively or symbolically present, vanquished. Thus, while promoting a sense of community among celebrants, Corpus Christi also occasioned suspicious regard of potential "enemy" elements within the local society. A regulation from 1468 in Murcia gave Jews and Moors in the street at the time of the procession, especially at the passing of the "body of Christ," two options: they could flee the streets and hide themselves, or kneel and demonstrate "due respect."[12]

These same Spaniards, who recognized the triumph of Corpus Christi as the triumph of the Spanish crown in southern Spain, are those who were, at the same period of time, introducing Corpus Christi to the Americas following its "conquest." Metonymically, through its precious metals for which it was first valued, America joined the Spanish Corpus Christi. Early in the sixteenth century, Queen Isabel had the monstrance that was to be used in the Corpus Christi procession in Toledo crafted from the first gold to reach Spain from the Indies.[13] Also fashioned from this "first gold that came from the Indies" was a processional cross for Seville.[14] In this way, the conquest of the

so-called New World was first integrated into a known pattern of historic confrontations with and triumphs over non-Christian peoples.

While gold symbolically summoned America's presence in early Corpus Christi celebrations in Spain, in the Spanish colonies indigenous people themselves joined in the triumph over heresy. In Cusco, Peru, for example, descendants of the Inka were prominent participants in colonial period celebrations of Corpus Christi. Indigenous dancers and musicians dressed in native regalia joined Andean parishioners and sodalities who paraded with their patron saints in festive configurations. In Spain, malleable American gold was fashioned into Christian emblems that were indistinguishable from those made of European metals; indigenous bodies in the Andes, however, were not so readily transformed into Spanish Christians. How, then, did Spanish colonizers understand indigenous performances in the context of their Corpus Christi festival?

Spaniards, confronting non-Christian religious beliefs and practices, distinguished between the means of celebration and the object being celebrated. One of the first Spaniards to observe that Andean religiosity was a good thing even if he decried the object of reverence, was the chronicler Bartolomé de Segovia (known as Cristóbal de Molina, el Almagrista). In April of 1535 he witnessed the Inka's harvest festival to the sun.[15] He concluded that,

> even though this [giving thanks to the sun for the harvest] is an abominable and detestable thing, because this festival honors that which was created rather than the Creator to whom gratitude was owed, *it makes a great example for understanding the thanks that we are obliged to give to God*, our true Lord, for the goods we have received, of that which we forget how much more do we owe.[16]

The chronicler thus valued the religiosity manifested in the Inka harvest festival and noted that it was not the giving of thanks to a supernatural being that was "wrong," but that the focus of worship was "misguided" from a Christian perspective.

Spaniards recognized the value of maintaining certain indigenous reverential behaviors in an effort to shift adoration from native supernaturals (celestial bodies, thunder and lightning, ancestors, geographically significant locations, and native shrines) to the Christian pantheon.[17] Spaniards did not necessarily find reference to pagan deities anathema, but used them to demonstrate the superiority of the Christian god; so too did they employ certain Andean religious practices.[18] *Constitución* 104 of the Council of Lima (1551–1772), for example, ordered that "pagan" seasonal festivals be refocused on temporally equivalent Christian celebrations. Significantly, Corpus Christi occurs just after the Andean autumnal harvest (May) and just prior to the June solstice.[19]

Sabine MacCormack, in her examination of the conversion effort in the sixteenth- and seventeenth-century Andes, notes that this practice of substituting Christian images and feasts for Andean ones was particularly problematic, as Spaniards could never be sure that the Christian god was the actual focus of

native reverential behaviors.[20] Nevertheless, Hispanic authorities attempted to refocus native religious practices very early in the colonial period. Garcilaso de la Vega, the son of a prominent Spaniard and an Inka noblewoman, writing about his childhood in Cusco, details the training of youth for the festival of Corpus Christi in the mid-sixteenth century.[21] He relates how the choirmaster of Cusco's cathedral composed a version of an Inkaic *haylli* (victory song) to be sung in honor of Corpus Christi by eight *mestizo* schoolboys who appeared dressed in Inkaic costume, each carrying a *chakitaklla* (the indigenous foot plow).[22] In pre-Hispanic times, an *haylli* was considered appropriate in celebrating both military victories and agricultural success (the victory over nature).[23] The choirmaster of Cusco thus coopted a portion of the native harvest ceremony by employing Christianized *mestizo* youth, with their plows, to replace "pagan" Inka (adult) elites who, in pre-Hispanic times, had performed an agricultural ceremony during the harvest festival.[24] The triumphal nature of the *haylli* meshed well with the triumphal nature of Corpus Christi. The conversion of an Inka *haylli* performed by youth in the costume of agricultural laborers was a purposeful manipulation of Andean harvest festive practices; the malleable youngsters embodied both the conquest and the religious conversion of their native elders. Is it any wonder that, as Garcilaso states, Spanish witnesses to this reinvestment of indigenous practices with Christian meanings were "very pleased"?[25]

Garcilaso also indicates that Spaniards encouraged Andeans to don native regalia during Corpus Christi celebrations and states that the *casiques* (native leaders) from around Cusco were to wear

> all the decorations, ornaments and devices that they used in the time of the [Inka] kings for their great festivals . . . Some came dressed in lion skins [puma skins], as Hercules is depicted, with their heads in the lion's head, since they claim descent from this animal. Others had the wings of a very large bird called cuntur [condor] fixed on their shoulders, as angel's wings are in pictures . . . Similarly others came with painted devices, such as springs, rivers, lakes, mountains, heaths, and caves, from which they believed that their earliest forefathers had emerged. Others had strange devices and dresses of gold and silver foil, or carried wreaths of gold or silver, or appeared as monsters with horrifying masks, bearing in their hands the pelts of various animals they pretended to have caught, . . . With these things . . . the Indians used to celebrate their royal festivities; and in the same way in my time, with such additions as they were capable of, they used to mark the feast of the Blessed Sacrament, the true God, our Lord and Redeemer. This they did with great joy, like people now truly disillusioned about their former heathendom.[26]

Significantly, Garcilaso's description of indigenous costume displayed at Cusco's Corpus Christi festival is almost identical to this same author's description of the Inka's festival of Inti Raymi found in part one of his *Royal Commentaries*.[27] According to Garcilaso, Corpus Christi contained many of the same practices as Inti Raymi.[28] He further relates that, for the festival of Corpus

Christi, Andeans in Cusco sang native songs accompanied by flutes, drums, and tambourines, but that these songs were in praise of "Our Lord God."

The delight of an anonymous witness to the indigenous celebrations in Cusco of the beatification of Jesuit founder Ignatius Loyola in May of 1610, which included several refocused Andean acts, also demonstrates how readily Spaniards applauded the display of indigenous reverential performances within Christian contexts.[29] Since the festivities were held in May, they closely preceded Corpus Christi and so may well have featured many performances designed for the celebration of that holiday.[30] The parishioners of Santiago sang a song of pre-Hispanic origin about a bird highly revered by the natives (the curiquenque), whose black feathers were compared to the black habits of the Jesuits, and whose virtues (*probiedades buenas*) were compared to those of Ignatius. Pre-Hispanic songs sung the following day by the parishioners of the Hospital parish were likewise applied to Ignatius; further, these parishioners were greeted at the Jesuit church by members of the confraternity of the Christ child who brought out their statue of Jesus dressed in the costume of Inkaic royalty. On Saturday, the parishioners of San Blas evoked, in song, a famous battle of Inkaic times comparing Ignatius to a triumphant Andean war commander who was the hero of the battle. Similarly, the parishioners of San Jerónimo sung of the legendary victory of the Inka over the Chanka, an ancient rival, applying the words of triumph to Ignatius. The anonymous reporter (probably the Jesuit friar Bérnabe Cobo) lauded these "converted" Andean celebratory acts saying that they *confirmed* that the natives were devoted to Father Ignatius.[31] The commentary suggests that, because the object of veneration was Christian, such fairly unadulterated Andean celebratory forms were generally not considered "idolatrous," at least not in the early colonial period.

In early colonial Cusco there was also an attempt to "convert" the central celebratory space of the Inkaic city—the Inka's Aucaypata-Kusipata double plaza complex—into a sacred Christian space for the celebration of Catholic festivals, which included refocused Andean performances. The physical conversion of the plazas paralleled the colonizers' evangelical project. The Inka's Aucaypata became, in the colonial period, the Plaza Mayor or Plaza de Armas. Prior to the conquest, this space was the main square the Inka used for major events such as victory celebrations, the announcement of new rulers, and the culmination of festivals. The Inkaic Kusipata ("place of joy") became the post-conquest Plaza Regocijo ("plaza of joy or celebration").[32] The Hispanicization of the Kusipata involved more than a translation of its name, however. Nonplussed by the spaciousness of the Inkaic double plaza, the Spaniards resolved to restructure it by decreasing its dimensions and building edifices over the Watanay river, which separated the Kusipata from the Aucaypata.[33] Juan Polo de Ondegardo, magistrate of Cusco in the latter half of the sixteenth century, in his *relación* of 1571, refers to the alterations made to the plazas of Cusco

(specifically, the addition of four bridges over the Watanay river as well as the erection of the cathedral), saying, "The primary function [of these alterations] was to eliminate the great reverence [Indians] held for this plaza."[34] He explains that the central plaza of Cusco was revered not only by the Indians of Cusco, but by those living throughout the realm. Hispanicizing the appearance of the Inkaic double plaza, he argues, was a step in Hispanicizing and converting to Christianity not only Cusco, but all of the viceroyalty of Peru.[35]

It was (and is) in this Hispanicized space that Christian festivals such as Corpus Christi were (and are) held. Converting the space of Inka *raymis* (festivals) into a space for Corpus Christi and other Catholic feasts was a calculated adjunct to the resignification of the celebrations themselves. Once the space for worship and the focus of worship were Christianized, Spaniards hoped that *certain* indigenous reverential practices would be conducive to Christian worship. The selectivity they exercised in determining which reverential practices to encourage, if not require, is important in understanding how they attempted to regulate the performance of alterity on which they insisted.

Spanish authorities orchestrated Andean participation in Christian festivals and selected dances as the appropriate native element. Spaniards, owing to their own cultural conditioning, understood songs, dances, and festive costuming to be expressions of "joy." Viceroy Toledo, in his ordinances of 1573 (the fifth ordinance of Título 27), specified that the natives of each parish in Cusco would present two or three dances during the Corpus Christi festival in order to demonstrate their happiness.[36] In contrast, the Andean festive practice of ritualized drinking was never considered an "appropriate" celebratory behavior. In fact, Viceroy Toledo took care to prohibit those dances (*taquíes*) which he linked with drinking bouts (*borracheras*) in his ordinances for the natives of Charcas of 1575.[37]

What we see in Cusco's Corpus Christi festival, then, is the European notion of an abbreviated and subjected Andean *raymi*. Not surprisingly, the triumph of the Christian god over Andean religions was nowhere more manifest in Peru than on the site most associated with "pagan" Andean religion — the city of Cusco. The participation of Andeans in Cusco's celebration was thus, on one level, a performance of their own subjugation. Spaniards could, at least sometimes, understand Andean dances — indigenous expressions of "joy" — as willing submission. These "exotic" displays, as exhibitions of cultural difference, affirmed both the success of the conquest and the religious conversion of the conquered. In performing alterity, Andeans were, or at least could be, in the early colonial period, perceived to rehearse religious conversion. Not only was the private, personal act of religious conversion publicized through performance, but conquest and subjugation were implicitly performed as well. Christian festivals such as Corpus Christi, then, were occasions for rehearsing Spanish and Christian triumph through the resignification of native Andean performances.

The Spanish triumph was often made explicit in the native performances themselves. For example, in the 1610 celebrations of Saint Ignatius discussed above, several demonstrations of submission were made to the city's Spanish magistrate. One consisted of a reenactment of a pre-Hispanic battle between two Andean ethnic groups, the Cañaris and the Canas, in which the Cañaris, fighting for the Inkas to whom they were subject, defeated the Canas and brought them into the Inka fold. The choreographed battle of 1610 ended with the capture of the Canas, but they were presented as prisoners to the Spanish magistrate; through this substitution of Spaniard for Inka, the vanquished were understood to be loyal Spanish subjects thenceforward.[38] During this same celebration, the presentation that "gave the most pleasure to the Spaniards" was a procession of impersonators of the pre-Hispanic Inka emperors (Manko Qhápaq through Wayna Qhápaq).[39] Each litter passed before the *corregidor* where it was lowered in order to demonstrate respect. Through performance, even the Andean past was conquered and converted.

As discussed above, the Spanish Corpus Christi procession allowed for, if not necessitated, the appearance of some vanquished opposition for the purpose of demonstrating the triumph of Christianity. Dances and costume were one of the accepted ways of showing ethnic difference in European contexts. While in Spain, the "opposition" was impersonated by celebrants taking the form of dancing demons, Turks, Arabs, or Moors, who tried but never succeeded in impeding the procession of the host; in the Andes, the native subaltern—the embodied Other himself—fulfilled this role (at least in the eyes of Spanish witnesses). The "curious" Indian costumes, so frequently noted by Spanish witnesses, met the needs of Hispanic observers to see Andean ethnic and cultural alterity as subject to the Christian god. Subjection, however, was not all they saw.

As it turns out, the representation of alterity in Corpus Christi was both its triumph and its failure. As Homi Bhabha has observed, cultural hybridity is the necessary product of colonization; the push and pull of the colonizer's command to "be *like* us, but don't *be* us" can have no other result.[40] The celebration of Corpus Christi in Cusco is, therefore, best understood as a cultivated composite consisting purposefully of both European and Andean elements, rather than a syncretic accident, as it has often been characterized. When the colonizers contemplated the colonized, performing their cultural and ethnic difference for the festival of Corpus Christi, they realized that Andean alterity transformed the familiar (their Spanish Corpus Christi) into something decidedly different. Andean religious converts, in performing indigeneity, necessarily converted the celebration into something Andean and, therefore, subverted—or at least evaded—the totalizing triumph of the Spanish Corpus Christi festival. What was performed in the Andes could not be recognized as Spanish and so raised questions about exactly what was being enacted.

As the sixteenth century came to a close, Hispanic clergy became increas-

ingly aware, to their consternation, that indigenous religious content had not been successfully separated from the celebratory form. Clearly, that which was thought (or hoped) to be absent—the pagan Andes—was still casting a perceptible shadow because of its performative presence. When extirpators of idolatry in the archdiocese of Lima found, in the early seventeenth century, that wak'as—native shrines and sacred objects—were being worshiped in native communities on Corpus Christi, many clergy came to suspect the "sincerity" of native conversion and question the pastness of native performances.[41]

While native behaviors could be observed as performances, their meanings were opaque. Intentions and beliefs—hearts and minds—were beyond evaluation. In this atmosphere, native dances were suspect and a debate ensued over their possible deleteriousness. The Augustinian Antonio de la Calancha and the Mercedarian Martín de Murúa, both writing in the early seventeenth century, indicate, for example, that the natives continued to celebrate their raymis through the performance of dances in Christian contexts.[42] The midcolonial period is marked by debates over the success of the evangelical project.[43] This extirpatory rhetoric little affected actual festivals, as did the discourse against masked performances and other spectacles in European Christian festivals of the baroque and earlier periods. While church leaders wrote and spoke against popular celebratory practices, accusing them of covering pagan or idolatrous behaviors, the church was unable to eliminate them.[44] Although some Peruvian "extirpators" emphasized the eradication of all signs once associated with pre-Hispanic supernaturals, this was clearly not a practical solution to the evangelists' dilemma. And so, while extirpatory rhetoric was characterized by absolutist phrasings, actual prohibitive gestures were, at most, conditional.

In the end, the colonizers' position regarding native performances during Cusco's Corpus Christi celebration was one of resigned ambivalence. What they failed to recognize is that ambivalence is built into the very structure of the imported Corpus Christi celebration, and, I would argue, into religious conversion itself. The festive format of Corpus Christi, which encouraged local festive practices as well as non-Christian elements, conditioned the Spanish viewing of native dances and predisposed them to both admire and distrust the performers. While Spaniards spoke and wrote about being wary of "idolatry" practiced under the guise of Corpus Christi, they also consciously promoted their own suspicions by encouraging/requiring the colonized to sing and dance and wear Andean costumes for the celebration. Their contradictory stance may have been a concession to their inability to monitor, much less eradicate, widespread native celebratory practices. It may also owe to their remarkable ability to interpret native behavior according to their own expectations—in other words, they saw in Andean performances what they both desired and feared to see.

Within the confines of Christian festivities, native dances and regalia be-

came exotic spectacles pregnant with "pagan" possibilities. While at times the desires of Hispanic authorities led them to see joyful Andeans successfully converted, their fears also compelled them to suspect that Corpus Christi might be nothing more than a sham covering a pre-Hispanic *raymi*. As mentioned earlier, Inti Raymi (the sun festival) was most commonly identified as "hidden" within Corpus Christi in Cusco. Examining those practices that Spaniards said proved that idolatrous *raymis* were covertly manifested in Cusco's Corpus festival reveals that, in fact, natives displayed no rite solely identified with any specific *raymi*, including Inti Raymi. After conquest, pre-Hispanic *raymis* did not endure long as a distinct set of rites because the Inka priesthood and religious and state apparatus disintegrated. Rather, the Andean songs and dances performed during Corpus Christi festivals were identified by witnesses as being from Inka *qhápaq ucha* rites, ceremonial sacrifices that were not exclusively a part of any particular *raymi*, but could be held on any occasion when great sacrifice was warranted (droughts, royal successions, wars, and so on).[45] According to all chroniclers who discuss *qhápaq ucha*, the central act was the sacrifice of human beings, usually children; feasting, drinking, and dancing were but companion activities.[46] Andean songs and dances, although derived from pre-Hispanic rites and performed for Corpus Christi in colonial Cusco, were clearly supplementary festive elements and certainly not, as suspicious Hispanic observers maintained, the celebration of any coherent *raymi*.[47] Hispanic witnesses summoned imagined, absent *raymis* out of their own apprehensions.

The specter of Inti Raymi haunted Cusco's Corpus Christi celebration precisely because Corpus Christi beckoned it. When the Christian godhead, the Corpus Christi in the form of the consecrated host, traced the path of Inka divine rulers and "idols," Andean festive signs and practices—in this case those of *qhápaq ucha*—were invested with new meanings. Much of the scholarship on Corpus Christi in Cusco fails to recognize this fact and focuses on the hybrid aspects of the Christian celebration as occurring *in spite of* rather than *because of* Spanish intentions. The Spaniards "found" Inti Raymi or other *raymis* in native dances and costume because Corpus Christi—in format and according to Christian tradition—needed it to be there.

Significantly, Inti Raymi honored the sun, the patron deity of the Inka state. In fact, Inti Raymi celebrated the triumph of the Inka state just as Corpus Christi celebrated Spanish as well as Christian triumph. The presence of Inti Raymi in Corpus Christi was thus doubly significant. The Spaniards found, however, that evocations of Andean supernaturals were potentially dangerous; in the Andes, the sometimes vivid memories of the Inkas challenged Spanish claims of political authority and legitimacy.[48] Not coincidentally, Spanish efforts to restrict Andean dancing were most frequently prompted by outbreaks of violence that threatened political as well as religious domination. The most salient example occurred in the late eighteenth century following the Túpac

Amaru II rebellion of 1780–83, when colonial authorities prohibited certain native dances in which masked (therefore disguised) Andeans performed armed and appeared dangerous.[49] In moments such as those, it becomes clear that for all the rhetoric about native souls, the performance of Andean political subjugation within Corpus Christi was likely more important than the proof of "sincere" religious conversion. These two goals, were, of course, so intimately linked in the colonizing process that it hardly serves to distinguish between them.

As Bhabha has argued, the necessary alterity of the colonized necessarily menaces.[50] The colonizer—who insists/depends on difference between himself and the colonized—is beset by what he cannot comprehend and, therefore, control. By inducing/inviting subalterns to perform their indigeneity through references to pre-conquest dress and dance, the colonizer actually kept, often to their discomfort, the Andean past forever present. Actualized absent pagans allowed for the (possible) presence of real ones. However, so long as the evocations of Inka religion could *appear* (to Hispanics) to be only nostalgic—safely and irrevocably in the past—they were generally applauded. Unless the dances provoked violence, Hispanic authorities did very little to alter either their form or content; exotic costuming—the visible evidence of alterity—seems to have been their primary interest.

Although the Inka past was housed in the Christian festival, clearly it was never contained by it. In fact, the Inka past was waiting there, within the festival of Corpus Christi, until modern Peruvians, infused by the spirit of *indigenismo* (indigenism) "discovered" Inti Raymi in Cusco's Corpus Christi. Descriptions of Cusco's Corpus Christi festival from the first half of the twentieth century laud its resilient indigenous spirit.[51] Although Andeans themselves were conquered and militarily, politically, and economically oppressed for centuries, the disembodied resilient indigenous spirit was found by nationalistic *indigenistas* to have "survived" inside the Corpus Christi celebration. The Inka presence there was, as we have seen, not a felicitous accident, but rather the inevitable result of the colonizer's compulsive insistence on the display of difference. Nevertheless, the imagined, noble Inka was there, in Cusco's Corpus Christi (rather than in the bodies of Peru's real, impoverished Indians), when Peru needed him in order to redefine its modern self.

In the 1920s, Peruvian President Leguía, responding to the *indigenismo* movement, named June 24 the "Día del Indio y festividad cívica nacional" (Day of the Indian and National Civic Festival). In 1944, Inti Raymi itself was reintroduced as the central act in Cusco's celebration of Peru's indigenous inheritance. The elements of the festival have changed over time; initially what was known as "The Day of the Indian" came to be called in midcentury (when the word *Indian* was out of favor) "The Day of Cusco." The celebration has expanded over time as well. By midcentury, the day extolling the city's indigenous heritage had become a jubilee week and has now, at the end of the

century, blossomed into El Mes Jubilar (jubilee month). Currently, festivities begin in May, the month preceding June solstice; they include parades, "folkloric" dances, art and craft exhibitions, civic fairs, and concerts. Although evocations of the Inka past continue throughout tourist season (May through August), the jubilee climaxes at noon on June 24 with the purported reenactment of the pre-Hispanic festival of June solstice—Inti Raymi. Corpus Christi, which once was held to triumph over Inti Raymi, is still fervently celebrated in Cusco, but it dims in comparison with the month-long, modern "Inka" festival, which begins the moment the body of Christ retires to the Cathedral after its brief fête.

The Inka "lived" inside the Corpus Christi festival only in part because colonial Spaniards lodged him there. Native Andeans themselves are also responsible for resurrecting the past, or, rather, particular pasts, through performance. Although the colonial-period Corpus Christi celebration invited Andeans to rehearse their own subjugation, this does not mean that Andeans consciously or willingly participated in the spectacle of totalizing triumph initially perceived by Europeans. In fact, because the performances were conceptually and culturally outside of the Hispanic festival, Andean performers aggressively pursued their own agendas.[52] Andeans choreographed the past, and performed histories that allowed them to reinvent themselves as colonial subjects who could be, if not entirely empowered, at least not enfeebled by alterity. Rather than accepting tragic selves who suffered "the chameleon's fate" (as Trinh has phrased it), it is clear that Andeans fully exploited the size and nature of the colonial stage onto which they were summoned in order to fashion *new* selves. While these new selves were inevitably colonial subjects, they were not abject. The menace of their alterity undercut the totalizing triumph of the Corpus Christi festival, and produced in colonial authorities an anxious, absolute ambivalence—a sticky web of contradictory significations that they themselves continuously spun.

NOTES

Trinh T. Minh-ha, *Woman, Native, Other: Writing Postcoloniality and Feminism* (Bloomington and Indianapolis: Indiana University Press, 1989), 52. This paper covers aspects of my *Inka Bodies and the Body of Christ: Corpus Christi in Colonial Cusco, Peru* (Durham: Duke University Press, forthcoming). Research has been supported by a J. Paul Getty Postdoctoral Fellowship in the History of Art and the Humanities, as well as research grants from the University of California, Santa Cruz.

1. The notion of transculturation was elaborated by Fernando Ortiz in his *Contrapunteo cubano del tabaco y el azúcar*, (1940; rpt., Caracas, 1978), as the emergence of new cultural forms common to neither the donor nor the recipient culture, and the suppression or loss of certain traditional ones following colonization. Transculturation suggests a more dynamic interchange between colonizer and colonized than does acculturation and recognizes the transformative character of colonial encounters.

2. Nina Epton, *Spanish Fiestas (Including Romerías, Excluding Bull-Fights)* (London: Cassell, 1968), 92.

3. William E. Addis and Thomas Arnold, *A Catholic Dictionary Containing Some Account of the Doctrine, Discipline, Rites, Ceremonies, Councils, and Religious Orders of the Catholic Church*, 15th ed., rev. by T. B. Scannel and further rev. by P. E. Hallett (London: Routledge and Kegan Paul, 1951), 787.

4. Like all Catholic festivals, the day itself is preceded by activities of the novena (the nine days prior to the feast day, a Thursday, in which preparations are made) and the octave (the eight days following the feast day). The final day, also known as the octave, usually has a small celebration to close the festival officially.

5. See Epton, *Spanish Fiestas*; see also Anselmo Gascón de Gotor, *El Corpus Christi y las custodias procesionales de España* (Barcelona: Tipografía la Académica de Serra, 1916), 6.

6. Gascón, *El Corpus Christi*, 11; Vincente Lleó Cañal, *Fiesta grande: el Corpus Christi en la historia de Sevilla* (Seville: Biblioteca de Temas Sevillanos, 1980), 19; Ignacio Zumalde, *Ensayos de historia local Vasca* (San Sebastián: Editorial Auñamendi, 1964), 37.

7. In festival description it is common to find references to Corpus Christi in order to discuss the size, the participation, the decorations, the processional route, and other celebratory features of extraordinary (i.e., not annually recurring) festivals. For example, when reporting on festive decorations of the processional route for a special celebration, an author might say, "The streets of the town were decorated as they are for Corpus Christi," suggesting that the citizenry had outdone itself on that occasion.

8. In Seville, the Tarasca was accompanied by individuals dressed as "savages" ("algunas figuras de salvajes [las mojarrillas], vestidos de unos justillos de lienzo pintados de colores")—this according to an early seventeenth-century author cited by Lleó Cañal, *Fiesta grande*, 39. Satanic imagery was commonly linked with foreign, non-Christian peoples in the context of Corpus Christi.

9. Gascón, *El Corpus Christi*, 33.

10. Ibid., 12–13.

11. Miguel Garrido Atienza, *Las fiestas del Corpus* (Granada: Imprenta de D. José López Guevara, 1889), 6.

12. Luís Rubio García, *La procesión de Corpus en el siglo XV en Murcia y religiosidad medieval*, lecture delivered June 7, 1983 (Murcia: Academia Alfonso X el Sabio, 1983), 67, 99–100.

13. Epton, *Spanish Fiestas*, 94.

14. Lleó Cañal, *Fiesta grande*, 30.

15. Segovia gives the time of year for this festival as April; harvest in the southern Andes usually occurs in late April or May.

16. Cristóbal de Molina [El Almagrista], "Destrucción del Perú" in *Las crónicas de los Molinas*, ed. Carlos A. Romero et al. (1535; Lima: Domingo Miranda, 1943), 50–53, my emphasis. He writes, "[A]unque esto es abominable y detestable cosa, por hacerse estas fiestas [gap in manuscript] a la criatura, dejado el Criador a quien se habían de hacer gracias debidas, es cosa de gran ejemplo para entender las gracias que somos obligados a dar a Dios, verdadero Señor Nuestro, por los bienes recibidos, de lo cual nos descuidamos tanto cuanto más le debemos."

17. The practice of substitution was nothing new to Europeans, who commonly associated Greek and Roman deities with members of the Christian pantheon; see, for example, J. Seznec, *The Survival of the Pagan Gods: The Mythological Tradition and Its Place in Renaissance Humanism and Art* (Princeton: Princeton University Press, 1953).

In fact, Greek and Roman deities even made appearances in colonial celebrations; see various accounts in Bartolomé Arzáns de Orsúa y Vela, *Historia de la Villa Imperial de Potosí*, 3 vols., ed. Lewis Hanke and Gunnar Mendoza (ca. 1735; Providence: Brown University Press, 1965); Rodrigo de Carvajal y Robles, *Fiestas de Lima por el nacimiento del Príncipe Don Baltasar Carlos*, ed. Francisco López Estrada (1632; Seville: Escuela de Estudios Hispano-Americanos, 1950); and Josephe de Mugaburu and Francisco de Mugaburu, *Chronicle of Colonial Lima: The Diary of Josephe and Francisco Mugaburu, 1640–1697*, trans. and ed. Robert Ryal Miller (1640–1697; Norman: University of Oklahoma Press, 1975). Also see José de Mesa and Teresa Gisbert, *Arquitectura Andina: 1530–1830, historia y análisis* (La Paz: Embajada de España en Bolivia, 1985), 27–39, for an excellent discussion of how some Greco-Roman-cum-Christian personages were manifested in the arts of viceregal Peru.

18. The ecclesiastic Councils of Lima, 1551–1772, emphasized not eradication but utilization of native religiosity and the careful application of substitutions. The first Council (called by Archbishop Jerónimo de Loaysa) set forth the philosophy of substitution in the third of forty *constituciones*; it dictated that in Andean communities where there was some conversion, *wak'as* were to be destroyed and churches built over them or crosses raised in their places (communities without converts were problematic and were referred to the viceroy). The second Council of Lima, convened in 1567 (also under Archbishop Loaysa), decreed that, where possible, crosses should be erected at all *wak'as* or *pachitas* (indigenous shrines often located on hills or promontories); see *Concilios limenses*, vol. 1, ed. Rubén Vargas Ugarte (1551–1772; Lima: S. A. Rávago e Hijos, 1951), 253, Constitución 99. Likewise Viceroy Toledo, in the latter half of the sixteenth century, gave his stamp of approval to the practical policy of substitution when he commanded that native images be removed and crosses and other Christian insignias be put in their places; see Francisco de Toledo, "Libro de la visita general del Virrey Don Francisco de Toledo," *Revista histórica del Instituto Histórico del Perú* (Lima) 7, no. 2 (1924): 171.

19. Priests were instructed to observe surreptitiously the native celebrations of Corpus Christi (celebrated at harvest time [May] in the Andes) to make sure that they were not using the feast of the Corpus as a pretext for worshiping their "idols." See *Concilios limenses*, 252, Constitución 95, which reads, in part, "que en las fiestas del corpus xpi e en otras, se recaten mucho los curas y miren que los indios, fingiendo hacer fiestas de xpianos, no adoren ocultamente sus ídolos y hagan otros ritos." The "suspicions" raised by the policy of substitution will be discussed further below.

20. Sabine MacCormack, *Religion in the Andes: Vision and Imagination in Early Colonial Peru* (Princeton: Princeton University Press, 1991).

21. El Inca Garcilaso de la Vega, *The Incas: The Royal Commentaries of the Inca Garcilaso de la Vega*, ed. Alain Gheerbrant, trans. Maria Jolas (1609; New York: The Orion Press, 1961), 158.

22. The choirmaster was acting in accordance with the Spanish practice of training groups of young boys to sing and dance for religious celebratory occasions; see Anna Ivanova, *The Dance in Spain* (New York: Praeger Publishers, 1970), 90.

23. In his early-seventeenth-century Quechua dictionary, Diego González de Holguín, *Arte y diccionario Qquechua-Español* (1608; Lima: Imprenta del Estado, 1901), 113, defines *haylli* as a "song of triumph in war; of satisfaction when agricultural labor has been finished" (*canto triunfal en guerra: de satisfacción cuando terminan la labor de una sementera*).

24. Segovia (as Molina [El Almagrista], 50–53), in his description of the plowing ritual of the harvest celebration of 1535, indicates that the Inka ruler (Manko II) took up the *chakitaclla* in a plowing rite. Other Andean lords joined the ruler after he began to

break the earth "in order that, from this time on, this would be done in all the realm" (*para que de allí adelante en todo su señorío hiciesen lo mismo*).

25. Garcilaso, *The Incas*, 158.

26. El Inca Garcilaso de la Vega, *Royal Commentaries of the Incas and General History of Peru*, 2 vols., trans. Harold V. Livermore (1609 and 1617; Austin: University of Texas Press, 1966), 1415–16.

27. Garcilaso, *The Incas*, 217.

28. The accuracy of Garcilaso's analogy is not argued here; what matters is that he believed that Corpus Christi was the successor to Inti Raymi.

29. Carlos A. Romero, *Los orígenes del periodismo en el Perú: de la relación al diario, 1594–1790* (Lima: Librería y Imprenta Gil, 1940).

30. R. Tom Zuidema, "Batallas Rituales en el Cusco Colonial," in *Cultures et sociétes Andes et Méso-Amérique: Mélange en hommage à Pierre Duviols*, 2 vols., ed. Raquel Thiercelin (Aix-en-Provence: Publications de l'Université de Provence, 1991).

31. Romero, *Los orígenes*, 20–21.

32. This smaller plaza was also called the Plaza del Tianguez (also often spelled Teanquiz), as it was the site of an Andean market; *tianquiz* is the Nahuatl (central Mexican) word for market.

33. In 1548, the municipal council authorized the building of houses over the river running between the two central plazas; see Jorge Cornejo Bouroncle, *Derroteros de arte Cuzqueño; datos para una historia del arte en el Perú* (Cusco: Ediciones Inca, 1960), 322–23. In 1571, the viceroy observed that Cusco's two main plazas were still "disproportionate and so large that festivals and other public acts cannot be enjoyed in them" ([*Las dos plazas principales*] *estan desproporcionadas y tan grandes que no pueden gozar bien en ellas las fiestas e otros autos publicos que se hazen en ellas*); see Francisco de Toledo, "Mandamientos del Virrey Toledo al Cabildo de Cusco," in *Gobernantes del Perú. Cartas y papeles . . .* , ed. Roberto Levillier (Madrid: Sucesores de Rivadeneyra, 1924), 7:70. It was decided that the Plaza Regocijo would be reduced by constructing houses and stores in front of the church and convent of La Merced. Construction stalled in part because the Mercedarians strenuously objected to the plan (which would have eliminated their prestigious position facing the plaza).

34. Juan Polo de Ondegardo, "Relación de los fundamentos acerca del notable daño que resulta de no guardar a los indios sus fueros—junio 26 de 1571," in *Colección de documentos inéditos del Archivo de Indias*, ser. 1, vol. 17 (1872), 80–81.

35. Polo, *Colección de documentos*, 80–81, writes,
lo principal fue quitarles la reverenzia grande que se tenya a aquella plaza por esta rrazon: la horden que dizen los viejos que tuvieron en traerla fue por tambos e provinzias, acudiendo toda la tierra al camyno rreal, e cada provincia lo ponya e llevaua por sus termynos, lo qual se les mandaua hacer en tiempos desocupados; a ansi no solamente en el Cusco, pero en todo el rreyno se tubo gran beneración a esta plaza; por esto e por las fiestas e sacrificios que en ella se hacian de hordinario por la salud del todo el rreyno, rreservadas solamente a los yngas, que por averlo tratado en su lugar no se haze rrelazion.

36. Francisco de Toledo, "Las ordenanzas de la ciudad del Cusco," in *Fundación española del Cusco y ordenanzas para su gobierno*, ed. Horacio H. Urteaga and Carlos A. Romero (Lima: Talleres Gráficos Sanmartí y Cia., 1926), 201–2.

37. Francisco de Toledo, "Ordenanzas para los indios de la provincia de Charcas (Arequipa, 6 de noviembre de 1575)," in *Gobernantes del Perú: Cartas y papeles . . .* , ed. Roberto Levillier (Madrid: Sucesores de Rivadeneyra, 1925), 8:370. In these ordinances Toledo reiterated earlier edicts of the Council of Lima regarding native dancing.

38. Romero, *Los orígenes*, 16–17.

39. Ibid., 17.

40. Homi Bhabha, "Of Mimicry and Man: The Ambivalence of Colonial Discourse," *October* 28 (1984): 125–33.

41. See Kenneth Mills, *Idolatry and Its Enemies: Colonial Andean Religion and Extirpation, 1640–1750* (Princeton: Princeton University Press, 1997), for a thorough examination of extirpatory discourse in the midcolonial period. Also writing extensively on the topic of religious conversion and extirpation in colonial Peru are Manuel Burga, *Nacimiento de una utopía: muerte y resurrección de los Incas* (Lima: Instituto de Apoyo Agrario, 1988); Pierre Duviols, *La destrucción de las religiones andinas (conquista y la colonia)*, trans. Albor Maruenda (Mexico: Universidad Nacional Autónoma de México, 1977); Manuel M. Marzal, *La transformación religiosa peruana* (Lima: Pontificia Universidad Católica del Perú, 1988); and MacCormack, *Religion in the Andes*.

42. Antonio de la Calancha, *Crónica moralizada*, 6 vols., ed. Ignacio Prado Pastor (1638; Lima: Universidad Nacional Mayor de San Marcos, 1974–81), 851; Martín de Murúa, *Historia general del Perú*, Crónicas de América no. 35, ed. Manuel Ballesteros (1611; Madrid: Historia 16, 1987), 450.

43. See Mills, *Idolatry and Its Enemies*, for a thorough discussion and analysis of this topic.

44. One of the most outspoken opponents of "pagan" (i.e., folk) spectacles was the Jesuit Juan de Mariana (1536–1624). In his *Tratado contra los juegos públicos* of 1609 he urged the prohibition of public performances rooted in pre-Christian celebratory practices; see Juan de Mariana, *Obras*, ed. d. F. P. y M., Biblioteca de autores españoles, vols. 30–31 (Madrid: M. Rivadeneyra, 1854). While his efforts resulted in no substantive changes, others joined Mariana in debates about the "cuestion de la licitud de danzas." In 1616 the municipal council of Castille forbade all dancing in the theater because the dances were found to be lacking in propriety and said to inspire immorality in those who saw them. According to Ivanova, 77, the order was never carried out, however. In seventeenth-century Seville, the denunciations of "abuses" (i.e., the revival of pagan and immoral practices) were constant, but again nothing much was done. Mikhail Mikhailovich Bakhtin, *Rabelais and His World*, trans. Helene Iswolsky (Cambridge, Mass.: MIT Press, 1968), has discussed the uneasy mix of sacred and profane in the festive mode. The carnevalesque, which is always a part of public celebrations, is also always the source of some suspicion on the part of those whose responsibility it is to see that order is maintained. Alessandro Falassi, *Time Out of Time: Essays on the Festival* (Albuquerque: University of New Mexico Press, 1987), 93, notes that

The Catholic church, from its beginnings, has thundered against "pagan" spectacles, celebrations, masks, and carnivals. . . . The Catholic polemic against festival, however, was essentially a matter of form, mostly aimed at modifying and substituting symbols, supernatural beings, and *actos*, replacing the profane with the sacred, the literal with the metaphoric, the old gods with the new saints.

45. See Murúa, *Historia general*, 453, and Juan Polo de Ondegardo, "Informaciones acerca de la religión y gobierno de los Incas seguidas de las instrucciones de los Concilios de Lima," in *Colección de libros y documentos referentes a la historia del Perú*, ed. Horacio H. Urteaga (1571; Lima: Imprenta y Librería Sanmartí, 1916), 3:21–22. Murúa describes these rites as having no specific designated performance time; rather they were to be done at times of dire need. He describes a gathering of the Inka following a two-day fast in which they abstained from sexual intercourse, salted food, and alcoholic beverages. They joined together in a plaza from which non-Inka and animals had been ousted. Dressed in special regalia, people held a silent procession playing drums. He makes special mention of the fact that some aspects of these rites appeared in viceregal Corpus Christi celebrations, but were gradually dying out.

46. See, for example, Juan de Betanzos, *Suma y narración de los Incas*, ed. María del Carmen Martín Rubio (1551; Madrid: Atlas, 1987), 71–72; Felipe Guaman Poma de Ayala, *El primer nueva corónica y buen gobierno*, 2nd ed., 3 vols., ed. John V. Murra and Rolena Adorno, trans. and analysis of the Quechua by Jorge L. Urioste (1615; 1980; rpt., Mexico: Siglo Veintiuno, 1988), 220–21, 232–33; Molina [El Almagrista], "Destrucción del Perú," 50–53; Cristóbal de Molina [El Cuzqueño], "Fábulas y ritos de los Incas," in *Las crónicas de los Molinas*, ed. Carlos A. Romero et al. (1574; Lima: Domingo Miranda, 1943), 25–28; and Murúa, 451.

47. Carol Ann Fiedler, "Corpus Christi in Cusco: Festival and Ethnic Identity in the Peruvian Andes," (Ph.D. diss., Tulane University, 1985), 271, who examined the Corpus Christi of modern Cusco, concluded that, structurally, Cusco's twentieth-century Corpus Christi was similar to the festive sacrifice of *qhápaq ucha*. She recognizes a structural similarity between the sacrificial order generated in Cusco and spreading to the provinces as echoed in Cusco's Corpus Christi, in which, in the weeks and months following the octave, a number of the participating parishes have their own "Corpus" celebrations. This festive configuration is not European and succeeds in acknowledging the cathedral as the regional ceremonial center just as *qhápaq ucha* acknowledged Cusco as the pre-conquest center of imperial ceremonial activity. Unfortunately, there is no documented indication of when began the festive configuration in which Cusqueño parishes echo the main feast of Corpus Christi with individual celebrations of their own. Spanish sources make no mention of the practice and parish records, available for the Hospital parish (*Libro del Cabildo del Hospital de los naturales*, uncatalogued MS, Archivo de la Venerable Curia de Cusco, 1585–1617), from the early seventeenth century, do not indicate that that parish planned such a ceremony. It seems likely that the *qhápaq ucha*–like pattern was introduced in the nineteenth century after control over the Corpus Christi presentation went from the cathedral to the parishes. By the time of Fiedler's study, Cusco's Feast of the Holy Sacrament had become essentially a parish production.

48. MacCormack, *Religion in the Andes*, 367–405.

49. David Cahill, "Ethología e historia. Los danzantes rituales del Cusco a fines de la colonia," *Boletin del Archivo Departamental del Cuzco* 2 (1986): 48–54.

50. Bhabha, "Of Mimicry and Man."

51. See, for example, Jorge Cornejo Bouroncle, *Por el Perú incaico y colonial* (Buenos Aires: Sociedad Geográfica Americana, Editorial y Cultural, 1946), 91–92; and José Uriel García, *Guía histórica-artística del Cusco* (Lima: Editorial Garcilaso, 1925), 71.

52. Elsewhere, I have suggested that Christian festivals occasioned tactical performances designed by Andeans to promote both corporate and individual interests by references to historic events; see Carolyn Dean, "Ethnic Conflict and Corpus Christi in Colonial Cusco," *Colonial Latin American Review* 2, nos. 1–2 (1993): 93–120; and Dean, "Martial Art: Imagery and Aggression in Colonial Peruvian Festivals," paper delivered at the Spanish Colonial Symposium, Denver Art Museum, Denver, October 20–24, 1993. One ethnic Cañari leader of Cusco, for example, used a sixteenth-century Corpus Christi performance to remind Spanish colonial authorities that the Inka had rebelled against the Spaniards shortly after the Spaniards had occupied Cusco while the Cañari had remained loyal. The Inka spectators attempted to kill the Cañari following his presentation—performances were serious business indeed. For their part, the Inka evoked, in numerous Corpus Christi appearances, their royal ancestry by which they retained certain elevated positions and privileges in the colonial order.

10. Gender Ambiguities and Erotic Excess in Seventeenth-Century Venetian Opera

U NTIL A FEW years ago, Shakespeare specialists acknowledged the fact that boys had acted the roles of all the Bard's heroines, but tended to get cranky if anyone tried to make anything of that fact. Without fail, generations of students have found this morsel of information highly titillating; and without fail, they have been shamed into accepting it as a mere convention. Their teachers insisted that they learn to see "straight" through this historical aberration to the natural binary oppositions of male and female that Shakespeare doubtless intended to represent, however skewed those intentions may have been by the prudery of his society, which refused women access to the stage.

But anyone who has kept up on recent literary criticism knows that scholars no longer treat the boy actor problem in this fashion. Indeed, this and related issues concerning gender representation in Elizabethan and Jacobean theater now sustain virtually a whole publication subindustry in and of themselves. Several factors have contributed to our fascination with these topics in recent years, among them the problematizing of the categories "male" and "female" by feminist and Foucauldian theorists, who have come to recognize that this stringent binary logic is in part a product of the Enlightenment.[1]

Another contributing factor, however, is the increasing malleability of gender in today's popular culture. Over the last twenty years, as artists as diverse as David Bowie, k.d. lang, Prince, RuPaul, and various glam-metal bands have flaunted androgynous and cross-dressed personae on stage, our tolerance for —even *expectation of*—flagrant gender bending has made us more receptive to similar moments in earlier cultural history.[2] And we have come to recognize seventeenth-century theater as the site most rife with public performances of sexual ambiguity and deliberately perverse gender construction prior to our own time. Consequently, the elements that used to provoke such embarrassment in the classroom now attract the rapt attention of scores of academics.

Not surprisingly, most of this work takes place in English departments, for the plays of Christopher Marlowe, Ben Jonson, and (of course) Shakespeare

stand as the cornerstone of the English literary canon. Moreover, because scholars have been poring over these plays for four hundred years, they constantly search for new directions in research and publication. Thus when queer theory began to emerge ten years ago, many Elizabethan scholars embraced it as a godsend. As a result, large numbers of monographs and collections have now appeared concerning these topics, with important contributions by Stephen Orgel, Marjorie Garber, Bruce Smith, Peter Stallybrass, Valerie Traub, Jonathan Goldberg, and especially the collection edited by Susan Zimmerman, *Erotic Politics: Desire on the Renaissance Stage*.[3]

As certain similarities among conventions indicate, the closest equivalent in music is Italian opera, especially the commercial opera that developed and flourished in Venice beginning in 1639. This genre has received far less critical and historical attention than Shakespeare's plays; despite the pathbreaking studies contributed by Nino Pirrotta, Lorenzo Bianconi, Ellen Rosand, and Wendy Heller, we still need to ask rather fundamental questions about opera in Venice.[4] And although delightful recordings of a few of these operas now exist, we have few published scores to which we can easily refer. Consequently, in order to study even the most influential compositions of the period, one must journey to see the original manuscripts in European libraries, consult eye-straining microfilms, or rely on brief, often unreliable excerpts in scholarly monographs.

In this essay, I want to consider some of the more glaring elements involving gender representation in mid-seventeenth-century Venetian opera. Like traditional professors of English, musicologists have often wanted to rush quickly past these curious anomalies to get at what they have regarded as more important issues—the music, the contexts, the institutions. Yet, if anything, Venetian opera raises questions concerning gender even more urgently than do Shakespeare's plays. I will have few answers; mostly I will offer problems and suggestions for further investigation. And although Elizabethan theater differs in many important respects from the later genre of Venetian opera, I will draw on certain ways of thinking about these issues that have emerged from English scholarship during the last decade.[5]

One convention appears in both genres and functions in roughly the same way in each: plots involving female characters who disguise themselves as males, usually in order to enjoy the sense of agency and freedom to travel that society granted only to men at the time. Thus, like many an Elizabethan heroine, Amastre (the only serious character in Cavalli's *Serse*) dresses as a man in order to track down and win Xerxes back. We are on relatively solid ground making connections between Italy and England with respect to female travesty, for we can trace this plot type back to sources shared by both: to *commedia dell'arte* plots and stories concerning cross-dressed female sojourners

that date back as far as medieval Spain. Indeed, it is worth noting that nearly all instances of this convention in English drama occur in plays purported to take place in Italy: in other words, even in the sixteenth century—long before the advent of commercial opera—the English imagination already strongly identified transvestism with Italian theater.[6]

Why were such plots popular? As with all historians of culture, we find ourselves trying to understand the pleasures of another time, a project admittedly fraught with difficulties, yet necessary to our attempt to make sense of conventions and their fortunes.[7] Although some of us may be tempted to read female transvestism unambiguously as a sign of feminist resistance, we have to exercise caution: as various writers have demonstrated in their examination of extant response from Elizabethan spectators, this convention played into male social and sexual fantasies—factors that undoubtedly account for much of its success and longevity.[8] Moreover, as Margaret Reynolds has argued, most disguise roles "offer a familiar model of female self-sacrifice that is not very inspiring," at least not to present-day women.[9]

Nevertheless, the plot device of disguising a female character as a man at least gestures toward the greater empowerment of women and critiques the social inequities that largely confined women to the home.[10] And male impersonation on the dramatic stage also potentially engages with women's desires. The recent collection *En Travesti: Women, Gender Subversion, Opera* contains several essays that focus on female cross-dressing in opera, for purposes of the plot (as in the disguises here under consideration), for "trouser roles" (adolescent boys, such as Mozart's Cherubino or Strauss's Octavian, designed from the outset to be performed by women), and for roles intended to be sung by castrati (now performed by women actualizing the absence of that voice type). As the essays in *En Travesti* reveal, such performances—whether or not intended as such by the composers and librettists—have long since provided women artists and audience members with a site for same-sex fantasies.[11]

Yet historians have difficulty documenting the responses of seventeenth-century women themselves, for the overwhelming majority of the playwrights, performers, audience members, and the critics whose opinions show up in the written record were male. The patron hovering over many of Shakespeare's productions, however, was Queen Elizabeth, whose favor was sought by most artists and whose tastes may well have shaped many of the plots composed during her reign.[12] Suzanne Cusick's examination of Francesca Caccini's work under Archduchess Maria Maddalena of Austria indicates that female patronage may also have made a difference in Florentine opera plots.[13] Finally, Queen Christina's reign over Roman culture in the 1660s and 1670s seems to have resulted in the emergence of story lines and lyrics that privilege women; Carolyn Gianturca argues that Christina may even have exerted enough pressure to allow female singers occasionally onto the *verboten* Roman stage.[14]

Feminist criticism came to musicology only around 1990, but it has already

revealed a previously unsuspected cultural world of motivations, interpretations, and pleasures hidden behind the traditional narratives of music history. We still have far less information about mid-seventeenth-century Italian opera than the genre warrants, but we have long known that popular female divas sometimes acquired sufficient box-office clout to affect many Venetian conventions, including the increasing domination of showcase arias over dramatic dialogue; indeed, composer-oriented musicologists have often complained of the inordinate power of "mere" singers, which quickly eroded the aesthetic integrity of Venetian opera.[15] Is it not possible that the divas' preferences also influenced the frequency of plots involving female transvestism?[16] As musicologists begin to regard female singers not merely as passive conduits for transmitting the works of composers but as cultural agents in their own right, we are learning to see the canon from very different vantage points.[17] Our notions of baroque opera will no doubt shift as we focus our attention on the women stars of the time.

The opposite situation—males cross-dressed as women—presents a more difficult array of questions, for the social-empowerment argument does not obtain in such cases. The English custom of having boys play the parts of women because of societal restrictions would seem to be relatively easy to accept as a convention of convenience: to some extent, at least, playwrights expected their audiences to ignore the fact of cross-dressing and accept the boys as women, as part of the suspension of disbelief already fundamental to the theatrical enterprise. Yet Peter Stallybrass has located an unexpectedly large number of passages in which the script encouraged Elizabethan audiences to contemplate erotically precisely those parts of the actor's body that differentiated it from that of the female character he played—thus, for instance, the references to naked, swelling breasts that abound in these plays.[18]

This convention, in other words, often positioned boy actors quite deliberately as objects of homoerotic desire. One of the most obvious pieces of evidence for this covert eroticizing of cross-dressed boy actors *as boys* occurs in the opening scene of Marlowe's *Edward II* (1593). Gaveston, the king's favorite, seeks to arouse Edward by presenting what he announces as an "Italian" entertainment, in which:

> . . . a lovely boy in Dian's shape,
> With hair that gilds the water as it glides,
> Crownets of pearl about his naked arms,
> And in his sportful hands an olive tree
> To hide those parts which men delight to see,
> Shall bathe him in a spring . . .

Musicologist Nino Pirrotta loves to describe an almost identical moment from the later Roman opera *Diana schernita* (1629), in which the male singer play-

ing the role of the goddess disrobes to the point just before signs of sexual dif-
ference would be revealed.[19] Gaveston's male pronouns insist throughout his
speech that we remember we are concerned with an alluring boy, and the
phallic olive tree in the boy's "sportful hands" scarcely suggests the female
genitals of the Goddess of the Hunt as "those parts which men delight to see."
 Note that Elizabethan scholars understand Marlowe to be marking Gaves-
ton as a sodomite simply by virtue of his references to Italy, which was suffi-
cient coding at the time for English audiences.[20] We have no reason to believe,
of course, that Italians indulged in same-sex activities more often than the
English, but we must recognize that the English commonly projected this ex-
oticist stereotype onto Italy (and Venetians onto Florentines, scholastics onto
humanists). In any case, whatever the realities of actual sexual behaviors at the
time, we cannot any longer regard the custom of having males play women's
roles as an uncomplicated "mere" convention in either tradition.

But the feature that most clearly distinguishes Venetian from Elizabethan rep-
resentations of gender—the feature that separates quite literally the men from
the boys—is the presence in Italian opera of the castrato. The very fact that
castrati existed constituted a sexual scandal (the operation that produced them
remained illegal during the entire period of their popularity), yet they ap-
peared not intermittently or surreptitiously, but as the leading characters in
this genre.[21] When they played women (as was the custom in Rome), we face
a predicament similar to the one English scholars encounter with Shake-
speare's boy actors—except that Italian female impersonators were adult males,
which introduces another cluster of implied pleasures and anxieties and raises
the stakes immeasurably. The critical work responding to Balzac's novella *Sar-
rasine* addresses many of these issues.[22]
 More often, however, castrati filled the roles of male romantic leads. This
element of Italian opera has proved difficult to "fix" in keeping with modern
sensibilities; for if we can recast women as the heroines in productions of
Shakespeare or Roman opera, we cannot easily substitute our own gender
economy for the one sustaining male heroes in Venetian scores. As performers
producing recordings of these operas have discovered, it does not truly work
either to transpose the music down to "natural" male ranges or to use cross-
dressed women for these parts.[23] Gradually, modern audiences have accus-
tomed themselves to hearing castrato roles performed by countertenors: male
falsettists who may sound somewhat like women (at least to untutored ears),
but whose feigned voices project fragility and vulnerability rather than the
power ascribed by eyewitnesses to castrati. And many of us, when presenting
these operas in our classes, still strive to scurry past this stumbling block as
quickly and efficiently as possible, covering over the strangeness of it all with
an appeal, once again, to convention.

Yet just as English plays often problematize the fact of boy actors' bodies, so operas using castrati as heroes sometimes acknowledge their own artifice by cracking castrato jokes, usually not in direct connection with the lead himself, but displaced onto characters whose lower-range voices exempt them personally from such jibes. For instance, in Cavalli and Cicognini's *Il Giasone* (1649), the servant character Besso (a fully mature bass) counters the suggestion that he is effeminate by appealing to his "members," a line to be accompanied, no doubt, with a time-honored lewd gesture. Later, when Besso tries to woo the maidservant Alinda, she asks suspiciously what voice part he sings, leading him to insist vehemently that he is *not* a castrato.

In both these scenes, the castrato becomes a target for hilarity and perhaps an outlet for latent anxieties. Quite evidently, audiences of the time were not expected to forget altogether the inconvenient fact that Giasone—the presumably oversexed protagonist of this opera—is a castrato, especially since Besso's boastful reference to his members immediately precedes Giasone's first entrance. If the status of castrato superstars and the unrelieved earnestness of eighteenth-century *opera seria* eventually minimized the scandal attached to this phenomenon, castrati in 1649 still invited sniggering, *even as they performed the roles of romantic leads.*

Too often modern scholars view the castrato through the lens of Freud's theories concerned with castration. Freud's constructions of identity depended heavily on the presence or lack of male genitals, and thus he translated all threats to the male subject into fears of metaphorical dismemberment. Up against that framework, the prospect of *literal* castration—the flaunted actualization of absence—looms as virtually unimaginable; we believe that this condition would so shatter the sense of male subjectivity that existence would become meaningless.

This is in part because post-Enlightenment thought increasingly understood the subject as an intensely privatized essence, with sexual apparatus as a fundamental element (Freud eventually theorized it as *the* foundation) of identity formation. To be sure, seventeenth-century men also prized their potential for procreation; we don't even have to leave the opera house to learn this, for libretti abound with boasts about potency. But their sense of self relied far more on relationships within a social fabric than on the individualized yet physiologically grounded essences of later models of identity. To fulfill the role of "male" demanded many kinds of social performance; masculinity was not reducible to the body as such. (A comparable move in history involves the shift from the concept of "the sodomite," as one who performs acts of sodomy, to "the homosexual," as one who is thus oriented by essence, regardless of actual behavior.)

Of course, nineteenth-century masculinity did not truly depend on sexual apparatus either. Yet the distrust of social convention that came along with romanticism displaced notions of identity increasingly onto sexual essence.

Bereft of theological certainty or faith in rationalism or social contract, nine-teenth-century man experienced himself as thrown back on (so to speak) his own devices. It is not a coincidence that in Lord Byron, Goethe, and Bee-thoven, the self must be bound up not just with masculinity, but with explic-itly phallic assertion. Freud only theorizes this custom after the fact.

I do not mean here to minimize the physical, emotional, and social distress attached to the sexual mutilation required for the manufacture of castrati in the seventeenth century. Nor do I wish to offer an argument of cultural rela-tivism condoning this practice, for it was regarded as inhumane even in its own day. But I *do* want to separate the actual operation, which allowed at least some individuals access to fame, fortune, and great social influence, from the figurative yet apparently far more traumatic condition of Freudian castration, which implies a general failure of self and social efficacy, even though the body remains intact. To persist in reading the castrato in Freudian terms is to obstruct any possible understanding of this cultural practice that dominated European music for nearly two hundred years.

What, then, are we to make of this custom of casting castrati in the roles of romantic leads? To stick with Giasone: as other characters describe him, he is a beautiful youth, one who still lacks facial hair, who proves irresistible to women. Within this context of ephebic eroticism, his unchanged voice makes perfect sense, especially when we recall that in the 1600s boys matured physi-cally only toward the end of their teens. Yet Giasone's creators also expected the audience to believe that he spends nearly all his time making love and that he is possessed of prodigious sexual potency; we are informed that he has fathered not one, but *two* sets of twins before the curtain even rises. He in-habits, in other words, a moment of development when he can pursue sexual activity without assuming the burden of patriarchal responsibility.

This androgynous figure is not as alien to today's sensibilities as we might initially think. Giasone's status as an object of desire resembles that of a whole string of twentieth-century matinee idols, ranging from Rudolph Valentino to Michael Jackson (who continues miraculously to sing with the still-unchanged voice of his early boyhood career) to Leonardo DiCaprio. As Marjorie Garber has argued, gender ambiguity in such cases registers not as a failure of mas-culinity, but as the contrary, a standard characteristic of marketed male sex symbols.[24] Although crucial differences remain between the castrato of Vene-tian opera and the teen idol of recent pop music and Hollywood film, observ-ing the similarities can help us understand why such unlikely figures might have exerted such erotic appeal. It may also push us to scrutinize more closely our own cultural pleasures.

But a more curious convention of Venetian opera concerns male roles that re-quire unaltered voices. The characters who sing bass or baritone, which vocal

range testifies that their genitals remain intact, almost never have anything to do with sexual or romantic activity. Historians often discuss how European men around 1800 gradually adopted the drab clothing identified with power in the new world of business and denied themselves the spectacular male garb of previous centuries, a denial known as the Great Masculine Renunciation.[25] But the gender economy of Venetian opera demands an even more severe renunciation: whether they serve as fathers, kings, philosophers, or the more prestigious gods, almost all the characters who sing bass have traded in erotic pleasure for social authority; they acquire the phallus only after they agree to retire the penis. We have, in other words, a bizarre situation in which only castrati can play sexually active characters, while unaltered males sing the roles of those judged by their culture as ineligible for sexual encounters. Alas, a taste for the deep-voiced "Love Daddy" persona of 1970s rhythm and blues (best exemplified by Barry White) had not yet materialized.

Pity, therefore, the intact male character in a seventeenth-century opera who finds himself enflamed by desire. More often than not, his untimely lust becomes a target for ribald commentary. A mature emperor possessed of a young wife, as in Cavalli's *Ormindo*, can expect to fall cuckold to a castrato. Moreover, adult servant characters who fall in love reliably offer episodes of comic relief. Too old not to know better, yet aware that sexual activities count among the few sources of delight for those of their class status, they taunt each other with jokes about size, endurance, and age. But such characters are not calculated to arouse the libidinous fantasies of the audience.

These strange paradoxes and inversions involving mature male voices and their sexualities reach a dizzying height with Cavalli and Faustino's *La Calisto* (1651). Based on one of Ovid's fables, this opera situates Giove (Jove, the most prominent of the gods) within a whole range of subject positions, each of which strains credibility more than the one before. At the beginning, Giove bears a strong resemblance to Mozart's Don Giovanni, with his lecherous sidekick Mercury, also (like *Don Giovanni's* Leporello) a bass-baritone. Giove's initial attempt to seduce the nymph Calisto fails, for not only is Calisto devoted to Diana's virgin cult, but Giove's voice betrays him as someone altogether inappropriate for courtship. Thus rebuffed, Giove disguises himself (like the boy in Gaveston's playlet and the castrato in *Diana schernita*) as Diana, which requires that he push his bass voice into a forced, comic falsetto; he must surrender, in other words, all evidence of his virility in order to qualify for romantic encounters.

In Ovid's version of the story, Giove drops his female disguise as soon as he has isolated Calisto, and he rapes her—the same occurs in Thomas Heywood's Jacobean version of the story, *The Golden Age*.[26] But in our Venetian sex comedy, Calisto never even notices that her partner in their entirely successful bedding is *not* Diana. Is this because Giove's disguise goes all the way down to the physiological level? Or perhaps because of Calisto's singular naïveté?

Maybe both, but also because this detail opens the floodgates for a veritable contagion of gender confusions, as Calisto invites an appalled Diana to join her in the bushes again and as Endymion (Diana's male devotee) mistakes Giove for his goddess and attempts to make love to her/him, to Giove's homophobic horror. Cross-dressing spills over into implied same-sex encounters—same-sex encounters, moreover, that cannot be set straight. For if Endymion's intentions toward pseudo-Diana and Giove's intentions toward Calisto both finally confirm opposite-sex norms, Calisto only acquiesces to Giove because she thinks he is Diana. Thus, the one consummation in the opera—heterosexual though it technically may be—is accomplished only under the guise of a same-sex liaison.

How do we account for such plot devices, in which not only cross-dressing, but also suggestions of same-sex encounters appear so blatantly? As with all forms of early theater, seventeenth-century Italian opera delighted in playing with the technologies of representation with which it engaged. Thus, when composers discovered the means to produce the illusion of "male" and "female,"[27] they simultaneously learned to use those same techniques to devise a whole menagerie of hitherto unsuspected options. Marjorie Garber, in her study of cross-dressing in early theater, concludes that:

> "Man" and "woman" are *already* constructs within drama; within what is often recognized as "great" drama, or "great" theater, the imaginative possibilities of a critique of gender in and through representation are already encoded as a system of signification . . . Transvestite theater recognizes that *all* of the figures on-stage are impersonators. The notion that there has to be a naturalness to the sign is exactly what great theater puts in question. In other words, there is no ground of Shakespeare that is not already cross-dressed.[28]

Moreover, the malleability of gender in the theater resonated strongly at the time with the possibility of class mobility. Mikhail Bakhtin has theorized the relationship between class and gender inversions in carnival festivities, of which Venetian opera was perhaps the most elaborate historical manifestation.[29] Thus, women characters acquire otherwise unavailable social privileges when dressed as men. And to cast the lofty Giove as a drag queen who falls into humiliating circumstances beyond his control is to play mischievously with class status, in what Pirrotta labels a "mockery of the gods" plot.[30]

Yet, as many other historians remind us, we cannot reduce cross-dressing and the flirtations with same-sex encounters to *nothing but* a fascination with the apparatus of representation or slippage with class-related issues.[31] The ease with which performers shaped and reshaped genders and configurations of desire on the stage had to have been received as provocative by at least some audience members, for to enact such sexual permutations on the stage raises the possibility of such arrangements in real life, even when the dramas appear to play them for laughs. Certainly, the English contingent in the Venetian

audience would have felt cheated without some innuendos along these lines; they expected no less of Italy, or, at least, of Italian theater.

But we are not quite finished with Giove. Having presented himself as an aging lecher and a female impersonator, he suddenly reverts to his natural bass voice in the final act and reestablishes his identity not simply as Giove, but as God-the-Father-of-the-Christian-Trinity. As you may recall from Ovid, Juno (Giove's endlessly betrayed spouse) avenges herself on Calisto by turning her into a she-bear. In the opera, Giove reappears to bestow his divine clemency on Calisto, who offers her gratitude in a prayer recalling the magnificat, lowly handmaiden trope and all:

Calisto:	Eccomi, ancella tua.	Behold your handmaid.
	Disponi a tuo piacere,	Make use as you please,
	monarca de le sfere,	Monarch of the Spheres,
	di colei che creasti,	of her whom you created,
	ché con frode felice,	whom, through a happy stratagem,
	oh mio gran fato,	O my great Creator,
	accorla ti degnasti	you have deigned to welcome
	nel tuo seno beato.	To your divine bosom.

As Giove foretells Calisto's ascension (to become the constellation Ursa Major), they sing together a rapturous duet between God and the soul that would be right at home musically in San Marco, where Cavalli had his day job.[32] Such an extreme measure—a flagrant appropriation of sacred iconography—seems required to justify a love duet involving a bass-baritone.

Our acceptance of this moment bordering on sacrilege is conditioned by the gorgeousness of the music. Here, as in so many of the productions linked to the Accademia degli Incogniti, an extraordinary cynicism reveals itself, as utterly loathsome characters suddenly overwhelm the listener with musical beauty, tempting us to doubt our previous moral judgments.[33] We do not have to wait for Bertolt Brecht's theory of the Alienation Effect to learn that the medium of music lies and seduces; the Incogniti offered that lesson over and over again.[34] Thus, just as we are subjected in Monteverdi's *L'incoronazione di Poppea* to Poppea and Nero's sweetly singing their final duet after they have committed unspeakable crimes, so in *Calisto* we are lulled into forgetting the lechery, the grotesque drag show of Giove's former manifestations, and even the Blessed Virgin's unfortunate bearlike muzzle, to which the libretto repeatedly refers. Our critical defenses drop as a beneficent Giove and Mercury (acting here as Holy Spirit) waft her angelic through the skies—through a timeless tetrachord ostinato.[35]

Giove:	Mio foco fatale:	Behold my fatal thunderbolt:
	son Giove e tonato.	I am Giove and I thunder.
Calisto:	Beata mi sento	I feel blessed
	a questa salita.	at this ascension.
Giove:	Per te, mia tradita.	For you, my betrayed one.

Calisto: Mercé del mio dio. The mercy of my God.

Giove & Calisto: O dolce amor mio. O, my sweet beloved!

A few words about the musical device Cavalli employs here. The tetra-chord ostinato counts as one of the most important musical devices of the mid-seventeenth century. Put quite simply, it involves the repetition of the same four-note descending figure over and over (the word *ostinato* is related to *obstinate*) in the bass. It was used to simulate trance-like psychological states (laments, erotic or religious ecstasy, etc.) in which the character no longer ex-periences time in a linear or progressive fashion.[36]

Although Giove initiates the duet by singing a countermelody against the ostinato, he spends most of the duet doubling the bass line. His duplication of the bass line identifies him musically as the foundation that controls the entire context. And however ornately she may sing, Calisto's melody must conform to its (his) dictates, for this line guarantees the coherence and direction of the entire duet. Theorists of the time increasingly conceived of musical syntax in terms of this "fundament," and they came to regard melodic lines as feminine epiphenomena in relation to the patriarchal security of the bass.[37]

But this identification of bass voices with harmonic bass lines also becomes something of a liability within the style of the day: it prevents lower voices from participating fully in the expressive domain, which is almost always rele-gated to higher voices in counterpoint with the bass. This is in part a technical problem; it accounts for why we have thousands of violin sonatas from the baroque and only a few—and necessarily contorted (if wonderful)—examples for, say, bassoon. The apparent power of the lower voice to regulate the direc-tion of the music also makes it ineligible to perform subjective feeling.

But this technical problem influenced immeasurably the conventions of the dramatic stage. Basso continuo devices developed in part in the context of the fabled *concerto di donne* in the court of Ferrara;[38] it was this group of virtuosic coloratura voices that made sopranos a highly prized commodity and that contributed to the opposite of penis envy that encouraged the wholesale production of castrati. Because opera's cultural work (and that of virtually all music of the baroque) focused on the display of the passions, composers of the day preferred to showcase the high voices and instruments that maximized the desired effect. Thus we arrive at the same conclusion from a "purely musical" direction:[39] the patriarchal authority of the bass voice's tessitura restricts his versatility in roles where emotions matter, which results in his subordination in plots to the freely expressive castrato.

I want to return now to the character Giasone, among the most fascinating in Venetian opera. This was the opera that eighteenth-century literary critic Giovanni Maria Crescimbeni both praised as the most perfect and also con-

demned as the one that most corrupted the tradition of Italian theater.[40] Cres-cimbeni focused on class-related promiscuities when he penned his critique, but the opera also raises questions concerning the proper constructions of masculinity; indeed, transgressive masculinity is repeatedly and urgently the-matized within the opera itself.

Giasone is the Jason of Argonaut fame, the hero who seduced and then abandoned Medea after she had assisted him in stealing the Golden Fleece, leading her to enact her spectacularly bloody revenge. In *Il Giasone*, however (as in so many Venetian operas), the story unfolds not as epic or tragedy, but as sex farce. Accompanied by his Argonauts, who are starved for heroic military adventure, Giasone has been drifting lazily around the Aegean, apparently im-pregnating a queen in every port. As the opera opens, Hercules and the servant Besso stand debating outside the palace where Giasone and Medea have been ensconced for a full year. It turns out that Giasone still has not actually *seen* Medea: they have been groping in the dark all those months, during which time she has given birth to twins. He hasn't even a clue about the identity of his bed partner; he knows only that he doesn't want to do much of anything else, least of all pursue the fleece.

Hercules complains bitterly of Giasone's effeminacy, by which he means the hero's extreme susceptibility to feminine wiles. It is not, in other words, the fact that a castrato sings the part of Giasone that renders him effeminate in the eyes of the other characters, nor does the word "effeminate" carry any sug-gestion of same-sex predilections. Quite the contrary: it is Giasone's single-minded devotion to making love with women—his erotic excess—that earns him this label.[41] For while the Argonauts stand by, ever ready to perform their legendary acts of courage, Giasone spends all his time frolicking in bed with Medea. Besso defends Giasone by pointing to his youth and beauty: the boy can't help it if women find him irresistible. But Hercules wants Giasone to live up to his own standard of manliness, to learn to embody such traits as leadership, responsibility, and, above all, indifference to sexual indulgence with women.

The opera will, in fact, trace a plot trajectory during which Giasone comes to accept his social duties, even though this means forfeiting Medea, who like-wise has to submit to marriage with a former suitor. In other words, the plot yanks the two principal characters from their private world devoted to sexual indulgence and inscribes them, quite against their wills, into a patriarchal economy that grants no space for pleasure. The prologue already forecasts this outcome, as the allegorical figure Amor advocates not the blind passion usu-ally associated with him, but instead strictly conjugal love. If, like Monte-verdi's *Poppea*, the opera enacts the triumph of Love, this Amor more closely resembles Juno's watchdog fidelity than Venus' delights of the flesh. With a Cupid like this one floating above them, the affair between Giasone and Medea doesn't stand a chance.

And yet. The pleasures of the opera clearly reside with this pair in their un-reconstituted state. It was, after all, for those last thrills of youth that young men from all over Europe gravitated to Venice, before they went home to shoulder their own adult responsibilities. If by the end of the opera duty has prevailed (how could it not, when this opera defines love *as* duty?), the figure of Giasone presents a model of masculinity rarely seen or heard in music until the forthright androgyny of recent gender-bending rock stars.

The discussion between Hercules and Besso stops when Giasone himself finally emerges, confirming every fear Hercules had expressed by launching into a prolonged aria. As Pirrotta has argued, the use of full-scale arias still posed problems of realism in the 1640s: serious characters had to be carefully incited to lyricism, and the bursting into song in itself betrayed a dangerous excess of passion (recall how gradually Poppea and Nero build toward their brief exchange of lyrical outpourings in their first scene together).[42] Evidently, Giasone is always already incited, and he stumbles from Medea's chamber out into the rosy-fingered dawn still swooning in a mist of *jouissance*.

If the fact that he sings an aria at his entrance is a bad sign, even worse from Hercules' point of view is the burden of the song itself. Lorenzo Bianconi has pointed out that the text Cicognini gives Giasone at this point has rhythmic peculiarities that make it resemble a lullaby,[43] and the lullaby genre will continue to mark Giasone's discourse, especially in his interactions with Medea, throughout the opera. One of the softer hip-hip radio stations in Los Angeles used to have as its motto, "The station where it's always bedtime," and Giasone could easily adopt such a motto for his own.

Giasone:	Delizie, contenti,	Delights, raptures
	che l'alma beate,	that ravish my soul,
	fermate, fermate:	stop, stop:
	su questo mio core	on this heart
	deh più non stillate	let not one more drop fall
	le gioie d'amore.	of love's joys.
	Delizie mie care,	My beloved delights,
	fermatevi qui!	stop here!
	Non so più bramare,	I know not how to desire more,
	mi basta così.	I have enough.
	In grembo gl'amori	In the lap of love
	fra dolci catene	in sweet chains
	morir mi conviene.	I would like to die.
	Dolcezza omicida,	Murderous sweetness
	a morte mi guida	lead me to my death
	in braccio al mio bene!	in the arms of my beloved.
	Delizie mie care (etc.)	My beloved delights (etc.)

The lyrics Giasone sings in his opening aria assert that he is sated with the delights of love and wants no more of desire. But his verbal tropes—chains, ravishment, and "murderous sweetness"—pull rhetorically against what he offers as his principal argument for abstention. And Cavalli's music too pre-

sents these lyrics as if Giasone were fighting a losing battle, for it all too happily wallows in pleasure (figure 18). Giasone produces a passive energy vacuum around himself that provokes the desires of others, something like the effect of Michelangelo's languorous *David*.[44]

Occasionally one of Giasone's musical lines will gesture toward desire. It will build intensity by sequencing or even modulating from D dorian up to the dominant, A minor, which requires him to alter his sleepy sixth-degree B-flat up to B-natural (in the first verse, compare the first statement of "deh più" on B-flat with the second, in which the pitch has been raised for a cadence on A minor on "gioie d'amore"). But these moments of potential action yield almost immediately to the subdominant tug back to B-flat and his more or less permanent eros-saturated state; they serve to make his collapse back into passivity all the more glorious. That (as he claims) he no longer *wants* to desire is clear enough: he can hardly muster the energy to remind us what desire might sound like. But that he wishes erotic pleasure to leave him alone seems doubtful, given the bliss with which he surrenders time and again in his rondo-shaped aria to its gravitational pull toward the subdominant.[45]

What we (and Hercules) expect of a hero of Giasone's reputation, I think, is an expression with greater aggression; a tendency to push forward on a modulatory quest, to extend phrases beyond their anticipated length by virtue of sheer willpower. Such formulations occur frequently enough in Cavalli, even in amorous situations; in *L'Ormindo*, for instance, the eponymous character's opening aria manifests these qualities, as do many of Medea's utterances. Giasone does not sing as he does, in other words, because he is trapped inside a piece of "early music." Rather, Cavalli labors in this aria to produce this image of extreme languor—a languor from which Giasone will emerge just barely long enough to seize the fleece. After his one, almost perfunctory heroic deed, he sinks back into his preferred state of mutual ecstasy with Medea. He would remain there indefinitely, were it not for the inopportune appearance of Isifile (a former lover, complete with twin set), a comic series of errors that nearly gets Medea killed, and a hastily arranged dénouement that pairs them both with spouses they don't particularly like but who offer the stability of socially sanctioned marriage.[46]

Later operas rarely present male characters whose principal attribute is hedonistic indulgence. To be sure, Mozart's Don Giovanni is just as sex-obsessed, but he operates within mechanisms of unbridled desire, not passive enjoyment. If Giovanni pursues insatiable lust, Giasone happily flops back and sings something like Prince's "Do Me, Baby"—a song that shares with Giasone's "Delizie, contenti" not only androgynous tessitura and surrender to bliss, but also a penchant for trance-like rocking.[47] Yet Giasone's propensity for sacrificing active agency on the altar of pleasure (although controversial, as

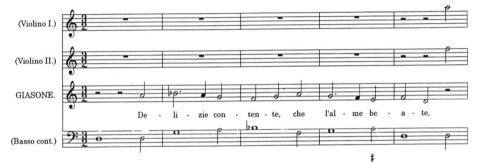

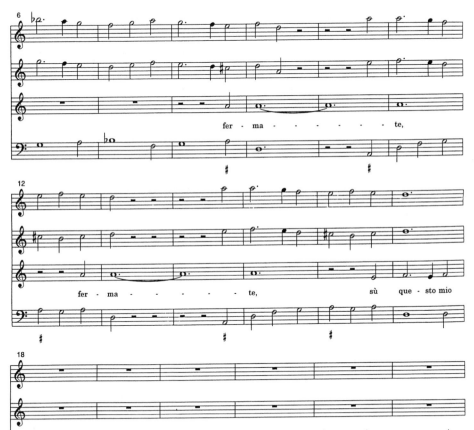

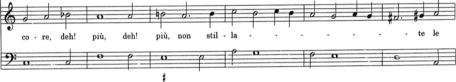

18. Giasone's aria, "Delizie conteni" from Cavalli's *Il Giasone* (1649).

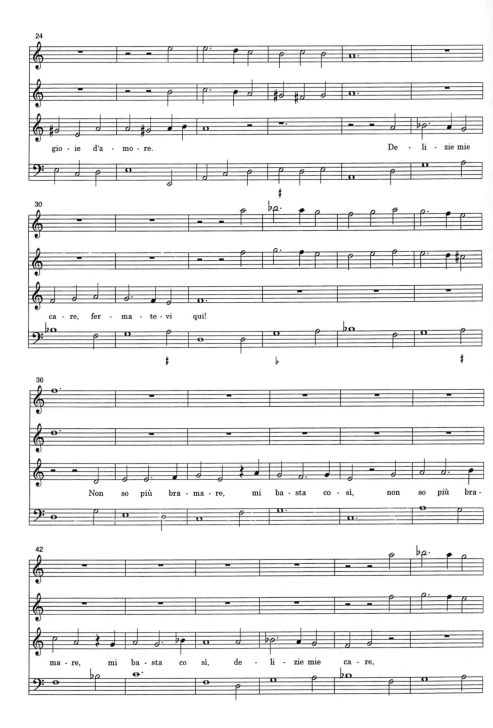

18. (*continued*) Giasone's aria, "Delizie conteni" from Cavalli's *Il Giasone* (1649).

18. (*concluded*) Giasone's aria, "Delizie conteni" from Cavalli's *Il Giasone* (1649).

the opera itself indicates) is a larger phenomenon of seventeenth-century culture, not simply a personal idiosyncrasy.

Think, for instance, of all those versions of "O quam tu pulchra es" that flourished in Venice in the first half of the century. Whether set by Alessandro Grandi or Heinrich Schütz, this passage from the Song of Songs alternated between fervent attempts at describing the lover's beauty and collapses back into a passive state of mind-numbing pleasure with each return of the refrain, "oh, how beautiful you are!" By the end of the Schütz setting, the singers can do little but moan, as the harmonies rock (Giasone-style) back and forth between subdominant and a tonic of severely weakened integrity.[48]

Recall also the poetry of Giambattista Marino, which eschews the dynamic power of Renaissance rhetoric and substitutes proliferating, overripe images of static sensuality. Both seventeenth-century and present-day critics are squeamish in the face of this poetry, especially when it appears to have seduced master composers such as Monteverdi in perverse artistic directions.[49] Certainly, the duets of Monteverdi's Book 7 reveal that he had fallen under the sway of this intensely erotic but passive sensibility, that he had set aside the rhetorical impulse that marked his early madrigals and the opera Orfeo. Monteverdi even thematizes the choice in his Book 8, Songs of Love and War, in his setting of the text: "Let others sing of Love, the tender archer: the sweet caresses, the sighing kisses in which two beings dissolve into one . . . but I will sing of Mars!" Like Giasone, Monteverdi lingers too long over the "delizie" of love to make his renunciation even remotely convincing. For those of us who prefer those luxuriant images, the call to arms (when it finally emerges, replete with military fanfares) spells disappointment, a surrender to duty and tedious saber-rattling.

It also spells a surrender in music technology to dynamic motion. If their destinies as empire builders snatch Aeneas from Dido's arms, Theseus from Arianna's, and Jason from Medea's, our favorite narratives of music history— in which it is the "destiny" of music to discover teleological tonality—make some musicologists impatient with these moments in which progressive, desire-driven images of subjectivity yield to passive erotic pleasure. And the verbal arguments that riddle Il Giasone reveal that the versions of masculinity performed in Marinist poetry or the Song of Songs were becoming controversial even by 1650. By the 1680s, few remnants of this moment of masculine indulgence in sensuality will remain, as dominant-oriented tonal schemata and rigorous binary oppositions come to prevail in opera seria gender representations.

But Giasone sings his aria without any anxiety or apology, even though the cultural debate concerning masculinity rages around his utterances. Admittedly, he does not present the most admirable role model in his behavior, as he participates in a series of affairs without giving thought to reproductive consequences, and the plot will conspire to reform him from hedonistic playboy to dutiful father. Yet in his resistance to channeling sexuality exclusively toward

procreation, his reluctance to forgo pleasure for the sake of patriarchal authority, Giasone stands as a performer of "gender trouble" from a distant era.

Students of Elizabethan theater have taught us to question the universality of the binary gender arrangements bequeathed to us by the Enlightenment. But we can learn even more by attending to the politics of pleasure in mid-seventeenth-century Venetian opera, which adds to the cross-dressing beloved of most Renaissance drama both the castrato and those musical performances of desire that run counter to our notions of "how music works."

Ten years ago, skeptics doubted that music had anything at all to do with gender—or even with representation, more broadly understood; music was thought to work according to its own austere premises, untouched by mundane concerns such as the body or sexuality. As our explorations of Giove and Giasone indicate, however, many of the most fundamental conventions of musical procedure took shape in tandem with changing and contested constructions of gender and eroticism. In the wake of "the artist formerly known as Prince," those bizarre performances by Giasone and Giove no longer seem like befuddled early attempts at operatic characterization; indeed, they may appear to us far more sophisticated than the predictably "masculine" stick-figure heroes of the nineteenth-century stage.

If gender-related questions cannot provide all the answers we might want to ask about culture, they have forced us to rethink much of what we thought we knew concerning not only the history of music, but also the history of subjectivity. The Elizabethans undertook pilgrimages to the Italian stage in order to expand their repertory of possible pleasures, and Venetian opera offers similar opportunities to us post-Enlightenment subjects as we begin to crawl out from under a particularly rigid economy of gender organization. No longer dusty museum pieces studied only by musicology graduate students for comprehensive examinations, the seventeenth-century music dramas of composers such as Cavalli can serve once again to incite carnival in the receptive imagination.

NOTES

1. See, for instance, Michel Foucault, *The History of Sexuality*, vol. 1, trans. Robert Hurley (New York: Vintage, 1980); Judith Butler, *Gender Trouble: Feminism and the Subversion of Identity* (New York and London: Routledge, 1990); Thomas Laqueur, *Making Sex: Body and Gender from the Greeks to Freud* (Cambridge, Mass.: Harvard University Press, 1990).

2. See, for instance, Robert Walser, *Running with the Devil: Power, Gender, and Madness in Heavy Metal Music* (Hanover, N.H.: University Press of New England/Wesleyan University Press, 1993); Walser, "Prince as Queer Poststructuralist," *Popular Music and Society* 18, no. 2 (Summer 1994): 87–98; John Gill, *Queer Noises* (Minneapolis: University of Minnesota Press, 1995); and Simon Reynolds and Joy Press, *The*

Sex Revolts: Gender, Rebellion and Rock 'n' Roll (Cambridge, Mass.: Harvard University Press, 1995).

3. See especially Stephen Orgel, "Nobody's Perfect: Or, Why Did the English Stage Take Boys for Women?" *South Atlantic Quarterly* 88, no. 1 (1989): 7–29; Marjorie Garber, *Vested Interests: Cross-Dressing and Cultural Anxiety* (New York and London: Routledge, 1992); Bruce Smith, *Homosexual Desire in Shakespeare's England: A Cultural Politics* (Chicago: University of Chicago Press, 1991); Susan Zimmerman, ed., *Erotic Politics: Desire on the Renaissance Stage* (New York and London: Routledge, 1992); Peter Stallybrass, "Transvestism and the 'Body Beneath': Speculating on the Boy Actor," in Zimmerman, *Erotic Politics*; Valerie Traub, *Desire and Anxiety: Circulations of Sexuality in Shakespearean Drama* (New York and London: Routledge, 1992); Jonathan Goldberg, *Sodometries: Renaissance Texts, Modern Sexualities* (Stanford: Stanford University Press, 1992); and Goldberg, ed., *Queering the Renaissance* (Durham and London: Duke University Press, 1994).

4. Nino Pirrotta, *Music and Culture in Italy from the Middle Ages to the Baroque* (Cambridge, Mass.: Harvard University Press, 1984), chapters 15–22; Lorenzo Bianconi, *Music in the Seventeenth Century* (Cambridge: Cambridge University Press, 1982); Ellen Rosand, *Opera in Seventeenth-Century Venice: The Creation of a Genre* (Berkeley and Los Angeles: University of California Press, 1991); and Wendy Heller, "The Queen as King: Refashioning Semiramide for *Seicento* Venice," *Cambridge Opera Journal* 5, no. 2 (1993): 93–114. See also my "Constructions of Gender in Monteverdi's Dramatic Music," in *Feminine Endings: Music, Gender, and Sexuality* (Minneapolis: University of Minnesota Press, 1991), and my review of Rosand in *Historical Performance* 4, no. 2 (Fall 1991): 109–17.

5. The situations in France and Spain differ from each other and from England or Italy. The French found most Italianate practices of the time nothing less than disgusting—especially those which involved castrati (Gluck had to rewrite his Italian operas for the French stage to purge them of these unnatural creatures). Gender-related issues in Spanish theater of this time have only recently been addressed. See Pilar Ramos López, "Mujeres, música y teatro en el Siglo de Oro," in *Música y Mujeres: género y poder*, ed. Marisa Manchado Torres (Madrid: horas y HORAS, 1998).

6. On Italy and English transvestism, see Bruce R. Smith, "Making a Difference: Male/Male 'Desire' in Tragedy, Comedy, and Tragi-Comedy," in Zimmerman, *Erotic Politics*, 132, 138, 142.

7. For more on the problems of dealing with the history of cultural pleasure, see Stephen J. Greenblatt, *Learning to Curse: Essays in Early Modern Culture* (New York and London: Routledge, 1990), 9–11.

8. For more on the range of fantasies invoked by female transvestism, see the essays in Zimmerman, ed., *Erotic Politics*, especially Stephen Orgel, "The Subtexts of *The Roaring Girl*"; Lisa Jardine, "Twins and Travesties: Gender, Dependency and Sexual Availability in *Twelfth Night*"; Valerie Traub, "The (In)significance of 'Lesbian' Desire in Early Modern England"; and Jean E. Howard, "Sex and Social Conflict: The Erotics of *The Roaring Girl.*"

9. Margaret Reynolds, "Ruggiero's Deceptions, Cherubino's Distractions," in *En Travesti: Women, Gender Subversion, Opera*, ed. Corrine E. Blackmer and Patricia Juliana Smith (New York: Columbia University Press, 1995), 135.

10. See Nina Treadwell, "Female Operatic Cross-Dressing: Bernardo Saddumene's Libretto for Leonardo Vinci's *Li zite'n galera* (1722)," *Cambridge Opera Journal* 10, no. 2 (July 1998): 131–56.

11. Blackmer and Smith, *En Travesti*.

12. On the differences in plots between Elizabethan and Jacobean Shakespeare,

see Leonard Tennenhouse, *Power on Display: The Politics of Shakespeare's Genres* (New York: Methuen, 1986).

13. Suzanne Cusick, "Of Women, Music, and Power: A Model from Seicento Florence," in *Musicology and Difference: Gender and Sexuality in Music Scholarship,* ed. Ruth Solie (Berkeley and Los Angeles: University of California Press, 1993). For a study that focuses on slightly earlier genres of music drama, see Nina Treadwell, "*Sirene* at Court: Musical and Balletic Performance at Ferrara under Lucrezia d'Este and Margherita Gonzaga (1580–97)" (Ph.D. diss., University of Southern California, in progress).

14. For a study of Roman musical culture under Christina, see Carolyn Gianturco, *Alessandro Stradella, 1639–1682* (Oxford: Oxford University Press, 1994).

15. For more on the increasing clout of divas in seventeenth-century opera, see Rosand, *Opera in Seventeenth-Century Venice.*

16. The most important work on gender in seventeenth-century opera is being carried out by Wendy Heller, whose book-length treatment of seventeenth-century Venetian opera will be published by the University of California Press.

17. See, for instance, Susan Leonardi and Rebecca Pope, eds., *The Diva's Mouth* (New York: Routledge, 1996); Mary Ann Smart, "The Lost Voice of Rosine Stoltz," in Blackmer and Smith, *En Travesti.*

18. Stallybrass, "Transvestism and the 'Body Beneath.'"

19. Libretto, Giacomo Francesco Parisani; music, Giacinto Cornacchioli.

20. For the English convention of associating Italy with sodomy, see Goldberg, *Sodometries,* 105–6; and Alan Bray, "Homosexuality and the Signs of Male Friendship in Elizabethan England," in Goldberg, ed., *Queering the Renaissance,* 49 and 60.

21. For more on castrati, see Angus Heriot, *The Castrati in Opera* (London: Calder and Boyars, 1975); John Rosselli, *Singers of Italian Opera: The History of a Profession* (Cambridge: Cambridge University Press, 1992); Michel Poizat, *The Angel's Cry: Beyond the Pleasure Principle in Opera,* trans. Arthur Denner (Ithaca: Cornell University Press, 1992); and Joke Dame, "Unveiled Voices: Sexual Difference and the Castrato," in *Queering the Pitch: The New Gay and Lesbian Musicology,* ed. Philip Brett, Elizabeth Wood, and Gary C. Thomas (New York: Routledge, 1994).

The most sympathetic engagement with castrati, sensationalistic though it may be, remains Anne Rice's novel *Cry to Heaven* (New York: Knopf, 1982). Rice makes a compelling case for the erotic fascination of the castrato, and she even explains why audiences would have sat spellbound throughout one lengthy da Capo aria after another. More than any historical account, Rice's novel seems to have influenced the film *Farinelli,* which (however it may stand as a film or historical document) at least makes plausible the castrato's sexual power. As we watch the lead character stand stock-still and spin his virtuoso ornaments on Handel's melodic lines, we probably get a better glimpse into the pleasures of *opera seria* than in all the books on the subject combined.

See also Dominique Fernandez, *Poporino, or The Secrets of Naples,* trans. Eileen Finletter (New York: Morrow, 1976), for another sympathetic castrato novel, this one focusing on the impending downfall of the castrati in the eighteenth century, along with the aristocracy that had sustained them.

22. See especially the classic study by Roland Barthes, *S/Z,* trans. Richard Miller (New York: Hill and Wang, 1974). See also David Henry Hwang, *M. Butterfly* (New York: Plume, 1989).

23. For a more extended discussion of this problem, see Dame, "Unveiled Voices," 148–51. Dame carefully distinguishes between the moment of the castrati and our own time. She argues that in the recasting of women in castrato roles,

the homoerotics of the castrati have been displaced by lesbian erotics. Those who are deaf to this, can stay deaf. Though male voyeurism has rarely objected to lesbianism in art, for my part I consider this lesbian representation in modern revivals of baroque operas a present from history, a history that has rendered the authentic casting of castrati impossible, probably for the good. (151)

Still, in their seventeenth-century contexts, these roles represented heroic males— *not* women—and this is the economy I seek to understand here. For purposes of this essay, I am thus resisting the now-frequent argument that reads baroque castrati as women for purposes of lesbian eroticism. To be sure, women sometimes played these roles—particularly in France, which found castrati despicable, and also in the years following the disappearance of castrati. Gluck's *Orfeo* was the only castrato opera to survive the change in taste, and this is the opera that usually inspires discussions of female/female eroticism (see, for example, Willa Cather's *Song of the Lark*). By the late eighteenth century, this custom had led to the creation of trouser roles: male parts designed for female singers, usually with the invitation to imagine same-sex encounters between women (Cherubino and "his" women, Strauss' Octavian and "his"). See the essays by Terry Castle, Margaret Reynolds, Hélène Cixous, and Wendy Bashant in Blackmer and Smith, *En Travesti*.

24. Garber, *Vested Interests*, chapter 13.

25. The concept of the Great Masculine Renunciation was introduced and explained in J. C. Flugel, *The Psychology of Clothes* (London: Hogarth Press, 1930), 113.

26. See the discussion of this play in Traub, "The (In)significance of 'Lesbian' Desire," 159–63.

27. For an examination of this project, see my "Constructions of Gender in Monteverdi's Dramatic Music."

28. Garber, *Vested Interests*, 39.

29. Mikhail Bakhtin, *Rabelais and His World*, trans. Hélène Iswolsky (Bloomington: Indiana University Press, 1984).

30. Pirrotta, *Music and Culture in Italy*, 248.

31. See, for instance, Goldberg in his introduction to *Queering the Renaissance*, 6: These essays do not know in advance where sexuality is or how it will manifest itself (indeed, there is pressure in several of these essays on the very crucial question of whether there is any such thing as sexuality in itself beyond its variegated historical manifestations), but they know that the failure to raise questions of sexuality in these texts has often meant nothing less than the tacit assumption that the only sexuality that ever obtains is a transhistorical heterosexuality.

32. See particularly the works of Alessandro Grandi, who specialized in sacred-erotic motets, and the *Symphoniae Sacrae* of Heinrich Schütz, a German composer who spent a sabbatical at San Marco and developed an especially intense version of this genre after his return to Dresden. I am at present writing on the phenomenon of Divine Love in seventeenth-century music and culture.

33. For more on the Incogniti, see Rosand, *Opera in Seventeenth-Century Venice*; Bianconi, *Music in the Seventeenth Century*; Iain Fenlon and Peter Miller, *The Song of the Soul: Understanding "Poppea"* (London: Royal Musical Association Monographs, 1992).

34. Bizarrely enough, Fenlon and Miller conclude from their interrogation of the Incogniti and Monteverdi's *L'Incoronazione di Poppea* that music *cannot* lie. See my review in *Music and Letters* 74, no. 2 (May 1993): 278–81.

35. Listen to the remarkable recording of *La Calisto* directed by René Jacobs, Harmonia Mundi 901515.17. The final scene of the opera continues the extravagant mixture of Christian imagery, erotic love, and references to she-bears.

36. The same device also characterizes much flamenco, which may have been among the original sources for this procedure, and it underlies a good deal of contemporary popular music, including metal, blues, and West Coast rap. See, for example, my "Wuthering Depths," a review of PJ Harvey's album *To Bring You My Love, Village Voice*, March 14, 1995.

37. See David Lewin, "Women's Voices and the Fundamental Bass," *Journal of Musicology* 10, no. 4 (Fall 1992): 464–82.

38. For more on the *concerto di donne*, see Anthony Newcomb, "Courtesans, Muses, or Musicians? Professional Women Musicians in Sixteenth-Century Italy," in *Women Making Music: The Western Art Tradition, 1150–1950*, ed. Jane Bowers and Judith Tick (Urbana: University of Illinois Press, 1986).

39. I resist understanding any practice as "purely musical," even though theorists often attempt to protect music from ideological critique by appealing to this blanket excuse. See my *Conventional Wisdom: The Content of Musical Form* (Berkeley and Los Angeles: University of California Press, forthcoming).

40. Giovanni Maria Crescimbeni, *La bellezza della volgar poesia* (Rome: Buagni, 1700), 106–7. Quoted in Rosand, *Opera in Seventeenth-Century Venice*, 275.

41. For more on the problem of erotic excess in Elizabethan drama, see Catherine Belsey, "Desire's Excess and the English Renaissance Theatre: *Edward II, Troilus and Cressida, Othello*, in Zimmerman, *Erotic Politics*.

42. Pirrotta, *Music and Culture in Italy*, 252–53.

43. Bianconi, *Music in the Seventeenth Century*, 206.

44. For more on the issue of passive/active masculinities in Italy, see Guido Ruggiero, "Marriage, Love, Sex, and Renaissance Civic Morality," in *Sexuality and Gender in Early Modern Europe: Institutions, Texts, Images*, ed. Hames Grantham Turner (Cambridge: Cambridge University Press, 1993).

45. Listen to the recording of *Il Giasone* directed by René Jacobs, Harmonia Mundi 901282.84.

46. This opera, which has mostly celebrated the sensuality of Giasone's and Medea's relationship, appeals suddenly to motherhood in a way that shocks at least as much as the earlier erotic excesses: Isifile begs Giasone to kill her if he no longer wants her, but asks only that he spare her breasts, so that her dead body may continue to suckle their infants with its mixture of milk and blood. Giasone capitulates immediately in the face of this over-the-top maternal guilt trip. The act ends abruptly with everyone singing the praises of the new couple, and the curtain falls before this bizarre semblance of closure can come undone. Incidentally, the blood-and-milk trope circulated in sacred music of the time: compare this with Chiara Margarita Cozzolani's "O quam bonus es," a dialogue in which devotees—respectively, of Christ's blood and Mary's milk—exchange hyperbolic erotic claims.

47. Prince, "Do Me Baby," *Controversy* (Warner Brothers, 1981). Prince derives his falsetto delivery in part from a long line of African-American high-voice virtuosos in both gospel and soul music (e.g., Claude Jeter of the Swan Silvertones, Smokey Robinson, Philip Bailey of Earth, Wind and Fire), none of whom have gender-bending in mind. But he developed his style in the 1970s when gender confusion became rampant in popular culture, and his lyrics and outrageous performing style make clear that he wishes to confound gender (the opening lines of "I Would Die 4 U" are "I'm not a woman / I'm not a man / I am something that you'll never understand"). His decision to discard his name in exchange for a symbol composed of male and female signs indicates how seriously he takes this project. Prince's work also draws heavily on sacred-erotic imagery.

I am not suggesting any direct link between Prince's late-twentieth-century work

and the seventeenth century; I only wish to argue that those earlier practices, which sometimes seem so alien, have analogues in today's popular culture.

48. The setting by Schütz is in *Symphoniae Sacrae I* (1629).

49. For other views, see Pirrotta, "Monteverdi's Poetic Choices," in *Music and Culture in Italy*; and Gary Tomlinson, *Monteverdi and the End of the Renaissance* (Berkeley and Los Angeles: University of California Press, 1987).

11. Christian Aerobics: The Afterlife of Ecclesia's Moralized Motions

I WAS TRACKING DOWN the origins of a modern sexual stereotype when I turned up the traces of an old Christian allegory. The stereotype is the dancing queen: the sex-crazed homosexual who parties his life away while straight society attends to the serious business of raising kids. Inevitably his dizzy social whirl drags him down into a sterile round of pleasures—the "Circuit" as he direly calls it—where he loses control of his life. Disco hits are his requiem. It's rainin' men. Can't stop the music. Slave to the rhythm. Burn, baby, burn.

While this absurd reduction of gay life has led to the production of countless bad drag acts and at least one great Bildungsroman (Andrew Holleran's *Dancer from the Dance*), a perniciously moralistic variation of the stereotype has recently resurfaced in the mainstream media in the wake of Andrew Cunanan's assassination of Gianni Versace. *Newsweek*, for instance, couldn't resist the theological temptation to link the demonic élan of Cunanan ("a great and gaudy pretender") with the divine éclat of Versace (the "fashion god") in a single icon of gay decadence.[1] Accompanying journalist Richard Alleman's glum "look at the homosexual scene" is a druggily unfocused photograph of a young male dancer at a South Beach nightclub (figure 19). What does this anonymous barboy have to do with the murder? Literally nothing. Figuratively, however, he "explains" everything. His body looms like an idol over the article as compelling evidence of the paganism of the homosexual scene—a metonymy of the flashy glamour and fleshy glow of the gayspace for which Versace created his fantasy lifestyle and through which Cunanan performed his dance of death.

Ironically, the old allegory from which Alleman's taboo-defining vision of predatory gigolos and vulnerable A-gays coupled "at the hottest clubs" derives its iconic power to produce transgressive frissons would not have been unfamiliar to Versace as an Italian Catholic. Versions of it have flourished in Italy since Late Antiquity, when Saint Ambrose was bishop of Milan and Saint Augustine was attending his sermons on the sacred dance of Ecclesia. Long

19. Dancer in South Beach nightclub. Jeffrey Knee/
Silver Image.

opposed to the immorally twisted movements of the go-go boys of South Beach—the dance of pagan debauchery—is the unbending performance of the Church's *honesta saltatio*.

1. *The Catholic Saltator*

All the bodily movements in the "honorable dance" defined for Ecclesia by the post-Nicene Latin Fathers were envisioned as symbolic exhibitions of otherwise invisible spiritual acts. In the performance of good works, preached Augustine, the faithful "show their limbs to the living God."[2] That is their only proper dance, and God is the only spectator they need to impress, for He alone is in a position to judge all their public and private acts of charity. Their command performance, the choral formation of the Church's "mystical body" with Christ at its head, is in progress even when the faithful are away from church. They are not only inside Ecclesia wherever and whenever their actions imitate those of Christ or express their gratitude for his actions. Ecclesia is also inside them.

Thus does the dance as a performance in the body come "inside" the mystical body of the Church—suddenly, shockingly, in the late fourth century C.E.

—despite the efforts of Ambrose's patristic predecessors in the Latin West to exclude *saltatio* from the range of honorable Christian activities.³ Through participation in Ecclesia's New Dance the faithful are taught to see that their Church is not a tent in the wilderness like the tabernacle of the Law but a holy society of Grace "stretching itself out to endure all hard and painful things" in the City of Man. Their show of limbs is to be valued primarily as a cultural alternative to the World's appalling exhibitions of lust, immodesty, and concupiscence.

Yet the performance of this unworldly dance in the bodily Here and Now was no substitute for the beatific activity of the virtues within the soul; rather it was an outward extension of that activity. Moved by the example of King David, who was "not embarrassed to dance before the Ark of the Lord," Ambrose suppressed his highbrow Ciceronian contempt for bodily exhibitions by humbly applauding the human body when it picked itself up, shook off its sinful torpor, worked its recalcitrant limbs, and strengthened its muscles for the New Dance.

Blatantly corporeal acts of worship like David's "may be unseemly in themselves," Ambrose observed, "but they must be revered and contemplated in the holy light of religion"—there was no getting around it—"because those who censure such displays of piety may be caught in the net of censure themselves."⁴ For all his fulminations against the Flesh, the bishop of Milan would not glare like Michal (Saul's prudish daughter) at a naked dancer leaping for the Lord. Instead of wholly internalizing the dynamics of sacred dance in order to purge it of potential theatricality, he boldly projected it into the theater of allegorical embodiment. Opposed both literally and figuratively to the World's unseemly shows, the physical moves in the *honesta saltatio* could be read as a sequence of enduring visual signs that expressed a multitude of anagogic or tropological meanings like the polysemous verbal signs in the Bible. The simple set of bodily movements he taught the Catholic Spectator to contemplate in a religious light became the kinetic "vocabulary" of the Catholic Saltator.

The simple character of these motions would long be perceived in the Latin West as healthy and chaste and "natural," for their prototypical performer would be a militant moralist who reflexively perceived the opposition of the Church's honorable dance to the contagiously erotic, artfully elaborate body language of the Theater. Showing the body for its own sake would never be the Church's aim. Like the Virgin of Israel, who went forth "in the dances of them that make merry" (Jeremiah 31:4), Ecclesia could rejoice in the knowledge that the Lord still loved her despite her ruinous earthly state and would build her up again as he had promised. Her moves must therefore be like those of an athlete in training—brisk, forceful, disciplined, repetitive, sometimes painful, but always good for the constitution.

Lest the *honesta saltatio* be regarded as a mere set of ascetic exercises, Ambrose was careful to present it as an aesthetic response to David's prophetic

harping. As a rehearsal for the eternal dance of the Saved the training of the Catholic Saltator would be a joy to behold, a pleasure to undertake. By regarding its enactment as a therapeutic practice, Ambrose turned the choral education of the classical past into a kind of moral "aerobics" for the Christian present—a present in which Ecclesia's apocalyptic future was being beautifully realized, moment by moment, through her restoration of David's dance. Under Ambrosian influence, ascetic discipline became a triumph of aesthetic discernment.

Ecclesia's workout began with straightening and stretching the limbs, for only when the body was warmed and limbered up with ascetic zeal could it complete the demanding routine of the New Dance by stamping, striding, springing, and stripping. Like the novice priests under Ambrose's instruction at the cathedral of Milan, let's follow the Catholic Saltator through each of these actions to the point where all is bared—as in David's dance—without embarrassment.

2. Six Movements of the New Dance

I. *Correctio*: Straightening Up

Correctio was the term the Latin Fathers commonly used to denote self-improvement and social reform. Originally it meant "setting things together in a straight line" or "guiding things along a straight course," and later, in the works of Cicero and the Roman Stoics, "adhering to a strictly rational code of ethics." Ambrose was particularly fond of the word, reviving its etymological meanings while revising its ethical significance along Catholic lines. The "straight" life of the Roman philosophers was not without its virtues, he conceded, but its rules for perfection tended to freeze the prudent, the brave, the just, and the temperate into attitudes of apathy, hauteur, smugness, and cynicism. Such attitudes were unsuitable for the Catholic Saltator, who learned how to dance along the straight and narrow by following lives rather than rules. To improve the Christian life as an ongoing performance, the honorable dancer imitated the life of Christ. The bent of the Catholic Saltator was not to bend—especially under pressure. If the chorus of Christ drooped in the strenuous process of self-correction, their lives would resemble the reviled *flexus* or "bendings" of the pantomime dancers in the Theater.

The opposite of *correctio* was mad *confusio*, a "pouring out, scattering around, and twisting together" of things that ought to be kept apart for the preservation of natural and cultural order. In the following evocation of the decadent movement of the imperial court in Milan, Ambrose sardonically invites us to the banquet of Pleasure where the genders of the young dancers are as "confusing" as the benders of their audience:

The banquet hall glittered with the luxurious splendor of a royal court . . . The slippery ground was littered with fish bones and flowers already wilting. Everything there was confused—the tumult of the banqueters, the clamour of orators, the slaughter of brawlers, the roaring of singers, the crashing of dancers [*saltatium strepitus*], the laughter of revelers, the applause of wanton rioters. Nothing there followed the order of nature. You could see dancing-girls with shaven heads and boys with curled locks, feasters with indigestion and gluttons belching, thirsty drunkards, and sots suffering either from yesterday's hangovers or today's tipsiness, and cups full of their vomit which gave off a stronger smell than fresh wine. Pleasure, standing amid them, said: "Drink, and be drunk, so that each of you will fall and rise no more." (*De Cain et Abel* 1.4.14)[5]

In Pleasure's utterly uncosmic dance, where nothing follows the order of nature and everything furthers the disorder of culture, the gravity of original sin works in a ludicrously literal sense on the dancers, duelists, diners, and drunks. Whatever they do here ends in a fall—for it all begins with the Fall. After ages of Trimalchio-style feasting the diners and drunks have splattered the once noble banquet-hall (a classical image of the cosmos) with wine and oil and vomit, making the floor so slippery that anyone who dances or duels on it is bound to take a tumble. Lust is naturally aroused at the dance of Pleasure only to be confused by its "unnatural" stimuli. The curly-haired belles of the ball turn out to be effeminate *pueri*, the ancestors of the South Beach go-go boys, while the dancing-girls accompanying them appear distinctly mannish with their shaven heads. Versace's fall outside the Medusa gates of his fabulously appointed Ca' Casuarina (*Newsweek's* version of the Palazzo of Pleasure) would not have surprised the bishop of Milan in the least. Behind Pleasure's façade lurks the Gorgon.

Correctio implied a moral regulation of bodily dynamics, a kinesiology of devotion. Ambrose explicitly commends diligent self-correction from an aesthetic viewpoint in his instructions to priests on how to comport themselves during the enactment of religious services. "An acceptable gait," he advises his novices, "is that which presents an image of authority, carries a weight of solemn dignity, and leaves an impression of tranquility . . . To avoid artifice, let there be no lack of amendment or improving practice [*correctio*]" (*De officiis ministrorum* 1.18.75).[6] Since Ambrose regarded the movement of the body as the "voice" of the soul, we should expect him to regard the bodily action of *correctio* as a mere secondary effect, an external expression, of the primarily internal activities of the corrigible soul—self-criticism, sincere repentance, and anagogic aspiration. However, in both this passage and the last, he suggests that corporeal agility and spiritual diligence are mutually reinforcing when body and soul work together to amend whatever is faulty in their symbiotic nature. The Catholic Saltator, by straightening out his bent limbs and raising his fallen frame into an attitude of ascendant hope, feels healthier, livelier, more hopeful than his moral antitype, the twisted *histrio* ("stage-dancer") of the Roman theater, and this physical feeling—the Late Antique equivalent of

the endorphin rush—in turn strengthens his spiritual resolve to improve human nature through moral discipline.

In contrast to the Neoplatonic Bacchant, who was doomed to yearn for impossible heights of hypostatic disembodiment, the Catholic Saltator always has faith that his diligent efforts at self-improvement will be crowned with everlasting success. Disembodiment is not his ascetic goal. The correct trajectory of his moral motion leads straight on to resurrection and up to beatitude, and his body will go with him (eventually) all the way. The fusion of etymological and tropological meanings of *correctio* in Ambrose's moral treatises illustrates the peculiarly holistic character of Catholic allegory, which tends to construct dynamic new visions of cosmic and cultural unity out of discordant elements drawn from the biblical and classical traditions.

Following Ambrose, Augustine boldly demonstrates the invincible truthfulness of the Church's dynamic visions of nature and culture by drawing the movements of the Catholic Spectator into the unfolding realization of the Divine Plan. Consequently, any actual dance observed or joined by the spectator in the short run of this life inescapably figures in the long run of sacred history. Just as the Incarnation dissolved the classically sane boundary between humanity and divinity by bringing both into miraculous proximity, so the incarnative allegory of the New Dance annihilates the distance between spectator and spectacle by incorporating the fleshly life of the sinner into the spiritual drama of the saints. Incarnative allegory functions like a figural vision: or rather it becomes a figural vision as soon as its characters are invested with typological meaning and impelled into narrative.

What the New Dance primarily exhibits is the human mind in a state of moral perfection: according to Augustine, dancing in the mind (*mente saltare*) must precede movement in the limbs (*motus membrorum*) if the sacred dance is truly to be sacred.[7] But mental dancing in this Latin ecclesiastical context does not mean an intellectual bacchanal high up in the Neoplatonic ether, beyond the dust kicked up by the body. *Mente saltare* takes place right here on earth, right now in church, through the long hard struggle of the faithful to straighten up their sinful lives. Hearts will be moved by the example of the martyrs, and bodies unbent by the corrective grace of God, but before that can happen, minds must be receptive to the inward melody Augustine called the "Good Song" of charity.

II. *Extensio*: Stretching Out

When a limb of the body is straightened to its limit, the resulting motion is an *extensio* or "stretch." The straighter the torso, the longer or higher the extensions of the limbs. Similarly, when the soul is corrected to the limit of moral amendment, the longer are its devotions and the higher its anagogic reaches to the limits of human understanding. Just as a dancer cannot perform an

extension without straining an arm or a leg toward a point beyond its relaxed reach, so a Christian cannot perform a charitable deed without raising the soul away from the heaviness of the fallen body toward a buoyant life beyond the grasp of the worldly.

Why and where the Catholic Saltator should stretch body and soul were questions to which Ambrose and Augustine gave somewhat different answers. Their divergent visions of the Christian happy life inevitably affected the spiritual motivations and directions they envisioned for the performers of the *honesta saltatio*. Ambrose tended to praise inward and upward extensions within the contemplative life of Ecclesia since he remained at heart a Christian Platonist, while Augustine eventually favored outward and downward stretches—outreaches of love toward the poor or the downtrodden within the social life of the Church—in reaction to the snooty perfectionism of the Pelagians. The distinctive emphases of Ambrose and Augustine as counterspectacular moralists are reflected in the different religious acts with which they figuratively associated the stretching of the Catholic Saltator and the different ends toward which they directed the cultural extensions of moral self-improvement.[8]

Ambrose liked to compare the pious act of *extensio* with Christ's earthly ministry and Paul's unearthly ecstasies. During his ministry Christ extended himself to humanity in many physical ways—by touching the sick, blessing the children, reaching out his hand to Peter on the waves. As an imitator of Christ the Catholic Saltator tries to make a big move in the right direction by responding not only to the New Song of the Gospels but also to its Pauline coda. In the Epistles, Paul beseeched his flock to go further than self-amendment in the quest for holiness. To attain the heavenly goal of salvation, which he defined as justification through faith, each sinner must yearn for divine grace and stretch body and soul beyond ordinary human limits in the race for the crown of everlasting life.

By analogy with *extensio*, which may be defined as *correctio* with a good push, piety in its active Catholic sense might be regarded as penitence with a good will—a zealous impulse to drive out pride and press oneself into religious service. So it was regarded by Ambrose in his treatise *On Penitence*, which was written between 384 and 394 in reaction to the heretical rigorism of Novatian. Commenting on Christ's dictum, "We have piped unto you, and ye have not danced" (Luke 8:32), he was careful to distinguish the "histrionic motions of a seductive dance" (*saltationis lubricae histrionicos motus*) from the body language of piety. The right sort of dance is promptly defined as a spiritual uplift with corporeal extensions:

> Therefore Christ did not mean the dance that is a partner of wantonness and extravagance [*illa deliciarum comes atque luxuriae praedicatur saltatio*], but the dance in which everyone lifts his body diligently and prevents his limbs from lying lazily on the ground or his steps from dragging sluggishly. (*De poenitentia* 2.6.42–43)[9]

Grace, lovingly extended from God to the penitent, sets the *extensio* of the Catholic Saltator apart from the characteristic *ephesis* or "straining" of the Neoplatonic Bacchant. When Plotinus danced in the spirit or circled "around Nous on the outside," his soul, which was ever stretching itself toward its unattainable object of desire, thrust itself with its own erotic energy out of the little world of the body and the great world of the cosmos into the ecstatic dance of Psyche.[10] But when Paul was caught up to the third heaven, his ecstasy had nothing to do with his own energies. The transhumanizing thrust behind his spiritual (and perhaps corporeal) extension came from Heaven as an undeserved gift, a grace, and he returned the unexpected favor not by leaping proudly for his own sake like an intellectual Corybant but by extending himself as a Christian missionary wholly *pro nobis*.

While Ambrose associated the extensions of the *honesta saltatio* with mystical impulses and penitential practices, Augustine tended to focus on stretches of a martyrological rather than mystical kind and to associate these specifically with corporeal acts of charity and fleshly imitations of the Crucifixion. In his commentary on Psalm 42, for instance, he praised the choristers in the tabernacle for disciplining their bodily members through patient suffering: "I respect a soul that . . . stretches itself out to endure all hard and painful things." In his commentary on Psalm 150, he translated the exhortation in verse 3 ("Let them dance and sing praises unto him with the timbrel and harp") into cues for the Catholic Saltator:

> Stretch out your hand to give bread to the poor . . . Then not only your voice but your hands too will produce concord. You have taken up an instrument and your fingers agree with your tongue. Now something must be said about the mystical meaning of the timbrel and the harp. Gut is stretched on a harp. On either instrument the Flesh is crucified. (*Enarratio in Psalmum CXLIX* [150], 8)[11]

How strange these musical cues would have sounded to the great cosmic dancers of the pre-Christian past! Philo's muselike Moses, for one, would have been shocked by Augustine's image of the flesh transformed.[12] The Catholic Saltator, by contrast, does not hear the ancient lyre of the cosmos — even when striving to appreciate the harmony of creation in relation to the New Song. All Augustine can hear in the distance are the mysterious gracenotes of the angels echoed by a human chorus, the *pacata societas* of the Church, while close to his ear he hears the steady beat of a charitable heart and the creak of tired bones stirred to devotion and the quiet strain of flesh chastened by a crucifying will.

III. *Percutio*: Stamping Down

After straightening up and stretching out, the chorus of Catholic saltatores are ready to make a loud noise like the pyrrhic dancers of old — except that what they beat is not a drum or a shield. It is their own flesh. And what they display

in their militant sign language is not violent fury toward a bloodthirsty crowd but virtuous service to their *pacata societas*. With pulsing blows to the timbrel of their skin they accompany the psalms ringing in their souls, and with hands clapping and feet stamping they liven up the grave procession of the penitent toward their exuberant (but never rowdy) celebration of Ecclesia's wedding to Christ.

By stamping and clapping they become prophets of holy mirth. "Scripture has taught us to chant solemnly," Ambrose sternly declared, "but it has also taught us to dance wisely, for the Lord said to Ezekiel: 'Clap your hands and stamp your foot.'"[13] This is as close to a joke as Ambrose ever came in his grave volumes of exegesis, and it is likely to be missed by anyone who fails to recall that the prophet clapped his hands and stamped his foot to reveal how the Lord would smite the idolatrous in their cities and trample down their altars and funeral cairns (Ezekiel 6:11). Dancing was the last thing on Ezekiel's mind when he acted on these orders. His percussive actions were the visual counterparts of ritual wailing, gestures of grief and frustration to accompany his mournful prophecies of divine vengeance.

While the Old Testament prophets typically envisioned dancing turned into mourning for the fallen and the faithless (see Lamentations 5:15), Ambrose happily turns mourning back into a dance. Of course the spirit-raising, body-rousing dance of the Resurrection, with its chaste separation of male and female choruses and its revelations of eternal love beyond temporal desire, must not be mistaken for a pseudomystical *confusio* of the Theater, with its merging and urging of the sexes, for "the Lord as the censor of morals would not have required men to bend their bodies and perform histrionic movements, or have ordered them to clap their hands in an effeminate manner, since such action would have led the prophet to the mockeries of the stage and the soft embraces of women" (*Expositio Evangelii secundum Lucam* 6:8). As a censor of morals himself, Ambrose was not about to bend on the issue of theatrical *opprobria*. Far be it from him to encourage the Catholic Saltator to flex his wrists and clap his hands like an effeminate mime! Bending the whole body or even a small part of it—if the action was not strictly necessary—was physically and morally "incorrect" from an Ambrosian viewpoint.

To stamp the foot (*percutere pede*) would require some bending at the knee even for the strictest prophet of the Resurrection, but the less of it the better. Too much *flexus* in the legs was a sure sign of moral unsteadiness and excessive sexual energy, and it would receive no commendatory *plausus* from the censor of morals. That is not to say that Ambrose could not bring himself to applaud the sometimes antic behavior, the divine playfulness, of the Old Testament prophets. Ezekiel, he noted with awe, "was ordered to clap his hands and stamp his foot and sing praises, for he already saw the [future] nuptials of the Bridegroom in which Ecclesia is wed and Christ is led forth as her lover." This was a cue for the Catholic Saltator to pick up the beat, to pulse

with the distant notes of jubilation. "You, too, take up the harp," Ambrose commanded,

> so that it may give back the sound of a good work after the chord of your veins has been inwardly struck with the plectrum of your spirit . . . Take up your drum so that your inward spirit may control with measured beats the instrument of your body and the sweet harmony of your morals may be expressed in the performance of gentle deeds. (*Expositio Evangelii secundum Lucam* 6:9–10)

The New Song heralded by the *percutio* of Ezekiel is incorporated into the life of the Catholic Saltator in a highly literal sense, an incarnative sense. It is strikingly embodied in the external and internal transformation of his body—once a silent, limp, and joyless weight of mortality—into an instrument of divine praise. His skin, dried, stretched, and beaten, serves as a timbrel to accompany the public exhibition of his harmonized motions and morals; his organs of speech become a psaltery taken up to express the concord of his words and work; his very veins, pulsing beneath the drum of his flesh, are struck by the plectrum of the Spirit.

All this Old Testament clapping and New Testament clamor may seem unclassical, even anticlassical, in inspiration. Yet at heart—as we can see by tracing the mystical vein of this allegory back to the hidden cause of its insistent rhythm—Ambrose's percussive version of *saltare sapienter* owes much to the musical sapience of the old academic philosophers. Still beating strongly in his commentary on Christ's choragic complaint "We have piped unto you, and ye have not danced" is the Platonic (and Neoplatonic) topos of the harmonious analogy between the human body and the cosmic body, a correspondence originally brought to perfection when the soul of a wise dancer moved with the cosmic soul under the influence of the god of wisdom. The plectrum striking these spirited Ambrosian chords was once in the hands of Apollo. Now it can be in the hands of any active Christian when the Spirit strikes.

The Spirit evidently struck Augustine, who followed Ambrose closely in his explanations of the moral significance of plausus, pulsus, and percutio. For instance, in his gloss on the exultant command "O clap your hands, all ye people!" at the start of Psalm 47, Augustine, assuming the dual role of choragus-pedagogus, asked the chorus of Christ what the word *clap* meant. Not simply "applaud," he insisted with Ambrosian exuberance, but also

> "rejoice." But why with "your hands"? Because that means "with good works." Do not rejoice with your mouth and keep your hands idle. If you rejoice, "clap your hands." Let Him who has deigned to dispense joys see the hands of the people. What does "hands of the people" mean? It refers to the actions of those who perform good works. (*Enarratio in Psalmum XLVI* [47], 3)[14]

Thus he extended the Ambrosian metaphor of moral *plausus* in a psychological direction by associating percussive movement and sound with the joys arising from the performance of fleshly mortifications and other good works.

Striking the body (however chastening the strike) was not in itself a good work, Augustine argued, unless it was prompted by an intellectual yearning for beatitude and a spiritual recreation of the self in the image of Christ. "For there is voice in the chorus, breath in the trumpet, striking on the harp," he observed in his commentary on Psalm 150:3, "signifying mind, spirit, body."[15] All three instruments had to be present and attuned to each other for the *honesta saltatio* to proceed, for its end was not incorporeal ecstasy as in the intellectual bacchanal of the Neoplatonists but resurrection of the flesh in the spiritual dance of the Blessed. This insistence on the present continuity and ultimate simultaneity of the intellectual, spiritual and corporeal phases of *honesta saltatio* was peculiarly Augustinian. Ambrose envisioned the body-harp of the Catholic Saltator struck only by the human *spiritus*, by which he meant simply the natural life-force directing all vital processes within the human body. For Augustine the *pulsus in citharo* signified more than the blood beat, more than the rhythmical evidence of our hexemeral origins. It was a direct consequence of Ecclesia's choral intellection, an unbroken communal response to her visionary perception of the trumpets of Judgment and troupes of *jubilantes*.

IV. *Progressio*: Stepping Forth

Walking, striding, climbing, marching, racing—all human actions requiring *gradus* or "steps" can be counted as moral motions in the New Dance as long as the impulse behind them is charity and their direction is resolutely progressive. Ambrose demonstrated his ascetic and aesthetic sensitivity to the moral implications of *gradus* in a chapter on modest deportment in his treatise on church offices. Like a demanding coryphaeus he warned his clergy that he would be watching their every step with a sharp eye and criticizing their processional gait with a sharp tongue. They must not forget the old Ciceronian lesson that the movement of the body is a voice of the soul. After the Arian ascendancy in Milan, moreover, conformity to a certain style of physical movement became deeply symbolic of adherence to Catholic orthodoxy. "I do not think it honorable to walk hastily," Ambrose instructed,

> unless the threat of danger or some other serious concern demands it. As for those who walk too slowly, I cannot approve of them because they move like statues. Nor do I care for those who march too fast, for they seem like outcasts hastening towards their ruin. (*De officiis ministrorum* 1.18.73–74)[16]

The satiric imagery of nodding statues and fleeing exiles is more than just socially vivid or politically charged: it is meant to be morally disturbing to the Catholic Saltator. Step like a statue in a public parade, proudly, stiffly, pompously, and you literally give an approving nod to the depraved culture of images that sustains the worldly empire. In fact you become an image of it yourself, an incarnation of its depravity, like the living statues who performed the dances of lust and intemperance in the Theater. Step like someone scur-

rying into exile, moreover, and you publicly prefigure your future banishment from the heavenly city. Your grimacing face, like the twisted visage of a lunatic, portends the agony of the Damned.

The carefully measured and modest step of the Catholic Saltator is a counterspectacular act of defiance: it figurally opposes the sinister retrogradation of the World by prefiguring the moral progress and mystical ascension of the Church. It is therefore the only *gressus probabilis* or "acceptable gait" for a Catholic priest because it humbly exhibits his faith in Ecclesia's forward march against the salacious pomp of secular history and calmly expresses his hope for salvation from the ruins of the present age.

Compared with his many public sermons on the triumphal march of Ecclesia, Augustine's justly celebrated meditation on the *gradus* of the converted sinner is at once more intimate and farther-reaching in its moral implications: "My weight is my love; by that am I carried, wherever I am carried. By your gift [of the Holy Spirit] we are set afire and carried upward: we glow inwardly and go onward. We ascend the high ways in the heart, and we sing 'a song of steps' [*canticum graduum*]" (*Confessions* 13.9)[17] Here we find the anagogic inversion of that memorable scene in his youth when he had been weighed down with guilt and inflamed with pleasure at the sight of dancers performing love tragedies on the Carthaginian stage. The skittishness of youth having left him, the mature Augustine is aglow with the charitable fire of the Holy Spirit and attuned to the mystical meaning of the *canticum graduum*.

What is this obscure "song of steps" directing him toward divine understanding? It is, first of all, the repeated title of Psalms 130–34, which in its original Hebrew usage may have simply meant "a walking song for pilgrims." Its psychological and pedagogical implications for the Catholic Saltator are clarified in Augustine's treatise on Christian culture (*De doctrina christiana* 2.7.9–11).[18] In his introductory remarks on the classification of signs, he defined a programmatic sequence of seven *gradus* to be followed by a converted soul aspiring to emotional and intellectual perfection in the Church.

The first step is a turning toward God out of fear of His wrath. Then follows a crucial movement toward piety in which the Catholic Saltator meekly affixes all his "proud motions to the wood of the cross as if they were fleshly limbs fastened with nails." The third *gradus*, a strict disciplining of the mind through the exercise of orthodox exegesis, is Augustine's special concern as a Doctor of the Church. Taking action is the fourth *gradus*, the step of fortitude, and here the Catholic Saltator prays for grace while marching against worldly tyranny into the arena of martyrdom. By now he has ascended high enough to see the immutable unity of the Trinity "glowing in the distance." The fifth step is taken when he reduces that distance by acting charitably toward fellow pilgrims as a priest or teacher or friend. Having cleansed his own heart and the hearts of others through his merciful intercessions, he can proceed to the seventh and final step: the attainment of pacific wisdom through direct percep-

tion of the Divine Face. At the culmination of his charitable ascent the Catholic Saltator becomes the ideal Catholic Spectator.

"Through these steps," Augustine concludes, "the Way extends from fear to wisdom." And so does the song of steps that is Ecclesia's dance. Behind its ascending scale we might glimpse the anagogic trajectory of the Neoplatonic Bacchants who were moved to dance by a love of wisdom. Unlike them, however, the Catholic Saltator does not strive to perform a purely intellectual dance around the mysteries of divine unity. His motion begins and ends in emotion, and it is passionate all the way like the steps toward Calvary. Nor is his ascetic sensitivity to the body lost in the ecstatic springing of the spirit: all that fades is his horror of bodily intransigence. To the very end his beat still comes from the heart.

V. *Exsultatio*: Springing Over

A joyous *saltus*, a stride lifted and impelled beyond the short span of an ordinary walking step, is the penultimate move in the New Dance. While a hell-bent dancer at the court of Pleasure would perceive this move as a mere leap —a temporary exaltation of the body—the heaven-bound Catholic Saltator regards it *sub specie aeternitatis* as a springing of the soul away from hard labor in the vineyard toward an eternal holiday in the House of God.

Considering the etymological meaning of *saltus* and *saltatio* ("leaping"), we should not be surprised to find images of elevation springing to Ambrose's mind when he came to define the ascendent order of the honorable dance.[19] After condemning the salacious revelations of the gods applauded in the Theater, for instance, he observed that the *honesta saltatio* is "that in which the mind dances and the body is raised up to perform good works as when 'we hang our harps upon the willows'" (Psalm 137: 1–2; *Expositio Evangelii secundum Lucam* 6:8). Hanging up the body-harp might be taken as a sign of the end of the *honesta saltatio* in a bodily sense—an ascetic farewell to arms, legs, nerves, sinews, and all the other chords plucked by the human *animus* as it exultantly leaps away from its muddy vesture of decay into the clear air of contemplation. What disciple of Philo or Plotinus would not be ecstatic over such a leap into suspended "animation"?

Ambrose was no stranger to the heights scaled by these intellectual Corybants, but his faith led him beyond high thinking in the Philonic or Plotinian style. He showed his true Catholic colors by *not* taking the suspended harps as a sign of the wise man's eager rejection of the corporeal world, by *not* reading the bitterest lament of the Jews as a joyful prophecy of the end of the soul's exile in the body. In fact, he expressly includes the body—when it is put to good practical Christian use—in the elevating dance of the mind. The dance is only honorable in his eyes when *animus tripudiat* and *corpus elevatur*: while the mind exults in the revelation of the Empty Tomb, the hands must be held

up in penitent prayer or busied in good works, the arms lifted high to bless a sinner or lament a sin, the legs borne up the steps of Ecclesia toward the baptismal font, and the New Song raised upon the chords of the fleshly "harp" in anticipation of the Last Judgment.

"Sweet indeed is the song that does not feminize the body but rather strengthens the mind and spirit," Ambrose insisted with a shuddering glance back at the gender-bending male dancers at the court of Pleasure. Always latent in the allegory of the *honesta saltatio* is a Roman patriarchal insistence on the "natural" (because divinely ordained) superiority of male strength to female softness: a hierarchy of corporeal traits sustained by the "correct" separation of masculinity and femininity as social identities or systems of conduct. The New Testament, he goes on to preach, is such a song "because as we are singing the Gospel together, we celebrate the remission of all sins and the just acts of the Lord with a gentle springing of the mind [*suavi mentis exsultatione*]" (*Expositio in Psalmum CXVIII* [119], sermon 7.26).[20] The New Song is more than a figure of speech in Ambrose's Church. It is actually sung. Similarly, the New Dance is more than an allegory of moral action. It *is* moral action—the kind of action not taken by the Jews of the Lord's generation who heard the singing in the marketplace but would not raise their minds and bodies in response to the divine cue. If you were to respond to it in a bodily way only, by making a big show of attending church or showering all your wealth on the poor, your performance would be no better in a moral sense than the extravagant gestures of a *histrio*. On the other hand, if you were to act on cue only in a spiritual sense, by sympathizing with the poor at a safe distance from the slums or by nodding approval of Christian doctrine at a safe intellectual distance from the masses pouring through the church vestibules every Sunday, then your presence would not truly be felt nor your voice heard amid the chorus of the faithful.

During his Milanese period Augustine probably heard in church some of the thirty-four expositions of the Psalms that have come down to us under Ambrose's name. He may even have heard his mentor's seventh homily on Psalm 119, in which the dance to the New Song was defined as both an *exsultatio mentis* and a *saltatio corporis*. Since Augustine's own plan to unveil the spiritual meaning of the Psalter may have taken shape while Ambrose's voice was literally ringing in his ears, we should not be surprised to hear many Ambrosian echoes in his own psalm commentaries. For instance, linking the image of the leap with the idea of Catholic perfection, he urged the Catholic Saltator to

> have "sprung over" some things in such a way that there is still some point toward which you are hastening; to have "sprung over" in such a way that something else remains toward which and over which you must spring when everything else has been passed over. (*Enarratio in Psalmum XXXVIII* [39], 14)[21]

There is always a "something else" for the chorus to approach and see and love in God. Of that the mystical leaper may be sure. "This is the faith that is

secure," concludes Augustine, heralding the defeat of Pelagius, "for whoever supposes that he has already attained perfection is setting himself up for a fall."

VI. *Revelatio*: Stripping Off

The last move we might expect the Catholic saints to make in Ecclesia's dance through time turns out to be their first move in eternity: a shameless baring of body and soul. Considered from an apocalyptic angle—which changes everything the Catholic Saltator might think about exultantly exposed flesh—the stripping of the blessed dancer declares the glory of God and the truth of the Gospels rather than the shame of Adam and Eve. It is the reverse of their guilty cover-up, for the few who are chosen to bare all (including Adam and Eve themselves) will blissfully "show their limbs to the living God" to prove the perfect obedience of the Church's mystical body.

In its immodest modesty this last sequence in the *honesta saltatio* will eclipse Satan's carnal showstopper, a hot striptease brazenly performed by a danseuse who hates the men she teasingly pleases. Ambrose, in his treatise *On Virgins* (ca. 377), cast the veiled virgin's whorish antitype in the role of Salome and set her infamous dance not just at the court of Herod but at the palace of Pleasure where dancing soon turns into mourning. Salome unveils herself as no saint ever will. "Now is anything more inclined to excite the lustful," Ambrose concluded, "than a performance in which the parts of the body hidden by nature or veiled by custom are exposed by disorderly movements in which the eyes are playfully rolled, the neck turned round, and the hair loosened and whirled through the air?" (*De virginibus* 3.6.27).[22] Instead of harping on the obvious—lust of the eyes, and all that—he teaches the virgins to find something of unusual value in even the vilest settings and spectacles by drawing a positive moral lesson from the negative side of fallen human experience. Salome's gift to the carnal crowd, a fleeting glimpse of her pudenda, provides the chorus of Christ with a proper standard of value for judging the vulgar pleasures of the Flesh, the transient gifts of the World, and the erotic shows of the Devil.

The Latin Fathers condemned the nudity of sluttish dancing-girls and the prurience of their male admirers so often, and so stormily, that we may hardly believe our ears when the voices of Ambrose and Augustine rise above the grating roar of antispectacular moralizing (the implacable waves of which their own writings sometimes swelled) to instruct the Catholic Saltator to peel off his worldly vestments and not feel the slightest embarrassment about it. "David was not embarrassed when he danced in public before the Ark of the Lord and neither was Isaiah when he went naked and barefoot through the crowd, shouting out heavenly prophecies," Ambrose insisted, since only a fool or a prude would confuse their *honesta saltatio* (which is the ally of faith and the companion of grace) with the *lascivia saltatio* of Salome.[23]

If there is one point the Latin preachers of that gospel drove home with philosophically shattering force, it is that the Christian afterlife will be more than a contemplative act since beatitude will be more than a state of mind. Everlasting life will be a corporeal activity too, a miraculous reinstatement of the body, as the honorable dancer will discover when his soul swiftly rises from the dust and races toward the dance of "them that make merry." To go naked in the spirit is one thing; to go naked in the spiritual body is quite another. What the contemplative prelude to resurrection felt like, Ambrose could describe easily enough since he was used to stretching out the bare "foot" of his mind toward the mystical wellspring of wisdom.[24] That was what a Christian Platonist did best. But something inhibited him from going all the way, from daring to imagine the corporeal dynamism of beatitude from the viewpoint of the risen saints. Perhaps it was his qualified intellectual allegiance to Christian Platonism that held him back, or his Western Christian contempt for the World, or simply his old-fashioned Roman modesty.

The challenge of imagining the limbs shown to the living God was taken up, as we might expect, by Augustine. Around 427, some three years before his death, he drew the final book of the *De civitate Dei* to a close with a prophetic chapter "On the Eternal Felicity of the City of God in its Perpetual Sabbath." The ineffable happiness he struggled to put into words is a harmony of intellectual, spiritual, and corporeal pleasures perpetually renewed and eternally enjoyed by the dancers in the Divine Presence. While the moral motions of the Catholic Saltator in this life are all work, he reflects, they will be all play in the life to come. Here is his preview of what the blessed dance will look (and feel) like after we have received our glorified bodies:

> All the limbs and organs of the incorruptible body—the parts that we now see distributed about the body for the performance of various necessary functions— will then be freed from all necessity by full, certain, secure, and eternal felicity so that they may contribute to the service of divine praise. Indeed, all those numerous parts of the corporeal harmony that I have already mentioned, the parts that are now hidden, will then be hidden no longer. Distributed internally and externally throughout the entire body and combined with other great and miraculous things which will there appear, they will inflame our rational minds with praise of the Great Artist through delight in the beauty that is endowed with reason.[25]

Think what this means. Breasts, buttocks, loins, intestines, bladders, genitals —all the private parts of our suits of dust—will be publicly exposed in the honorable dance. No limb or organ, however embarrassing to us now, will be quietly lost in the grave. All that will change is their use. Instead of performing their former "necessary" functions like procreation, lactation, digestion, and excretion, they will be free to operate for playfully unnecessary, purely aesthetic reasons, moving together in perfect harmony with the New Song and delighting the newly awakened senses of the Catholic chorus as they praise

God in the dance. Imagine using your private parts to praise God for ever and ever, world without end, in a perfectly lovely church service, and the utter bizarreness of this revelation will soon become apparent.

To the Gnostic spiritualists and Pelagian prudes who might dream that resurrection means a happy reduction or elimination of vile organic tissue, Augustine delivers a truly shocking prophecy: our glorified bodies are likely to grow new limbs and organs with "other great and miraculous things," parts yet to be named, in order to perfect the corporeal harmony envisioned by the Great Artist. And just as nothing good or rational will be hidden from our minds in the celebration of perfect morality, so nothing beautiful or harmonious will be concealed from our eyes in the festive dance of the mystical body. In the ultra nakedness of the Blessed, internal organs will be as visible as external limbs. Bones will gleam through translucent skin. We shall be changed indeed. As a kinetic experience, participation in the perpetual Sabbath will feel virtually weightless and frictionless. The only friction felt by glorified bodies will be an exultant moral resistance to unhappiness; the only weight, the reverse gravitation of love. "I dare not rashly define what sort of motion such bodies will possess in the future life," Augustine sighs,

> for I have not the mental powers to contemplate or imagine it. However, their motion and rest will be seemly there just like their appearance, and everything deformed or indecent will be excluded. We may be certain that the body will immediately be where the spirit wills it to be, and that the spirit will never will anything that does not enhance its own beauty and that of the body. (*De civitate Dei* 22.30)

The task of filling in the missing details of this vision fell to the allegorical poets of the Catholic West, the most dance-minded of whom was certainly Dante. As a prophetic psalmist of the Age of Grace, Dante took up the challenge of describing the rationally beautiful configurations, ritual gestures, symbolic directions, mimetic functions, and ecstatic highlights of the blessed dance by raising his spiritual vision to the chorus of the Saved. But to appreciate the exultant freedom of their performance, he had first to confront its immoral opposite. Directing his corporeal gaze downward to the hottest floor in Hell, a dancing-ground designed by God for the forced carols of the Damned, he dared to break the patristic taboo against participation in the *lascivia saltatio*.

3. Disco Inferno

Dancing queens make their first entrance into Western literature as sodomites in the Seventh Circle of Dante's *Inferno* (14–16).[26] Here Dante did more than demonize the image of the sodomite as a lascivious dancer; he invented it. Before him, patristic efforts to define sodomy had produced a confusing variety of significations in medieval philosophy. Some moralists regarded it as a

violation of the Creator's commandment to increase and multiply; others conceived it as a preference for natural philosophy over revealed religion; still others represented it as a rape of nature. Thanks to Dante, the most concealed and private of vices would be persistently allegorized as a public performance, a demonic spectacle, a transgressive show of limbs compelled by an intense hostility toward God.[27]

The sodomites of the Seventh Circle are compulsive dancers in a direly literal sense: their "outing" in the afterlife forces them to perform the *lascivia saltatio* under God's wrathful eye for Dante's moral edification. So hot are the sands beneath their feet that they must caper about in "many herds" (14.19) to ease their scorched soles, their incessant motion providing a bestial parody of the sacred stepping (*gradus*) and hopping (*saltus*) of the Catholic Saltator. Meanwhile their hands are kept busy slapping away the "huge flakes of fire" (14.29) raining down on their skin from the cavernous vault of the Inferno, an endless meteorological replay of the destruction of Sodom and Gomorrah.

Their wretched hands perform a *tresca* "without repose, now here, now there, as they beat off the fresh burning from themselves" (14.40–44). Cognate with the English verbs *thrash* and *thresh*, the verb *trescare* from which *tresca* derives denotes a vigorous percussive motion—the stamping of feet on the ground, the slapping of hands against skin, the beating of sheaves to separate kernels from stalks. Not surprisingly, the root *tresc-* developed indelicate sexual connotations that have lingered on in modern Italian. *Fare la tresca* now means "to have an illicit love affair" or "to screw up." A *trescone* is a big imbroglio as well as a foot-stompin' country dance. English has danced down the same semantic route with the noun "fling."

If the pounding thrust of violent intercourse or the rhythmic thrashing of masturbation were in the poet's mind when he chose *tresca* for this passage, then perhaps we are meant to imagine the Seventh Circle as a medieval Meat Rack with the boys in the sand "beating off" intransitively as well as transitively. Like the perpetual orgasm of the lustful in the Second Circle, the sexual pleasures of the dancing queens have only to be extended *ad infinitum* to become sadistic punishments. Since the sodomites are damned for violence against nature, the thrashing of their hands is a fittingly violent sign of their sexual "disorientation" and the pernicious mind-fucking behind it.[28]

Initially their manual *tresca* looks like a natural reflex—what anyone would do facing chemical warfare in the nude under Desert Storm conditions. From a typological viewpoint, however, their show presents a sinful cheironomia that Dante must read as Ambrose once read the unholy handplay of the *histriones*. They are not only performing sodomy as a dance, they are dancing out their own annihilation on the unholy ground of Old Testament genocide. Their radical negation as a *gente* or "people" is individually repeated in the blackening of their bodies under the fire, each dancer becoming a shadow of his former self or a silhouette of a "real man." The apparent randomness of

their discolike motions—flitting to and fro over the dance floor, slapping their sides "now here, now there," pulling away from the herd for unpredictable solos, forming tight configurations that soon break apart—adds to the impression of their corporeal insubstantiality an ominous hint of their own willed erasure. Moment by moment, as each spark hits its target, it is extinguished. Moment by moment their performance wipes itself out.

What has yet to be appreciated about Disco Inferno is the degree to which the physical performance of sodomy as a dance demonically imitates the moral motions of the Catholic Saltator. By slapping their hands against the darkened hide of their bodies instead of extending them in prayer, the sodomites mock the characteristic *extensio* and *percutio* of the Old Testament prophets. Where the dancing prophets beat the drum of their skin to celebrate God's victories or to exalt the spirit over the flesh, the dancing queens thrash out a painful parody of David's ecstasy and Ezekiel's mortifications. In a bitterly ironic reversal of the Old Testament prophecy that "our dance shall be turned into mourning," their eternal mourning is turned into a dance by the pitiless promptings of the brimstone. To make matters worse, the vestige of free will that still clings to their souls serves only to exacerbate their punishment. They have the power to stop their dance at any time. If any of them chooses to do so, however, he is instantly condemned to lie on the ground for a hundred years of intensified torment.

On entering their cruel theater, Dante the pilgrim also has a hard choice to make between stopping and stepping. For a moment he and his guide stay their steps on the edge of the scene (14.12), preferring static detachment from the horrors of the desert to moral progress across it. This interruption of their journey, though psychologically needed, is spiritually unsustainable if the pilgrim is ever to spring out of Hell into the blessed dance. At Virgil's command they soon set off along one of the elevated banks of a channel through which the River Phlegethon rages its way to a thunderous cascade into the abyss of fraud. Though mysteriously untouched by the corrosive shower from above and the boiling spray from below, their cold pathway is "l'un de' duri margini" (15.1)—one of those "hard margins" designed by God to make the pilgrim especially conscious of his footing.

Thus marginalized, Dante teeters between two torments. If he steps to one side, he will fall onto the burning sands of the sodomites under the rain of fire. If he steps to the other, he will plunge into the stream of boiling blood flowing from the ditch of the homicides. Like a tightrope walker, he cannot bend his body at the waist or twist it to the right or left without risking a fatal fall. His natural (and instinctively moral) impulse is to remain tensely upright, eyes fixed down and focused steadily ahead. Amid so much heat he must try hard not to freeze. Stopping could be fatal. As if this balancing act were not hard enough—given the small margin of error on either side—the pilgrim must keep his cool while pressing bravely on toward the brink of a dark precipice. No

wonder he concentrates on setting one foot after another with careful place-ment, as Virgil directed him when they first ascended the levee (14.73–74).

If Ambrose had been the architect of the Seventh Circle, he could not have designed a better stage for the performance of moral motions than this "hard margin." The levee not only provides a protected vantage point for the Cath-olic Spectator to survey the prolongation of the *lascivia saltatio* into the after-life. It also serves as a training ground for the lapsed soul who wishes to be-come a moral high-stepper in the *honesta saltatio*. It even elevates the steps of the (potentially) honorable dancer above the wretched *tresca* of the sexually disgraced. Ironically, for one who had lost "the straight way" (1.3) before en-tering the Inferno, Dante is compelled here to imitate the measured gait of the Catholic Saltator, who zealously treads the straight and narrow with "cor-rect" posture. The way itself straightens out his erring steps, raises up his body from the wander ground of sodomy.

En route over the levee he makes three wrong moves, three tiny faux pas with huge moral implications that betray his physical unreadiness for the sacred dance and his psychological attraction to its sodomitical opposite. First, when a shade approaches him from below and stretches out an arm to grab the hem of his robe, Dante reflexively extends his own hand down toward the burnt but still familiar face of his old teacher Brunetto Latini (15.25–29). The reaching of hands is an important gesture in the honorable dance, but its moral direction is traditionally upward to God in repentant prayer or outward to the needy in kindly intercession. Brunetto's upward extension is neither repentant nor char-itable. At best it can be read as a willful break from the hand-slapping routine of the *tresca*—a return, in fantasy, to the good old days when the master affec-tionately greeted his student in the streets of Florence. If the *tresca* was a dance for medieval rubes, Brunetto may well have found it socially as well as physi-cally excruciating to perform. Imagine an urbane aesthete forced to dance the Achey-Breaky *in flagrante* (literally) for the moral entertainment of good Christians everywhere. Imagine Gore Vidal exiled for eternity to the Nashville Network.

At worst Brunetto's outreach to Dante is a devious setup, an attempt to mimic the cheironomia of grace. By grabbing the garment of the Outer Man (a symbol of the flesh) the sodomite plays out his demonic role as a sexual tempter whose ultimate aim is to draw the Inner Man down to his own wretched level. Even if Dante's downward *extensio* were motivated by com-passion for the old scholar, it is the wrong act to perform in the arena of the sodomites.

One bad move leads to another. Though Dante does not interrupt his mor-ally required *progressio* along the levee, his head follows his hand in its down-ward inclination. "I didn't dare descend from the path to go on his level," he shudders to recall (15.43–45): "But I kept my head bowed like a man who walks reverently." How can this common ecclesiastical gesture of respect be a bad

move in the honorable dance? Didn't Ambrose recommend such humble motions to his clergy? In the infernal theater, however, Dante's bowed head must be perversely "read" as a sign of misdirected reverence. It directs his gaze away from Virgil, his "sweet father" up ahead on the path, toward the damned face of an erstwhile father figure whose philosophical teachings made him lose the straight way in the first place. With hand and head inclined toward the plain, he literally loses moral stature. His body slightly bends. His soul still requires *correctio*.

Further along, after Brunetto has run off in a futile reprise of the Catholic Saltator's race for an everlasting crown, Dante peers down over the levee again and makes his third bad move. He halts his steps. The honorable dancer is not supposed to take a break from the urgent pressing forward of body and soul toward salvation. What stops Dante in his tracks is the unexpected sight of three new dancers, a trio of naked sodomites who perform a twisted version of an old Italian folk dance known as *la rota* or "the wheel" (16.19–27). This nimble threesome join hands and start circling only when their *rota* can be closely observed by Dante. Like well-oiled and deep-tanned veterans at a gay resort, excited by the prospect of fresh company and eager to show off their buff physiques to best advantage, they stop beating off the flakes for a while in order to stage a one-time performance for the new guy on the team. He is not just a spectator here; he is a target. By stopping to observe them he has made himself vulnerable to their attack, which, as the simile of the oiled and naked *campioni* suggests, may be violent or erotic—or both. Is Dante being sized up for homoerotic combat by a gang of Latino tops? One of them, a former Guelph commander, rejoices in the macho name of Guido Guerra ("Guy War"), while his partners are identified as the valorous Florentine *cavalieri* Tegghiaio Aldobrandi and Jacopo Rusticucci. When gays in the military go bad, they end up as nude dancers at Disco Inferno.

From the viewpoint of the Catholic Spectator, the first clear sign that their dance is distinctly dishonorable is its gender-transgressing configuration: the *rota* was traditionally danced by graceful and modest maidens to the accompaniment of their own sweet carolings on the delights of spring and the joys of love. So what are the unmistakably butch guys of the Seventh Circle doing in a choral round originally designed to show off the charms of eligible maidens to prospective husbands? As a kinetic extension of the cross-dressing deplored by Ambrose at the court of Pleasure, the immoral cross-dancing of Guido and the boys is clearly intended to stimulate and confound Dante's hitherto heteroerotic male gaze. Their evil spin on the love dance is meant to catch his eye, even as his tentative motion along the straight and narrow has caught theirs. Can they suck him into the vortex of their immoral motions?

Fixedly they cruise him with upturned faces—twisting their necks round in a *continuo viaggio* (16.27) contrary to their footsteps to ensure that their gaze is always directed at him. The strange torsion in their bodies reveals to the Cath-

olic Spectator their relentless opposition to *correctio*. If their heads are literally turning in a continual rotation contrary to the direction of their footsteps—which is to say, contrary to the revolution of their bodies—so that their faces are always turned toward Dante no matter where they happen to be on the circumference of the wheel, then their necks must be twisting round a full 360 degrees (like Linda Blair's in *The Exorcist*) in a truly demonic display of flexibility *contra naturam*.

While the harmonious wheeling of the cosmos culminates in anagogic liftoff for the Catholic Saltator—an *elevatio* into the Empyrean—the revolutions of the sodomites amount to nothing in the end except a dispiriting demonstration of their misery. As Jacopo describes it with bitchy accuracy, the movement from the inside feels like a futile game of follow-the-leader: he must go round and round "trampling the tracks" of Guido, who goes before him "naked and peeled," while Tegghiaio "treads the sand" behind him (16.34–40). No lift-off from this kind of *gradus*. No saintly stripping at the end of this round.

So how is Dante's game of follow-the-leader any different from Jacopo's? Does he not "trample the tracks" of a sodomite too? Though Virgil remains discretely silent about his erotic preference for boys, it may well have given Dante grounds for psychosexual panic—not to mention doctrinal vertigo—at the brink of the homo-vortex.[29] What's to prevent him from hurling himself over the edge into the maelstrom of all-male action? Certainly not the words or actions of his guide. "Had I not been protected from the fire," Dante confesses in a vertiginous moment of sexual introspection (16.46–48): "I would have hurled myself down among them and I think my teacher would have permitted it." Fear of divine punishment alone keeps him on the straight and narrow, though the desire to join ranks with the "champions" is strong enough in his soul to overcome the homophobic interdictions of the *contra naturam* argument. "But because I should have been burnt and cooked," he recalls (16.49–51), "fear overcame the good will in me, which made me greedy to embrace them."

Though queer theorists may be tempted to interpret Dante's eagerness to embrace the sodomites as a subversive political desire for outreach across the homo/hetero divide, it can hardly be that.[30] Consistent with his elaborations of the patristic allegory of moralized motions, it clearly signals a tropological crisis in which his will must choose between the vicious circle of concupiscence and the virtuous steps of charity. At the end of the charitable march is the exultant elevation of Ecclesia's chorus. At the end of the concupiscent vortex is the excruciating abasement of Satan's champions.

The *rota* of the sodomites looks alluringly vortiginous in William Blake's unfinished drawing of the scene (figure 20). Instead of trampling the sands below the levee, the dancers seem to be flying through the air above it as if the momentum of their muscular limbs has created a tornado of hot male desire

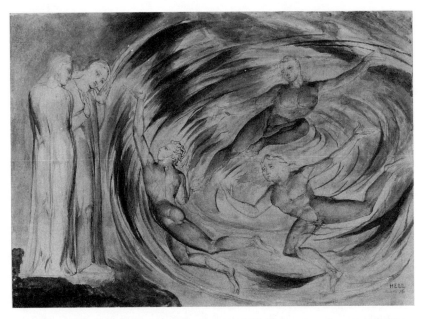

20. William Blake, *The Punishment of Rusticucci and His Companions*, from Dante's *Divine Comedy*. Courtesy of the Fogg Art Museum, Harvard University Art Museums, Bequest of Grenville L. Winthrop. Photo by Photographic Services © President and Fellows of Harvard College, Harvard University.

over the deserts of pious repression. Their wheel has visibly loosened up. A wild bid for freedom unchains their hands. Their arms fly out with Glad Day abandon. No longer do their necks twist unnaturally in a contrary motion to their feet. Once blackened with third-degree burns, their bodies have clearly benefited from plastic surgery and extensive workouts. Even their penises, which might have flapped gracelessly or bobbed stiffly in the wind, exquisitely conform to the dictates of the buoyant swirl.

With head bent and eyes transfixed by Jacopo's gaze, Blake's Dante raises his hands in wonder rather than panic at the frankly aesthetic sight of the Sodom corps de ballet. He is not merely struck by the Apollonian beauty of their physiques. He is utterly mesmerized by the Dionysian energies unleashed by their performance—as if the *rota* were magically transforming him from a heaven-bound Catholic Spectator into a romantic poet hell-bent on embracing the cause of revolutionary liberation. No longer quite Dante, the wondering poet is on the verge of becoming Blake. Though the old distinction between solemn uprightness and salacious levity is certainly preserved in the contrasting postures of the spectators and the dancers, Blake has perversely inverted the traditional moral significance of *correctio* and *flexus*. Stand stiff, and you serve an evil, repressive God. Let loose, and the cosmos dances for you once again.

4. Dancing with the Mirror

The dancing queens of contemporary gay fiction typically put a Blakean spin on their experience of the *lascivia saltatio*. Not for them the dire Dantean moralization of their motions, though a camp apocalypticism occasionally darkens their aesthetic reflections on the erotic dance. As Malone, the hero of *Dancer from the Dance* (1981), remarks to his drag mentor Sutherland at a Fire Island ball: "It's all *we'll* ever see of the Beatific Vision!"[31]

If the sands at Fire Island seem remote from the desert of the Seventh Circle, the vigorous dancing at Sutherland's party creates an illusion of perpetual motion—a motion restlessly extended into the doomed queen's afterlife like the amorous *giri* of the sodomites but without their punishment. As the narrator exultantly observes on the brink of world-weariness, "these people would never stop dancing." Their devotion to disco defines them as a people, in fact, just as the active preservation of folk-dance traditions serves to define the ethnic identity of an otherwise disparate folk. Even when Sutherland dies of an overdose at the height of the great party that was the seventies, his dance goes on. He is swept up in it only to be fused with the whirl of romantic sexual energy, like Blake's Jacopo or like the mystic dancer in the last line of Yeats' "Among School Children" (whence the novel's title).[32] Sutherland's funeral reunites the dancing queens, from whose viewpoint the wake takes on the ritual function of a psychopompic initiation. It was "attended by everyone he considered beyond the pale of simple good manners, but who could have danced him into the other world: the crowd Sutherland called 'the hard-core tit-shakers,' with whom he had danced for nearly twenty years."[33]

Invert Disco Inferno, and the result is Gay Heaven, a neopagan zone of mystical dance that is no less moralized in its configurations (or tropologically readable in its signs) than the sacred dance floor of Ecclesia. To reach its out-of-body heights requires an ascetic transport beyond the hedonistic whirl of the World, a strenuous initiation ironically comparable to the *gradus* and *elevatio* of the Catholic Saltator. Many a gay ironist since Stonewall has observed that coming out of the closet is a kind of rebirth, even as born-again conversion is an exiting from the confines of the Flesh. Felice Picano, for one, has called the narcissistic interaction of reflexively opposed cultural movements "dancing with the mirror."[34]

All too predictably, the religious right's fierce opposition to gay liberation as a social movement has revived the old allegorical performance of sodomy as a theatrical movement—a bent and twisted dance staged for the moral edification of Christian spectators. Multitudes of horrified converts can now witness the *lascivia saltatio* through the miracle of the electronic media, which acts as the Pauline glass through which the elect look darkly at their dopplegangery foes. With the millenarian revival of age-old fears of mass destruction—fears

that did not disappear at the end of the Cold War—has come a "reinfernaliza-tion" of the dancing sodomite as an antitype of the Saved.

The proud visibility of the post-Stonewall dancing queens might have been enough in itself to provoke a traditional Christian (or Christianoid) reaction against the spectacularized eroticism of the Fire Island Circuit. However, even if they had been prepared for ecclesiastical curses back in 1979, few of them outside of fiction could have predicted the intensification of apocalyptic moralization of their motions in the ensuing "Age of AIDS." The epidemic has loosed the frightful lightning of allegory, and the media, wielders of its ter-rible swift sword, have electronically flashed it in the KS-blazoned faces of "AIDS victims" to reveal the blackened and peeling skin of Brunetto's infernal brood. Instead of rainin' men on Fire Island, it's rainin' fire once again.

Nothing bears clearer witness to the astonishing afterlife of Ecclesia's mor-alized motions in America's living rooms and church basements than the antigay videos produced in the 1990s for the consumers of religious prophecy —a sizeable niche market, to judge from the thousands of evangelical book-stores and eschatological gift shoppes across the continent. "WATCH THIS VIDEO!" commands the package of *Gay Rights/Special Rights*, a VHS jeremiad produced in 1993 by Jeremiah Films of Hemet, California: "Send it to your Congressman . . . Mayor . . . Police Chief! Act now! Fight Back!" The zeal with which AIDS activists used to chant "Act Up! Fight Back!" is evidently contagious: it has spread to protesters on the fundamentalist side of the mirror.

The mirror design of *Gay Rights/Special Rights* is established in its open-ing sequence. Against a black screen the date "August 28, 1963" appears in gleaming gold characters. A crackly voice-over of Martin Luther King de-claiming "I Have a Dream" provides the moral gloss on the scenes to come. Dissolve to an old black-and-white TV news clip of King on the steps of the Lincoln Memorial. Slow pan across the multitude of civil rights marchers, now standing together as one body, solemnly listening as their hallowed leader announces his vision of "a nation where people will not be judged by the color of their skin but by the content of their characters." While the messianic voice-over of King continues, a quick flashback to the march leading up to the speech: a stalwart legion of protesters waving placards ("We march for effec-tive civil rights laws now!") projects a hopeful image of history marching on in the Land of the Free, which in the typological context of King's prophecy also reads as Ecclesia's victorious *gradus* towards the Promised Land. Suddenly the steps of the righteous fade from view. Their progress is halted. Have demonic forces wrested control of America's destiny?

Dissolve to black screen again. A new date ominously appears in the same gilt characters as before: "August 25, 1993." Another quick dissolve takes us through the glass darkly into the parody present of the sodomites, who, accord-ing to a disgusted announcer, have just participated in a preposterous "March on Washington for Gay, Lesbian, Bisexual, and Transgendered Rights." The

dignity of the original march for civil rights has been lost in the eroticization of its moral momentum, now sadly a thing of the past. Where Reverend King once robustly stood, the unblinking screen now reveals the gaunt figure of an "AIDS-carrier" at a podium surrounded by placards depicting President Clinton with a lewdly elongated nose. Though the present is shot in living color, the man at the podium looks deathly pale. Since only sodomites would recognize him, his identity must be spelled out at the bottom of the screen: "Larry Kramer, homosexual, founder—ACT-UP."

Presenting himself as a prophet of truth—in sharp contrast to President Pinocchio, who had lied about ending discrimination on gays in the military —Kramer struggles to assert the seriousness of his cause beneath the phallic nose of the good old boy who might have been a Lincoln to the Stonewall generation. Right on cue Kramer does his King shtick, delivering a gay rendition of "I Have a Dream" in a nasal whine that is guaranteed to resound down the centuries only in antigay videos. Like the homosexual lifestyle for which Kramer is here inaccurately (and absurdly) represented as the decadent champion, his jeremiad on the inalienable rights of gay people inevitably fails to measure up to its straight cultural model. It comes off as a bad travesty.

When the sods come marching in, as the mirror-logic of the video demands they do in a flashback paralleling the archival footage of the 1963 march, their riotous parade presents the starkest possible contrast to the procession of King's morally inspired followers. Not since Brueghel pitted Carnival against Lent have two multitudes opposed each other with such tropological force. Where the civil rights marchers carried themselves with dignity, standing tall, stepping resolutely forward, stretching their hands out to their saintly leader, their counterparts in the gay parade look as if they're deliberately mocking these "correct" motions every step of the way. The ironically "cruising" eye of the fundy-cam freely zeroes in on drag-queens swinging their hips, leather-dykes jiggling their breasts, barboys boogying up a storm, fairies mincing like there's no tomorrow, queer youth stripping down to their skivvies, and angry act-uppers making the figs at God and the President.

To drive home the point that gays live only for sex, the appalled but unflinching fundy-cam zooms in on a poster advertising "The 72-Hour Party on Washington with Nonstop Continuous Dancing from Noon Friday to Noon Monday!" Lined up across the lower half of the poster, like satyrs on a Greek vase, eight hunky dancing queens cheerfully mimic oral sex, genital frottage, chain fucking, and master worship (figure 21). Their frozen parade of sexual positions and possibilities fixes in the memory the hitherto fleeting impression gained from quick-cut moving images of the march itself that Washington is no longer the nation's capital but Queer Nation's dancing-ground, a vast disco of the damned.

The video lasts thirty-five minutes—just long enough to convince piously nauseated patriots that Washington has been invaded by aliens from the Planet

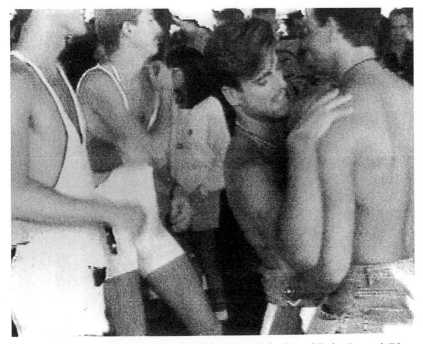

21. Gay couple dancing at Inaugural Ball. Still from *Gay Rights/Special Rights*, Jeremiah Films, 1993.

ABBA without turning them into dancing queens. By far the most insistent image in the video is the *lascivia saltatio*. Spliced between oracular tabloid-style interviews—don't miss AIDS prophetess Morgan Fairchild warning America that HIV is likely to "go airborne" at any moment—are fifteen titillating segments exhibiting the full range of immoral motions in the dancing queen repertoire. That works out to an eyeful of sodomitical flesh writhing, bumping, grinding, thrusting, sashaying, thrashing, flitting, twisting, flexing, or hula dancing (figure 22) every 2.3 minutes during the show.

If the video merely afforded glimpse after nervous glimpse of the unholy levity suggested by the term "gay," it would hardly make much of a moral or political impact these days. To exorcize America's soul of the gay incubuses who have possessed it, Jeremiah Films must also expose the "dark reality" lurking beneath the disco-ball brilliance of their compulsive dance culture. That reality is the gay plague, of course, and it is literally brought up to the luminous surface of the video screen (like KS lesions raised up from subcutaneous tissue onto the skin) by close-up interviews with former dancers from the dance who present their paralyzed and mottled bodies as evidence of God's opposition to the Homosexual Agenda. Their dancing has turned into mourning, as the Good Book predicts, and now they testify to the eternal darkness

22. The 72-Hour Party in Washington. Still from *Gay Rights/Special Rights*, Jeremiah Films, 1993.

in store for America's sodomites and for the America they have sodomized *spiritaliter.*

By adopting the viewpoint of these grim witnesses to the Lord's power, the video effectively casts an infernal pall over all the dance segments following Kramer's speech. Particularly Dantesque is a flashback to a gay ball celebrating President Pinocchio's inauguration: two black-tie guppies waltz into center-screen under a red floodlight eerily reminiscent of the lighting in the Seventh Circle. If they seem blissfully unaware of the camera, it may be because they are also oblivious to the allegory of moralized motions into which they have just stepped.

5. Do Not Bend at the Waist

On a reconnaissance mission to my local evangelical bookstore, I discovered the pious counterspectacle to the impious revels captured in *Gay Rights/ Special Rights.* Little did I suspect at the time—though now it seems direly obvious to me from the binarizing imperative of the allegory of moralized mo-

tions—that contemporary revivals of the *lascivia saltatio* as heterosexist propaganda should also generate militant images of heterosexuals as physically and morally fit participants in the "straightening" exercise program of Christian aerobics.

The evidence for moralized motions on the heavenbound side of the allegory jumped out at me from a shelf labeled "Christian Fitness." There, neatly stacked in cellophaned packages, was a line of aerobics tapes with relentlessly inspirational titles such as *Fit for a King*, *Praise Workout 1 and 2*, and *Step into Praise*. Plunking down thirty dollars at the cash register, I hustled off with a copy of *Step into Praise* because it promised me a "unique 80-minute step aerobic workout set to upbeat, contemporary songs from Integrity Music that strengthens your body and refreshes your spirit." How could I go wrong with a product from Integrity Music? My body could always use a little strengthening, and my spirit definitely needed refreshment after prolonged exposure to the horrors of the Homosexual Agenda. Besides, the mystical injunction on the package—"Enjoy the presence of God as you step up your fitness program with Step into Praise!"—boded well for my conversion to the New Dance.

The cover photo of fitness instructor Sheri Chambers and her charming assistants Carmen and Laurie is an icon of *correctio*. By holding their upper bodies in a perfectly upright position, vertebrae vertically stacked, necks stretched tall, chins up, shoulders down, hips square, bosoms aligned, they present themselves as a corporeal *figura* of moral rectitude such as Ambrose would have applauded in the fourth century or Dante in the fourteenth. Sheri's splashy spandex unitard might have unsettled the allegorists of the blessed dance somewhat, but they would certainly have approved of her disciplined posture, outstretched arms, and clenched fists as signs of the heresy-attacking spirit of the Church Militant. With exquisite regard for the symbolic correspondences between physical and spiritual movements, Sheri has posed herself and her assistants with their arms held at different heights to represent workouts of "low, medium, and high intensity." Nothing about them is bent except for their right legs, which are right-angled at the knee to suggest that they are vigorously marching to the New Song. With their left feet firmly planted on three low plastic benches, they are lifting up their bodies toward the Lord at precisely the same moment in the music. Zeal has rarely looked so synchronized. Here is an apparently objective image of Christ's chorus stamping down the hollow supports of the material world while lifting up their spiritual bodies to the joys of Heaven.

Though the *Divine Comedy* was probably far from their thoughts when they posed for the shot, their triadic chorus bears a striking iconographic resemblance to the three Theological Virtues who dance in perfect concord on the summit of Mount Purgatory. After Dante has passed through the aerobic torments on the Cornice of the Lustful, he is rewarded with a glimpse of Faith, Hope, and Charity stepping into praise beside Beatrice's chariot:

Three ladies came dancing in a round beside the right wheel: one so red that she hardly seemed distinguishable from fire [Charity]; another so green that her flesh and bones seemed of emerald [Hope]; the third so white that she looked like new-fallen snow [Faith]. And they seemed to be led, now by the white, now by the red, and from this one's song the others took their cue to speed up or slow down their movements. (*Purgatorio* 24.121–29)

Though the Dantean color scheme of the Virtues is only partially reflected in the outfits of the aerobic Graces—Sheri's spandex is mottled with red, white, and green, while Laurie's is emerald and Carmen's yellow—the group dynamics of the virtuous dance remain virtually unchanged in the adaptation from medieval vision to modern video. Leadership of the dance subtly shifts between two of the *donne*, Sheri and Carmen, who perform the workout at the medium and high level of intensity respectively. Laurie consistently plays the role of their low-intensity follower. Just as Charity set the tempo of the dance with her song, so Sheri acts as the "caller" of the workout with her sing-song commands. Now she accelerates the pace of the exercise during warm-up. Now she slows it for cool-down. Like Faith and Hope, Carmen and Laurie adjust their movements in tandem with their spiritual leader.

While my consumer confidence was boosted by the revelation on the package blurb that "Sheri holds a B.S. [*sic*] in Corporate Fitness," I suspected that Dante would not have recognized this odd degree as a qualification for leadership in the New Dance. The corporate fitness part he would have understood perfectly, however, since participation in the old Christian chorus required a merging of individual dancers into the mystical body of Christ where all our morally corrected limbs and musically synchronized hearts will finally move as one. But would I really "discover *all* the healthy benefits of step aerobics" (as advertised) under Sheri's tutelage? Would I step far enough into praise to receive my Glorified Body on the steps of the eternal temple? After two million kicks, leaps, and straddles toward heterosexual fitness, would I finally emerge from Sheri's workout a changed man in the deepest sense, a sodomite no more, a lean mean philistine ready for the Ex-Gay Movement?

It hasn't happened yet, I must report, though I have tried Sheri's workout several times at all three levels of intensity in the privacy of my living room. The presence of God may well surround me and my VCR, but my impenitently sodomitical soul remains unable to enjoy it at an anagogic level. What has happened at the literal level of my limbs (besides some minor weight loss) is that I have gained a new appreciation of the durability of the patristic schema of moralized motions. While Sheri's intellectual connection with Ambrose is probably tenuous, her physical command of his "movement vocabulary" is truly impressive. Every move in the old *honesta saltatio* turns up in her new aerobics routine, often highlighted by white subtitles that scroll across the bottom of the screen beneath her indefatigable feet.

"Do not bend at the waist" commands one tropological gloss on her per-

formance, its antierotic moral implications hard to miss after a millennium and a half of Christian preaching on the benefits of straightening up. Nothing could be farther from the flamboyant court of Pleasure than the tasteful bourgeois patio set in the Integrity Music studio where Sheri strictly enforces the rule of *correctio*. No lewd flexing of muscles is staged outside her prim French doors. No loose bending of limbs is permitted amid her potted ficus trees. When she warms up her girls with a few pelvic tilts—a potentially lascivious move for maidens—her goal is to stretch their lower back muscles to improve their posture. The erotic suggestiveness of certain commands ("Chest up and open," "Intensity can be increased," "Samba with Ball Change," "Over the Top Step") is instantly canceled by the militant appearance of the moral steppers. When Laurie heaves up her chest, she looks like a pyrrhic dancer training for the Psychomachia. When Sheri increases her intensity, she takes off like a rocket from her launching pad. When Carmen sambas with a ball change or takes things over the top, she keeps her spine commandingly vertical.

Though *gradus* is the basic motion moralized by the video—which effectively turns a secular step aerobics class into a sacred service of praise—*extensio, percutio*, and *elevatio* are also zealously performed throughout the routine. The simple stretching of legs and arms in the preliminary "Warm-Up Section" gives way to complex combinations of steps onto, upon, off, around, and astride the benches. Usually the step patterns begin at ground level as a steady march beside the bench but soon gain momentum as straddles, kicks, lunges, jumps, hops, and leaps are added to the exercise. The instructive camera frequently zooms in on Sheri's feet stamping the bench or kicking the air to illustrate "proper step technique." Though these closeups are clearly intended to demonstrate the perfection of her Apollonian discipline, they have the ironic effect of adding a bizarrely Dionysian touch to the dance. If Sheri were ever to leap off her bench in a bacchic ecstasy, woe betide any lustful viewer within kicking range of her super-fit legs.

Saintly stripping is the only moralized motion that appears to be absent from Sheri's workout, which is perhaps just as well considering the need to keep a counterspectacular distance between *Step into Praise* and the porno spinoffs of *The Bacchae*. The anagogic climax of the *honesta saltatio* is hinted at, however, in a shot of Carmen and Laurie adjusting their spandex tops and stretching their tights to mid-thigh before the class begins. "Wear clothes that allow your body to breathe naturally," advises Sheri earnestly as the camera zeroes in on Laurie's crotch and Carmen's calves. No Puritan maidens, they. Their fashion choices alone suggest that they are ready to bare all to the Lord —and much of their bodies to us—to celebrate the triumph of the Spirit over the Flesh. Anyone who would view their skimpy uniforms as a sign of sexual looseness or levity has clearly ignored their strict adherence to the semiotics of *correctio*. When the Christian rock hits the soundtrack and their Barbie ponytails start swinging to the beat, they look ready to accompany David behind his

Ark as well as Sheri behind her bench. To Hell with Michal's scruples about modesty in dress: when the Spirit is upon you, off with your heavy worldly robes and on with a triumphantly light second skin that allows your body to breathe *super*naturally.

How will you ever dance with Christ in your spiritual body if your fleshly body remains bound by the Devil's trappings? "The SPIRIT of the LORD is great and mighty!" booms the refrain of a rock anthem on Sheri's tape, a refrain that David himself might have chanted as he stripped down to his linen ephod: "The SPIRIT of the LORD is my victory!" As Augustine preached long ago, David was conveyed to heavenly bliss by following a certain sweet sound, a mysterious kind of delight hidden within his soul: "And when he stepped into the tabernacle with this music resounding inwardly, led by its sweetness, following its melody, withdrawing from the percussive din of flesh and blood, he came all the way to the House of God."[35] So the aerobic Christian is drawn away from the percussive din of stamping down the flesh and pumping up the blood in the House of Sheri to the sweetness of Paradise by following the guitar twangs of Integrity Music hidden within the audio band on *Step into Praise*. Without its immortal soundtrack, the video would offer as profane a workout as the vanity-driven routines of Jane Fonda and her dancing-queen rival Richard Simmons.

To feel the presence of God the aerobic Christian must do more than burn calories for Jesus, or change unsightly cellulite into hard muscle for the defence of Family Values. However praiseworthy these corporeal transformations may be in themselves—for instance, as signs of the evangelical will triumphing over the wayward flesh—they are not enough to draw the heterosexual soul out of the profane world of the Here and Now into Sheri's sacred patio at the backdoor of the Father's mansion. Hard physical labor over the aerobics bench must be also be perceived *sub specie aeternitatis*. It must be spiritually translated into divine play.

By continually impelling the aerobic Christian toward religious enthusiasm, *Step into Praise* converts the erotic drive of secular rock music and its infernal disco moves into sacred dance—a ritual of humility, chastity, and obedience prophetically rehearsing the exultant steps of Jesus and the Saved at the end of time. The apocalyptic *telos* of Christian aerobics is explicitly proclaimed in the lyrics accompanying Sheri's anagogic combination of repeater knee-lifts and over-the-top steps:

> He's turned my mournin' into dancin' again—
> Lifted my sorrow—
> I can't stay silent!
> I must sing for His joy has come!

Thus is the fatalistic seasonal round of Ecclesiastes ("a time to mourn and a time to dance") translated into a paean to the Second Coming, even as the re-

lentless cycle of the old dance of time gives way to the eternalizing "over-the-top" of the New Dance. These aesthetic conversions are experienced inwardly by the aerobic Christian as an emotional recovery, a therapy for the wounded heterosexual soul:

> Where there once was only hurt,
> He gave his healin' hand;
> Where there once was only pain,
> He brought comfort like a friend.

Rolling across the screen at this point is Sheri's favorite cue ("Intensity can be increased") which the female vocalist on the soundtrack allegorically intensifies into a prompting to agapic ecstasy:

> I feel the sweetness of His love
> Kissin' my darkness!
> I see the bright'nin' mornin' sun
> As it ushers in his joyful gladness![36]

This is about as hot as it gets at Integrity Music. The fundy version of the New Dance climaxes in the divinely ordained heterosexual union of the aerobic maenad with her male Savior, a union utterly untroubled by the threat of anarchic eroticism and perverted sexuality. Since Sheri refrains from acting out this passionate scene—she's far too polite to lurch back on her bench, with parted lips, like Saint Theresa on her cloud—orgasmic abandon must remain only a mystical possibility for her and her step class. In fact, the possibility is no sooner expressed than it is veiled in the postcoital glow of theophanic metaphor. The fallen female body lurking under the unitard becomes a Dionysian "darkness" awaiting the penetrating rays of Apollo-Christ. When the Sun God appears in the rapturous finale of history, his rays will dispel the shadow of death and usher in the brightening morn of everlasting life. Until then, like the Bride in the Song of Songs, Sheri must pace about her *hortus conclusus* burning with zealously sublimated desire for the Bridegroom who'll come leaping for the aerobic benches and tripping over the doorsills to bring "comfort" like a friend.

In sharp contrast to *Gay Rights/Special Rights*, *Step into Praise* appears to be utterly innocent of history. Though a copyright date appears on the tape after the final credits as well as in small print on the back of the package—it just happens to be the catastrophically "queer" year 1993—nothing is made of this production fact within the performance itself. Though Sheri may have encountered a few lesbian gym teachers in her climb up the corporate fitness ladder, she seems blissfully unaware of the March on Washington for Lesbian, Gay, Bisexual, and Transgendered Rights. No twisted parallels between 1963 and 1993 appear to trouble her fervent meditations on the proper execution of a samba with a ball change. No flashbacks to the civil rights marches interrupt her over-the-top straddles. No dancing queens parody her pelvic tilts. So insu-

lated is her privileged domestic world from the social justice movements that have "shocked" America in the anti-gay videos that she seems to step into praise by stepping out of time. In fact, no historical movements of any sort impinge on her spiritual dancing-ground—not even the history of movement itself, the diachronic study of dance. She is no Martha Graham in Nikes, reacting to the Apollonian strictures of traditional ballet technique. Her triumphant vision of Christian fitness is utterly untroubled by backward glances to the good old days of eurhythmic exercise and heterosexist health under the Third Reich.

As a counterspectacle designed to convert worldly spectators into otherworldly dancers, *Step into Praise* proceeds in its own little self-contained present—an immediate "now" for which no shadowy "then" is presented as a contrastive parallel. The aerobic Virtues have no past when they were fat and unfit, no personal history from which "before" photos might be culled to provide a dramatic foil to their aerobicized "after" lives. Their souls need only justification on the Last Day to attain perfection. Their bodies are practically perfect now. By making that "now" endlessly repeatable through the push of a rewind button, video technology has granted the fat and unfit (not to mention the gay and ungainly) a miraculous opportunity to participate in Sheri's next-to-blessed state, to share her motivating belief that the sinful past can be erased through a transcendent leap into the presence of God.

Rewind the tape, and the *honesta saltatio* begins again as if there had been no previous performances of it. God has the master tape of the whole performance, of course, but the righteous consumer may be assured that the bright dawn of heterosexual fitness will not fade even after endless reproductions of *Step into Praise* have been manufactured for sale in evangelical outlet malls. Repeated screenings of it only heighten the transfigured sense of the present afforded by Integrity Music's resolute suppression of the past. The vanishing of cultural memory into one little cassette—the memory of David's spiritual leaps, Ambrose's moral stretches, Augustine's choral marches, Dante's measured steps—does not mean that the old allegory of moralized motions has been lost or superseded in the counterspectacle of Christian aerobics. Quite the contrary. Nothing confirms its persistence more clearly than Sheri's unwitting adherence to its apocalyptic dictates. Even as the dancing queens bend their bodies into figures of damnation, so the aerobic Virtues stretch theirs into the very shape of beatitude. Their morally divergent dances spring from the same tropological origin in Christian Antiquity and reach the same transcendent conclusion in Christian Apocalypse. If the "absence of past performance is marked by its flagrant returns," as Mark Franko and Annette Richards have argued, then no returns have been more flagrant in the radically erasing presence of contemporary dance than theirs.[37]

NOTES

1. "Facing Death," *Newsweek* (July 28, 1997): 20–30; Richard Alleman, "Glamour after Dark: From 'A-gays' to Young Hustlers, a Look at the Homosexual Scene," 28–29.

2. *Enarratio in Psalmum XLI* [42], 9 "nec exhibent membra sua arma iniquitatis peccato, sed exhibent Deo vivo in bonis operibus": *Sancti Aurelii Augustini opera omnia*, ed. J.-P. Migne, *Patrologia Latina* 36 (Paris: Migne, 1841), col. 469. All translations from Latin, Greek, and Italian in this essay are my own.

3. For the earliest (and still the direst) example of theater-bashing in the Latin Christian tradition, see Tertullian's *Liber de spectaculis*, ed. J.-P. Migne, *Patrologia Latina* 1 (Paris: Migne, 1844), col. 627–62.

4. On stretching as an ascetic endurance test, see Augustine's *Enarratio in Psalmum XLI*, 9, *Patrologia Latina* 36, col. 470, "extendentem se ad omnia aspera et dura toleranda"; on David's lack of embarrassment, see Ambrose's *Epistola LVIII* 4–6 in *Epistolarum classis I, Sancti Ambrosii omnia opera*, ed. J.-P. Migne, *Patrologia Latina* 16, col. 1179.

5. *Patrologia Latina* 14, col. 322–23.

6. *Patrologia Latina* 16, col. 45.

7. *Sermo "In natali Cypriani martyris"* 111.7 "exhibuit se, non corpore, sed mente saltantem": *Patrologia Latina* 38, col. 1416. For the Neoplatonic background of the idea of mental dancing, see James Miller, *Measures of Wisdom: The Cosmic Dance in Classical and Christian Antiquity* (Toronto: University of Toronto Press, 1985), 200–32, 434–49.

8. Whether enacted *corporaliter* or envisioned *spiritaliter*, a "counterspectacle" is a morally uplifting performance designed to rival and displace the tempting shows of the World, the Flesh, and the Devil. An "antispectacle," by contrast, is an idolatrous or blasphemous exhibition opposed to the moral ethos of Ecclesia. While antispectacular moralists simply oppose the Theater to the Church, counterspectacular moralists create a new sacred Theater within the Church by converting certain traditional aspects of stage performance (such as choral dance) into show-stopping productions of Christian virtue.

9. *Patrologia Latina* 16, col. 508. For a Gnostic version of Christ's piping and dancing in the Apocryphal Acts of John, see Miller, *Measures of Wisdom*, 81–139.

10. Plotinus, *Ennead* 1.8.2: "ex then peri touton choreuousa." For a translation and discussion of this passage, see Miller, *Measures of Wisdom*, 206–8.

11. *Enarratio in Psalmum XLI* [42], *Patrologia Latina* 36, col. 469; *Enarratio in Psalmum XCLIX* [150], *Patrologia Latina* 37, col. 1953.

12. Philo, *On the Life of Moses* 2.7. For a discussion of the spiritual character of the Mosaic dance in Philo's commentaries on the Pentateuch, see Miller, *Measures of Wisdom*, 64–69.

13. *Expositio Evangelii secundum Lucam* 6.8, *Patrologia Latina* 15, cols. 1670–71.

14. *Patrologia Latina* 36, col. 469.

15. *Enarratio in Psalmum CL* [149], 5–6 "nam vox est in choro, flatus in tuba, pulsus in cithara; tanquam mens, spiritus, corpus": *Patrologia Latina* 37, col. 1965.

16. *Patrologia Latina* 16, col. 45.

17. *Sancti Aurelii Augustini opera omnia*, vol. 1, Benedictine edition (Paris: Gaume, 1836), col. 384. Compare this meditation on love with Augustine's recollections of the love tragedies danced out on the Carthaginian stage in *Confessions* 3.2, cols. 162–64.

18. *Patrologia Latina* 34, cols. 39–40.

19. The nouns *saltatio* and *saltator* spring from the verb *saltare*, which descends from the noun *saltus* ("single leap" or "series of hops, skips, leaps"). *Saltus*, in turn, derives from the highly active verb *salire* ("to jump" or in erotic contexts, "to hump"). A *salax* was a lusty leaper, whence the modern adjective "salacious." From *salire* and *saltare* descends a large family of composite verbs, including *exsilire* ("to spring out") and *exsultare* ("to leap wildly, run riot") and *praesultare* ("to leap before"). From the latter comes the noun *praesul* ("one who leaps and dances before a procession") which denotes a high priest in pagan contexts and in later ecclesiastical usage a bishop.

20. *Patrologia Latina* 15, col. 1290.

21. *Patrologia Latina* 36, col. 425.

22. *Patrologia Latina* 16, col. 228.

23. *Epistolarum classis I, Epistola* 18.4, *Patrologia Latina* 16, col. 1179.

24. On the patristic image of the feet of the soul, see John Freccero, "Dante's Firm Foot and the Journey without a Guide," *Harvard Theological Review* 52 (1959): 245–281. This image, I suspect, was an extension of the allegory of moralized motions.

25. *De civitate Dei* 22.30, *Sancti Aurelii Augustini opera omnia*, vol. 7, Benedictine edition, cols. 1112–13.

26. Dante Alighieri, *The Divine Comedy*, vol. 1, *Inferno*, translation and commentary by Charles S. Singleton, Bollingen Series 80 (Princeton: Princeton University Press, 1970). Though the translations from Dante in this essay are my own, Singleton's renderings and grammatical notes have aided me at every turn. On the classical source of Dante's use of the noun *regina* ("queen") to signify "same-sex lover," see Singleton's note on *Purgatorio* 26.77–78 in *Dante Alighieri: The Divine Comedy*, vol. 2, *Purgatorio* (commentary), Bollingen Series 80 (Princeton: Princeton University Press, 1973), 633–34.

27. On medieval definitions of sodomy, see John Boswell, *Christianity, Social Tolerance, and Homosexuality* (Chicago and London: University of Chicago Press, 1980), 203–5, 280, 289, 293, 375–78.

28. On sodomy as an evil penetration of the intellect by pagan philosophical doctrines, see Elio Costa, "From *locus amoris* to Infernal Pentacost: The Sin of Brunetto Latini," *Quaderni d'Italianistica* 10 (1989): 109–32.

29. On Virgil's love for his slave Alexander, the long-suspected prototype for Alexis in *Eclogue* 2, see Gregory Woods, *A History of Gay Literature: The Male Tradition* (New Haven and London: Yale University Press, 1998), 39–40.

30. "When Dante states his own wish to 'throw' himself 'down there among' the sodomites immediately following Rusticucci's pronouncement, he both identifies his own desire with those that led the Florentine to leave his wife and, by his own admission, comes very close to abandoning his visionary quest for Beatrice in favour of the company of the sodomites," argues Bruce W. Holsinger in "Sodomy and Resurrection: The Homoerotic Subject of the *Divine Comedy*," in *Premodern Sexualities*, ed. Louise Fradenburg and Carla Freccero (New York and London: Routledge, 1996), 251–52.

31. Andrew Holleran, *Dancer from the Dance* (New York: Plume, 1978), 227. On the theological implications of this remark, see James Miller, "Dante on Fire Island: Reinventing Heaven in the AIDS Elegy," in *Writing AIDS: Gay Literature, Language, and Analysis*, ed. Timothy F. Murphy and Suzanne Poirier (New York: Columbia University Press, 1993), 268–69.

32. Lines 63–64: "O body swayed to music, O brightening glance, / How can we know the dancer from the dance?" By citing the entire eighth stanza as the epigraph for Malone's story, Holleran renders deeply ironic (in a Sutherlandian way) Yeats' mystical vision of a beauty not "born out of its own despair."

33. Holleran, *Dancer from the Dance*, 234.

34. Felice Picano, *Like People in History* (Harmondsworth and New York: Penguin,

1995), 267. For Picano's visionary translation of a mirrored disco scene at the Fire Island Ice Palace into a cosmic dance prophesying the AIDS crisis, see *Like People in History*, 338–39.

35. *Enarratio in Psalmum XLI* [42], 9 "abstrahens se ab omni strepitu carnis et sanguinis, pervenit usque ad domum Dei": *Patrologia Latina* 36, col. 470.

36. "The Spirit of the Lord," lyrics and music by Billy Funk (1992), Integrity's Praise! Music/BMI; "Mourning Into Dancing," lyrics and music by Tommy Walker (1992), Integrity's Praise! Music/BMI.

37. See introduction to the present volume, p. 8.

CONTRIBUTOR BIOGRAPHIES

KAREN BASSI is associate professor of classics and pre- and early modern studies at the University of California at Santa Cruz. She is author of *Acting Like Men: Gender, Drama and Nostalgia in Ancient Greece* (1998).

JOHN BUTT is university lecturer and fellow of King's College, Cambridge. He is the author of *Bach Interpretation* (1990) and *Music Education and the Art of Performance in the German Baroque* (1994), and is the editor of the *Cambridge Companion to Bach* (1997). He is currently working on a study of the philosophy and criticism of historical performance practice, and maintains an active career as a performer on the organ and early keyboard instruments.

MARY CARRUTHERS was born in India of medical missionary parents, and educated in India, Canada, and the United States. She is professor of English and director of the Center for Research in the Middle Ages and the Renaissance at New York University. Her publications include many books and essays on medieval English and Latin literature and on the history of rhetoric and language theory during the Middle Ages, including *The Book of Memory* (1990) and *The Craft of Thought: Meditation, Rhetoric, and the Making of Images, 400–1200* (1998).

CAROLYN DEAN, assistant professor of Art History at the University of California, Santa Cruz, researches pre- and post-Hispanic visual culture. Her book, *Inka Bodies and the Body of Christ: Corpus Christi in Colonial Cusco, Peru* is forthcoming.

MARK FRANKO is author of *Dance as Text: Ideologies of the Baroque Body* (1993), *Dancing Modernism/Performing Politics* (1995), and *The Dancing Body in Renaissance Choreography* (1986). He is a choreographer, director of the dance company NovAntiqua, and professor of dance and performance studies at the University of California, Santa Cruz.

SUSAN MCCLARY teaches musicology at UCLA, where she specializes in the cultural criticism of music. She is best known for her book *Feminine Endings: Music, Gender, and Sexuality* (1991), which examines cultural constructions of gender, sexuality, and the body in various musical repertories. McClary was awarded a MacArthur Foundation Fellowship in 1995.

JAMES MILLER is professor at the University of Western Ontario and founding director of the UWO Research Facility for Gay and Lesbian Studies. He is the author of *Measures of Wisdom: The Cosmic Dance in Classical and Christian Antiquity* (1985) and the editor of *Fluid Exchanges: Artists and Critics in the AIDS Crisis* (1992). He is looking forward to several centuries on the Cornice of the Lustful in Purgatory after completing his current project, a collection of dangerous essays entitled *Dante & the Unorthodox*.

ANNETTE RICHARDS teaches musicology at Cornell University and pursues an active concert career as an organist. She writes on eighteenth-century musical culture, aesthetics, and criticism, and is the author of *Fantastical Landscapes: A Theory of the Musical Picturesque* (forthcoming).

SHELBY RICHARDSON is a doctoral degree candidate in English at Tulane University. She has worked extensively on the novels of Frances Burney and is currently explor-

ing the writing of Renaissance author Mary Wroth. Her other areas of interest include early medical and magical practices in England through the eighteenth century.

JOSEPH ROACH, professor of English and theater studies at Yale University, is the author of *The Player's Passion: Studies in the Science of Acting* (1993) and *Cities of the Dead: Circum-Atlantic Performance* (1996).

CATHERINE M. SOUSSLOFF is the author of *The Absolute Artist: The Historiography of a Concept* (1997) and the editor of *Jewish Identity in Art History: Discourse in the Modern Era* (1999). She has published and lectured on a wide variety of topics related to early modern art theory, European aesthetics, and Jewish identity and visual representation. She is professor of art history at University of California, Santa Cruz.